The Journey Home

My Life in Pinstripes

Jorge Posada

with Gary Brozek

HARPER LUXE

An Imprint of HarperCollinsPublishers

PARA MI FAMILIA.

MY MOTHER, MY FATHER, MY SISTER, LAURA,

JORGE, AND PAULINA. YOU ALL TAUGHT ME SO MUCH,

ESPECIALLY HOW TO LOVE.

All photographs are courtesy of the author unless otherwise indicated.

THE JOURNEY HOME. Copyright © 2015 by Jorge Posada. All rights reserved. Printed in the United States of America. No part of this book may be used or reproduced in any manner whatsoever without written permission except in the case of brief quotations embodied in critical articles and reviews. For information, address HarperCollins Publishers, 195 Broadway, New York, NY 10007.

HarperCollins books may be purchased for educational, business, or sales promotional use. For information, please e-mail the Special Markets Department at SPsales@harpercollins.com.

FIRST HARPERLUXE EDITION

HarperLuxe™ is a trademark of HarperCollins Publishers

Library of Congress Cataloging-in-Publication Data is available upon request.

ISBN 978-0-06-239284-8

15 ID/RRD 10 9 8 7 6 5 4 3 2 1

Contents

Prologue
The Pile

In 2009, a few days after we'd won the World Series, I was out with my family enjoying a celebratory dinner. We were heading home to South Florida in a few days, and it felt good to have the season over and to be enjoying a warm late fall evening. After we finished, Laura and I sat while Jorge Jr. and Paulina spooned up some ice cream. I saw the look of mischief in my daughter's eyes, shook my head, and whispered, "Don't even think about it." She went back to using her spoon as she was supposed to, instead of as a launcher.

When we stood to leave the restaurant, a man came up to me, his Yankees hat in his hand. I appreciated that he'd waited for us to finish before approaching.

"Jorge, excuse me, but I was hoping you could . . ."

He held out the hat and a silver marker.

"Of course." I took the hat and signed it.

"I'm a huge fan," he said, nodding over to where his family sat. "My wife did a great thing for me this year. I don't know how she did it, but she got us seats for our anniversary. Section 20. Right behind the plate. Best seats in the house. I could see everything, just like you."

"It must be great back there," I said and handed back his hat.

"The whole field is spread out in front of us. Amazing. Thank you and congratulations."

He was right that it's amazing to have nearly every part of a baseball game play out in front of you—the view from that part of the stadium is remarkable— but he got one thing wrong: I had the best seat in the house, on that night and every night I sat behind home plate. If he thought that those seats in the Legends section of the new Yankee Stadium made him feel like he was a part of the action, imagine what it was like for me to squat behind the plate and participate in every pitch.

I always wanted to play in the big leagues. It was a desire that my father planted and nurtured in me from a young age. "Planted and nurtured" may not be the best expression because it might make you think of someone working in a pretty garden raising flowers. What

I went through, starting as a small child, was more like a farmer rising very early every day and working his butt off in the heat, the sun, and the rain and enduring whatever else Mother Nature threw at him.

When I think of my career with the Yankees and remember those games from behind the plate, I see Mariano's cutter splintering another bat, Derek cruising into the hole, Bernie stalking a fly ball into the gap, Clemens scowling over the top of his glove, Andy smiling as another double-play ball wraps up an inning, the dog-pile near the mound as we celebrate another World Series win. What may not make sense is that there are many times when those images get edged out by visions of another kind of pile.

In 1983, I was 12 years old. I woke up one summer morning to a whining sound and regular beeps coming from in front of our house in Santurce, Puerto Rico. I looked out the window and watched as a dump truck backed up our driveway. Seconds later, its bed rose in the air and an avalanche of dirt, the color of terra-cotta tile, puked onto our driveway. I felt each clod hit me in the pit of my stomach. This was not good.

I quickly got dressed and went into the kitchen. My mother, Tamara, was busy at the stove, and the sound of something sizzling made it hard for her to hear my whispered question: "*¿Que pasó? ¿Donde está Papí?*"

Almost on cue, my father came in. He tucked a paper into the pocket of his guayabera shirt and then nodded his head toward the door that led from the kitchen to the backyard.

"*¿Lo ves?*" He held his arm out to indicate our backyard, an expanse of scrub grass that ran downhill from the house.

"*Sí*," I said, wondering why he was asking me if I saw what was obvious.

Without another word, he led me around the side of the house to the driveway. Again we stopped and he pointed: "*¿Lo ves?*"

I looked at the pile of dirt that rose above the level of our single-story home's roof.

I felt my heart drop.

"*Sí. Lo veo.*" Something told me that I wasn't just out with my father to test my vision.

He went on: "*Tienes que mover la tierra para la parte de atrás de la casa.*" He pointed at the pile and then moved his head, indicating the backyard. "*Para nivelar el terreno.*" He ran his hand parallel to the ground to indicate what my task was.

"*Tienes dos meses.*" He held up two fingers, and I understood that I would be hauling dirt from the driveway to the backyard for essentially most of my summer vacation.

"*El trabajo será bueno para usted.*" My father flexed his biceps and nodded at me.

I stood there shaking inside, thinking that this was some kind of punishment and not work. I didn't dare to indicate my displeasure, my disbelief, my feeling that, if I could, I would use that dirt to bury this man, not to level off our backyard. My father walked around the pile and disappeared for a moment. I took the opportunity to shake my head in disgust. What was I going to tell my friends when they wanted me to go to the beach with them? Or to the club? Or even just to ride our bikes?

My father came back, pushing a wheelbarrow. In it lay a shovel. I started grabbing handfuls of the dirt. Surprised by how cool and slick the dirt was, I dropped each handful into the wheelbarrow. Nearly as much stuck to my hands as landed in the wheelbarrow. I took a quick glance at my father, who stood there with a "how could this boy be so dumb?" expression on his face. I grabbed the tool and jabbed it into the ooze. It resisted my efforts. I dug in again. I hoisted the full shovel and felt it strain against the muscles of my arms and shoulders. I lifted it over my head and shook it, seeing the few clods tumble into the wheelbarrow.

My father went back into the house. I shut my eyes and brought my hands to my face to press them against

my eyes and shut out the frustration and anger welling inside me. I'd show him. I'd get this job done in no time. I wouldn't let him take my summer of fun away from me.

For the next two weeks, I went after that dirt pile with a vengeance. With the exception of breaks for lunch and dinner, I dug into that pile hour after hour, both cursing and being grateful for the daily rains. The rain washed away some of the dirt in a red bloodstream down our driveway. After the rain, the sun baked that pile into a hardened mass, a kind of upside-down clay pot that I had to hammer at.

At 12, I was a skinny kid with spindly arms and legs, built like a spider with a not very substantial torso. Initially, I thought that wheeling the dirt would be the fun part. It wasn't. Gravity was a fierce opponent. The handle of both the shovel and the wheelbarrow tore at my skin.

Even though I got used to the routine of the work, at that time—and for a long time after—I didn't appreciate my father giving me that task, let alone understand why he made me take it on. On my worst days, I'd return to the house vowing that I would never touch that pile of dirt again—I didn't care what my father did to me.

As always, my mother was there for me. She treated and dressed my wounds. She assured me that I'd be

okay. At night, after I'd gone to bed, I heard her take up my case for me.

"He's a boy. This is so hard."

"Leave it alone. I know what I'm doing."

Like me, my mother knew it was best to drop it. Just like that earth that solidified in the driveway, over time my father would become an even more solidified and unmovable object. His stubbornness was legendary.

In the end, I finished the task in a few weeks instead of all summer. (My stubbornness was like my father's.) I'd like to tell you that I celebrated and felt a great sense of accomplishment, but all I felt back then was relief that the ordeal was over and regret that it had been a waste of my time. I wanted to be with my friends and forget the whole thing had ever happened.

Now as I sit here, 31 years later, a tear comes to my eye as I think of those days. The tears come from a mixture of anger and gratitude. I understand better what my father was teaching me, because it was in that backyard and other places around Puerto Rico that my dreams took hold. I recognize now that the summer of '83 was just part of my education as a man and as a ballplayer.

In time, my hands stopped hurting and my grip—on any handle but also on what life is really like—got stronger. During my 17 years in the big leagues, I never wore a batting glove—after that summer spent

with a wooden shovel in my hands, I didn't want anything to come between the feeling of that wooden bat and me. Over the course of that summer, wheeling the dirt became easier. I developed strength in my arms, shoulders, and back; my balance improved; and my legs got stronger. I was just starting the transition from spindly little kid to young man. More than that, I used my stubbornness and my passion in a positive way to get something done.

My reward for my hard work? The morning after I finished, I saw on the back patio a stack of paint cans, brushes, scrapers, and sheets of sandpaper. I shut my eyes and waited, knowing that my father would join me in a few moments to tell me what was next.

From the day I was born and throughout my adult life, my father wanted me to be a ballplayer. I was enrolled in a very special kind of school run by my father, Jorge Luis de Posada, a Cuban refugee who endured more than I ever knew or experienced as a kid. Because of the lessons he taught me—about the game, about how to approach life—I had the foundation I needed to succeed in attaining that goal. I learned those lessons early and then applied them as a way to get to the top of my profession.

I am incredibly privileged to have played for the New York Yankees at a time when we enjoyed so much

success. I was fortunate to come to a city that I came to think of as my home away from home and to play in front of the most passionate, knowledgeable, and loyal fans in the country. Living and playing in New York let me experience some incredible moments off the field—the highs of riding down the Canyon of Heroes in a shower of ticker tape, as well as the lows of being present when the country I'd come to love was attacked.

But I was also lucky to have a father who cared so passionately about my success and about me. He knew a lot about the game of baseball: he played it in his youth and young adulthood in Cuba and served as a major league scout. Baseball was in my blood and in my house. It still is, and I feel privileged to work with my son, Jorge Jr., as he refines his skills.

I also recognize this: I wouldn't have enjoyed the life I've lived as a Yankee and as a man if it weren't for my mother and father. That pile of dirt and clay was a lot like me—it took both my parents to get it moving, to make it useful, and to transform it. That's what my mother and father—and later other men like Joe Torre—did for me. My father especially taught me this: life seldom presents you with a level playing field. If you work hard enough, believe in yourself enough, and have enough passion and stubbornness, you can level that field yourself.

In the pages that follow, I'm going to take you back with me, giving you the best seat in the house so that you can see the world from behind the mask. I had a great view of an amazing era in Yankees history. It could have been greater, and that's part of the story as well. It's no secret that I hated to lose. My dad taught me that, but he added this: if you hate it so much do everything you can so you don't. I feel like we're losing time; let's play ball.

Chapter One
Bad Boys

I don't think that anybody is born to play a certain position, but I do know this: when I came into this world on August 17, 1970, there was at least one person who believed that I should be a ballplayer. That was my father. He was so excited to have a son, and he told my mom, Tamara, that he was going to make me into a ballplayer. I'm sure that lots of fathers have big dreams for their children and they all want them to succeed. I'm not sure that all of them have a plan in mind, though, or are willing to take the steps my dad did to ensure that their vision becomes a reality. Mine was.

As I kid, I wondered how I could live out such a big dream when I was one of the smallest in my grade. I also wondered how I could ever be as accomplished an athlete as my father was. My father didn't brag, but

we had two large albums filled with yellowing pages of newsprint that showed all the things my father had done as an athlete while living in Cuba. One was for "before" and the other "after." The big event in the middle that helped define those two words was Castro's take-over of the nation that my father's family had loved and enjoyed living in for generations. My paternal grandfather had worked in sales for a pharmaceutical company. He drove himself hard to make a good life for his wife, son, and three daughters. He was not around much because of his devotion to his job, but my father learned from his example. No one is going to hand you anything in this life; if you get ahead it is because you wanted to be proud of yourself and what you were able to do for your family. My grandfather was a good track athlete in his day, running 5,000-and 10,000-meter races where endurance mattered as much as speed.

In looking at the "before" scrapbook, I didn't fully understand that sometimes circumstances could occur to take things away from you. What I saw was an account of my father setting a national record in the breaststroke, leading his team to a win in basketball, and making a name for himself in baseball to the point that a Philadelphia A's scout who came to see another player noticed my father's hustle and talent and offered

him a contract. For a long time, I didn't understand why it was that my father signed that contract but never got to play. I didn't think too much about what that said about him. I was mostly interested in charting my father's physical development. I was always the smallest in my grade, a skinny kid with thin limbs. My dad had looked the same way in the early photographs of him as a swimmer, but over the years he became taller and broader and I hoped that I would take after him. I also hoped that one day I'd be able to fill two scrapbooks with my achievements.

Well before I could read and think at all about my dad's past and how he was influencing my present and my future, I was already in love with baseball.

I just loved swinging a bat and watching the ball fly off it in the Puerto Rican sky. I was spending time with my dad, and that was a good thing. Eventually I'd make friends in the neighborhood and also learn to toss the ball to myself and hit mini-versions of fungoes, but almost all of my earliest memories of my dad revolve around either playing or watching baseball together.

My dad wasn't big about telling me why he had me do some of the things he did. He was more like that quiet guy in the clubhouse who chooses to lead by example. I knew that my dad worked hard, doing a bunch of different jobs to make a living for us. We lived in a nice

house, my dad drove a car, and he left every day early in the morning, came home around dinnertime, and frequently went out again. During the days, my father worked for Richardson-Vicks, a pharmaceutical company, and later for Procter & Gamble. He also coached baseball and basketball, played softball a couple nights a week, and seemed to be in constant motion. Along with his regular job, he sold cigars and baseball gloves to make more money. A few times he made brief mentions of how he had once gone without food, but I never experienced anything like that. Christmas was always a big deal and I can still picture my first bike—a Tyler bike—and my Ford Mustang pedal car. Our car always smelled of leather and cigars—not from armchairs or upholstery but from baseball gloves. To this day, if I could, I wouldn't mind having the scent of baseball gloves piped into my house. I can still remember sitting there with some of those gloves, trying to figure out what those letters meant. H-E-A-R-T-O-F-T-H-E-H-I-D-E and E-D-U-C-A-T-E-D-H-E-E-L were my first spelling lessons in English.

Sometimes my dad would take me with him on those after-work sales calls, and I'd sit there watching the palm trees and the hills pass by as we drove around. I'd sit in the car sometimes and watch him hustle away, gloves and boxes of cigars tucked under his arm, him

looking like a running back busting through a hole in the line. He wasn't a big guy—five feet nine inches—but very muscular.

My mom was always home with me; in fact, she didn't learn to drive a car until I was in my midteens. Eventually my sister, Michelle, came along, four years later, in 1974. About the time she was born my dad was doing some part-time scouting for the Houston Astros, then later on for the Yankees, and then the Blue Jays. He'd be away on those trips, but never for very long. When I think of those days now, it was like I lived in two different houses. The one I spent time in with my mom and sister had a lot of light and air and laughter in it. In a way, it was like a classroom when the teacher isn't present. When Dad came home, it wasn't like everything got dark and suffocating, but we all came to attention, sat up straighter, and wiped those goofy smiles off our faces. My dad commanded respect, and over time I'd learn to fear him as well.

If I associate my father with the odors of leather and tobacco, my mom reminds me of the mouthwatering cooking smells of *arroz con frijoles negros, carne,* and *platanitos.* My dad worked hard to provide for us, and my mom worked hard to keep us well fed and neatly clothed. She was from the Dominican Republic, and she had brought her favorite recipes with her. The

best things she brought with her were her parents, my grandmother Lupe and my grandfather Rafael. To give you an idea how close I was to them and how different my relationship with them was, I called him Papí Fello and her Mamí Upe.

I spent a lot of time with them both, until Papí Fello died when I was eight. Mamí Upe remained a big part of my life well into my adulthood. I loved that woman so much. Every summer when I was growing up we would travel to Dominicana—Santo Domingo, to be precise—to spend time with the two of them. Also, before and after Papí Fello died, Mamí Upe would come to Puerto Rico to spend a few weeks and sometimes a couple of months with us.

Latin Americans have a reputation for being passionate and sometimes loud people who talk over one another and break into song and start dancing at any moment. That was Mamí Upe, a walking, talking, clothes-making, cooking Carnaval Ponceño of a grandmother. She came in and made life fun for us, and when she left, the Lent of the rest of our lives returned and we gave up a lot of our festive nature until her return. She told us great stories about her life and the rest of the Villeta family, including my aunts Madrinita, Leda, Mili, Nora (whom I called Nona), and my mom. I especially loved the stories she'd tell about going to the

National Parade in Santo Domingo, the oldest carnival celebration in the Americas. Her eyes would light up when she told us about the Diablos Cojuelos—people dressed in elaborate costumes that suggested the Devil and his helpers.

She'd sit there sipping her rum and milk, her high-pitched voice rising and falling as she described being chased along the Malecón (the waterfront) by these devilish characters with their huge teeth and gaping mouths. She'd take a big gulp of her drink and sit there laughing, her shoulders heaving, and she'd pat her leg and I would climb into her lap, the sweet and sharp smell of alcohol and milk and the sound of her wheezing breath forming a pleasant cloud around my head. She'd tuck me in at night, making sure that I said my prayers. I can still picture her stopping at the doorway after the lights were off. I waited for her to mouth the words "*Te amo*" before I'd shut my eyes.

She always told me how handsome I was, and that was good to hear since at school I was teased constantly with the nickname "Dumbo" because of my protruding ears. If life with my father on his return to the house was like a classroom falling silent when a teacher enters the room, then life when Mamí Upe left was a necessary but no fun post-party cleanup. Then, a few days or even weeks later, you'd come across something

you hadn't picked up and you'd smile, thinking of how great that night was.

Like my dad, she was tough. My mom didn't drive, so we only had the one car. To get groceries I'd take my bike with a basket attached to the handlebars several times a week and sometimes several times a day. But when Mamí Upe was there, we'd all walk to the grocery store sometimes as much as three times a day. Kid miles are different from real miles, but it didn't seem like it was that long of a trip. I remember Mamí Upe and me, both at home and in the DR, walking along together, her with bunches of groceries under her arms and one hand on my shoulder, steadying me and making sure I didn't wobble into traffic.

Those trips to Santo Domingo weren't quite as much fun for me. I enjoyed being with her, but my cousins were all girls, so my baseball obsession had to be put on hold. Not entirely though. I'd listen to games on the radio with Papí Fello. He was a huge baseball fan, so when he was still alive things were better on that front. He told me that I was lucky that my father was Cuban—after all, the Cuban exiles who fled the Ten Years' War that lasted from 1868 to 1878 had brought the game with them to the DR. He was a big fan of one of the four original professional teams that made up the Dominican league, Los Tigres del Licey. They

were kind of like the Yankees of their day (the 1920s) and were so dominant that the owners of the three other teams in the league decided that to make things more competitive they'd create another team formed with their best players. That team was Los Leones del Escogido.

"Tigers" and "Lions" were great names for those teams, but when I heard more about another dictator and his role in baseball, it was like my mind shut down. I knew that Rafael Leónidas Trujillo was someone important, but I wasn't all that interested in my grandfather's history lessons about Caribbean baseball. I loved the game, but the politics of it just didn't matter to me then. Later on, I'd appreciate a bit more the history of baseball in my region. But my young mind was on baseball played on a continent not too far from where I lived.

When I was back in Puerto Rico with my two best friends, Manuel, who lived across the street from me, and Ernesto, who lived next door, we played baseball with a plastic ball and a stick every chance we got. I don't think I understood this at the time, but I was fortunate that Ernesto was two years older and Manuel one year older than me. I could hold my own against them, and playing against kids who were more physically mature helped me. It also established a pattern

that stayed in place for nearly my entire baseball career. No matter the team I played on, no matter the league, I was never the superstar, the stud, the phenom that a lot of big league players were. Along with what my father was teaching me about hard work, I realized that because I wasn't as gifted as everybody else, I had to work hard, but also that my passion for the game could help me overcome some of my deficiencies.

I was kind of a skinny version of a bobble-head doll with a tiny body and an oversized head. I'd eventually catch up to everyone else physically, but it wouldn't be until late in my high school days.

When I was in the backyard with Ernesto and Manuel, I wasn't thinking about any of that. I was just thinking that I was lucky to be able to scrounge up the materials to make baselines in the grass with house paint, install a home plate, a pitching rubber, and bases I "borrowed" from my dad.

We had some unusual ground rules in my home park. A ball hit onto the roof of the house was an out because the ball would get stuck on the flat roof and we'd have to suspend the action for a bit while someone climbed up there to get it. We had some iron grates that ran around the house; hitting the ball over the grate was a home run, hitting it on a fly was a double, and bouncing one off it was a single. Talk about having

to have good bat control. A homer required just enough power, but not too much.

I liked pitching just enough as well. There were instructions on the box about how to hold the Wiffle ball in your hand to get it to move certain ways, but mastering the art of the Wiffle ball didn't interest me. I didn't get nearly the same sense of satisfaction when I heard the sound of a bat slicing through air when no contact was made as I did when I heard the sharp plastic *thwack* of a well-struck ball. That didn't mean that I never tossed a ball around. I did that constantly, even in the house, lying in my bed and tossing a baseball off the ceiling and letting it plop into my glove. That thumping sound was always followed by my mother's voice, "Ay, Jorge. Leave the ball alone." My mother supported my baseball habit as much as my dad did, but they each had different limits. My mom was okay with me getting off the bus and dashing into the house, tossing my books down, and going out to play. She just didn't want to have to hear that constant thumping and have to clean up the ball marks on the ceiling.

Even then, I saw a big difference between throwing something and pitching a baseball. If I didn't love pitching, I did love throwing a ball or just about anything. I could spend hours in the backyard tossing rocks at various targets. As I got older I enjoyed games

of burnout with my teammates and friends. The object is to throw the ball as hard as you can so that you hurt the hand of the guy you're playing against. As you get older and more accurate, you add the element of hitting the target your opponent holds. If he has to move the glove to catch the ball, you don't earn any points. I could also make myself dizzy-sick by tossing pop-ups into the air and running to catch them.

Sometimes people not directly involved in our games became my opponent. Because of the way my field was set on our property, we had our own version of a quirky Green Monster—hitting one over this fence resulted in an out because it was the worst possible outcome: the fence bordered the home of a cranky guy who didn't want anybody in his yard. He was unpredictable. Sometimes he'd be cool and he'd toss the ball back to us. Other times he'd toss the ball onto the roof of his house and stand there with his hands on his hips, daring us to come over onto his property.

Once, when I was about eight or nine, Mamí Upe was visiting and I was out in Jorge Posada Jr. Stadium playing with my two buddies. I threw a nasty rising fastball in on Manuel's hands, and he fouled it back. I sank to my knees as the ball landed in Mr. Mad Man's yard. We called out to him, and he slid his patio door open and rubbed the palms of his hands in his eyes.

His dog, a standard poodle that was nearly as tall as me but very friendly, trotted alongside my neighbor as we walked over to where our Wiffle ball lay. Without saying anything to us, he picked up the ball and handed it to his dog. In a few seconds that perfectly round ball was a flattened disk of slobber and plastic.

I couldn't believe it. We all stood there muttering "*Dios mío*" and a lot worse under our breath. Mr. Mad Man walked back inside his house and shut the door. We had a couple of other balls, but they were scuffed up and one was held together with electrical tape. In my mind, I could hear my dad saying something about how balls don't grow on trees. We played a couple more innings, then Ernesto and Manuel had to go home for lunch. Because of my dad's work schedule, especially in the summer, we ate lunch kind of late—at two o'clock precisely. I had an hour or so to kill, and without baseball or school to occupy my mind, some not so good thoughts crept in.

I crept into the house, careful not to alert my mom or Mamí Upe to my presence. I went to my room and tucked my BB gun under my shirt and snuck back outside. The midday air was thick with clouds gathering for a storm. I did the Marine crawl to the back fence, and without really giving it much thought, opened fire on Mr. Mad Man's patio door. I heard a few high-pitched

plinks and then crawled back toward the house. Once I got inside the house, Mamí Upe stood there. When she saw my gun, she first shut her eyes and then raised them toward the ceiling.

"I know you did something, Jorge," she said. "I can see it in your face."

I shrugged my shoulders. She knew that I wasn't allowed to use the gun unless my dad was around. My body was vibrating with guilt and adrenaline. I couldn't believe what I'd done. I didn't know how Mamí Upe would have responded, let alone my dad, if she knew what I'd done, and I didn't want to find out. I'd never done anything like that before. I'd been disobedient, but never that destructive or that vengeful. It was as if the Mad Man's spite had infected me, and the whole "two wrongs don't make a right" lesson was ringing in my ears and in my mind as images of me pulling that trigger got my tears starting. I wanted to undo those past few minutes, but I couldn't.

Then my mom came into the kitchen.

Mamí Upe rolled her eyes and pointed at my gun and said, "*¡Mira! ¡Lo que el diablo te ha hecho hacer!*"

I told her that the Devil hadn't made me do anything. But seeing the look on her face made me feel sick to my stomach. I'd disappointed her, and that hurt more than anything else.

The two women shook their heads and looked at the clock. It was five minutes to two, and my father was due home any second. He was very strict about our two o'clock lunchtime. If you weren't there at exactly two, you didn't get to eat. I was there on time, but I had been told that I could not use the gun unless he was around. If only my mom and my grandmother had known what I had really been up to.

"Hurry now," Mamí Upe said to me. "Go into your room. Close the door and pray. Ask Jesus to calm your father. Make him calm, please. Say this again and again."

I did as she asked, until my heart skipped a beat when I heard my father's car in the driveway. I hustled back into the kitchen and sat at the table. Michelle was already there, and my father kissed her forehead as he passed her before taking his seat.

I sat there, silently praying again, asking God to keep those two women quiet. We all sat there in silence, listening to the thunder and the huge drops of rain spattering outside. Lightning flashed and the lights flickered. My father frowned and said, "This will pass quickly." He then pointed at me and said, "When I get home later, we have some work to do."

I nodded and gulped a bit of rice and beans past my tense throat, a tear coming to my eye.

"Yes," I said. "I know. I'll be ready."

After my father finished and left, we were all still at the table. I was about to thank the two of them. My mother held up her hand. "Don't thank us. Just be better."

"May I be excused?" I asked.

Mamí Upe held out her arms to me and I walked into her hug.

"Be a good boy," she said.

In addition to all his other jobs, my father worked for years as a baseball scout; in 1983 he began to do that work full-time for the Toronto Blue Jays. I quickly came to know their lineup by heart. The 1983 Blue Jays had some names familiar to most fans—Dámaso García, Alfredo Griffin, Jesse Barfield, and Cliff Johnson. But there were some less familiar guys as well, like Rance Mulliniks, Ernie Whitt, and others whose names—Garth Iorg, Mickey Klutts—just stick in your mind.

To be honest, I followed major league baseball in general, not one particular team. That was one advantage of following baseball from Puerto Rico: because none of the teams were based there, I didn't feel a need to be a fan of any one team. I didn't inherit any fan history from my family, so I was kind of a free agent.

I guess in a way I was like the Yankees of the 1980s, always looking to acquire a guy for my mental team (I can't say "fantasy" team because of what that has come to mean) that I liked. I loved Don Mattingly and Dave Winfield—they were two of my favorite players. But when it came time to step up to the plate in my backyard, the guy I always wanted to be was George Brett. During my elementary school years, the Kansas City Royals were at the middle and then nearing the end of a run that had begun in 1976 and included two World Series appearances. After that, they wouldn't get into the playoffs from 1986 until 2014. George Brett was the leader of that earlier team, and a hitter I really admired.

What I thought was cool about Brett was his approach at the plate. He would settle into the box, rock back on his heels, arch his back so his head was behind his butt, and then bounce out like a guy getting out of bed. I'd watch him hit and think that he was going to fall asleep before the pitcher delivered the ball.

But the guy I really loved to imitate and watch was Don Mattingly. It seemed like he used a different stance every game. Every time one of his games came on TV, I'd watch it and wonder what he was going to do that day. Was he going to turn his left foot (his back foot) sideways? How many degrees was he going to twist it? And it wasn't just from game to game that he'd do

something different—during the course of a game he'd seem to never get up there the same way twice, and sometimes he even switched things up a bit during an individual at-bat.

I wasn't some kind of childhood baseball genius who picked up on all of this naturally. I spent some time watching games with my dad—a lot of time actually, especially as I got into my teens. Before that, we'd watch the game and he'd point out a few things, but I don't think I consciously understood everything he was saying. I learned just by being around the game almost constantly. Living in Puerto Rico was great because we basically played the game year-round.

Before I started to play competitively, it wasn't like my dad had me out doing fielding drills and hitting in a batting cage every day—that would come later. But he was always working on the mental skills it takes to succeed, I now realize, at anything. My dad instilled in me two important points that are part of what you could call having a good work ethic—don't quit and never get comfortable with losing or failing.

I took those lessons to heart on the playing fields as I competed in all kinds of sports, but they didn't really take hold in the classroom. Because my father had some connections, I was able to attend the American Military Academy (AMA) in San Juan. It was located

near the border of two of San Juan's districts, Guaynabo and Bayamón—which were named for the two rivers that intersect near them. Today the website of the AMA in San Juan tells the story—it mentions the academy's high academic standards and the excellent sports teams. I would have been okay with the school, and the school might have been okay with me in the long run if it hadn't been for those academic standards. I wasn't a horrible student, but I wasn't the most motivated student either. I liked history, particularly the Puerto Rican part of it, but I really didn't like studying English at all. I got passing grades in just about every class but English.

I'd tell my mom that I was doing my best, and she'd believe me. I'd tell my dad that and he'd be doubtful. I think that back then I really did believe that I was trying my best, but I can see now that I wasn't. My best would have meant spending a lot more extra time studying, seeing teachers for help, and all the rest. I was used to being pretty good at doing things, so struggling so much with a class was frustrating. Once I got frustrated, I got angry or tearful, and often some combination of the two feelings, neither of which produced the kind of results that my parents wanted to see.

Not succeeding in getting good grades complicated my life in lots of ways. First, I had to attain a certain

grade point average to be allowed to compete in the sports programs the school was so proud of. I wasn't that motivated to stay eligible for the AMA sports programs because I was also able to compete in a number of different sports through the various social clubs that were a big part of life in San Juan and elsewhere.

Unfortunately for me, my dad understood very well the connection between grades and sports. Like I said, I was a pretty good kid who didn't get in trouble with his teachers for being loud or out of control. I had a lot of respect for my teachers, though I did frustrate my fifth-grade math teacher when I responded to her question about why my book wasn't open by replying, "It doesn't matter. I'm going to be a ballplayer." How could you be upset with a kid who told the truth like that? In my mind, I wasn't trying to be disrespectful or snotty—I was just telling it like I saw it. I can see now how those words came across, and I also see the error of them. In time I would learn that being a professional ballplayer meant performing well not just on the field but off it. Experience would be a harsher teacher than any I faced in school.

Whether or not I was telling the truth to my teacher didn't matter so much to my father as the truth my report card told about how I was doing. A few weeks after confessing the reason for my disinterest in math

class, I came inside after riding bikes with Ernesto and Manuel. We didn't go to the same school, but we'd meet up nearly every day after the bus spit me out after a half-hour commute. I stepped into the kitchen, and my dad stood there looking at a piece of paper. He was leaning against the counter, holding the paper in one hand and his forehead in the other. He looked up over the top of the paper, and I recognized that look. Instinct took over, and I ran out of the house and into the back-yard. My mother shrieked, and my father yelled at me to stop. I didn't listen. I could hear his footsteps behind me, but everything else was blank in my world except for a mango tree that stood along one edge of our prop-erty. Its roots formed a trunk that was like fingers clawing their way out of the ground. I jumped onto one of them and then started to climb up, thinking I'd be safe up there in the tree.

I wasn't.

My father didn't climb all the way up the tree, but he did manage to get in range of me with his belt. I was standing on one branch with my hands above my head, clinging to another branch for balance. It was like the belt lashes were tongues of flame rising up to get me. I was doing a little dance trying to get away from them, but I couldn't always avoid them. I knew that by run-ning and hiding in that tree I had made my dad angrier

than he was before, but I couldn't help myself. This wasn't like it was later on when I was learning to catch and had to ignore all the potential dangers and pains of being behind the plate. This was me as a fifth-grader doing his best to avoid the pain of being disciplined.

On the one hand, I knew that I had been warned about keeping my grades up. I'd failed to do that and deserved to suffer some consequences. I also knew that I shouldn't have run away from my father and defied him like I had. I'd added fuel to a very small fire. I knew better than to run out of the house, but something inside me, some impulse, took over and often made me do things I hadn't planned on doing. On the other hand, I never expected my father to get so infuriated that he'd chase me up a tree. My father believed in corporal punishment; he might have just spanked me if I hadn't run away, and that would have been the end of it. I didn't like any kind of physical punishment, but that's how things were in my house and in the homes of a lot of my friends. My dad was using the belt as a last resort; he literally couldn't reach me any other way.

At that point, we were both beyond words. My mother had briefly tried to intervene, but he had sent her into the house. I don't know how long the two of us stayed up there. I'd climb higher; he'd scramble up

a little bit more. Eventually, he climbed back down out of the tree and stood there. He made a big show of putting his belt back on and said, his tone still angry but his anger under control, "Come down here. This is no way for us to behave." My only response was to work my way down the tree. I knew that the worst was over, at least for that night.

When I was back on solid ground, my dad nodded his head toward the house, and I followed behind him. At one point, he slowed to look at me. An adrenaline buzz ran through me, and I covered my head to protect myself. When I didn't feel anything hitting me, I stood up straighter and looked at him. Instead of seeing shame or embarrassment on his face, I saw sadness when he shook his head, obviously disappointed in how I'd responded. I got into the house and immediately ran toward my mother, who stood in the kitchen twisting a dish towel in her hands.

"No!" my father shouted, and he pointed down the hallway toward my room.

I stepped past my crying mother and went into my room. I spent the next hour lying on my back staring at the ceiling, resisting the urge to toss the ball. Outside my window, cicadas buzzed and moths flung themselves against the screen, rattling the wire mesh. I didn't dare look at my bare legs. A few spots stung, but

I wasn't going to cry, not this time. I must have drifted off into a troubled sleep.

I woke up and squinted into the bright light. I could see only the outline of who was in the room. It was my dad. With the light behind him, I couldn't see his expression. He stepped into the room, and I heard him rustling around. I saw him grab my new glove and my heart sank. That was going to be my punishment. He was going to take that from me, maybe not let me play again until I passed all my classes. I shut my eyes.

I heard a chair scrape across the floor and then a creak and a sigh as my father settled into it. A second later, I smelled something familiar. I heard a kind of scratching sound, and I put it all together. My father was rubbing castor oil into the palm of my glove. I heard him humming something under his breath. He held up the glove and inspected it and then pounded his fist into it.

"It's getting better. Make sure you keep doing this, every day, a little bit at a time. Don't go crazy with the oil."

He took a ball and thudded it into the glove.

He turned to look around the room, squinting. "Where are they?"

I pointed toward my nightstand. The sound of the rubber bands going around the glove was a kind of

twangy music. He held out the glove to me and said, "You've got to take care of things. You know that, right?"

I nodded.

"Then put that away."

I reached for the glove, a McGregor the color of a cigar, careful to avoid looking him in the eye. Then I slipped the bound-up glove between the mattress and the box spring. I lay back down, feeling the lump in my throat as well as the lump in the bed, one of them a strange comfort.

"And this," my father said, taking my portable cassette player and a handful of tapes, "you'll get this back next week after you get your grade up. I'll be talking to your teacher, and you will do better. You know that is going to happen."

He stepped out of the room, and I heard him walking away. I sat up again and reached over to my desk. I pulled out my English workbook. A lot of times when I studied, I liked to listen to American pop music, telling myself that the lyrics would help me. Now, with no tape player, I couldn't do that. So I sat there, alternately staring at the lines of translation I had to do and the label on the tape I'd recorded. I was proud of myself for being able to record Casey Kasem's "America's Top 40" off the radio. I had gotten to the point where

I could hit the Stop and then the Record buttons perfectly, eliminating the commercials. It had taken me a while to perfect the technique, but I'd stuck with it. So there I was that late spring of 1986, staring at the label, reading my homework pages, and twirling the cassette on one finger. I imagined that I could hear Gloria Estefan and the Miami Sound Machine's "Bad Boy" in my mind. I lay there snapping my fingers and grinning as the words "Boys will be boys" floated across my vision, like a blooper dropping safely into the outfield. It landed, and I found myself thinking about what those words really meant—in English and in Spanish. I thought again of how lucky I was that no one knew about what I'd done to the neighbor's patio door all those weeks before.

When the song ended in my head, so did whatever pleasure I'd taken from that immature revenge. All three of us—the Mad Man, my father, and I—were apparently capable of being taken over by some kind of anger or frustration that clouded our better judgment for a while. None of us were really bad boys to the core. There was just something in us that we didn't keep under control all the time. Later on, I'd figure out why it was that anger sometimes helped me and other times hurt me. At that point, I was grateful that I hadn't done more damage to the neighbor's house, both because

I recognized that doing what I had done was wrong and because I didn't want to have to fully face up to the consequences. In a way, I saw getting away with that act as something I deserved for having been punished for my bad grades. It was a complicated equation, trying to determine deserved and undeserved, guilt and innocence. The calculation exhausted me, so I gave up.

I reached under my mattress and pulled out my glove and unwound it. I set my books aside and tossed the ball in the air, careful not to make contact with the walls or the ceiling. The comforting feel of the ball and the glove made me forget how hungry I was.

Chapter Two
Yo Soy Puertorriqueño

Many fathers and sons have a complicated relationship—we don't always talk about it, them, but we know it can be confusing. Even so, it's hard to convey just how complicated the relationship I had with my father was, and what that complexity meant for me both growing up and today. It made more sense to me later on when I worked with pitchers. They had different mechanics, release points, ways of approaching hitters. Some were good at communicating their intent and desires, others weren't. Some spoke the same languages I did; others didn't, or sometimes seemed not to. Understanding methods and means to an end wasn't always easy on or off the field.

To be honest, I still don't have the puzzle of my father completely solved (show me a son who does), but

I will say this again: if it weren't for my father and all the things he did for me and to me, I wouldn't have become a big league player. I enjoyed a lot of advantages being the son of Jorge Luis de Posada Sr. There was a method to my father's madness, but I didn't see that at the time. Partly, that's because he never explained to me why he had me do some of the things he did. He was very old-school in that regard. I have no way of knowing this for a fact, but I suspect that even if I had asked my father his reasons for many of the things he had me do, he would have issued the intentional walk, the standard "because I say so" response. Still, I never would have asked him because I also inherited from him a bit of his stubborn streak. While I didn't actively or directly rebel against what he asked me to do, partic-ularly when it came to baseball, I also didn't take on the responsibility of improving communications between us. A few things he had me do were clear enough that they needed no explanation: running sprints, climbing hills, spending countless hours in the batting cage or on the field taking ground balls. But a few were more like mental tests he was putting me through, and often my relative immaturity—physically—bumped up against what he was trying to get me to do mentally.

Today I can see that my dad's parenting represented a generational difference, the old-school mentality I've

mentioned. It also may have been partly cultural. The stereotype of Latin American men, for better or worse, does have some truth in it. We are more likely than other men to express our emotions and be reactive. Whether that was me taking a BB gun to a neighbor's house, my dad chasing me up a tree, Manny Ramirez responding to an inside fastball that was nowhere near hitting him, Pedro Martinez mouthing off and then slinging a 70-year-old man to the ground—in one way or another those are the kinds of things that happen when you've got guys who are temperamental. I don't just wear my heart on my sleeve: my emotions are the clothes that cover my whole body. What you see is what you get.

I may suffer from a unique variety of that Latin American passion, since I'm a combination of Cuban, Dominican, and Puerto Rican. Just as the relationship I have with my father is complicated, so is my heritage. But I will say this: my relationship with my birthplace is simple. I love Puerto Rico, and I consider myself to be Puerto Rican. As I write this, President Barack Obama has just announced the reestablishment of ties between the United States and Cuba. It is still early days, and it's hard for me to know what will happen, but I've gone on record for many years stating that I would like to visit Cuba someday. That doesn't mean that I'm disloyal to

Puerto Rico or the United States. I like to travel, and as I get older I get more and more curious about the place where my father grew up. I'd like my kids to see where their grandfather spent his youth.

As much as my dad shaped who I became, I think that Puerto Rico had a nearly equal influence on me. Because of the weather, I had several baseball seasons in the same calendar year. Playing outside year-round was great.

Puerto Rico's influence on me runs far deeper than just being the place where I could play baseball year-round. I identify myself as Puerto Rican, not so much as a way to fill in a line on a form but as a real part of who I am, even if Puerto Rico, in the big picture, is a really, really small place. With only 3.6 million residents, it's dwarfed by the Dominican Republic's more than 10 million in population and by Cuba's more than 11 million. That makes Puerto Rico an underdog, and I like the underdog mentality. When you look at boxing, one of Puerto Rico's favorite sports, I think you'll understand what I mean about identifying as Puerto Rican. I'm proud of Puerto Rico's contributions to baseball, but when you think about the fact that this tiny commonwealth with its small population ranks third in the world among boxing title holders—across all divisions, not just heavyweights, who get

most of the attention in the United States—that says something.

Boxing in Puerto Rico dates back to when it was still a Spanish colony and workers on the sugar and coffee plantations organized secret tournaments. The United States helped develop boxing into a more formal and legal activity within the military, though wildcat matches were always held in various places in Old San Juan. During World War I, US and Puerto Rican soldiers stationed on the island participated in the Campeonato Las Casas (House Championship), but civilians couldn't participate. For a long time boxing in Puerto Rico was controlled, at least officially, by the military. Fighting a war and boxing seemed to go hand in hand. Eventually that changed, and guys like Wilfredo Benítez, Félix Trinidad, and Héctor Camacho, along with women like Melissa Del Valle and Cindy and Amanda Serrano, followed the line that Sixto Escobar established in 1934 and became world champions.

I didn't know these things as a kid. I thought of myself as Puerto Rican because that was where I lived. I didn't go around asking all my classmates about their backgrounds. I just was Puerto Rican. I liked Puerto Rican history. I thought it was cool that Christopher Columbus was credited with discovering Puerto Rico just like he did America. Since Puerto Rico enjoyed

commonwealth status with the United States, I looked at my adopted home positively as well. I also looked at it as a source of entertainment, with not just US music but movies and television shows and, obviously, baseball holding my attention.

I don't think I fully understood why, but the story of Puerto Rico's native people, the Taínos, really mattered to me. To hear about their struggle to survive European disease and their harsh treatment by the Spanish reminded me of the combative spirit of boxers and underdogs. Though my roots in Puerto Rico aren't as deep as many other people's, I've been at a Marc Antony concert and felt a little thrill of pleasure and pride when he shouted "*¡Yo soy Boricua!*" and the crowd went nuts. When I'm alone driving, and many times when the family is with me, I crank up the volume to listen to Gilberto Santa Rosa and Víctor Manuelle. I'm a big fan of music of all types, but those guys are special to me. Playing in New York was great because of the large number of Puerto Ricans in the city, and because of her work with our foundation, Laura got to ride in the Puerto Rican Day parade. That was a special honor for her, and I would love to have been there, but the Yankees were always playing on Puerto Rican Day. My job frequently took me away from events and people I cared about.

No one is more important to my identification as Puerto Rican than Roberto Clemente. One of my proudest moments came a few months ago when my four-year-old nephew Miguelo saw a picture of Roberto Clemente and said, "That's my uncle." To me, Roberto Clemente is the guy we should all try to model ourselves after. He was an amazingly talented baseball player and played the game the right way, but he was also an amazing human being who lost his life in a plane crash trying to bring relief supplies to people suffering from the effects of a terrible earthquake in Nicaragua. He lived the right way, and I grew up hearing about him. I can still see him rounding second base and tearing for third, his helmet flying off and coming in standing up for a triple.

I got a little sad toward the end of my career when I realized that some of the young Latin players I spoke with knew only vaguely who Clemente was and what he had meant to the game and to the world. Maybe that's a bit of my dad's old-school "respect your elders" rubbing off on me, but I hope that Roberto Clemente will be remembered as more than just a name to enter into your phone when you're looking for directions to the Coliseum or the Stadium named in his honor. Clemente wasn't just a ballplayer; he was a warrior, a guy who fought hard on and off the field. I would love

to have received the award named for him that Major League Baseball hands out to the player who best combines achievement on and off the field. I'm not that into personal honors, but to be voted the player who "best exemplifies the game of baseball, sportsmanship, community involvement and the individual's contribution to his team" would have been an amazing honor even if it hadn't been named for a personal hero of mine.

Contributing to a team's success was always important to me, but the truth is, in order to do that, you have to succeed as an individual. I wanted to be the best at baseball from a very early age. What I couldn't figure out was why my father seemed to put up roadblocks to slow or even block my progress. In 1980, when I was nine years old, my dad drove me over to the Caparra Country Club, where he helped coach the baseball team. Country clubs like Caparra weren't places with fancy golf courses where rich people hung out—they were places where what I'd today think of as lower-middle-class families like mine spent time together. They were privately owned, but in truth, they were more like the facilities you find in communities with parks and recreation departments.

The country club my family belonged to was called Casa Cuba, and it was situated along the beach—none

of the other clubs were. Because we had access to the beach, we'd play nearly every sport in the sand— American football, soccer, and even a version of five-on-five baseball that I loved. I made a bat out of a sawed-off shovel handle, and I'd cover a Wiffle ball completely with tape so that the shore breezes wouldn't toss it around quite so much. We'd play sports all morning, getting sweaty, dash into the water, play some more, go to the cafeteria and tell them our member number, then pile our trays with all kinds of food. I can still taste and feel the gritty crunch of the sand I downed with those meals. I can't say for sure that my dad chose Casa Cuba because it was along the beach, but playing all those sports in the sand really helped to build up my leg strength and endurance. I can't say that eating some of it helped my jaw.

Though we belonged to Casa Cuba, my dad coached at Caparra, our biggest rival. Why didn't he coach where he had a membership and where I played? Another one of those complicated things that I never really asked about. Besides all the kids at the club playing together informally, we also had organized sports teams and competed against the other clubs in the area. That was the only organized baseball I played until I was older and played some Little League and later American Legion ball.

Even though I played for Casa Cuba's baseball team, my father took me to Caparra one day in 1980, when I was nine, to practice with his guys. I stepped into the box to take my cuts in batting practice. My dad stepped off the mound and took a couple of steps toward me. He nodded his head toward his left. I looked over that way, thinking that he wanted me to see whatever was in that direction. I guess you could say that we had a failure to communicate.

"*¿Que pasó?*" he asked me.

I shrugged.

He raised his index finger in the air and spun it.

I turned around in the batter's box to see what was behind me. The catcher pulled up his mask and turned to do the same.

"No," my father shouted. I looked at him as he took his glove off, stuffed it under his arm, and walked toward me, heaving a heavy sigh and shaking his head.

As he got closer I could hear him muttering, "*El otro lado, el otro lado,*" over and over again.

He took me by the shoulders and led me to the left-hand batter's box.

"*¿Entiendes?*" he asked.

I did and I didn't. I knew what he wanted me to do—to bat left-handed—but I didn't understand why. It wasn't that I'd never hit from the left side before.

In our Wiffle ball battles in El Estadio Jorge Posada, I'd done it a bunch of times. After all, Don Mattingly batted left-handed, and I'd imitated him with dozens of variations. But this wasn't Wiffle ball. I'd never batted lefty when it actually counted for something.

My dad got back on the mound, I settled uncomfortably into a stance, my heart racing, trying to figure out which of the many variations of the Mattingly Method I should use. The ball came in, a fastball waist-high and on the outer half. I swung and felt my feet sliding out from under me as I whiffed (I guess this was Wiffle ball after all) and nearly corkscrewed myself into the ground. I felt my jaw tense and on the next pitch took another hack, missing completely again. I could feel tears welling in my eyes and the salty taste of blood in my mouth from where I'd bitten my cheek.

This is ugly. Really ugly.

I didn't swing on the next two pitches, so I was down to one more strike. I finally managed to tip one weakly off the end of the bat. The ball sat there in the right-hand box as if trying to tell me that was where I belonged. My vision clouded by tears, I trotted to the bench, put my bat down, and jogged past my usual position at shortstop and went into the outfield. I kept my back to the infield and stood there grinding my teeth, my fists clenched, until the tears really started

to roll out of me. I folded my arms across my chest and tried to suffocate myself to keep from crying.

Why is he doing this to me? I can't bat left-handed. I'm a good hitter. What's the point?

My sulking was interrupted when one of the other guys hit a ball that rolled just past me. I picked it up and turned toward home plate. My dad stood on the mound, holding his glove out to me. I reached back and fired the ball high and hard. It was as if I'd launched my anger and humiliation, and I felt a small thrill of pleasure and defiance as the ball arced over my dad's head, over the catcher, and over the backstop. It came to rest in the dry grass beyond the bleachers next to a pile of mowed Styrofoam cup shrapnel.

Without thinking, I took off running—my dad was fanatical about always hustling—to shag my overthrow. My cheeks were burning when I crossed the first-base line, and I could feel my dad's eyes stabbing into my back. I retrieved the ball, rubbed it up a bit, and tossed it to him. Meanwhile, the whole place had fallen silent. My dad caught the ball and then let it fall from his glove, like I'd thrown him something disgusting that he didn't want staining his mitt. I started to make my way back toward the outfield, but he held up his hand and I stopped. He pointed to the bench, and I went and sat down. Through the rest of the practice, I sat there,

writing "*Yo te odio*" over and over in the dirt with my shoe, erasing it and starting over, knowing that, in that moment, I hated myself as much as I hated my dad.

From an early age, I took losing and failing really hard—losing was like a physical presence. I could feel the weight of it on me, could hear its voice in my head taunting me. The older I got the less I imagined loss as a person, but that sense I got from losing, that I was being weakened or held back, was always there. I just had to dig deeper, work harder, to overcome the weight of it.

I wasn't the best player out there, far from it, and I also wasn't the worst—but I definitely looked like it in that left-hand box. Failure was horrible, but the feeling that I'd let my dad down was worse. It was hard to take my anger out on myself or whoever it was I heard in my head. My dad was the easiest target to hit—or in this case, to overthrow. While I sat on the bench and the practice went on without me, I tried to understand what my father had done and why. My nine-year-old brain couldn't come up with a very sophisticated set of answers. It mostly came down to an attempt to humiliate me for some reason, to make me look bad in front of his players, who also happened to be my rivals. I see now that it was my inability and failure to control my emotions that was the real culprit. Back then I blamed my dad.

Why had my father made me switch to batting left-handed? There must have been something inside of me that he didn't like. I reviewed everything I'd done over the course of the last few days, trying to figure out where that treatment came from. My dad didn't like me taking the newer game balls out of the ball bag he kept in the closet, and I'd snuck one out and thrown it against the house, scuffing up both the ball and the house's stucco. Though I'd put it back in the bag when I was done, maybe the scuff and the faint trace of paint I couldn't quite rub out had given me away. As I sat there I regretted not cleaning the ball in milk the way my dad had shown me to get rid of grass and dirt stains.

I didn't have long to think about it. Practice ended, and then there was the silent drive home with no explanation from my father about why he'd chosen that day to humiliate me. My bad thoughts ballooned and festered overnight. The next day I had a game with my Casa Cuba team against Ponce, one of the weakest of the five teams in our league. Again my dad made me bat lefty, and my performance was the same as at practice the previous day—I struck out all three times. After the last strikeout, I couldn't hold it in any longer: when I got to the bench, I sat there and cried. My coach, "El Flaco" (his real name was Hector Fuentes, but we all

called him by his nickname), came up to me and put his hand on my back and told me it was going to be okay. I went out to shortstop, and the first batter up hit a ground ball to me. I fielded it easily and for an instant thought about hurling it over the first baseman and out of the park.

I didn't. We were only up two runs, thanks to my leaving a bunch of guys on base, and I didn't want to let the tying run come to the plate in the last inning. I gunned it to first and heard our fans screaming for me. I looked into the stands, and there was my mom pumping her fist and rising out of her seat. I looked for my dad, even though I knew that he had practice that day with Caparra. Then, out of the corner of my eye, I saw him. He was standing with a couple of other coaches and fathers, all of them with their arms folded across their chests, rocking back on their heels. I couldn't help but think that my dad's smile meant that he was proud of me.

After the game, as we walked to the car together, he told me that he knew that it was going to be tough, but that if I kept at it, batting from both sides of the plate was going to pay off for me someday. It was okay to struggle, but I better not quit.

"We'll get there. We'll work at it. But every time you face a right-handed pitcher, you're going to bat

left-handed. That's how it has to be. No question. Left-handed. Understood?"

I nodded. My dad was true to his word, both short and long term. We did work at it, and it did eventually pay off in a way that not even he expected and that I'm still not sure he liked. My consecutive strikeout streak would reach 13, but eventually it was my dad who was unlucky.

At the end of the season, Casa Cuba and Caparra faced off in the league finals. We hadn't beaten them all season, and it was tough riding home in the car after they'd won yet again, sitting in the backseat next to my sister, seeing that look of satisfaction on my dad's face reflected in the rearview mirror. It seemed like no matter what we did, the Caparra team found a way to win. We lost in every conceivable manner—blowouts, blown leads, blasts, bloopers, and bleeders. It was bad, bad, bad. I didn't dare act like a sore loser in front of my father or his team. I didn't want to give them the satisfaction of knowing that they'd gotten inside my head.

There was a good reason why Caparra kicked our butts all the time—my dad. He would have his team show up for an hour before the game to practice. He'd hit ground balls and fly balls, work on infield plays—bunt coverage mostly—and then take batting practice.

Casa Cuba players showed up 15 minutes before a game. We'd play catch and throw each other grounders or pop-ups, but it wasn't the same. I was lucky that my dad took me to the field early to be with him and his squad. I'd participate in their practice for a while, and then sit and wait, the only kid on the bench until my teammates showed up. It was kind of weird, but I got used to it, and so did everyone else.

That final game in 1980, I came up in the fifth inning. We were down by two. When I dug in, two men were on—one on second and the other on third—two men were out, and there was a right-handed pitcher on the mound. I got in the left-hand box, adjusted my helmet, and leveled the bat over the plate. This was a possible turning point in the game, and I expected my dad to be looking on intently.

He wasn't.

He sat there, his legs stretched out in front of him, his hands on top of his head like he was being held prisoner. The first pitch came in high, and I let it go, glad to be ahead in the count. Only I wasn't. The umpire called it a strike, and I stood there blinking like I had to clear something from my eye. The next pitch was just as high, and one that I would have normally taken, but given what had just happened, I couldn't. I knew I was going to have to get on top of it, so I stood as straight as

I could, and while rising onto my toes and shifting my weight forward, I let loose. I had that satisfying feeling of making solid contact when no vibration at all is transmitted through your hands. I watched as the ball traveled on a trajectory a lot like the one traveled by the ball I'd thrown away in that earlier practice. It rose into the outfield, and I saw the numbers on the back of the jersey of the right fielder, who raised his glove in surrender as the ball bounced once and hit the wall. I came into second base standing up, knowing that the game was now tied. I didn't want to show my excitement, so I bent over and pulled up my socks and tugged at the cuffs of my pants, smoothing everything.

I looked over at my coach in the third-base box, and he pumped his fist and smiled at me. I nodded and got into running position, one foot on the bag, the other spread out like a sprinter in front of me. I didn't score, but in the top of the sixth we scored a run by taking advantage of a crucial Caparra error to edge into the lead. We had a tense bottom of the sixth, but when their number-three hitter grounded weakly back to the mound, it was over.

An enormous sense of relief and joy coursed through my veins. I felt like I had to pee really bad. I threw my hands up in the air, tossed my hat and glove down, and sprinted toward the mound. I dove into the dog-pile,

screaming at the top of my lungs. I'd come up with a big hit when we really needed it—and left-handed!

You may not believe this, but of all the games I've ever played, I still get chills thinking about that victory. That wasn't my first hit batting left-handed that season, but it was by *far* the most important. I remember running the bases and having no sensation of my feet touching the ground.

The whole car ride home I talked excitedly with my mother, saying again and again, "Can you believe it?"

After a while my cheeks hurt from smiling so much. My father hadn't said a word to me after the game when we went through the handshake line. We'd just briefly slapped palms, both of us looking away. I turned to Michelle and said, "This is the best. I thought it would be good, but this is the best. Especially beating them. And did you see how they threw the ball away?"

Michelle nodded.

"That can't happen! But it did!"

To his credit, my dad didn't say a thing. He sat there expressionless the whole way home. When we pulled into the driveway, I scrambled out of the car, eager to tell Manuel and Ernesto my good news. Before I could run into the house, I felt my dad's hand on my shoulder. I thought I was about to get a talking-to, but he just gave it a nice firm squeeze that was over in a second.

I looked at him for a moment, expecting he might say something, but he didn't. He didn't need to. I could see that he was proud of me.

I don't know if most kids competed with their parents as fiercely as my dad and I did, but the two of us went at it often, and neither of us would have ever given in or given up. I felt I had his approval after the victory over Caparra, but there were plenty of other times when I felt like my dad had ripped my heart out of my chest.

At home we had a Ping-Pong table, and my dad wanted me to play as often as I could. Lots of middle infielders develop quick and soft hands by playing table tennis, and I think it also eventually helped me as a catcher, but as a youngster and even as an adolescent, I struggled against my father.

He had a wicked serve, and he would dominate me most of the time. I never really came close to beating him, and he never let up on me. Once, when I was maybe 11 years old, he was on. A couple of times he hit big looping serves with a lot of top spin that hit the very edge of the table and fell at my feet. Lucky shots, really. Those got to me. Not only was I losing to somebody who was better than me, but I was struggling just to get the ball in play. A lot of times he wouldn't even

say anything; sometimes he'd trash-talk. "Look at that. Now that's how you play the game. Perfect shot. You don't stand a chance against me." Losing to him was hard; having him rub it in like that was harder.

One day when I was 11, I got so frustrated that I started to cry. I wasn't sobbing, but tears of frustration ran down my cheeks. I slammed the paddle down on the table. My dad held up both hands, the paddle in one, the ball in the other, as though he'd been interrupted midserve. Then he started laughing. That really made me mad. I was already so frustrated, at being unable to stop crying as much as hearing that voice in my head mocking me for my poor play. Now I had to deal with my dad laughing at me on top of that. It was almost too much. My dad set his paddle down and walked over to a shelf in the garage.

He pulled out a pair of boxing gloves and held them out to me. Okay, this was going to be good. I took them and pulled them on and then held them out to him so that he could lace them up for me. He knelt down while he did them up, and visions of me knocking him out swam in front of me. The garage smelled of gasoline and motor oil and damp rags and car wax, a macho odor that blocked my tear ducts and gave me courage. My dad stayed on his knees as he tugged on his gloves, and then, holding them in front of his face, he gestured

toward himself, letting me know it was time to bring it on.

We'd boxed since I was a very little guy, but somehow this was different. I knew that my dad wanted me to find a more appropriate outlet for my frustration than tears, but our bout started out like a lot of the rest of them. I charged in, and we engaged in a kind of bear hug mix of wrestling and boxing, with me landing ineffective blows on his back, my face buried against his chest and shoulder. I found something comforting about being that close to him. It wasn't that my father wasn't physically affectionate toward Michelle and me. He would give us hugs, but words seemed to fail him.

I don't know what got into me that afternoon in the garage, but at one point my dad pushed his fist toward my forehead and held it there. He kept me at a distance like that, keeping me connected to him but unable to reach him with my swings. I felt foolish, like I was failing once again. I tried to move to the side, but still there was that glove feeling like it was glued to my head. Furious and frustrated, I stepped back, bulled my neck and ducked my head, and then put all my power into a low hook that caught my dad flush in the belly. I heard the air rush out of him, and I knew that I'd either surprised him or hurt him, or both. He rocked back and caught himself with his gloved hands

behind him on the floor. He stayed in that position, vulnerable and exposed, but I knew better than to go after him. I kept my fists up and started to dance a bit, doing my version of the Muhammad Ali shuffle, a kind of taunting and mocking victory dance. Seconds later, I stopped the clowning and narrowed my eyes and furrowed my brow, still in the proper boxing position. My dad nodded his head and got back up into position.

I think that both of us just made a show of fighting after that. We resumed our wrestling and clinching, but after a few minutes he worked his arms inside of mine and pushed me away. That was the end of it. I walked over to the far wall to put our gloves away, turning my head slightly so I could watch him get up. He denied me the pleasure of seeing him struggle and offering him help. He stayed down, made it seem like there was something on the floor he was searching for.

"Get ready for lunch," he said, waving me away.

I did as I was told, but the farther away I walked the smaller the thrill of that punch grew. By lunchtime my father was back to himself. Though we would continue to put the gloves on and go at it, I don't think I ever again did so with the same level of anger.

That was a big moment for me, not because I hurt my dad, but because I made a connection that stuck with me throughout my life: I always performed my best

when I was angry, and I developed a real I'll-show-you mentality. Wanting to make my dad proud and to prove to others who doubted me drove me my whole career— even at the peak of my days playing with the Yankees. It would take some time, but I eventually figured out that my dad was truly and completely on my side.

The thing is, my dad and I spent an enormous amount of time together. On days when we didn't have practice or a game—and sometimes even after we did—he'd take me out to field ground balls he hit to me. I also never felt like I didn't have the things that I needed or wanted. He was a great provider for our family, and I did appreciate that. I would be much older before I realized that some dads aren't around a lot for their kids. Even when my dad was scouting, he was still around most of the time. Maybe it was when I had kids of my own and I was gone for so much of the time that I realized even more just how lucky I was to have a dad who had played such a big role in my life. I didn't always like his methods, but in time I couldn't argue with the results they produced. I wasn't always the best at anything I did in sports, but I worked as hard as anybody I knew, and I certainly hated to lose more than anyone I competed against.

Despite the tension between us, there was one big exception: cycling. If most things my dad and I did

together were a competitive struggle with the two of us butting heads, cycling was the one thing we both did with great joy. If baseball hadn't been the love of my life, cycling would have been not just the rebound girl but the one I would have happily settled into a different kind of life with. My dad loved to ride his bike, and from the time I was able to safely negotiate the roads with him, I went along with him on his workout rides, often covering as many as 20 miles.

You have to remember that these were the pre–Lance Armstrong days when next to no one in the United States or Puerto Rico really paid much attention to the sport. Yes, people rode bikes, but they didn't care or even know about the competitive side of it. In 1981, when I was 10 and pedaling around the area with my dad, Greg LeMond was the first American (and now the only one) to win the Tour de France. If I had asked my friends back then if they knew who he was, they would have shrugged their shoulders or maybe thought I was mispronouncing the name of one of the Allman Brothers. But I did know who Greg LeMond was because my dad was a big fan of what are called "The Grand Tours"—races like the Tour de France, Vuelta a España, and others. He was interested in them because he'd been a cyclist in Cuba and even participated in the Cuban version of a Grand Tour, the Vuelta

a Cuba. Like the other races, the Vuelta is a multiday stage race with riders covering hundreds of miles all over Cuba. The first one was held in 1964, and the race still goes on in February each year.

Along with 100 other riders, my dad competed in that first Vuelta. The first day of the event was held in Santiago de Cuba at the southeastern end of the island. It began with a fierce climb that offered a prize to the first to reach the top. The rest of that day's stage then took the riders up the spine of the country into Camagüey. Over the course of the next five days, the riders enjoyed the flat sections through the sugar plantations and endured the punishing climbs through the Escambray Mountains and eventually into Havana. Of the 100 riders who started, only 45 finished the event— my dad among them. Through the towns and villages, crowds cheered them on, but for long stretches they rode alone with the exception of the support vehicles.

My father didn't do any real training for the grueling event. He rode his bike everywhere, up to 20 or so miles a day. All his friends thought that he was crazy, but he really didn't have much choice. He couldn't afford a car and any money spent on bus fare was money he wouldn't be able to spend on food. He was 25 years old and living entirely on his own with no real hopes that his financial situation was going to suddenly improve.

My dad was proud of his cycling career. His cousin Leo was also a cyclist, and the two of them would sit around and reminisce about the good old days. My dad was good enough to win a few races, and his prize was often a bike. He'd given those away to my uncle and to friends, and he really felt good about being able to do that for them. Even as a kid, I recognized that my father was a very generous man, someone who gave his time and attention to other people. It wasn't that I didn't believe what my dad told me himself about his days in Cuba, but it was fun later on when I spent more of my time in Miami and got to know some of my dad's friends who lived in the area. They'd tell me all the time about what a great athlete my father was, how he excelled in cycling but also in basketball, baseball, swimming, and track.

For my father and me, cycling could always bring us together. My dad's two greatest loves were baseball and cycling, and they became mine. At a time when most kids are starting to drift away from their parents, when they enter their teens, my relationship with my dad actually began to get better. I was growing up, of course, and seeing things a bit differently, and that's not to say that there weren't still times when I felt like some of my dad's methods went overboard, but we seemed to enjoy being together and doing the same things.

I can still remember my first ten-speed racing bike, an all-white flyer: the seat, the handlebar tape, the brake lever hoods, and the frame were all the same color. I was the only one around who rode a bike like that. Bicycle motocross, or BMX racing, had traveled all the way to Puerto Rico from its roots in California, and all of my friends were on those small-framed, small-wheeled bikes and were into doing jumps and stunts. I couldn't do any of those things, and I sometimes struggled on my skinny-tire bike when we rode in sand or dirt, but once we hit the pavement I was so far out ahead of them, they were specks on the horizon behind me. I loved the feeling of speed I got while riding. In fact, I enjoyed the sun on my face and the wind blowing across my skin so much that I didn't even mind the bit of teasing I got from friends about wearing cycling shorts.

I was in my teens by the time my dad and I started to ride regularly, making the trip from home to Isla Verde regularly and also riding to the club nearly every Saturday and Sunday. That was very good training for baseball and for another event that, looking back on it now, had a big effect on me and helped to shape my competitive streak.

For three years, from 1983 to 1985, Casa Cuba held a kind of age-group Olympics for the young people among its membership. We participated in five events,

so I guess you could call it a pentathlon, but it wasn't like the official Olympic event. Instead, we competed in a mini-marathon (a mile run), one-on-one basketball, a 200-meter beach sprint, squash, and a 100-meter swim. We earned points based on where we finished in each event, and then eventually an overall champion was determined.

The first year I didn't bother to train for the Casa Cuba Olympics. After all, we were all so active all the time that we were in pretty good shape and were playing all these sports anyway. I was excited to compete in them and looked forward to the event, but I didn't get too crazy about it. Kids have a way of kind of picking out a batting order among themselves—figuring out who is good at what and where they fit on a scale of the best athletes. For us, the number-one guy was Kike Hernandez. (Today his son Enrique plays for the Los Angeles Dodgers.) He was my number-one rival as a result. Kike and I were buddies, mostly because we were both pretty good at all the sports we played and that's how friendships mostly worked—you hung out with the guys who were at the top of the heap.

Kike kicked my butt that first year, and I wound up finishing second to him. We had a little awards ceremony, and as we stood up there I had to pretend I was happy, shaking Kike's hand when he got the trophy.

I can't say that I obsessed about losing too much, and I didn't rededicate my entire life to training for the event the following summer, but I did do some things to prepare.

In 1984 I walked up to the starting line of the mini-marathon more determined than ever to beat Kike. The gun went off, and I took off as fast as I could. I could feel the hot clay coming up through my Nikes, and that seemed to make my feet move even faster. After lap one of four, I had built up a lead of ten yards or so. I was feeling good, and though I slowed a bit once the after-burn of my adrenaline rush was complete, I was still in the lead as lap two concluded. By the time we got to lap three, the fact that I couldn't feel my legs at all and my mouth felt like I was sucking the insole of a shoe made me realize the error of my ways. I'd gone out too fast too soon, and as we rounded the top of the home stretch Kike came past me looking fresh compared to my barely-holding-it-together stride. I did finish second, and ultimately that's where I was at the end of the day. I beat him in the sprint, though that was no real consolation.

The next year I not only trained a bit more but thought more strategically about how to approach each event. I figured I wasn't going to beat Kike in the mini-marathon, so I should conserve some energy. I'd go out

at Kike's pace and stick with him and then hopefully outsprint him to the finish. When the race started, I did exactly as I planned. I was like Kike's noon-hour shadow, right there with him the whole way. My plan worked perfectly, and we came around the last turn dead even. I was still a pretty scrawny little guy, but all that cycling had put some muscle into my legs. I managed to get ahead of Kike and crossed the line in first place. He finished just ahead of me in one-on-one basketball, so we were essentially tied after two events. I liked my chances in the sprint, and for the third year in a row I beat him. With two events to go, I had a slight edge on Kike.

I didn't want to get too far ahead of myself, but I felt like I had a good shot at finally winning. Also, I had a secret weapon that I hoped would pay off.

I don't know if Kike and I were looking too far ahead, but neither of us got to the squash finals, both of us losing in an upset in the semifinals. I remember, as I was stretched to full length, watching the ball pass my racket and feeling that grenade-going-off-inside-me emptiness when I lost.

The championship of the club came down to the swim. As I toed the starting block I looked over at Kike, who was in the next lane. I felt a bit sorry for him. He didn't know what was about to hit him. Okay,

I'm making that up. I didn't feel a bit sorry for him, and I couldn't wait to unleash my secret weapon on him. The gun went off, and we both dove headlong into the water. I always felt comfortable swimming, and spending a bunch of time in the pool and in open water had contributed to that—so did hanging out with my surfer family in the Dominican. As we neared the end of the pool Kike and I were dead even. I watched the lane marker go from a line to a bit of a T, and I revealed my secret weapon—a flip turn. In the previous years, I'd just gotten to the wall, touched it with my hand, and then pushed off. Not this time, suckers!

That first flip turn earned me the lead, and I was going nuts. The second one wasn't as good, but I was still in the lead. All I had to do was stay calm and finish the next 40 yards or so and victory would be mine. As I approached the last of the turns I did what the legendary Satchel Paige said not to do. I looked behind me to see who was catching up to me. Kike was within a body's length of me. Distracted, I mistimed my flip, and when I was back upright, I kicked out, expecting to meet solid wall, but all I felt was water.

I panicked.

I kicked and kicked, but I wasn't going anywhere. Finally, I gave in and went backward a bit, then shoved water away from me with a fearsomeness I normally

reserved for water wars. I made contact with the wall and pushed off, knowing that it was pointless now. Kike had a couple of seconds on me, and I couldn't make that up. I swam the last length of the pool with my hands balled into fists, punching at the water, the pool feeling like it was filled with my tears. When I finally got to the finish wall, I punched at it too, giving it a glancing blow. I barely had the energy to climb out of the pool. My chest was heaving, not from exerting myself but from anger and humiliation. I'd messed it all up.

When the awards ceremony started, I didn't want to go up there. I stood wrapped in a towel, chewing on its edge, shivering in frustration. When my name was called as the second-place overall finisher, I wanted to run to the car. I felt my mom's hand on my back nudging me forward. I walked up there, head down, looking at all the big and little shrimp shapes of our footprints, feeling a lot like a little fish who was about to be swallowed up by shame and disappointment. I took my medal instead of letting the club president put it over my head. I didn't want to wear that symbol of failure.

I don't know why the club didn't hold that event again. Secretly, I was relieved that we weren't going to have a contest that would show how we were really stacked up. Kike and I remained friends, and we are to this day. Every time I'm back in San Juan and I drive

past Casa Cuba, I pick up my phone and thumb my way through my contacts, thinking that I should ask Kike to meet me there and to bring his swim trunks, running shoes, and squash racket. Since I've retired from baseball, I've had a chance to work on a few things. I like my chances on the court and in the pool.

People say that you learn more from losing than you do from winning. I loved to win, but from one perspective, I think that back then I needed to lose—not just at the Casa Cuba Olympics but at Ping-Pong and hitting from both sides of the plate. Painful as it was, I needed to understand what losing did to me. Losing was no fun at all, and I'm not exactly proud of the struggles I had, but I didn't give up. I kept at it, and over time I'd see that I was improving. If I had given myself a break back then, acknowledged that as a preteen I was pretty small for my age and shouldn't have expected so much of myself, I don't think I'd have developed the passion and the drive that I did.

I wasn't a great student in the classroom, but outside it, I was learning some valuable lessons. It's tough to be patient, but back then I had little choice. Still, something inside me told me that I'd get there. I just had to dig deep and keep pedaling hard.

Chapter Three
No Pain, No Gain

Riding bikes with my dad to get to the club made me feel special—few of the other guys I knew shared that kind of experience with their dads. Still, it wasn't like we rode side by side and spent the time bonding, with him giving me tips about the best way to go up hills. He rode ahead of me, expecting me to keep up as best I could. To be honest, though, I didn't mind that. I knew the route, and the sight of his body crouched over the handlebars gave me a goal to shoot for.

Of course this activity also had to come with a lesson. One weekend morning, I got a flat while my dad was well out in front of me. I still had about a half-mile to Casa Cuba. By then, my dad was quickly disappearing as the road wound down toward the beach. I couldn't yell for him to come help me. I hefted the top tube of

the bike's frame over my shoulder and walked the rest of the way.

Later, after lunch, we were going to ride over to my grandparents' house for the rest of the afternoon and for dinner. When we got to the bikes, my dad looked the situation over. He reached into a small pack he carried underneath his seat and pulled out a new tube and a couple of plastic tire levers.

"Here you are," he said, setting the stuff down on my bike seat. "I'll see you when you get there."

"Wait. I haven't done this before," I said, whining more than I intended. "Aren't you going to do this or help me?"

"You've seen me do it before. I need to get there. Your grandmother has something she needs me to do. Don't be late for dinner."

With that, he mounted his bike and rode away, leaving me to figure it out on my own and expecting that I would still make it to my grandparents' house.

I would have forgotten the incident except that recently I was getting ready to go for a ride with my son, Jorge. The racing bikes we use have very narrow, very low-profile tires, even skinnier than the ones my dad and I rode on. I was filling them up for both of us. More than 100 pounds of pressure is a lot, and I wasn't prepared for what happened when one of them

let go. It sounded like a gunshot. Jorge and Laura came running into the garage to see what had happened, and their worried looks made me laugh. I couldn't help it. I pointed to the tire and then said, "I guess I don't know my own strength." Laura rolled her eyes and shook her head, then smiled before walking back into the house.

Jorge stuck around, and I showed him how to remove the tire so that we could either replace or repair the tube. I admit that I'm not the most patient person in the world. Waiting in lines, being stuck in traffic— all the little irritants of life get to me. But in working with Jorge, whether it's with his baseball or teaching him to fix a flat on his bike, I try really hard to be calm, especially when I see in him some of that same impatience I've always struggled with. For this reason, it was interesting to sit there in the garage with him and show him how to fix the tire. I was trying to give him the clearest set of instructions I could about how to remove the tire from the rim, but I could see him getting frustrated with me. Finally, tutorial incomplete, I said, "Here, just try it." I told him that he had to learn to do this himself, especially if it happened out on the road when I wasn't around.

I watched as the veins in his temple pulsed and his complexion reddened until he looked like he wanted to toss the bike across the garage. Sensing his frustration,

I started my demonstration again. Instead of let-ting Jorge finish the job I'd started, I pressed the tire back onto the rim and told him, "Now you do it. I'll be back." I left him to the task, figuring, without me there, some of the pressure would be off him. Before I closed the door to the house I said, "Take your time. We'll go when you're ready."

What I didn't tell my son in that lesson was that those high-pressure tubes were kind of like my dad and me. He had high expectations for me. He was strict and expected me to stay within a narrow band of proper behavior—how I dressed, how I played the game, how I performed in school, how I spoke to my elders, and all the rest that went into living under the rules of his regime. "My house, my rules" was something I heard quite a bit growing up. The pressure of those expecta-tions was so high that, when I needed to be free of them, I sometimes popped—and not in a slow leak but in a quick release, like when I shot that neighbor's house. It didn't happen a lot, but because I was usually so well behaved and so firmly under my dad's control, it was even more noticeable when I did pop. The tough part for me to deal with, both then and to an extent later on, was that, when I did something to remove the pres-sure I felt to excel, it seemed like the expectations built up even more and even more things went wrong, until

I finally felt like I couldn't put up with it anymore. It seemed like every time I decided to take a chance and defy my dad's rules, things went way wrong. Not all the time, but often enough.

Although I didn't understand it at the time, this was another way my dad was preparing me to be a big league ballplayer: all those expectations he had for me made me feel like I was supposed to behave like an adult. He wanted me to be mature, and maybe more advanced for my age than I was ready to be—like having me switch-hit when I felt I wasn't ready to. I can't help but think of that time my dad had me level off the backyard in the light of these kinds of expectations. Sure, he was training my hands to be strong enough to grip the wood of the shovel, but more than that, he was showing me what he expected from me as a person and the standards that he expected me to meet. Most parents I know, if they wanted to have their yard transformed like that, would call in a landscaping crew to do the work. A bunch of adults would come and do it. But that was not his way—simply getting the work done was not the point.

Every summer after I turned 13 I had to paint the ornamental grillwork around our house, a task that also terrorized my days out of school. Because iron and humidity don't work well with paint, it was constantly

peeling. Our sidewalk frequently looked like Fifth Avenue after a victory parade, speckled with flecks of paint. My job was to clean up the sidewalk and repaint the iron bars.

I hated that job.

It wasn't as demanding physically as hauling dirt, but it was still nasty work. I had to take a sheet of sandpaper and a metal scraper and go after the iron bars to smooth them out. The paint dust and the rust that I kicked up clogged my nose and throat; I scraped my knuckles raw trying to get into every tiny crevice and curve of those pieces. The ones that were spiraled like a corkscrew were the absolute worst, a work of the same Devil my parents thought sometimes urged me to misbehave. I think it was down in the fires of hell that El Diablo forged those pieces of iron. Painting them wasn't much fun either. A lot of what I had sanded off clung to the old paint. At first, I didn't bother to wipe it all down, and I'd just slap the new paint on, covering the dust and flecks. Since some of the paint would glob onto the iron and some would cling to the brush, even if I painted over an area that was free of debris, the painted surface would be pebbled and bumpy.

I didn't really care. At least the surfaces were all black and no rust was showing through. No bare spots were good, right? Unfortunately, my dad would come

out and do a daily inspection of my work and point out all the flaws in what I considered to be the finished sections.

"Sand that again. I want it smoooooth," my dad would say, drawing out the word to make his point and making me want to put the point of the scraper to my neck and end my suffering.

I learned my lesson pretty quickly about rushing through the job. If I thought that sanding and scraping *old* paint was difficult, trying to get the *fresh* stuff off was another kind of torment.

Once, when I was complaining to Manuel and Ernesto about the tortures of my labor, Manuel suggested using a stripper.

After a couple of jokes about what a stripper did, I got the picture—let chemicals do the work.

When my dad came home at lunch, he took me out for a tour of my work. He pursed his lips and nodded. "*Mucho mejor.*"

I knew it was looking better, but I was interested in it looking better *faster.*

I told him all that I knew about paint strippers and tried to make my case that the modern way was the best way. I'd barely gotten a few words into my sales pitch when he silenced me. He held up both of his hands, "*Tus manos. Que van a hacer el trabajo.*"

It figured. My hands would have to do the work, not some chemical concoction.

And so it was that every summer I'd battle the elements, with my dad fanatically clinging to the idea that the old way was the right way. All I know is that the steel bristles of that scraper couldn't have irritated me more or done more damage than I did gritting my teeth and cursing under my breath, inhaling the by-products of my sweaty efforts. To this day, I can't go into a home supply store and not tear up when I see a can of Sherwin-Williams paint. It's the logo of a can of paint dripping over the earth that makes me queasy. I felt like I'd done the same thing all those years—covered all 196.9 million square miles of the earth's surface with my sanding and painting, summer after summer, until the *t* in the word "paint" was no longer visible.

My hands had to do old-school work in another way as well. When I was first learning to hit and later to switch-hit, I used an aluminum bat most of the time. That all changed in 1983, when I was 13. I was still playing club baseball primarily. I was forced to switch schools because I wasn't earning good enough grades at the American Military Academy. I didn't really mind. It was a long bus ride there and getting up at 6:00 A.M. and getting home at 6:30 P.M. after practice was wearing me out.

It's funny to think of it now, but even back then I was more concerned about my dad switching me from an aluminum bat to a wooden bat than I was about switching schools. I didn't think of having to leave AMA as a failure, though it was just that. I didn't have failing grades, but I didn't achieve at the level that everyone wanted me to or I needed to.

In retrospect, I was lucky to have a father who came down hard on me when my grades fell short of what they needed to be for me to participate in sports but who never took the privilege of playing sports away from me. My dad wanted me to focus on doing the things I was good at. I played a bit of soccer and basketball at school and at the club—I wasn't very good at soccer but really liked hoops and was decent at it—but eventually he told me to give them up completely to focus on baseball. I didn't mind that much at all.

I wound up attending a Catholic school, La Merced, for seventh through ninth grades. La Merced lived up to its Spanish name: it was a bit of mercy for me. My mom had learned to drive by then, so I didn't have to get up before sunrise to catch a bus. Also, classes let out at 1:30, a full two hours ahead of the military school. In comparison, attending La Merced was like going on vacation. However, I did have to pay a bit of a price: my aluminum bat privileges were revoked.

To anyone who has ever played the game over the last 40 years, an aluminum bat is either a blessing or a curse. If you have sensitive ears—and keep in mind that I was still called Dumbo on occasion back then—the piercing sound of a *ping* off an Easton aluminum bat can give you either chills of pleasure or waves of pain. I grew up with aluminum bats, so I was accustomed to the sound and, more important, to the feel. The ball just jumps off those things, and I was using them in the era when those bats were at their hottest. Eventually, because of how fast the ball came off aluminum bats, organizations like the NCAA got bat-makers to tone them down for fear that someone was going to get killed by a well-struck ball.

With that in mind, I think you can understand why I was upset with my dad for taking away my aluminum bats and requiring me to use wooden bats only. The way I saw it, I was going to be at a disadvantage compared to other players. Of course, there was a method to his madness—which, once again, I can only appreciate looking back.

As a scout, my dad had heard lots of stories about guys who put up big numbers in the amateur ranks but couldn't make the transition to using wooden bats when they turned pro. My dad didn't go into too much detail in explaining why I had to use wood. He simply said that big leaguers used them. I wanted to be a big

leaguer, so I should too. I understood that, and it wasn't really that hard of a habit to break, but I did notice a difference in how the ball came off my bat. Part of that was due to the fact that the sweet spot on an aluminum bat is larger than it is on a wooden bat. Depending on who you talk to, the difference can be as much as 100 percent—six inches for an aluminum bat and three inches for a wooden bat.

What that meant in practical terms was that I had to really groove my swing, fine-tune my eye, and develop greater concentration in order to square up a ball and hit it well. I couldn't be lazy with my swing or my approach at the plate. I understood all that intellectually, but emotionally it was hard for me to deal with not producing the kind of results that I sometimes saw other, less talented hitters producing. For some adults that transition was tough; I was still just a kid and my dad expected me to make it.

I understood the game well, and from the bench I'd watch my teammates—or my opponents from my position at shortstop—hitting balls off their fists, off the end of the bat, and driving them into the outfield for hits. If I hit the ball off those same spots on a wooden bat, I'd ground out weakly or hit a little humpbacked liner that wasn't struck hard enough to make a dent in a fielder's glove.

I don't have access to my batting statistics from back then to verify this point, but I know that based on never being named most valuable, most outstanding, most improved, or most anything until late in my youth, except most likely to bleed—I never wore batting gloves and took so many swings that I shredded the skin on my hands—those bats were a blessing and a curse to me. I understood the economic need for aluminum bats. They were more expensive, but they didn't break. I was fortunate that my dad had access to wooden bats, and I never really gave that access much thought. He told me to use them. He provided them for me, and when I broke one, I always had at least a couple of others on hand to use. I knew that money didn't grow on trees, but bats did.

When I did travel to the DR to visit family, or later to play in some tournaments, I saw how lucky I was. Some of the teams we played seemed to have just one or two wooden or aluminum bats, and all the guys on the team used them. My bats were mine. It wasn't like I wouldn't have let someone else use one, and a few guys did mess around with them during batting practice, but no one wanted to have the disadvantage of a wooden bat, so for the most part they left my bats alone.

In the end, having a wooden bat was just another way I was going to stand out as different from the other

guys, another sign that I was the son of a scout, a boy with expectations heaped on him. At first, I felt privileged to have a father who worked for a major league baseball team. I was able to get T-shirts, pants, and uniform tops from the Blue Jays. I wore them to practice but nowhere else. I wore the same khakis and polo shirts uniform to school as before, and off the field I didn't wear any team logo gear. That was especially true with hats. Even though baseball hats had become a popular fashion item, I seldom wore them other than on the field.

While I was proud of these clothes, they also pointed out another painful part of my reality: my dad was a scout while I was struggling to be a good ballplayer, sometimes finding myself stuck out in right field because I couldn't make the plays anywhere in the infield. Everybody knew my dad and knew that I was his kid. So when I didn't do well, it was always "Jorge Posada's kid," "the scout's kid," who didn't do well. Everybody looked at me and figured that, given who my dad was, I should have been all-league, all-star, all the time. I wasn't. I got really frustrated a lot of the time, and my dad never really consoled me or encouraged me; instead, he'd tell me that I had to work harder. That's great advice to give, but back then it wasn't always what I wanted to hear. I needed to hear it, but I didn't like it.

Just because I wanted to be better at the game didn't mean I liked having to work harder to improve. Nobody likes having to work that hard; you do it because you have to, and when you see some positive changes, you like the fact that your hard work is paying off and it makes the work easier. I can't say that when my dad told me to take 100 swings at the chain-link fence to practice getting the barrel of the bat out in front and to strengthen my hands and arms, I was laughing and shaking my head at how much of a pleasure it was going to be to do that. I enjoyed getting some of my frustrations out, but I can't say that beating on that fence was fun. It was work, and a part of me, a big part of me, wished that I didn't have to work so hard. I wanted to *play* better, and that took work. It's great when the work of baseball combines with the pleasure of playing it, but for me, at least until the late stages of my high school and American Legion career, there was a lot more work than play to it.

Not only did my dad show me just how much of the game is an actual job, but I also benefited from his involvement in baseball in another way. He didn't play baseball any longer, but he was still playing and coaching softball. At the club, and against the other clubs, my dad played nine-inch softball in a league with somewhat modified rules. It wasn't slow-pitch,

where the pitcher lobs the ball up there with a high arc; it also wasn't fast-pitch, like you see when women play in the Olympics, where they throw hard risers and that kind of thing. In my dad's softball league, they did pitch underhand, but most of the guys threw a kind of knuckleball that moved around. The ball never really got much above the head of the batter as it came in. Still, those guys could make the ball move pretty good.

My dad was a good pitcher, and my first experiences with catching took place outside our house on the sidewalk when he'd use me as his practice catcher for the club competitions. Eventually my dad progressed to forming and playing for a team that used the fast-pitch rules—the big windmill windup like Jennie Finch and others would use. That team competed all around the island and was made up of some really good athletes, including a few ex-professional baseball players. Nelson Pedraza was the shortstop, and Eddie Santos batted cleanup and played right field. So this wasn't a beer league for guys with big guts hanging over their bellies who could only do one thing—belt the ball a long way. In fast-pitch, even though the ball is bigger, you have to play small ball—make contact, hit behind runners, bunt, and that sort of thing.

When I was 15, my dad recruited me to play on his tournament team. They needed a catcher because their

star pitcher, Esteban Ramallo, could really, really bring it. In fast-pitch softball, the pitcher's mound is 46 feet away from home plate. That's 14½ feet closer than it is in baseball. With his windup moving him toward the batter, the pitcher releases the ball closer to 42 or so feet away. That doesn't give a hitter a lot of time to react.

Esteban Ramallo threw in the mid-to high 80s. It was hard to catch him because with that underhand delivery, it was like the ball was coming out of his midsection. It came out of his hand low and stayed low on a flat plane rather than make any kind of eye-level change. That made it hard to track. The first few times I caught him I was more like a soccer or hockey goalie—I was just trying to keep the ball from getting past me. Plus, a 6-inch softball's bigger circumference made it hard to get the ball to nestle in the glove.

I liked the challenge of catching fast-pitch, though, and it was cool to be playing with and against adults. Facing those pitchers, even with an aluminum bat in my hand, I had to shorten my stroke and really focus on making solid contact. That was especially important because when we got into tournament play I batted leadoff. I managed to have some good games, as did the team, but we fell short of winning the championship.

Still, the experience was great, and I learned a lot. It's a huge advantage for developing players to compete

against the best competition possible. It's hard psycho-
logically when you struggle against older guys, but when
you do succeed you get an extra dose of confidence.
Also, your physical skills inevitably improve when you
manage to go up against players who are older, bigger,
and faster. I've heard a lot of athletes, football play-
ers especially, say that the transition from high school
to college, or from college to the NFL, was difficult
because the game seemed so much faster. The same is
true for a lot of baseball players when they advance:
the pitchers seem to throw harder from one level to the
next. At a certain point, though, what makes it more
difficult to hit isn't so much how hard guys throw but
their ability to throw off-speed and breaking balls for
strikes.

Playing those softball games and hitting and catch-
ing guys like Esteban helped to sharpen my skills. I
also enjoyed watching my dad coach and play. I'd seen
my dad react with joy when he beat my butt at Ping-
Pong, but when he was out on the field competing at
softball, and to some extent on the basketball court, he
seemed transformed. He took it seriously, but there was
a pleasure to that seriousness that I could identify with.
He was having fun. Competing was fun. Winning was
fun. All the things he told me to do—work hard, hustle,
find a competitive edge—weren't just things he said,

they were things that he could do. It was like having your teacher demonstrate that he didn't just have some knowledge of a subject but was skilled at it too.

We had those scrapbooks at home filled with stories about my dad's sporting efforts. When I was young, I'd flip through them, mostly to look at the pictures, but when I hit my midteens and started to work with his softball team, I began to look at those stories a little more closely. I never doubted that my dad knew what he was talking about when it came to baseball, but I saw that his knowledge came from his own experiences, not just from reading a book or picking it up in some other way. That was huge for me, I can see now, though at the time I still had a few remaining questions about why he was having me do some of the things he was.

I also finally asked my dad to share with me some of the experiences that weren't in those scrapbooks—how he got to Puerto Rico was something that I didn't fully understand before then.

Though he loved the country and life had been good for them there, my grandfather sensed that Castro was going to change things for the worse. He decided to take his family to Puerto Rico in 1962. At that point, my father was 23 years old. That meant that he fell within the age range of males (15–27) that Castro had targeted

with a law forbidding them from leaving the country. With his visa torn up, my father had no choice but to remain. He worked at the Ministerio del Comercio Exterior de Cuba (MINCEX) in the shipyards monitoring exports of products like cigars. He lived in the house that his parents owned, but still had to sell off nearly all the furniture, including a piano, and other household items in order to survive. His being held in Cuba also meant that he couldn't honor the contract he'd signed with the A's.

He was allowed to play for sports teams that his government ministry sponsored. The pages of the "after" scrapbook detailed his contributions to his basketball team as a point guard. He was named to various all-star squads and played for them in different tournaments. Eventually he traveled to places like the Soviet Union, Bulgaria, Hungary, and other communist countries. His government job gave him the flexibility to do that, since Castro believed that sports could promote his political agenda. My father didn't like Castro and what he was doing to the country and wanted to leave. Just as on those basketball trips where they were guarded heavily to prevent anyone from defecting, he was being watched at home.

He never knew how, but someone must have informed a government official about his opinion of

Castro. In 1965, he was arrested, stripped of his government job, and imprisoned for ten days. When he was released, he was sent to sugarcane fields to cut the crop. The work was backbreaking. He did have some incentive, though. Depending upon how many rows of cane he completed, he could earn time off to visit other family members still in Cuba.

He knew that he couldn't stay under those conditions, so he devised a plan. Each time he earned that pass to visit family in Havana, he took steps to put that plan into action. On one of the trips after he'd earned a pass, he went down to the docks where he once worked. He found a Greek captain who he had been friendly with and told the man that he planned to get out by boat and hoped he could get help. The captain was sympathetic and he agreed, with a couple of conditions. It was up to my dad to figure out the rest of his escape. After six months of working in the fields and making all the other arrangements, my dad decided that the time was right. The Greek captain's ship was scheduled to be in Havana Harbor in a few days. My dad snuck away from the cane field and then rode a horse many miles to get to where his uncle had hidden a coffin. From there, he rode many hours in a closed coffin—with a hole drilled into it so that he could breathe. Eventually, they reached Havana. On January 2, 1967, my father

dressed in a suit and tie, carried his old work credentials, and entered the docks where he boarded the ship. He stowed away inside a wooden crate filled with boxes of cigars, and only when he knew that they were at least 18 miles outside of Cuba did he bang on the crate and get released.

A few days later, they were in Greece. Because the Greek captain was concerned about getting in trouble with Cuban authorities, he had to report my father the day they set out. The Cuban authorities knew where the ship was destined and Greek policmen were waiting for him at the docks. My father's athletic skills paid off. He scrambled down the cargo netting and outran the police. Eventually, he found sanctuary in a Greek Orthodox church that was known for aiding refugees. They sent him to Madrid where he found work, played baseball, and seemed content to live out his life. But the pull of family was too great in the end, and by July 1968, he was in Puerto Rico. Six months later he met my mother, and then I came along in 1970.

Clearly, I didn't understand back then what pain and sacrifice really were, especially not in comparison to what my father endured. Only now, as a father myself, do I fully understand what my father was trying to do for me, why his stubborn insistence that I do things his way was really the right way and would benefit me.

He left his home country with literally nothing but the clothes on his back and within months of arriving in Puerto Rico was working hard to make a comfortable life for himself and his family. In a way, I feel silly for sharing stories of what I saw then as sacrifices I had to make. I didn't know the complete history for many years, but heard my father and his Cuban friends talking about riding on an elephant's foot, holding on to its legs, and other crazy things they did in Cuba and how much they missed the good old days. They seldom spoke of the hardships. And it seemed like when he played sports my dad was able to recapture some of the spirit of what life had been like before Castro took over.

Catching Esteban Ramallo wasn't easy—and he did inflict a bit of pain on me—but it was fun because it wasn't easy. Just as over time my ability to hit left-handed went from feeling unnatural to natural, I was learning that mastering something difficult is rewarding. I don't know if it was because of a strange set of circumstances or what, but it felt like for a long time I wasn't a switch-hitter at all: for years at a time, I only seemed to face right-handed pitchers, so batting lefty became my default. In fact, I got so comfortable on the left side of the plate that when I finally faced my first lefty around the time I was 15, I honestly didn't know

what to do. My dad kind of shook his head in disbelief and told me to bat right-handed. I'd been taking batting practice right-handed all along, but just a few cuts each time.

Digging into that right-hand box felt a bit odd at first, but that feeling disappeared pretty quickly. I couldn't have said this at the time, but learning to be adaptable—for example, going from facing my peers in baseball to playing with adults in fast-pitch softball—was important to my development and maturity as a ballplayer. Ultimately this ability to switch—whether from one side of the plate to another, from an aluminum bat to a wooden one, or from my expectations for myself to someone else's—would prove to be an incredible asset, and one that only my father could teach me.

I might have been surrounded by expectations, but that didn't mean that I was becoming a perfect little angel—far from it. I tried as hard as I could to meet my father's standards, sometimes too hard, and when I couldn't be as adult as he wanted me to be—like when I went for my BB gun instead of simply asking for my ball back—I snapped and acted very immaturely.

I didn't always respect the rules and restrictions that were placed on me, and often I rebelled against the

pressure put on me without totally understanding why. In fact, I nearly threw away all my dad's hard work, as well as my own, because I couldn't resist the temptation of speed.

Manuel had a Yamaha scooter, and I wanted one too. As much as I liked cycling, being able to ride around and not have to pedal was amazing. Manuel would take me on the back of his—even though my mother told me not to—and I loved the sensation of being able to zip along. Eventually, Manuel gave in and let me take it out on my own, but just in front of the house.

Of course, I wasn't satisfied with just doing that, so I then began to beg him to let me take it out in the neighborhood. "Just around the block, man. Just around the block." I wore him down, and he said, "Okay. But be careful." I hate those words.

I was careful, but I was and wasn't lucky.

I came to a tight curve, got the scooter leaning into it nicely, and the next thing I knew I was tumbling on the ground, feeling the skin on my hands and knees being shredded off. I came to a stop on my stomach and could feel the grit and stones of the gravel that had caused my slide. The scooter was on its side next to the curb, its engine still running and its rear tire spinning. In an adrenaline rush, I got up and ran to the scooter and switched off the engine. I got it back upright. I hopped

back on, fired up the motor, and rode back toward the house. Only then did I feel any pain. The gouges in my knees and hands stung, though they were superficial, but as I twisted the throttle I felt a sharp pain in my wrist. I looked down at it and could see that the swelling had already begun.

I came to a stop and Manuel came running.

"I heard the motor revving all the way over here. What were you—" He stopped himself and his eyes grew wide. He then squeezed them shut. "Why did I—"

"I'm sorry. I'm sorry. I don't know what happened."

By this time, the pain was getting really bad. I felt light-headed and a bit nauseated. I levered the kickstand down and staggered onto the sidewalk, where I sat with my head between my knees.

I don't know how long I sat there, thinking all the time how stupid I was and how unlucky I was. Manuel's mom came and knelt next to me. A moment later my mom, her expression a mix of anguish and anger, joined her.

I kept mumbling how sorry I was, told her over and over that it wasn't that bad. She told me to keep quiet, that she was going to make sure I was okay. They loaded me into Manuel's family car, and we headed off to the emergency room. I was feeling a bit woozy, and every

time we went over a bump I winced in pain. I tried not to think about the most painful thing of all—how my dad was going to react when he found out. I knew that my wrist was bad, and there was no way I was going to be able to hide from him the fact that I had gotten hurt. I could tell him that I fell off my bike, but that would require my mom playing along. I knew that she was hurt that I hadn't listened to her when she'd told me to stay off the scooter. The bike excuse would have been believable—a few years earlier, I had fallen off my bike and injured the other wrist. I'd felt like I deserved that injury because I'd gone to the mall to get a Wiffle ball for our games, even though my mom had said that I wasn't to ride all the way over there; I did anyway, and along the way I'd fallen.

Now, as I was escorted into the emergency room and plopped into a chair, I kept thinking about how odd it seemed that every time my mom told me not to do something and I did it anyway, I somehow ended up getting hurt. My wrist hurt like hell. I was afraid of what my dad was going to do to me, and anxious about what the doctor was going to discover, but I shed no tears. Maybe that was a good sign?

As it turned out, I was very fortunate that I only sprained my wrist. I wore a hard cast for a month, and then a removable one until it completely healed. All of

my scrapes, what we called "road rash," got cleaned up. The worst part was the doctor using a pair of long tweezers to pick bits of stone out from underneath flaps of skin. Only now do I realize what could have happened, how wrong things could have gone.

I was hurting quite a bit from my injury, but the psychological torture of knowing that my dad was going to come home and I was going to have to confess to him what I'd done was even more painful. I lay in bed, my wrist propped up on a pillow, my fingers feeling fatter and fatter as I watched the shadows crawl across the ceiling and down the far wall. By the time they touched the floor, I heard my father's car squeak to a stop in the driveway. I figured it was best to just face the music, and I hoped that it would be my music that he'd take away from me this time—though I was certain it was going to be a lot worse than that.

I went to the kitchen and stood at the table, my wrist resting on the back of the chair in full view of my dad as soon as he entered the house. He came in, stopped in his tracks, brought the flats of his palms to his eyes, and rubbed his face, seemingly smearing it with a deep red paint.

"¡Idiota!" he snarled. "¿En qué estabas pensando?"

The words "I wasn't thinking" nearly escaped my mouth, but I swallowed them and just looked at the

floor, noticing for the first time that the skin under-
neath the nail on my big toe had turned purple.

My dad went on yelling, telling me what I'd already
been thinking myself but had dismissed as unneces-
sary worry: "You'll never make it to the big leagues.
The wrist is a complicated joint. You damage it, you
can't throw, you can't hit. What good are you then?"

He didn't even ask me how it had happened, and I
was glad about that. But when he said, "Someone needs
to keep a better eye on you, you can't be trusted," he
looked at my mother and then at me. I started to tear
up, sad that I might have caused my mother even more
grief than I already had.

"It was my fault—" I began.

He swiftly cut me off. "¡*Por supuesto!*" He had his
hands on his hips and leaned forward, bug-eyed, like
a cartoon lion about to raise his head to devour me.
"Who else is there to blame?"

The question hung there in silence, along with the
smell of rice burning. My mother took in a sharp breath
and scrambled to the stove.

I didn't need to hear anymore, but my father added,
"Get out of here. I can't look at you right now."

I retreated to my room. About a half hour later,
Michelle came in, tiptoeing and carrying a bowl of rice
and beans. She set it on my nightstand and darted out

again. My stomach growled, but I didn't eat a bite. I knew I deserved this punishment and wasn't going to do anything to lessen it.

My dad didn't look at me or talk to me for a few days after that, but when I was finally able to get the cast off my wrist permanently, he examined it when he came home that night.

"Take it easy. Just a few swings off the tee for a few days. Twenty-five to thirty. If it hurts too much, stop."

I had to fight a smile. My batting tee had gone from being another of my misadventures to a regular part of my routine. I'd "salvaged" the tee from a hose at the back of our washing machine and a broomstick I cut to length. When my mom learned that the washer had a sudden leak, she shouted so loud I could hear her all the way at the far end of the yard, where I was busy digging a posthole so that the broomstick would stand upright. Understandably, she was not pleased, but the hose fit neatly over the piece of wood and held the ball securely. Of course, when my mom went to find the broom to sweep up the water, the count was 0-2.

There were times when anyone who didn't know us well would have thought that my name was J-O-R-G-E-U-G-H! for the note of exasperation that my parents had to add to the end of it. My mom covered

for me on that one, not mentioning anything about the rubber pipe and broomstick I'd borrowed. She got the pipe replaced, the laundry got clean, and all was well until my dad came home to find me bashing balls off the tee into our chain-link fence. At first he stood there appraising my swing. Then his brow wrinkled and his eyes grew wide. He didn't want to look at me again that evening. Maybe because this was a baseball-positive failure to do the right thing, he only seemed mad for a few hours afterward. But every time he saw me using the tee he would shake his head slowly and say, "Swing is okay. Tee is bad."

That whole incident went down better than my attempt to build a backstop out of a few concrete blocks we had lying around. My mom didn't like me throwing a ball against the house, so I figured I'd do the right thing and take those blocks, less than a half-dozen of them, and stack them in the yard. They worked well in keeping the ball from getting away, providing good targets for my throws, and making no noise that would bother my mother. Of course, there was a downside— they really scuffed up the cover of the balls. That didn't matter to me, because my dad's closet had a laundry basket full of baseballs. It was like one of those *Star Trek* machines they could walk up to, tell it what they wanted, and there it was. I wanted baseballs, and when

I went to my dad's closet, there they were. I wasn't paying close attention, though, and one of the balls I took out of the closet—well, it wasn't in the laundry basket but on a small shelf, and it happened to be a ball signed by Roberto Clemente. My dad didn't care so much that I'd decreased the value of the ball if he wanted to sell it; his concern was that it was disrespectful of me to take something he prized, and stupid of me to not even notice the signature on it.

I got a taste of my own medicine one afternoon in 1984. I rode my bike on a regular loop through our surrounding area. Since I no longer had to get up early to get to school, and inspired by my dad's example, I got out of bed to ride 20 miles. On days when practices or games didn't prevent it, I'd do the same after school. That—and my dream of cycling heroics—ended when a gang of kids attacked me. I was in a poor part of our neighborhood and I saw a group of guys walking along. They carried chains and sticks, but I didn't really think they would use them. They were shouting and laughing, and then one of them lashed out with his chain, hitting my front tire and knocking me to the ground. A moment later, I felt one of those sticks hitting me. I had on a helmet, one of the old-fashioned bike helmets that looked like partially inflated inner tubes, and along with the dull ache of the stick hitting me I felt a

sharp pain. A moment later, I felt blood running down my head, into my eyes.

We were in a well-traveled area, and the thing that hurt me most was seeing people in their cars staring at me but no one helping me. The guys took my bike, and I had to figure out how to get home. My grandparents lived nearby, so I stopped there. I thought my grandmother was going to faint when she saw her bloody grandson at her front door. I got cleaned up and my dad and mom came to get me. For the next few weeks, my dad came home from work and drove through the area, hoping to spot my bike so that he could take on whoever had attacked me. He never saw it, but I appreciated his efforts. For many years after that I didn't ride a bike at all, only resuming the activity when I was an adult. I hated the idea that something I valued also made me a target.

In spite of all that I did wrong—disobeying rules, getting bad grades—I was especially lucky that my dad never took away the one privilege that really meant the most to me growing up: attending spring training in the United States with whatever team he was scouting for. We had an agreement: if my grades were good enough—which meant passing my classes—and if school wasn't in session, then I could go with him when he reported for spring training.

The first spring training I attended was in 1981 when he was with the Blue Jays. The head of Latin American scouting for the club, my dad's boss, was Epy Guerrero. To me and to my family, he was just Epy, the guy who worked with my dad and was a knowledgeable and fun baseball guy and the brother of Miguel Guerrero. He was also the father of five sons, Miguel, Sandy, Frederick, Lawrence, and Patrick, who was named after the Blue Jays' general manager Pat Gillick. I hung out with those guys when my family traveled to the DR.

It wasn't until later that I realized just how important a figure Epifanio Obdulio Guerrero was. He signed more than 50 Latin ballplayers who eventually played Major League Baseball, including guys like Tony Fernández, Carlos Delgado, Dámaso García, Alfredo Griffin, José Mesa, and Freddy García. He was so successful and influential that he was named a member of the Dominican Republic's Sports Hall of Fame and earned the Professional Baseball Scouts Foundation's Legend in Scouting Award. Sadly, he passed away in 2013 at the age of 71. I don't know for sure what role he played in my eventually getting drafted, but I know it didn't hurt to have him and my father in the picture.

He also was acknowledged as helping the Blue Jays develop from an expansion team into a powerhouse

through the development of Latin ballplayers. Toronto came into the league in 1977 and won World Series championships in 1992 and 1993; they were very competitive very quickly, especially in comparison to the other team that came into the league that same year, the Seattle Mariners. The Mariners didn't even have a winning season until 1991 and still haven't won a World Series or even gotten into one. When Epy passed, a lot of Toronto's management gave him, along with many other scouts in the organization, credit for having built that team through the draft and trades. No one had ever heard of a lot of the young players involved in those expansion-era trades, but some of them became a big deal for teams down the line. Epy played a role, for instance, in the Jays eventually trading for Fred McGriff. The Jays then traded him for Robbie Alomar and Joe Carter, two guys who were important in bringing them their championships.

In 1981, Epy was on the Jays' coaching staff, and that was the year I got to attend my first spring training camp, in Dunedin, Florida. This wasn't my first trip to the States, though. A few years earlier, my dad had taken our family to visit Disney World in Orlando. Michelle and I were thrilled. We'd seen television ads for the place, and after talking to other kids who had gone, we developed a game plan for riding all the attractions.

Flying was a big deal for us, but we were so excited that we could have flown there without the plane. When we got to the park, we were both like racehorses in the starting gate. With their cooler heads, though, my mom and dad kept us from dashing into the park.

Disney World was as advertised—a kid's version of heaven. We had a great time, and I didn't even mind seeing the Dumbo the Flying Elephant ride.

We were sad to see the day come to an end, but we knew that all we had to do was eat dinner, fall asleep, and then come back to the park. In baseball, going 2-for-3 is a very good day. In Disney World terms, it isn't a very good day at all. And the emphasis here is on the word "day." We got up the next morning and got on a shuttle bus. Instead of going from the hotel to the park, it took us to the airport. Michelle and I looked at one another and then at my mom. She shrugged her shoulders and said, "Yesterday was good, right?" We nodded. Then my father added, "What else is there to see? One day was enough." Michelle leaned against me, and I could feel her shoulders shaking. I sat there dumbfounded, thinking that we had to be the only family in the history of Disney World to fly in and spend only one day—and to be precise, it wasn't even a full day—at the Most Magical Place on Earth. It was magical all right—my dad made it disappear.

When I returned to the States for spring training in 1981, I knew going in that my dad couldn't make the Jays' spring training complex disappear. And to be honest, no offense to the Disney people, for me, all those baseball diamonds, batting cages, and major and minor leaguers made Dunedin, Florida, the happiest place on earth.

I was only eleven years old, so I was more in awe of the place than I was later on. Seeing all the guys on the team working out, though, had an impact on me. It wasn't that they weren't having fun, but I saw that guys at that level were doing some of the same things that my dad was having me do. They took ground ball after ground ball. They hit in the cages, did soft-toss against a barrier, and worked on their swings hitting tires or a fence. What I remember most, though, was how green those diamonds were, how red the dirt was, and how bright the white lines and the bases were. As lush as Puerto Rico was, most of the fields I played on were dusty brown patches of dirt and grass. When those pure white balls rolled across the ground—and it seemed like there were thousands of those pearls lying around and being used everywhere—they stood out against the darker colors of the ground and sky.

Watching those practices and eventually a few intra-squad games was like watching a fireworks display.

Everything seemed bright and loud, and even if I didn't make the sounds, I was oohing and aahing at everything I saw. I felt nearly as bad at having to leave there after five days as I did having to leave Disney World.

I didn't get a chance to return to spring training in person for a few more years. In my mind, though, I was there every day. In a way, spring training was like going to the best zoo in the world, a nature preserve where the animals on display were in their natural environment living the way they did in the wild. I couldn't imagine anything better than that. That is, not until my dad loaded us up in the car and took us to the airport in 1983.

We were going to New York City, and through some connections he had with other scouts, we were going to Yankee Stadium to see a game. On Monday, June 27, the Yankees were playing an afternoon game with the Orioles.

The bus ride we took from where we were staying with friends of my dad's was like another fireworks display. People crowded on, and I stood in the aisle to let adults sit, riding the waves as the bus bumped over the road, wobbling and bending my knees like I was one of my surfing cousins in the DR. When we exited the bus outside the stadium, it was like Carnaval Ponceño as Mamí Upe described it to me. The Diablos Cojuelos

were street vendors selling everything from giant bags of peanuts to pendants to T-shirts and bottles of water. Nearly anything you wanted or needed was for sale outside the stadium.

Once we got through the turnstile, my heart started beating faster. When I caught sight of the striped outfield grass, I nearly broke out of my mother's grip. I turned and looked up at her and said, "Someday I'm going to be out there." I pointed at the field. My dad was with Michelle, but he heard me.

"That's up to you," he said. "You want it. You work for it."

My mouth went dry. That was as close to words of praise as I'd ever really gotten from my dad. That would be true for quite a few more years as well. It didn't matter.

Something about seeing the crowd and feeling the energy at the stadium was almost too much for me. Though I was there as a part of the Blue Jays organization, I knew about the Yankees and their long tradition. Who didn't? They had been so good for so long that you couldn't help but know about them, even in my little corner of Puerto Rico. When we took our seats, my dad handed me a scorecard and I started to pencil in the names of the players. For the Orioles, the names that stood out were Ripken, Murray, and Singleton, but

I also liked Benny Ayala, who was from Yauco, Puerto Rico, and Aurelio Rodríguez, a third baseman from Mexico who would play in the big leagues for 17 years.

I can still feel in my feet how the stadium's concrete buzzed and throbbed when the Yankees tied it late in the game and then won it in the eleventh.

What could have been better than an extra-inning walk-off victory to make up for my dad's previous efforts to rain out that special trip in Orlando? It was as if the baseball gods decided to let me enjoy even more than was scheduled. We decided to walk back to our place after the game. Normally, I might have moaned a bit, but I kept quiet, taking in the scene. As we got farther from the stadium the crowds on the sidewalk thinned and there were fewer cars on the road, but still the air smelled of exhaust and dinners being cooked. We were just past the longest day of the summer, so the evening shadows trailed behind us as we made our way west and north toward the Hudson River.

Though I wished for it, I had no way of knowing then that those neighborhoods would one day become my neighborhoods, that I'd drive these streets of the Bronx when I went to work. I'd eventually think of catching for the Yankees as my job, and I'd have to put a lot of work into it to get there, but there's a reason why we say we "play" a sport. I felt a deep satisfaction in the

Yankees' victory that day. They'd scored the tying run thanks to an Oriole's error and Lou Piniella's hustle. They'd taken advantage of the other team's mistake, and that was good. But if I felt so good about a result that I had played no part in, I couldn't even begin to imagine what it would be like to play a part in putting a W in that all-important W-L column.

More than that, I was happy to be walking through the streets of the Bronx with my family. I kept telling my dad over and over, "Thank you. Thank you." Perhaps it's strange that I could thank him for one game he arranged for us to attend, but not for all he'd been doing for me for many years. We often take for granted the things our parents do for us, and I was certainly guilty of that as a kid and as a teen, and even later. But in my case, there was always someone "granting" me things. I wasn't a very good student of English in my early years, or even later, but when I decided to look up the word "granted," I discovered that it means "to give," "to agree," "to admit," and "to transfer." I can see now that my dad and I were involved in a complicated exchange of grants.

Another way to look at it was that there was a lot of give-and-take going on. At the time, I felt like I had to take a lot of what my father was handing out—his discipline, his demands, and his sometimes unexpected

and inexplicable desires. But I was also being given a whole lot of opportunities. You have to take advantage of opportunities, just like fielding errors, and you often don't know when they're going to come along.

In 1986, when I was 15 and going into my sophomore year at the Catholic high school, my dad was working part-time for the Braves organization. I got the chance to attend their spring training in West Palm Beach. By then, I wasn't just a little snot-nosed kid. I got to suit up and work out—not with the team, but I could take advantage of the facilities. Just like I'd done in 1983, I got to see the players go about their business.

I still had a bit of scavenger in me. When I'd find broken and discarded bats, I'd tape them up as best I could with some athletic tape I had with me and then use those bats. And I mean *use* them. I took batting practice off the machines until my hands bled. I'd tape up my broken skin and go back to it. When one of the Braves' minor league coaches saw me one afternoon, he pointed at the bloodstains on my pants. "You're crazy," he laughed. "You don't know when to quit, do you?" He might as well have told me that I was the next sure thing. He couldn't have paid me a higher compliment.

A day or so later I was in the cage hitting when Dale Murphy, the Braves slugger, came up to the cage. I

immediately stepped out of the box and started to pick up the balls.

"No, stay in there. I want to see you hit."

"No, sir," I said, nearly choking on my words, surprised that he even acknowledged that I was there. "I can't do that. You need it. You take it." I felt like I was talking like a little kid. My face and ears burned.

"I mean it. Keep swinging."

I looked down at the ground. It seemed to me like I could have fit my whole bed from home in his shadow. He was six feet four inches tall and weighed more than 200 pounds. I was intimidated by who he was but not by how he was treating me. He was a big guy with a deep but friendly voice and a broad, open smile. He stepped into the cage and started to pick up the balls with me.

"You could have stayed in there," he said. "You've got a really nice swing."

I mumbled something that was as broken and taped up as my bat. The balls thudded into the five-gallon bucket, making it hard for me to hear or to be heard.

I walked out of the cage and fought the urge to run.

I heard him say something else, what sounded like "Stick with it." At least that was what I hoped he'd said. Maybe he said, "Get your stick," in reference to my bat, or who knows what else.

All I knew for sure was that he'd said, "Nice swing." As I made my way toward a diamond where I knew my dad was watching some of the minor leaguers, I thought about telling him what had just happened. By the time I got there and saw him sitting with a bunch of other scouts, one hand on his chin, the other holding his clipboard, a stopwatch dangling around his neck, I decided that it would be better to keep this gift to myself. I knew that my dad would want me to keep my hat on, to not let my head grow too big.

Instead of sitting with him, I hunted around for another empty cage. I was still there as the sun set, matching the bloodstains on my pants and making the ball grow dim. I was having too much fun to stop.

Chapter Four
Growing Pains

If there was one pain that I was hoping to feel, it was the mythical pain of growing. I'd always been one of the smaller kids in my class, but at 16 I was still only five feet six inches tall and weighed 135 pounds. I know for a fact that was my height and weight because both my dad and I were concerned enough that I went to a doctor to see if there was something wrong with me that was stunting my growth.

The doctor who treated our family, Dr. Areces, was an older man in his 60s. He wore thick glasses down toward the end of his nose and had the habit of tilting his head up to look through them, squinting until his vision focused. As a result, he had a surprised look on his face most of the time. When my mom told him why she'd brought me in, he did his head tilt and said, "I

can see you're really worried about it. We can do some X-rays."

My dad had already told us that we were to do whatever we could, so we agreed. After the X-rays were taken, it took a couple of days to get them back, and I spent a lot of that time doing what I'd been doing for the last two years—worrying and standing on my toes trying to stretch my spine.

When my dad and I went back to discuss the X-rays, Dr. Areces spent most of the time doing the talking. What I got from the conversation was this: There were gaps between the bones of my arms and legs at the elbows and the knees. That gap would allow for the bones to grow longer, which meant I'd get taller. When that gap closed, that was it—I'd be done gaining height. I remember staring at those cloudy images of my bones and seeing those small gaps and thinking, *That's only a half an inch or so. I've got to get bigger than that.* My dad must have been thinking the same thing because he tapped the X-ray and asked, "*¿No más?*"

Dr. Areces explained that the gaps weren't the measure of how much I might grow, but just a relative space that would adjust, we all hoped and God willing, as my bones lengthened.

Neither my dad nor I wanted to leave it in the hands of God or Mother Nature or whoever or whatever

was going to determine how tall I got. We didn't like to let other people or beings or forces take control of our lives. So the solution was the same one that we'd applied to other problems—hard work.

Eventually, viewing the world upside-down became almost normal for me. Shortly after that meeting with Dr. Areces, my dad installed an iron pipe in the frame of the door leading out of the kitchen. I'd do a pull-up, swing my legs up to hook the bar with the backs of my knees, and then let my head drop back. I'd spend hours a week hanging upside-down to make sure those gaps didn't close.

At first it was hard to get used to the sensation of blood rushing to my head. My sister told me that my big ears getting red reminded her of pictures she'd seen of bats in a cave. I didn't care what I looked like.

Along with hanging upside-down, I also held on to the bar with my hands and hung suspended, or I did pull-ups to make sure that the gap didn't close in my arms. No point in getting taller if my arms stayed the same length. I was especially religious about doing those pull-ups, rarely missing a day.

Now, after years of working with some of the best trainers in sports and being treated by some of the best sports medicine doctors in the game, I understand that all the work with the bar had no impact on my ability

to grow taller. Regardless, by the time Dale Murphy saw me in the cage nearly a year later, I'd put on three inches and close to 15 pounds. It might not have been the bar work that did it, but I was finally getting bigger.

Still, being small when you're younger has a way of staying with you, even after you've literally outgrown it. I've heard people talk about the "small guy complex"—the feeling that you have to be tougher and maybe a little bit meaner or crazier to get respect and recognition on and off the field. I've known a bunch of smaller guys who were like that. Add in that Latin temperament and you can get somebody who, I heard later in my career, had a bit of the red ass.

That definitely applied to me before I started to grow. I was used to being made fun of, and the Dumbo references and people flicking my ears got old really fast. At first I tried using humor to get people to lay off. When they called me Dumbo or made some other remark about my ears, I'd say, "Well, if I'm Dumbo, then you should see my trunk." That got a few laughs, but that didn't end the teasing. So I decided that I had to be a little feisty and started to take swings at a few of the people whose mouths I couldn't stand. Even though I didn't stand very tall, I had to stand up for myself.

Fighting was always a tricky thing. I got a reputation for being a bit of a hothead, and that made some

people want to see how I'd respond. They liked the idea of pouring gas on a flame. None of the fights were very serious, and I'm not sure if they had anything to do with how the school's faculty viewed me, but I really didn't care—if I was being harassed, I wasn't going to take it.

It's funny, but the only really big fight I got into resulted from a misunderstanding, not from being teased. When I was in eighth grade, I was walking down the hallway between classes when a senior named Ricardo cornered me and said, "Are you messing with my girl?"

"I don't even know who your girl is."

"I heard from people you've been talking to her. In your history class. You can't be doing that shit with Jeanine."

Jeanine was in one of my classes, but I didn't like her; I barely knew her or talked to her, and I liked another girl at that time anyway. I knew it was stupid to try to talk to this guy, so when he told me to meet him outside the school grounds later that afternoon, I told him I'd be there. So was my dad. He was scheduled to pick me up to take me to baseball practice.

Like in a scene out of a coming-of-age movie, people were trailing after me to watch me get my ass kicked. I walked out of school and into the parking lot. My dad

sat in the car, reading something. I walked up to him and said, "I can't come with you right now."

"What did you do? They keeping you after class? Jorge, this is—"

"No," I said, my voice louder and more forceful than I intended it to be. That took my dad by surprise, and he let me go on. "That guy," I nodded toward Ricardo, "wants to fight me. If I don't fight that guy, then I'm going to be a loser. Everyone's going to think I have no balls."

My dad shut off the ignition and opened the door. I thought for sure that he was going to go over there and say something to the other kid; instead, he tugged at my shirt.

"Take this off. Don't get it dirty."

I took off my school shirt and then adjusted my T-shirt. I started to walk over toward Ricardo, who had a confused look on his face. I turned around and saw that my dad was a few paces behind me. He stopped and then said, "You go on. I just want to be sure this is a fair fight." He took a few steps back and folded his arms, looking just like I'd seen him so many times on a scouting mission.

Ricardo charged hard at me, and I stayed low and caught him with my shoulder at his belt. I used my legs and lifted him off the ground and then drove

forward. I tumbled on top of him, but he squirmed away. I could sense that I'd literally and mentally knocked him off-balance. He thought he was going to be able to just trample me, but I wasn't going to let that happen.

The wrestling match over, we circled one another with our fists up. I thought of all the times my dad and I had done this kind of dance before. Ricardo wasn't a big guy, but he was taller than me and had a reach advantage. I knew that I'd have to get inside on him, and I bulled my neck and came at him, my arms and hands in front of my face. He threw a couple of big roundhouse punches that had no hope of connecting.

I hit him once in the stomach and then grazed his cheek with a short jab. I was a bit off-balance, and he hit me in the mouth. It wasn't a direct hit, but I wore braces (of course), and the coppery taste of my blood ran down my throat. I felt like I was going to gag on it, so I spit, and that got the crowd all stirred up when they saw red. Ricardo came at me, not using his long arms to his advantage, and I snuck in a couple of quick punches to his face and neck. He was panting, and I wasn't winded at all. I got inside on him again and got him in a headlock. He kept swinging and I kept squeezing, staggering him and dragging him to the ground. I got on top of him and pounded my fists on his back a

few times, more for show than to do any real damage. I stood up and he stayed down. I knew not to turn my back on him. I backpedaled away and bumped into my dad.

"That's enough," he said. "Let's go."

I slid into the car and watched as the crowd scattered. I got a few fist pumps and thumbs-ups from some of the underclassmen. My dad handed me my shirt, and I folded it carefully and set it in my lap. As I sat there looking at it, I saw it shaking and realized that my legs were vibrating like crazy. I had to take my hands and put them on my thighs to still them. I was feeling pretty good about myself, but I didn't dare look at my dad. He reached over and tilted my chin toward him. Frowning, he asked, "You ready?"

"Let's go," I said, consciously echoing his words from earlier. "He had enough."

My dad drove off, and we stopped at a gas station just a few blocks from the school. I started to open the door to get out to pump, but my dad said, "You stay." I watched him walk inside the station. His hands in his pockets, he kind of skipped and jumped onto the sidewalk along the entrance. He clapped his hand on the back of another man who held the door open for him. A few moments later, he came out with a bag of ice and a small plastic cup that he proceeded to fill.

"Hold this against it," he said, handing me the cup and gesturing toward my lower lip. "We have to get the swelling down."

We drove to baseball practice in silence, but unlike other silent times, I felt no tension in the air. With one hand holding the cup to my face, I hung my other arm out the window. Letting my hand ride the air currents, I angled it left and right and felt it being pushed in the direction I chose, not wildly but under control. I felt like Wilfredo Gómez, the tough bantamweight, only I'd been fighting outside my weight class. But I wouldn't let pride weigh me down too much. I'd enjoy the victory, but even more, I'd enjoy walking down the hallways at school having people know that I was not someone to mess with.

My mom wasn't someone to mess with either. After practice, I tried to slip in the back door unnoticed, but she came into my room and stood there shaking her head, her lip quivering, holding back tears. She grabbed me by the arm and led me to the mirror above my dresser.

"*¿Era necesario pelear?*"

I knew better than to tell her the fight *was* needed, but I said what I really felt. "*Sí. A veces.*"

"*¿De veras?*" she said and continued squeezing my arm tighter with each word. "*No. No. Nunca. Nunca. Nunca.*"

She went on to tell me that fighting wasn't ever an answer. Talking was the answer, the solution. I had to learn to communicate better at some point, or I was really going to get myself in trouble.

"You don't want to be a hothead like your father," she added. "You need to be humble."

She walked out of the room, and I felt like I'd been sucker-punched. I sat down on the bed, feeling a mixture of pride, sorrow, and pain. A few seconds later, my mom returned. She held out a dish towel to me. In it, she'd placed a few ice cubes that I could apply more easily to my mouth.

"For your hot head," she added. I looked at her, hoping that she was going to smile to take the sting out of her statement.

She didn't.

The next day I saw Ricardo standing near his locker. I could see that I'd done a bit of damage. Both his eyes were slightly swollen. Our eyes met briefly, and then he turned and dug into his locker like he was searching for something. I'd found what I needed. A few of my buddies and a couple of classmates wanted to hear about the fight and held out their hands to congratulate me, but I told them it was over. I'd made my point. I no longer had to let my mouth or my fists do the talking for me, mostly because that was the nature of going to school. When some other bit of gossip got stirred up, I wasn't a

headline anymore. That was fine with me. Mostly I just wanted to be left alone, and I got what I wanted.

A few months later, my dad had me join him in the garage, where he tossed me my boxing gloves. For the first time in a while, I slipped them on and waited for him to lace them up. Then, instead of getting down on his knees, he stood there. I was confused for a moment and then smiled. I should have known better. My dad delivered a hard blow to my right biceps, making it feel like I'd lost all control of that arm.

"Keep your guard up," he said. He nodded and winked at me. I got up on my toes and started moving, knowing that it's harder to hit a moving target but also more gratifying when you do. I can see now that I'd grown in my father's eyes in more ways than one. He had to get up off his knees because I'd started to get a bit taller, but more than that, my father respected me in a new way. Even if I'd been on the receiving end of more of the punches than the other guy, I think he would have still looked at me a bit different after the fight. The lesson may not have come directly from him, but I'd stood up to someone and done exactly what he'd have wanted me to do.

Long after that fight ended, and into high school, I spent my time on the field focusing on the things I could control. In August 1986, shortly after I turned

16, my dad said to me, "I want you to try out for a team I'm putting together."

At that point, I was done with my American Legion season, which was one of the organized leagues I played in.

My game had been improving, and I'd become a decent middle infielder. I liked playing shortstop, and the thousands of ground balls my dad had hit to me, along with my naturally strong arm, helped me play the position well. It was becoming clearer to me and to both my teammates and opponents that I wasn't out there just because my dad the scout/coach wanted me to be there. That respect felt good, but I knew that it wasn't going to be enough to realize my dream of making it all the way to the big leagues. I always wanted to be judged on my own skills, but looking back, given how rough my start in organized ball was, I see that might not have always been the case.

The day of the tryout I was just one of a couple of dozen players out there on the field in T-shirts and uniform pants taking ground balls, hitting, and being assessed by the coaches. The numbers pinned to our shirts were supposed to make us easy to identify, though to be honest, we all basically knew who was who. Toward the end the coaches waved us over, and we gathered down the left-field line. They told us that

we were going to run the 60-yard dash. We'd have three attempts at it, and the coaches were going to record our times.

Though he was nowhere to be seen, I instantly searched for my father. A couple of years earlier, shortly after I'd started eighth grade, my dad had taken me outside after dinner one evening to institute a new element in my training—wind sprints. Of course, this being my dad, they couldn't just be plain old sprints on a track. We lived at the top of a fairly shallow incline. He led me away from the house, down to the bottom of the hill, and told me to wait there.

He then walked back uphill, putting one foot in front of the other to count off the distance. Once he got to where he wanted to be, he turned to me and said, "Sixty yards. Every day after school. Ten times." He swatted at a mosquito and then added, "Under seven seconds. You've got to get under seven seconds."

I had no idea how fast that was or even why he chose seven as the magic number. Anticipating some of my other questions, he said, "Michelle will come out with you with the watch. She'll write them down. All ten. Every day. You need to be under seven seconds."

I can't say that I did as he ordered every day over the course of the next two and a half years, but I did so more than 90 percent of the time. I probably wore out

four pairs of shoes going up that slope over and over again. At first I was in the high eight-second range, and it seemed like it would be a piece of cake to cut just shy of two seconds off my time. The thing was, those sprint workouts coincided with my growth spurt, when I was finally putting on a bit more weight and growing a bit taller. Those added pounds made a difference. All the cycling and playing sports in the sand had helped me build up strong legs, but I was losing some quickness and lightness on my feet.

If I close my eyes, I can still hear the sound of my footsteps reverberating off the houses on either side of the street as I tried to get down to under seven seconds like my dad told me I had to. I tried a bunch of different approaches—longer stride, shorter stride, leaning forward, staying fully upright, and over the years I saw some improvement. When I got down below eight seconds, I thought I was doing pretty good.

The coaches at the tryout that day didn't say how much a part of their decision the sprint was going to be, but in my head I kept hearing my dad talking about being under seven seconds. If I wanted to be a ballplayer, I had to be under seven seconds. Well, I wanted to be a ballplayer on that all-star team, and I figured that anything other than a sub-seven-second time was going to doom me.

Glancing out at the field, I saw my father spooling out a long tape measure to establish the official finish line. He set down two bats with a gap between them and then jogged back toward me.

"You go last," he told me.

"Okay," I replied, wondering why he wanted me to be the last of the runners.

I stood there while the other guys all did their three sprints. The coaches didn't announce anyone's time, and we all stood there talking about who seemed to be moving fast and who wasn't. Seeing those guys tear away from the starting line, the foul line, and watching as their cleats dug up little divots, I started to wonder how much of an effect running on grass was going to have on my time. I'd been running on pavement in cross-training shoes that had good grip but were a lot lighter than my baseball spikes. I felt a bit of nervousness swirling around in my stomach. A lot was on the line, and I really wanted to make this team. It was going to travel to the United States for a tournament, and I really wanted to see another part of the country.

When I stepped up to the line for the first of my three sprints, all I could think about was the 60 yards of somewhat chewed-up turf that stood between me and success. For my first effort, I faced the finish line, hunched over slightly at the waist. When I heard the

word "Go," I dug in hard. I felt my spikes catch and then slip a bit, and I tried to count—one-one-hundred, two-one-hundred—but I lost track and just concentrated on pumping my arms and legs. I felt pretty good about it, but who knew? For the second and third tries, I turned sideways to the finish line and pivoted like a base stealer, hoping to improve my momentum at the start. I didn't count, didn't really even focus on my running technique, just trusted that all the training I'd done would be enough. I saw nothing but those two bats and the six feet of grass between them.

When I was done, I trotted back to the finish line. My dad was gathering up the bats.

"How did I do?"

"Seven-three the first one. The other one's like seven-two. Then the last one was good, like seven-one or something, almost seven-two."

I felt like I did when I first started hanging upside-down, like my eyes were going to pop out of their sockets and my head was in a vice. I wanted so much to finish under seven seconds, and while I'd come close, I hadn't gotten all the way there. The sting of that didn't last long, though. I thought about where I'd started, running it in more than eight seconds. I'd improved, and that was a good thing. If I lost out on this opportunity because of one-or two-tenths of a second, I'd be

disappointed—well, I'd be crushed—but still, I had that improvement to hold on to as a positive sign.

We gathered again as a group and were told that we'd find out in the next day or two whether we'd made the squad. On the drive home, my dad leaned over and nudged me with his elbow.

"So, you want to know?"

"Yes," I said, staring at him bug-eyed. What did he think? I wanted to wait on pins and needles for the next few days?

"All I can tell you is this. You know how fast you ran the sixty?"

"You said seven-point-one or-two."

He let a sly grin spread across his face before he said, drawing out each word, "*Seis. Punto. Siete. ¡Cinco!*"

I let out a huge shout and slapped out a drumbeat on the dashboard. Six. Point. Seven. Five! My dad beeped the car horn a couple of times in celebration, and then we both just sat there.

I know that it must sound strange coming from a guy who spent 17 years in the big leagues and played for a World Series–winning team, but as I think about that moment, even now the hair rises on my arms and I feel a quick thrill of pleasure in my belly. Of all the things I did in my years in baseball, hearing my dad say that I had run under seven seconds, one-quarter

of a second under, remains among my best memories in the game. I was so happy that I forgot all about my dad not telling me the truth when I'd asked him on the field about my times. That didn't matter. The clock doesn't lie.

I sat there in the car, and for the day or so afterward, thinking that I'd done it. I'd become a ballplayer in achieving the goal that my father had set for me two years earlier. In one sense, whether I made that team or not didn't matter; I'd achieved the goal my father set for me. That meant I was a ballplayer.

If nothing else, that moment, that achievement, best summarizes my career and how I want people to remember me as a ballplayer. I had a goal and I worked at it, bit by bit, day by day. I didn't go through any kind of huge transformation, but one-tenth of a second at a time, one half-inch at a time, one pound at a time, I got bigger and I got better. Yet, it wasn't like I'd gone 4-for-4, hit two home runs, and driven in six, or that I'd gone deep into the hole to field a grounder and then gunned the runner out with a leaping, spinning throw. I measured success differently back then, and that was true for a lot of my career.

For a lot of my young life, it was like my dad sat me down at a table, dumped a bunch of puzzle pieces out of a paper bag, and said, "Okay, put this together."

He'd take a couple of pieces and assemble them, then say, "I'll check on you in a bit." I didn't have a full picture to guide me.

Well, that day it was like a vision of the image I was supposed to be putting together came to me. I still had quite a few more pieces to put together, but at least I knew what the finished product was supposed to look like. Things were going to be easier from that point forward, but the burden was on my shoulders. I knew what had to be done, and it was just a question of having enough patience and enough stamina and enough focus to fill in that picture.

I did end up being selected for that all-star team. The tournament in the United States turned out to be a quick trip to a desolate spot in New Mexico called Farmington, during which we got off the plane, played one game, lost, and got back on the plane to come home (Disney World: The Sequel). I was left with memories of a crazy blue sky and the reddest dirt I'd ever seen.

I don't remember a whole lot of the specifics of that game, or any of the other games I played in American Legion ball. Okay, I have to admit that, even though a lot of the games I played as a kid have faded from memory, I do remember my first home run. I wasn't completely selfless and all about the team winning.

I was playing Legion ball for Caguas, batting eighth. Leading off the third inning, I made good contact and drove the ball to right field. I took off running like a madman, hoping to get extra bases. I didn't understand what I'd done until I came into third base standing up, rounded it, and heard my coach say, "Hey! Slow down! It was out of here!"

I didn't get to celebrate the whole way around the bases, just when I was at home and my teammates greeted me. That was how it should have been.

Playing in the United States on that team made me think more about the bigger picture of my baseball career—what might be possible once I graduated from high school. The best-case scenario was that I'd get drafted and go into professional baseball immediately, but that didn't seem likely. My dad always said that it was best to have options. You didn't want to be in the position where you had no choice but to sign. The team would have leverage over you and could offer you very little money as a signing bonus, and the attention, my dad said, sounding both sad and a bit angry, went to the guys the teams had invested the most money in. That was a lot for me to take in at 16, but he wanted to be realistic with me. He told me that it was becoming more common for guys who played in college in the States to move through MLB organizations quickly.

The level of coaching and competition was getting better, and scouts spent a lot of time at college games.

A couple of years earlier, my dad and I had gone into San Juan to watch the final game of the NCAA College World Series on television. I'd watched the University of Miami Hurricanes beat the University of Texas, 10–6, to win their second title in four years. After the game was over, the TV announcers named the all-tournament team, and my dad said, "Will Clark, he's the guy." Clark played for Mississippi State, but all I could think about was Miami. After all, they'd won the College World Series, and Florida was a place, despite my brief Disney World experience, that I knew about and heard about quite a bit. What was Mississippi other than a big river? I also liked Miami's green and orange colors. I later did some reading about the place, and the University of Miami's baseball program was a huge part of the community. The Florida Marlins weren't there yet, so a lot of baseball fans had adopted the Hurricanes as their team. A lot of families I knew visited Miami or had relatives or friends living there. My uncle Leo—he was my dad's cousin but I called him Uncle out of respect—was there, as well as my grandmother.

The following summer, at the end of my junior year of high school, while I was still playing American

Legion ball, I got a letter from the coach of Florida International University, Dave Price, letting me know that they were interested in having me play for the school. Eventually, one of his assistants, Rolando "Cas" Casanova, a former player on the team, called me and said that they'd like to have me there, that I should come and check out the school. So, once school let out, we made a plan for me to visit.

My whole family was going to go since the school was in Miami and we had family we could stay with and visit. My first impression of FIU was that it seemed as big as San Juan. Today it markets itself as having one of the largest enrollments in the country, with 54,000 students. It wasn't quite that big then, but I was completely overwhelmed at first. Still, I felt comfortable knowing that a very large percentage of the students enrolled came from Latin backgrounds. What I really wanted to see, of course, was the baseball field. It didn't disappoint.

It was as nicely kept a field as any I'd seen, with the exception of Yankee Stadium. We got there just as the grounds crew was done mowing it, and the smell of fresh-cut grass, the dew reflecting light like diamonds, all had my eyes wide in anticipation. The school, and the baseball program, had only been around since 1965, but it had advanced to the NCAA Regionals and

Super-Regionals. They'd fallen short of their goal of getting to the College World Series, but Cas said that getting there was the goal every year and he hoped I'd be part of the first team to do so. He also said that they hoped to upgrade the field, turn it into a true stadium instead of just a field with bleachers.

I don't know if my dad talked scholarships with him, but I walked away from my introduction to the place thinking that FIU was a great option for me. I liked the idea of having family nearby and a familiar culture and language I could rely on. Coach Cas told me that all I needed to do was score an 800 on the Scholastic Aptitude Test and I'd be set. I'd heard other students at home talking about the SAT, but even though I was going into my senior year, I hadn't made any plans to take it. That would change.

So would my thoughts about attending FIU. When we got back home, my dad sat me down and said, "I don't think it's a good idea for you to go there. There will be too many distractions with family around. Miami would be too easy for you to fall in love with and forget about your baseball and your studies. You won't use your English enough and that will be bad for you later on. You're not going."

I was disappointed, but my dad wasn't someone I could disagree with. I'd trusted my father with every

aspect of my baseball life up until then, and I didn't doubt that he knew best about college too. I knew that now that my dad had vetoed the city, the University of Miami was also out, even though Miami hadn't expressed any real interest in me.

I had one more college trip to look forward to. My aunt Leda and her husband, Bruce Brubaker, lived in Lexington, Kentucky. The University of Kentucky was known for its legendary basketball program, but as a member of the Southeastern Conference, one of the elite sports programs in the country, Kentucky was competitive in all sports, and in particular baseball. We flew into Louisville and made a quick detour down-town to drive past the Louisville Slugger factory before going on to Lexington.

I really wanted to experience college life as I'd seen it in the movies, and the University of Kentucky campus and its facilities seemed like something from a film. I fell in love with the place and its stately old buildings and central campus area.

Once again, the number 800 came up, a reminder of the minimum SAT score I needed to be eligible for a scholarship. That was the goal, just like under seven seconds had been the goal. My parents encouraged and sometimes forced me to study, even enrolling me in an after-school SAT preparation class. Despite doing the

full ten sessions, for some reason the lessons I'd learned about hard work on the field didn't translate to the classroom—mostly because I didn't put in a full effort. I'm not proud of that, but I'm fortunate that things worked out like they did.

I can't say that I've spent a lot of time looking back and wondering what if. But now that my kids are getting older and I'm beginning to think about them going to college, I am even more grateful that I was able to seize the opportunity I did, with the help of others. I loved baseball, and it was good enough to reward me. I didn't love studying, and I can still remember sitting in the cafeteria, where I took that SAT test in early January 1989, feeling a bit envious as I saw others around me, their heads bent in concentration, turning page after page of that booklet and confidently filling in their answer sheet. I sat there struggling at times just to understand exactly what the question was, especially in the analogies section, and being puzzled by the fact that desire and result didn't have the same relationship when it came to taking that test that they had on the field. In the end, I scored only 730—a full 70 points below what I needed.

I was disappointed, but not crushed. Maybe it's because in baseball, as everyone always says, you have to get used to failure and getting a hit three times out

of every ten could get you into the Hall of Fame. I just figured there was going to be some other way for me to get where I wanted to go. I could have taken the test again, maybe my family could have hired a tutor, or I could have found another book or another class on test preparation that might have helped me, but none of that happened. I was okay with giving up the University of Kentucky. I treated it like a little corner piece of the big puzzle, but one that could easily be replaced with something else.

My dad told me not to worry about the SAT, even after Coach Cas at FIU called and tried to talk me into taking the test one more time. He was sure that just by having taken it once, I'd be able to make up the 70 points I needed. I felt bad telling him no, but I also knew what my dad had said about Miami not being the place for me. My dad was thinking strategically, and now he said that I should try to enroll in a junior college. His words made sense. If I enrolled in a two-year school, I wouldn't have to wait to be a junior to be drafted, like I would if I enrolled in a four-year school. The goal all along was to get to the big leagues, so we needed to use the system to our advantage. We weren't breaking any rules, but my dad knew that the odds were stacked against every player who wanted to live the dream.

The trouble was, which junior college? Unlike baseball programs at four-year schools, junior college programs didn't have recruiting budgets that would help them find a guy like me from Puerto Rico. Here's where I was really fortunate again. My dad was working for the Braves, and a fellow Braves scout happened to talk to a junior college coach in Calhoun, Alabama. The coach, Fred Frickie, told this scout that he needed a shortstop for the coming season. My dad's buddy knew about me and told Coach Frickie that I was a good ballplayer, the son of a major league scout, and that I was looking for someplace to play.

I knew none of this when the phone rang one late afternoon in April. I picked up and heard an unfamiliar voice. The man introduced himself, but at first I didn't quite catch his name. In fact, I had a hard time understanding him at all. His accent was so thick that it was like I had to chop through all kinds of sounds to get at the words. He said that he knew my dad and had spoken with him, and he wanted to offer me a chance to come and play for him in Decatur, Alabama.

"Where's Alabama?" I asked. I didn't mean to sound rude or anything, but I knew that I wanted to play someplace where the weather was warm, like Florida or Texas, someplace where the national championship contenders came from.

"Well, son, I can tell you this. You get yourself on a flight to Atlanta, and I'll be happy to show you."

"Okay," I said, knowing that the team that employed my dad was in the South. I didn't have a clear vision of where I was going, whether there would be palm trees or plastic flamingos or pyramids. All that mattered was that I was taking the next step. It didn't matter that in a few months I'd be stepping out of a plane into the unknown. If they had a baseball field, I was pretty sure that I'd be able to find my way around. I just wished that the man who was going to be helping me take those steps spoke the same language as me—whether it was English or Spanish.

Chapter Five
The Next Step

In June 1989, the summer before I began at Calhoun Community College, another piece of the puzzle fell into place—at least temporarily. I came home from practice one day to find a letter sitting on my dresser; on the envelope was the logo of the New York Yankees. I tore it open and devoured the words on the page. Only three sentences long, the letter congratulated me on being drafted by the New York Yankees, and there at the bottom, in bold pen, was the signature of George Steinbrenner himself.

The Yankees had selected me in the 43rd round of that year's draft, and while I was ecstatic, my happiness didn't last long. My dad sat me down that evening and explained to me that even though I was drafted, I wasn't going to sign. I'd been too low in the draft—the

1,116th guy selected—so the Yankees wouldn't be making a serious offer. (It's funny to note that Jason Giambi was selected two slots after me, and that, of the 26 first-round selections, only Frank Thomas, Chuck Knoblauch, Charles Johnson, and Mo Vaughn became All-Stars, while Thomas also became a Hall of Famer.)

My dad also said that, because I had other options, he doubted whether the Yankees would even make much of an effort to contact me. This proved true: in the days after the draft I didn't hear from anyone in the Yankee organization. My dad had let people know that I was pursuing college, and that was enough to inform the Yankees that it wasn't worth their time to pursue me. They'd done what they'd wanted to—let me know of their interest in me and made me aware that, if things fell through on the college option, they were interested.

You have to remember that this was back in the day when the draft wasn't as big of a deal as it is today. No TV network carried it live, and we didn't have round-by-round coverage on the Internet—if such a thing was out there in any form, I wasn't aware of it. So when my dad told me that we were going to stick with our plan, I was okay with it. Decatur, Alabama, here I come.

I framed the letter I got from the Yankees, and it hung on my wall, far more important to me than my high school diploma. All I could think about was what

the next step in my baseball life was going to be. I'd been hanging out with a girl back home named Lydia, and we had fun together, but there was nothing serious between us. I knew I would miss her, but I had my priorities and she had hers. She was going to university in San Juan, and we weren't going to be able to see each other much anyway. More than her, I was going to miss my car.

A few weeks after I'd turned 16, I came home from school, and sitting in the driveway was a white Cadillac Coupe de Ville. As the name implies, it was a two-door, and it had a blue landau roof—a kind of fake leather or suede that made it look like a convertible. I realize now that it looked like something that wouldn't even need to be a part of the "pimp my ride" program, but I loved it for its white leather seats and all the rest of its luxury and glamour. I sank whatever money I was earning at my jobs into serious performance and safety upgrades—including a new stereo-cassette player and speakers. Sitting here now, all I have to do is recline a bit in my chair, put on my shades, kick my feet way out in front of me, stretch my right arm out to its full length—and you know that was a looong way thanks to all those pull-ups and hanging I was doing—and I'm right back there doing my Sonny Crockett and Ricardo Tubbs thing, even if I was in San Juan and not Miami.

I spent some of my happiest hours cruising with the windows down and Def Leppard cranked loud enough that I could have gone deaf. A man never forgets his first love, especially one that he spends so much time pampering. I bathed her and put on coat after coat of wax to keep the sun from dulling her finish.

From the perspective of more than 20 years later, I realize now that spending so much time taking care of that car was a way of showing my dad how much I appreciated what he had done for me in buying it. We're men, after all, so I told him thank you when I got it, but I didn't ever spend any more real time saying to him how much the gesture meant to me, how much I liked the car, and I never asked him to come for a ride with me so that he could hear how great the stereo sounded. It was basically a one-and-done: thanks, Papí, and now let's move on to something else.

In some ways, the gift of that car was symbolic of other changes in our relationship. As I'd gotten older and my prospects as a baseball player had improved, my dad and I got along better. I'm not saying there was a direct cause-and-effect relationship there—my dad would have loved me even if I hadn't gotten better as a player—but the two of us started to have more respect for one another. We were becoming, in a sense, team-mates. We shared a vision for my career, and though we

differed a bit in how to get me there, at least we both agreed where "there" was. And for the time being, "there" was going to be Decatur, Alabama.

The day after that first phone conversation with Calhoun's Coach Frickie, I think the coach and I both knew we had some homework to do. I had to check a map to be sure I knew exactly where Alabama was, and then I had to find Decatur. It seemed south enough. For his part, I later learned, Coach Frickie was as concerned about our inability to understand one another as I was. In spite of my strong Puerto Rican accent and his heavy Southern one, my limited English and his almost nonexistent Spanish, we both thought we understood each other, but he wanted to be sure. To do that, he got a woman from his church who was a Spanish teacher to get on the follow-up phone call he made to me. It was made clear to me that I was being offered a full scholarship to play for Calhoun Community College for the spring 1990 season.

A few short months later, my dad and I were on a flight to Atlanta so that I could register for classes and move into the dorms. First we caught a Braves game, and then we started the four-hour-or-so drive to Decatur, with my dad behind the wheel. For the first little bit, he was pretty quiet, and I sat silent in the passenger seat, trying not to think about what I'd

signed up for. Then, out of the blue, my dad started talking to me. I was half asleep and had the window open, so the sound of his voice, the tires on the road, other cars passing by, all seemed to kind of merge together.

It took a while, but eventually I figured out that he was giving me "the talk." Not the "birds and the bees" talk, but the "now that you are leaving home and being on your own, we expect you to conduct yourself like a man" talk. He kept going on and on, and I kind of turned away and rolled my eyes, thinking, *This is painful. I can't wait to get there and put an end to this lecture. I don't need his advice. He doesn't get it at all. I want to get away from home and be my own man. I want to be known as Jorge Posada and not Junior, not "the scout's kid" and all the rest of that.*

When we got to the campus, we drove over to the baseball field, where we'd arranged to meet Coach Frickie. We were a bit early, so we sat there in silence, my dad having finally exhausted his long list of "*Escúchame*" items. Then something odd happened. I sat there looking at the field. It wasn't much more than the diamond, the dugouts, and a batting cage down each line. A few trees stood on the other side of the outfield fence, and beyond them stretched farm fields, rolling on and on into the distance.

And taking it all in, I started to cry, not because of the facilities, but because I realized how foreign this all looked to me. This was no Miami, no familiar palm trees and beaches. The city of Decatur sat along the banks of the Tennessee River, but as far as I could tell, there would be no beach Wiffle ball, football, or swimming going on there. I also realized how much I was going to miss my family and friends. A few seconds before, I couldn't wait for my dad to leave so that I could start my new life, and now here I was hoping that time would slow way down and even stop.

It didn't.

I wiped my eyes, and when I looked up, I saw Coach Frickie waving at us from a pickup truck with a refrigerator tied to the bed. I'll admit that, even living in Puerto Rico, some of the stereotypes about the South had reached us. Coach Frickie's thick accent added to that impression, but he could have said the same things about my accent and me.

We exchanged brief hellos; with me acting as translator to help my dad with his limited English. No more than four or five words were traded. My dad went to the car's trunk, took my bags out, set them on the ground, kissed me and hugged me, and then, without another word, drove off. I stood there listening as the car's tires crackled across the parking lot, wishing that I'd been

able to say something to him, hoping that before he disappeared he'd have a few more words that would fill the hole that suddenly seemed to be swallowing me up.

Years later, my mom would tell me that right after dropping me off, my dad found a place where he could call her. She said that he was so upset about leaving me there that he could barely put together a sentence while talking to her because he was crying so hard. Hearing that story meant more to me than it would have if he had acted that way in front of me. I guess that's the way it is with fathers and sons sometimes—it's hard to really say what we mean to one another.

After my father and I parted ways, I had another set of poor communications to be concerned about. Coach Frickie told me that he was going to take me to the dormitories, a place he referred to as "the Cabanas." Of course, I would have spelled it, and pronounced it, *cabaña,* but the word was flattened and Anglicized. I don't know why the dorms were called the Cabanas. They looked nothing at all like a hut or something you'd find on a resort beach. At first I thought he was using the word to make me more comfortable. Eventually I found out that everyone called the dorms by that name, but no one could explain why.

The Cabanas were mobile homes that had been subdivided into separate rooms for each of the athletes who

lived there. Because this was a community college, 95 percent or more of the students lived nearby and drove to school each day for classes and practices. The only reason anyone from outside the area would go to Calhoun Community College was to play a sport. The school was too small to have a football program, so the only teams that played were baseball and softball and men's and women's basketball. I was living with the baseball and basketball players; female athletes were housed in a second set of trailer homes on the other side of campus.

To be honest, it was probably a good thing that they didn't have a football program. Big linemen probably would not have been able to live in the Cabanas. The rooms were tiny. I didn't realize how small they were until Coach stopped in front of one. I got out and stood there staring. The trailer was maybe 50 feet long and 20 feet wide. I didn't think I'd have the whole thing to myself, but who knew? I took a few steps toward the wooden stairs, when I heard Coach say something like, "Weryagoin?"

He pointed to a refrigerator sitting in the back of the truck. "That's for you."

I gave him a hand unloading it, thinking that the place must be all mine since this was a big refrigerator. We tilted it out of the bed of the truck and then carried it to the trailer home's entrance.

"Let's take a look," Coach said. I wasn't quite sure what he meant, but when he went inside, I followed. The trailer's space was divided into eight rooms, four on each side of a central hallway. Coach opened the nearest door and waved me inside. Within that approximately 12-by-7 space, I had my own bed, a shower and sink in one corner, a toilet in another, a small rack on which I could hang my clothes, and a small desk. It was snug in there, but it was about to get snugger.

"I figured you could use a big one," Coach said as we struggled to wedge the refrigerator into the room. "Those little guys don't hold a whole lot, Hortek."

I looked at him, trying to figure out what that last word was. He'd mispronounced my name from the beginning, but I thought that maybe it was the phone lines that were distorting things. Now, in person, I heard more clearly that he was pronouncing my name HOR-tek. I didn't want to make a big deal out of it or make him feel bad, so I just let it go.

We finally managed to get the fridge into a place where I could still walk around, but it partially blocked access to the toilet and shower.

We were both sweating at that point, and Coach turned on one of the taps. The whole sink shook for a moment, but then a rush of water came flying out.

"Good pressure here."

I stood with my hands in my back pockets, nodding, thinking that I didn't have even a glass. Where was I going to get all the things I needed to live here? The bed was bare, I hadn't brought towels, I had a big refrigerator but no food to put in it, and how was I going to be able to cook if I ever learned how to?

All those questions were put on hold when I heard a tap at the door frame.

"Steve, attaboy," Coach said. "Thanks for coming by."

Coach introduced me to my "double-play" partner, Steve Gongwer. Steve and I shook hands. I expected to see a scrappy little second baseman type, but Steve was six-three and more than 200 pounds. He had a ready smile and gave off a high-frequency energy.

Coach said, "You need to get to know Steve. He's going to help take care of you on and off the field."

Steve was from the Atlanta area, so he lived on campus; in his second year, he knew his way around Decatur and with the team. I liked him immediately.

I said to him after Coach left, "I'm going to need your help. I don't understand what he's saying."

"Don't worry. None of us do. Just nod your head and keep on doing what you're doing, HOR-tek." He laughed and shook his head. "I know it's not that hard

to pronounce, but we'll figure out something to help Coach out. He's a good guy."

As it turned out, Coach Frickie was a wonderful man, and someone I've kept in touch with since my playing days at Calhoun. He knew that I was in a tough spot, and he helped me out, as did Steve, in every way possible. Steve and a couple of other teammates even helped out with the name issue. We all tried various ways to help Coach pronounce my name correctly, but he never could master it. Eventually he called me by the Anglo version of my name, George. That eventually caught on, and most people at Calhoun called me that and thought of me as George. Mispronunciations have been a big part of my baseball career, including the big leagues, but that's a story for another day.

Steve had a car, so he helped me get to the mall by driving me or letting me take his car to go get the things I needed. He wasn't nearby, though, when I went into a store to ask for bedding and said to a clerk what I thought was "I need sheets." She looked at me funny and said, "You need what? Shits? What do you mean?" That gives you some idea of how my transition went.

That first night, though, Steve showed me the rest of the facilities and the places where I'd be spending most of my time when I wasn't in class or on the diamond. A large gym with a basketball court and seating

for a couple thousand was the first stop. That was also where the weight rooms, a pool, and the coaches' offices were, and I'd eventually spend a fair amount of time in that building. I was happy to see a kind of recreational room with Ping-Pong tables set up and all of them occupied. Steve introduced me to a few of the players. Their names and sports kind of went in one ear and out the other, but they invited me to play. I didn't want to go back to the Cabanas and that bare room, so I stayed and played match after match. There was no language barrier to overcome, just the net and my opponents, who clearly spent a lot of time practicing.

Baseball practice wasn't until 2:00 in the afternoon, so I stayed until everyone else left. Then I went back to my room and started writing letters because I was bored. And I was homesick. I wrote to my mom. "The place is small. There's nothing here. I don't know what I'm doing here." I was honest with her, even though I knew that it would make her sad to read those words. That's how it is with mothers and sons. We can be honest with each other about our feelings.

On the baseball field I felt comfortable. No one had to translate anything for me there. I was the only Latin player on the team, and that was unusual for me, but when the guys saw that I could play a good short-stop and third base, they were even more accepting.

Nothing overcomes barriers on the field like doing your job well. In this case, though, there weren't really any barriers. The guys on the team were all great, and they helped me out just like Steve did from day one. Still, I'm sure some of the guys had their doubts about me, and I felt like I had to prove myself. After all, I was the outsider, the one from Puerto Rico, and I was there on a scholarship. There was some pressure on me to perform well, especially because people knew that I'd been drafted. There was something almost mythical about being drafted by a professional sports team.

Unfortunately for me, being the outsider and a drafted player seemed to stir up some bad feelings among the basketball players, especially among the guys who lived in the Cabanas. Maybe it was partly a miscommunication or a cultural thing, but the guys on the basketball team talked a lot of trash to me. And some of that had nothing to do with the sport I played or the fact that I'd been drafted. It mostly had to do with the color of my skin and the language I spoke. I also had a few run-ins with some of the locals, the type of people some others would call rednecks, and that was tough to deal with. I know that people aren't always as understanding and compassionate as they could be, but this was my first real encounter with prejudice of any kind. Looking back, I probably could have handled some of

these encounters better, but I was still someone who wasn't going to quietly back down when confronted.

I tried not to think too much about those relatively few times when there was trouble, because what made the experience difficult was my own naïveté and inexperience as much as anything else. That point got driven home about two weeks into my stay.

The Cabanas were located about a quarter-mile from the baseball field if you took the direct route, and almost a mile if you took the road and path that led to it. A cotton field and a small airport stood between my cabana and the field—that was the direct route. The airport was home to just a couple of small single-engine private planes. The runway was situated on an angle that went from the right-field corner out and away from center field and the flagpole. The long way took a winding road past the girls' softball diamond and a couple of parking lots and outbuildings.

One afternoon I decided that it didn't make sense for me to walk all that way when I could get there just by walking through the field. I hopped the fence and joined the guys warming up. A half hour later, I was taking ground balls at short when I saw a police car pull up to the field, its lights on but no siren sounding. After the officer got his attention, Coach told us to just keep working. The two men stood talking for a

few minutes, gazing out toward the outfield and then, I thought, at me.

My thought was confirmed a few minutes later when I heard Coach yell, "George, c'mon over here."

I trotted over, my heart pounding. What was going on? Could something have happened at home? I wasn't usually a worrier, but this was weird. Coach introduced me to the policeman, an officer somebody whose name I couldn't catch. I was still adjusting to Coach's accent, and I did as Steve had said—I nodded like I understood. Then the officer started talking, and I had a hard time understanding him. I caught something he was asking about my number, and I nodded, but he shook his head and gestured for me to turn around.

"Six," I heard him say to Coach. "They said they seen six."

He ran all those words together, and it just sounded like a bunch of sticks snapping and catching on fire.

Then the officer said a bunch more to me, and the only word I really caught was "fence." Something about a "federal fence."

Desperate, I looked at Coach for help translating.

Eventually, with a lot of gesturing and talking slowly, I got the point. "Stay off," Coach said, indicating the airport runway. "Illegal. Other way. Get back out there."

I jogged to my vacated position, and I could hear the rest of the guys laughing and whistling and hooting at me. For a while a few of the guys called me "Runway," which turned into "No Way" and then "Other Way." I didn't tell my mom or dad about that one, but I was glad to give the guys something to rally around, even if it was my own ignorance. There were only so many things they could help me with. I had to learn a few lessons the hard way.

As I became more comfortable, I learned quickly that there was a lot more than the language that I had to learn about life in the United States. I was fortunate to have my tuition, books, fees, and housing taken care of, but what we hear college athletes saying today about having so little money was true then as well. Because of the time commitments we had to make to our sports, we couldn't hold down jobs to earn spending money. I wouldn't have wanted to do that, and my parents didn't want me to either, so my dad put $300 on a debit card for me every month for food and other expenses.

The first month I was out of cash by the end of the first two weeks. I'd spent a lot of it on supplies, but there were runs to the local Hardee's and Taco Bell and frequent pizza orders. I called home and pleaded with him for more money, but he wouldn't alter the arrangement,

not by a single dollar. Fortunately, my mom was there to rescue me and my poor financial planning skills. She sent me boxes of packaged food and clothes. If she bought me a pair of jeans, she'd tuck a twenty or two in the pockets so that my dad wouldn't know.

Fairly early on, I met a girl on the basketball team, and we started to hang out together. That meant a few more dinners out and a movie every now and then, and the cost of those things added up. I also wanted to pay guys for the gas they used taking me around town or put some gas in their tanks when they let me borrow their cars.

I also wanted to make some major purchases to make life in the Cabanas more convenient. I could not stomach much of the cafeteria food. I wasn't much of a cook, so a microwave oven was the solution. Other people had them, and I'd ask to use them, but that got old after a while—though, surprisingly, it took longer for the taste of Hungry Man frozen dinners to grow old. When I think of how poorly I ate back then, it is amazing that I was able to survive, let alone play the games. I was also very fortunate that Steve went home every now and then and took me with him. His parents were great, and I still miss his mom's spaghetti. I later learned how to make noodles with tomato sauce, but I never could approach what she made for us.

Steve and I became like brothers and worked out together a lot. He was a good ballplayer and one of the harder workers on the team. I put him through some of what my dad had done to me. Steve was a natural right-handed hitter, but that fall I had him take just as many cuts from the left side as the right during our unofficial batting practice sessions so that he could strengthen his left side. We worked a lot on his ability to drive the ball to right-center. Like it is with a lot of guys, his dominant hand and the dominant side of his body were a lot stronger than his nondominant side. I could see that imbalance in his swing. So when we did weights or those sessions in the cage, I helped him fix that. I didn't need to tell him about running the 60 in under 7.0 seconds, and didn't need to. He was much faster than me, and I tried to beat him in every sprint. It was great to have him there, and we always pushed one another to get better, to do more, to run faster.

Steve ended up having a great sophomore year, hitting .419. He went on to play at Montavello College, where he became an NCAA Division II All-American. The guy worked hard, and I owe him so much for how he and his family welcomed me and supported me.

After a couple of weeks of practice, we started to play games during the fall season. We were a junior college, but the NCAA rules allowed four-year schools to

compete against us, including in the fall, or off-season. The first time I walked around on the campus of the University of Alabama, I was sure that was where I wanted to play next. The campus was gorgeous, and the baseball field was even better.

Not that ours was too bad. I have to say, Coach Frickie was smart in this way. After every practice, we became the grounds crew. Because I was the shortstop and wanted to get the truest hops I could, I took great care of that infield. We spent hours manicuring that field, and even though we didn't have a fancy stadium with large seating areas or a clubhouse or lights, the field itself was in great condition and was something we took pride in. Still, I don't think the guys at Alabama had to worry about those kinds of tasks.

Before that first game I was issued my Calhoun uniform, and I was so proud I laid it out on the bed and took a photo of it. We had Nike uniforms, Turfs, an equipment bag, and our own individual aluminum bat. My dad said that I could use it in the games, but I still needed to hit with wooden bats during batting practice. The first time I felt that sweet sensation of an aluminum bat after having been away from them for so long, I thought that I was really going to be able to do some damage with it. As it turned out, I was pretty good at predicting the future.

In that first fall game against Alabama, I homered in my first at-bat. I was surprised by that, especially because the difference between guys playing for a high-quality Division I school and the guys I faced in our intrasquad games at Calhoun was substantial. This isn't a knock on them; it's just the way it is. The guys at Alabama were all heavily recruited, had probably been the top players on their high school or junior college teams, and were among the best in every league in which they had played. I had no doubt that I could catch up to any fastball, but it was going to be hard to stay disciplined enough to not go chasing after breaking balls and changeups outside the strike zone. Belting that home run right away gave me a shot of confidence, and also caught the attention of the Alabama coaches. Down the line, I signed a letter of intent to play for Alabama, but I never got a chance to compete for them.

I liked seeing other parts of Alabama besides Calhoun, so those trips to Tuscaloosa, Birmingham (where the University of Alabama–Birmingham was located), and Florence (home to the University of North Alabama) were fun adventures. Packing up the vans and hanging out with the guys was all a part of the experience, and my teammates helped take my mind off how homesick I was. Over time, as my English got better, I enjoyed the trips even more and was able to

laugh and joke with the guys, participating in more of their conversations and arguments about what was the better band or movie comedy and whose feet and farts smelled the worst. That was all an important part of my education and prepared me well for my future life in the minor and major leagues.

Coach Frickie selected all my classes for me, and for the first time in my academic career I didn't really struggle at all. My math class was relatively easy, and I took a low-level English class that I managed to do okay in, mostly because I was more motivated than before out of necessity—I didn't want to have any more "shits" incidents, and it was no fun going out to eat and not getting what I thought I'd ordered. I also took a Spanish class, which, unsurprisingly, was very easy. I ended up being an unofficial teaching assistant since the instructor, who helped me a lot with my English, allowed me to help out by demonstrating the more everyday ways of speaking Spanish than the "book" Spanish that was taught. I was also fortunate that Coach Frickie's neighbor and fellow church member, Mrs. Mary Faulkner, the one who helped him on those early phone calls, was willing to help me with my English.

I can't say enough good things about Mrs. Faulkner and Coach Frickie. He really helped me out a lot, driving me places and also letting me live with him when

I was "asked" to stop living at the Cabanas for a while. I was in college and away from home for the first time, and as much as I missed Puerto Rico, I still wanted to have some fun. Sometimes, though, having fun meant doing things that I later regretted—or at least regretted getting caught at.

I wasn't completely reckless. The first time I went out with the guys to a party, I did consume alcohol for the first time. I didn't really enjoy the taste, but I was feeling pretty good—until the next morning. After that, I still drank, but not as much. I did not want to experience a hangover again, and I learned what my limits were pretty quickly.

I had a fake ID from Puerto Rico, and that helped me supply beer for the parties. I could have gone out every night, but I didn't. I only went to parties on weekends, and I also only went to parties where I was confident that I knew most of the people who would be there. That meant other athletes for the most part. I had a couple of incidents where people said things to me about my background, and I wanted to avoid any kind of confrontation like that. Mostly, though, I was cautious and shy. I didn't like meeting new people and feeling awkward or like I was sticking out because I wasn't from the area.

We did some cool things like driving away from Decatur into the fields and woods that surrounded the

city. It was fun to be able to just relax, stand near a bonfire—I was surprised when it got so cold that fall—drink a few beers, and hear people laughing and enjoying themselves. Eventually my English improved to the point where I was pretty sure that if I said something funny, people were laughing because of what I said and not because of how I said it or how I mangled the language. Of course, they also wanted me to teach them Spanish swear words, and I was happy to do that.

Sometimes we'd party in the cotton field that was beyond the outfield fences. A railroad line bisected the field and the freight trains slowed down there because they were coming up to the river crossing and either bridges or a terminal. We made a game of hopping on the trains and riding them for a while. That sounds more dangerous than it really was, but it felt like a very American thing to be doing—sitting in a box car drinking beer and watching cotton fields roll by. I was still in transition, though: the mornings after those parties, I'd wake up and wander down to the pay phone to call my parents. I spoke to my mom more often because my dad was working. When we had a game, though, I'd call him every time to let him know how I'd done, a habit that continued for many years after that.

Looking back on this time now, I can't help but think of how lucky I was to get used to life in the United States,

to get used to the idea of having American teammates, with American jokes and American humor. It wasn't that Alabama was so different from Puerto Rico, but living there prepared me to deal with the differences in language and all of the confusion that could come with life in the United States. I learned more than just words in English—I learned how to use them. So many Latin players don't have the time to get more comfortable with the language and with themselves before being thrown into professional ball. For me, my time at Calhoun was as much about becoming comfortable in a new country as it was about becoming more comfortable on the baseball field.

When Thanksgiving rolled around and most everyone left for a few days on break, I stayed behind. There were a few of us on the team who didn't go home, and we kept up the usual routine. By then it had gotten too cold to practice outside, so we practiced in the gym doing running and base-stealing drills, taking ground balls, hitting in the batting cage, and working out.

We had a strength and conditioning coach who worked with us, and for the first time I started to lift weights. We did circuit training, which emphasized speed over muscle mass. We also did light weights and lots of repetitions. The weights helped me put on a few pounds, and Mother Nature contributed with another

growth spurt that increased my height by a couple of inches. I came into the summer after high school standing a little under five-ten, and by the time I went back to Puerto Rico for Christmas I was just shy of six feet tall.

I remember how my dad reacted when he saw me. He said, "Whatever they have you doing over there, keep doing it." It was great to be home, and I dug into my mom's home cooking, knowing it was going to be a long time before I could eat anything like it again. I was looking forward to the season coming up, but it was hard to be home knowing that I would have to leave everything that was so comfortable and familiar again.

It was also going to be hard to leave knowing that back at school I'd have to stop basking in the warm glow of being a conquering hero. I think my dad and I waited maybe one day before we went out to the garage to play table tennis. I'd been playing nearly every day while I was gone, and I was feeling pretty good about myself. I let my dad serve, and he hit a low hard one to my backhand, always my weakness in the past. I rifled a winner past him going cross-table.

I caught him sneaking a look at me out of the corner of his eye, assessing me. He then hit a slow spinning serve to change the pace, and I hammered that one past him. I served a winner, and then we got into a long rally, with both of us switching from attacking to

defending. He won that point, but he didn't win too many more the rest of the game or that match.

"You've been practicing. That's good," he said at one point.

"Not good for you," I responded, grinning until my face hurt.

I whipped him pretty badly that night, and most nights after that, and took every opportunity to remind him, taunting him when he asked if I wanted to play again: "Are you sure you want to do that to yourself?" He took it well, but the intensity of those games heated up quite a bit.

There was something different now about how we competed. At that point, it seemed to be more about the game, about the competition itself, and less about him trying to teach me some lesson about life and me being frustrated and resistant to being more of a pupil than an opponent. Now we were two guys playing a game, both of us loving to win and hating to lose, but with no other kind of psychological overtones to it. We were engaged in a grudgeless match.

Some of how I felt about those battles with my dad had to do with him writing to me while I was away. Even if they'd been boring "how's the weather?" letters, I was pleased to get them. But they were more than that. Like me, my dad's a very emotional guy, and

growing up, I mostly saw the negative side of that. In those letters, though, he told me how much he missed me. I didn't expect to hear that. I sat in my room in the Cabanas, reading his letters, and at first felt a little bit stunned, but that feeling was edged aside by a feeling of warmth and affection that I didn't always associate with my dad. I loved him, but this guy was someone I liked, someone who wasn't up there while I was down here. The funny thing was, that other guy, my dad with a capital D, was still present in those letters. He'd provide me with warnings and guidance and make me feel like a little kid in a way, but then there were those other sections where he'd share his feelings and fill me in on some of what was going on in his work. The shift was subtle, but it meant a lot to me.

Still, he never told me how proud he was of me for what I'd accomplished to that point. He kept urging me to work harder and keep achieving more. He wanted me never to be satisfied. So things between us remained complicated. I reported back to him after every game, and fortunately I had a very strong freshman year. At the end of the season and the school year, I went right back home. I knew that the Yankees still held the rights to me, and I liked having that option available to me, even if my dad wasn't thrilled about the idea of me going to the Yankees.

"*No es bueno,*" my dad would say about the Yankees. He'd worked for them very early on in his scouting career, and he knew the organization was a very good one, but he was troubled by a couple of different aspects of it. The Yankees hadn't really signed that many players out of Latin America for whatever reason. My dad knew who was getting drafted by whom, and he wanted me to go to a team where I'd have more Latin players around me. He was aware that I'd adapted well to playing in Alabama, but he also knew that the transition to pro ball would be even tougher. I'd been homesick and had complained to my mom, and he didn't want those kinds of distractions to hurt my chances. He believed that a happy, comfortable player does well on the field and ultimately that's all that matters. Still, the reality was that, no matter the circumstances, if I didn't produce, I'd be gone.

So when the Yankees drafted me again in 1990, this time in the 24th round, my dad and I had to talk about the Yankees again. He stood firm. He wanted me to go back to Alabama to play for Calhoun. They'd given me an opportunity, I'd taken advantage of it, the program was good, and I'd been drafted twice by one of the best organizations in all of sports. I was likely to get even more attention from other teams. If the Yankees wanted me, they were going to have to pay for me. They would

have my rights until just before the draft in 1991. If I had a good year at Calhoun, the price would go up.

This wasn't just a bargaining ploy. He really felt that it was in my interest to go to another organization. His concern wasn't just about what he perceived as a relatively low number of Latin players in the Yankees system. At that point in Yankees history they had also shown a willingness to trade younger players in their minor league system for veterans. My dad believed in loyalty, and while you could look at a trade in two ways—someone wanted you, but someone else wanted to get rid of you—he believed that I'd be better off staying within the organization that drafted me. You have to remember that he was a scout, and he was very loyal to his guys, the ones he drafted. He didn't like seeing them shipped off to another team where he would no longer be one of the guys looking after their career.

In the end, I don't know if his strong sense of loyalty, his desire to have control, and his deep concern for me as his son got all jumbled up in his mind. Or maybe he saw my opportunity more as the shot at playing pro ball that he'd wanted for himself at my age. Regardless, I trusted his experience to help me make the right decision. The problem was, I really wanted to be a New York Yankee.

Chapter Six
Moving On

I was happy to be able to take a bit of Puerto Rico back to Alabama with me for the 1990–1991 season. Wilson Ronda was one of the better pitchers I faced in American Legion ball back home, and Coach Frickie was glad to have him join us. Wilson moved into the same cabana I was in, and it was good to have a familiar face around the dorm and on the team. I wanted to help Ney (the nickname he went by) adjust, so the two of us pooled our money, about $300, and went out and bought a car—a 1970 Chevy Nova. The Nova is a classic example of a product being given a bad name. In North America, among English speakers, it's no big deal—Nova. But in Latin American or other Spanish-speaking countries, Nova sounds like *no-va,* which means "no go." Well, our Nova went. It wasn't the

best-looking car, or in the best condition, but it got the two of us around.

I don't know if it was having Ney around or what it was, but that Nova didn't satisfy completely our need to get around on four wheels. Next door to the Cabanas sat a small manufacturing plant that had a semitrailer truck parked on a crushed-gravel area. Most of the time it was just the cab that sat there, without a trailer. One Sunday when no one was around the Cabanas and the whole campus seemed empty, Ney and I decided to check out that truck. As you know, I didn't have the best history when it came to two-wheeled vehicles—though I still would have loved to have owned a scooter or a motorcycle—but I have always loved cars and trucks of all kinds.

Climbing up into the truck's cab, we immediately noticed the keys in the ignition. I looked around. The area was still empty. I could hear one song leaking out of the far end of the most distant cabana. I squinted my eyes to listen and could just barely make out Technotronic's "Pump Up the Jam."

I knew how to drive a stick shift, so if we were going to do this thing, I needed to be behind the wheel. Scattering papers and soda bottles, Ney settled into the passenger seat.

I got the engine going, and then as I eased the clutch out carefully while giving it just enough gas, we edged

forward. I knew better than to take the truck too far. But the thrill of just creeping along wasn't going to be enough, so I drove it down one of the two-lane roads that bordered the campus. I got it to shift a couple of times, but we didn't get up to more than 15 or 20 miles an hour. Still, we couldn't stop laughing at how the thing bumped along and made the loudest racket, with every bit of the interior rattling, shaking, and vibrating. It was more like being on an amusement park ride than in a vehicle.

In the end, our little joy ride onto campus lasted only about 20 minutes, but it felt like we'd gone cross-country in the thing. I steered it back toward the factory.

"Oh, shit," I heard Ney shout. He was staring at the monster side-view mirrors on the truck. All I could see was dust and I thought he was overreacting. Then I took another glance at the driver's-side mirror and saw what he was panicking about. A golf cart was following us. It would have been funny seeing a chase between a semi and a golf cart, but I knew who was in the golf cart—some of the campus security guards. They were following us—and gaining on us. A semi isn't exactly very good at accelerating, but I floored it.

We both ducked down low so that the guards couldn't see us in the mirrors. I guess if one of the other guys on the team had been telling the story instead of me living

it, I would have found the whole situation funny, but I was starting to panic as well. I felt bad for Ney, since all he'd meant to do was sit in the truck and start it—it was completely my idea to drive it. I decided I'd get him back to our cabana and drop him off. The golf cart was now a little dot behind us. I got him there, and he jumped out of the truck as I slowed to a crawl.

After parking the truck, I felt that thrill every kid does of having avoided getting caught—a high that's greater than whatever action made you have to hide out in the first place. The following days were quiet, but then the security guards started to go from room to room, questioning people about the truck and asking if anyone had seen anything. All we said was that we didn't see anything, and that seemed to be it.

Then the whole situation evolved into a kind of family drama. After the dean eventually got involved, he said that somebody at the Cabanas had to have seen something, known something, or done something. Since none of us kids were willing to rat on the others, he was going to have to punish every one of us by taking away our living privileges—unless, of course, somebody stepped forward and confessed. That same day I saw local police outside the truck, and they were dusting it for fingerprints. I knew that the next step was for them to fingerprint everybody in the entire Cabanas, and they'd eventually get Ney and me.

At that point I couldn't stand the idea of everyone being punished for something Ney and I had done. I also figured that Ney, being a new guy, would have been in more trouble with Coach Frickie than me, and I didn't want to see him get kicked off the team. After all, I was the one who'd gotten him to Alabama, and I felt responsible for him.

So I went to Coach Frickie and told him what I'd done and what the dean had said. He made the call for me, and I was banned from living in the Cabanas for 90 days. With no place to live or any way to rent something—my "allowance" wouldn't cover it—Coach Frickie took mercy on me.

"George," he told me, "I know boys will be boys, but that was a dumb one. Pack your stuff. You're moving in." I did, and his wife, Martha, took mercy on me and fed me breakfast and dinner nearly every day. The room in their house was much nicer than the one in the Cabanas, and I had a TV in it, but there was one downside. Coach was an early riser, and he liked to get to the athletic offices around seven or eight. I didn't have any classes until midmorning, so I spent a lot of time hanging out in the lounge near the cafeteria. I'd eat a second breakfast, which was helping me put on the pounds I needed.

Throughout the spring of 1991, the Yankees continued to look at me. It didn't hurt that during that time

I continued to grow. By the end of my second spring at Calhoun Community College, I'd grown to six-foot-one and weighed more than 180 pounds. I had split my time between third base and shortstop while at CCC, playing third my freshman year and shortstop the second. I was big for a middle infielder, but the model of a stocky or smaller guy playing second and short had been changing—think of Cal Ripken Jr., who was 30 at the time and just at the start of his MVP season in 1991.

The Yankees had scouts show up at quite a few of our games during that spring. Since they'd drafted me before, they were in contact with me besides just watching me, letting me know of their continued interest. Though I'd scaled back on my calls home to three times a week, I still checked in with my dad after every game, especially when I had something to report about the Yankees or other scouts being around. He said that he was going to hold a hard line with them.

The Yankees ramped up their attention as my season at Calhoun drew to a close and the draft neared. The Yankees still had my rights, but if they didn't sign me before the next draft, I'd be a free agent and any team could draft me. It took another man, Victor Pellot, to help us shift our perspective. You may know Victor by the name he used when he became just the second Puerto Rican of African descent to play in

the big leagues. He played for 12 years, from 1954 to 1965, as Vic Power, but every year when he came back to Puerto Rico to play winter ball he was known by his given name. Many consider him the second-best Puerto Rican player in Major League Baseball, behind only the great Roberto Clemente.

And of course my dad knew him. Vic told my dad that there was another way to look at the Yankees and their pursuit of me. They drafted me once. I didn't sign. They drafted me again. That was a *good* thing. If they were willing to do that, that meant they saw a future for me in the organization. That gave my dad something to think about. And the Yankees gave him something else to think about.

As draft day 1991 approached, the Yankees' attention turned serious. Leon Wurth was the main scout who'd been following me, and at one point in May he was joined by a cross-checker who put me through a workout. I ran, fielded, and hit, all under their watchful eyes. They never showed any sign of emotion when I was out there, and I did feel kind of like a farm animal up for auction. I also didn't get too nervous during the workout. I pretty much knew that I was going to be drafted again, by the Yankees or someone else.

Adding to my comfort was that I signed a letter of intent to play with the University of Alabama. If we

didn't get the deal we wanted, then I had another option. We could also use that option as leverage in negotiations down the line. It may sound callous to say that I didn't care which option materialized, but that's really the truth. I wanted to do what was going to help me realize the dream I had of playing pro ball. If that could mean either signing or going on to a four-year school, I was cool with whatever was going to work to my advantage. Teams will often stick longer with guys who are drafted higher and get larger signing bonuses. That's the economic reality of it. Still, if the Yankees didn't come up with the money, I would be very happy to go to Alabama to play. I knew I'd enjoy college life in Tuscaloosa, while playing a high caliber of baseball that would prepare me well for the pros.

In his role as a scout, my dad had Caribbean countries as his territory, and because he knew about players from the Caribbean and Latin America, he was very honest on this point: culturally, the guys he scouted were different from American prospects. Latin players weren't used to being away from home as much as American kids were. More and more, teams were selecting college players, who were used to being on their own and away from home. If I hadn't played baseball, I would have been like 90 percent of the guys I knew and grew up with—I would have lived at home until I got

married. That's just how it was. My dad knew that we Latin players took a bit longer to mature. He also knew that we didn't face the kind of competition that college players did in the States, and in his mind we weren't as mentally or emotionally mature as the guys we'd be competing against in the minor leagues who came from the States. He'd signed more than a few young players out of the Dominican Republic or Puerto Rico who were talented, but because of language issues, homesickness, or a bunch of other reasons that didn't have to do with their physical skills, things had not worked out and they had been released. He told me over and over again that the odds were tough for anybody, but the odds were tougher for Latin players. I needed to do as many things as I could to be prepared and to be protected.

Accordingly, my dad wanted to do something to make it more difficult for the Yankees to release me if I didn't impress them from the get-go. We knew that in moving from the 43rd round to the 24th, the Yankees had shown greater interest in me, so we were looking for them to show something extra in their offer to me, something that might set me apart from other players besides draft position or signing bonus—a more substantial commitment from the team. For my part, I wanted the dollars. In my mind, that was like an

insurance policy. The more they spent on me the less likely they were to discard me. In the end, my dad, the Yankees, and I each got our way.

At the end of the season and the school year, instead of going right home, I stuck around and played for a semipro team in Hartsell, a community just a few miles south of Decatur. A semipro team has that name because amateurs like me play alongside former professional baseball players. Some of the guys on that Hartsell team had played minor league ball and were as old as their mid-30s, and some had wives and kids. Because many of the guys had jobs, they sometimes couldn't make games because of work or family commitments. One day we showed up for a game, and our starting catcher couldn't make it. I volunteered to put the gear on, and I played that game behind the plate. The Yankees scout Leon Wurth was there, and I began to wonder if I'd given them that added value my dad had been talking about—that extra reason to think twice before giving up on me.

As the deadline for signing me before I became a free agent again neared, I headed home to Puerto Rico. The Yankees sent a couple of their representatives to negotiate with my dad. Robert Rivera was one of the Yankees scouts whose territory was Puerto Rico. This complicated things a bit for us, because whenever we

were with Leon Wurth, we could speak Spanish to keep him from understanding our strategy talks. We overcame that with Robert. Still, my confidence was also boosted by the fact that the Yankees had sent some actual representatives to Puerto Rico to get me to sign. This was a lot different from the form letter I'd received the first go-round.

In the end, the Yankees upped their offer by $10,000 and gave me $30,000 as a signing bonus. While I liked the $30,000 and was glad that my dad was able to get them to up that offer, he fell short of his own goal. He wanted them to guarantee that they'd give me three years with the organization. That's basically unheard of, especially for a guy drafted as low as I was. My dad knew me well: in addition to hoping that I'd be in a place where I'd be comfortable, with Latin players, he knew that a commitment like the one he was seeking would help take some of the pressure off me and allow me to play better. But in truth, even if he'd managed that miracle of negotiation, I was still going to feel the pressure—in pro ball there's no way around it. I'd always been eager to prove myself, however, and from then on that was going to be especially important.

For their part, the Yankees did stick with standard operating procedure. They weren't going to guarantee anything other than that I'd join the more than

1,200 guys drafted and be given a shot. What I did with that shot was up to me—not even my dad could do anything to influence that. I was okay with the money, though I have to admit that I would have liked to have gotten more, both to support myself and to give me a better chance of sticking around with the team. When you're not yet 20 years old, $30,000 sounds like a lot of money, and it is, but I also knew that I was nowhere near the kind of signing bonuses some of the other guys in the draft were likely to get.

That was okay, though. I knew the overall odds were long—only one in six guys drafted ever makes it to the big leagues for even one game—but I believed that ultimately talent and desire were going to count more than the dollars handed out in signing bonuses. Once we reported to our teams, we were all going to be earning the same amount, and I figured that everybody was going to really go after it as hard as they could regardless of the round they were drafted in. Just let me compete and I'd be okay. Now I was in control of what would happen next, and I liked the feeling of having my fate in my own hands. Signing that contract was like making a promise to myself: I was going to do everything I could to show people that I deserved this opportunity and that I'd more than pay them back for the faith they had shown in me.

My family didn't do anything elaborate to celebrate my getting drafted and signing with the Yankees. We were a baseball family, so in some ways it was not a big moment. Think about it this way: if you were raised in a family where everyone had advanced degrees and worked as doctors, lawyers, and professors, no one would go nuts when you graduated from high school. They'd expect you to get to that point and would be pleased that phase was over, but then it would be time to focus on the next bigger and better thing. I didn't just want to be a pro baseball player; I wanted to be a big leaguer.

My teammates were pretty excited for me though. A couple of them phoned me to let me know that a few beers were downed in my honor. Coach Frickie was really happy for me as well as for his program. We got a little bit more attention in the local papers as a result, and we both hoped it would help him attract more ballplayers to the school. And Ney benefited from my being drafted—I let him keep the car. He was coming back for a second season, and I didn't think that it would make the drive to Oneonta, New York, where the Yankees were having me report to their low A team in the New York–Penn League. Steve Gongwer also called, and I let him know that I was grateful to him and really happy that he'd become an All-American.

Steve also told me something that I didn't really quite get until later on. He said that when I showed up at Calhoun and we started practicing together, after a few days he called his dad and said that he was giving up his hope of playing pro ball. He told his dad that he'd seen what a pro ballplayer looked like, and that he was impressed by me and my God-given talent and my work ethic. That meant a lot to me. I still don't really think that I had that much God-given talent—He gave me whatever I had—but I was also blessed with a desire to succeed and a dad who made sure I stayed on track and did things the right way. Where I was going, I'd need every bit of that.

When I reported to Oneonta, I was joined there by a group of guys who seemed older than me—22- and 23-year-olds who had mostly played at four-year schools. Among them were Lyle Mouton, who'd had a great college career at LSU, and Steve Phillips, the oldest at 23, who'd played for the University of Kentucky and was an unsigned free agent. We also had Shane Spencer, who signed out of high school in California. Nearly every single one of us was starting out his pro career in 1991.

I wasn't the only Latin guy on the team, though the other guy, Sandi Santiago, stuck around only for a week.

He missed his buddies too much. The Yankees agreed to let him return to the Rookie League team in Florida. I was shocked, not that the Yankees let him do that, but that Sandi even asked them to essentially demote him. He was going into his second year in the minors, and to move back down the ladder made no sense to me in some ways. In other ways, Sandi illustrated what my dad had been saying to me all along about Latin players, about their need for an adjustment period and their levels of maturity. Seeing what happened with Sandi helped me put in perspective some of the long-standing complications between my dad and me.

Though I had been listening to my dad for years, now some of what he had been having me do, even going back to those early days of hauling dirt and painting wrought iron, started to make more sense. I had to be serious and I had to be disciplined. He wanted to help me so much, and did so much for me, but he wanted me to conduct myself like a man when I was still a little boy. Then there were times when he'd acted like he was a boy and we were buddies, and that confused me even more. I wanted to act like what I was—a kid. I wanted to do what my peers were doing, I wanted to have fun, I wanted to be stupid and irresponsible. And I'd needed to get that stuff out of my system so that when I got to the point I was now at—starting *my*

professional baseball career—I could be a professional, a man, and not have those stupid urges that got me into trouble (though probably not as much as they should have or could have). Meanwhile, my dad had wanted me to grow up long before I got to pro ball so that I wouldn't become someone like Sandi who damaged his chances of succeeding.

Even though Sandi didn't stick around very long, he got to experience what "the Yankee Way" was all about. At our first team meeting, our manager, Jack Gillis, got up in front of everyone and told us that from that day on, no matter where we were from, or who we played for, we were going to do things the Yankee Way. That included how we wore our uniforms. One of the coaches, Brian Milner, came out and demonstrated just what that meant. He had one of the guys join him in front of everybody and showed us how to put on the uniform every day. Four inches of blue on the socks had to be exposed. The pinstripes had to be perfectly vertical on the pants and the top. No hair on the collar. No chains around the neck. No facial hair of any kind.

We all took those lessons to heart. They were part of a complete approach the staff took to making sure we did things a certain way. I had to get used to the idea very quickly that I was being judged 24 hours a day, seven days a week—even more strenuously observed

and reported on than I ever had been with my father. After a few days, I saw some guys who wanted to test the system. They were the guys who'd gotten drafted high and showed up in Oneonta, maybe not with the flashiest new cars, but with the nicest muscle cars and a few foreign ones like BMWs. Me? I was literally *no-va,* except on the new bicycle I bought. I knew that being judged like I was, I had to toe the line, so I made sure my uniform met every specification. Those other guys who tried to get away with pushing the limits didn't get away with it. They got fined, and while the money didn't seem to matter to them, I sometimes wondered why they would risk getting a bad reputation.

I don't know if I can make it clear how seriously I took this opportunity. I'd had jobs before—chores at home, working at the hardware store La Casa de los Tornillos, coaching at the camps—but this was a *job.* I was being paid to do something I loved, $800 a month, which was big money for me, and I also knew that as I advanced my earnings were going to rise. More than that, though, I remembered my dad talking about Eddie Santos, a guy he signed for the Blue Jays. I couldn't help but remember him because my dad told me about him all the time. Santos was coming up through the Blue Jays organization about the same time as Fred McGriff. He had really good numbers, and then, all of a sudden,

he was released and no other team signed him. It was like he just disappeared. My dad never knew why, and Eddie Santos became a cautionary tale, with my dad telling me, "You don't want that to happen to you."

Since I didn't know exactly why Santos got released, I figured that, when it came time to play pro ball, I had to do everything I could to make sure that I didn't give the team a single reason to even consider getting rid of me. That included how I conducted myself outside the game. If I was told to be somewhere at 2:00, I'd get there at 1:30 to make sure I wasn't going to be late. I also didn't fraternize too much with guys who partied a lot or who badmouthed the coaches or the organization. The expression "keep your nose clean" isn't one we have in Puerto Rico, but if we did, I would have gone overboard and said "keep your whole body clean." I wasn't going to do anything to jeopardize my chances. Gone were the days when I'd take shortcuts—across airports or anywhere else—go for semitrailer-truck joy rides, hop on scooters, or do any of the other silly stuff I'd done as a kid. My dad's plan had worked once again. At 20, I may still have been a "kid" when I went to Oneonta, but I was going to conduct myself like a man.

In those first weeks with Oneonta, I also saw a few guys who had a lot of talent but who didn't put in a whole lot of effort in practices—and believe me,

we practiced a lot. Once the season began, we played nearly every day, but we also either worked out in the gym—we were close to the campus of SUNY Oneonta—or were out on the field, in the cages, or in the training room getting worked on. I had very little downtime, and what little I'd had disappeared because I was switching positions. The Yankees wanted me to play second, and it's a lot harder than you might imagine switching to the right side of the diamond from the left, where I'd been playing most of my life, and especially for the last two years. The angle the ball comes off the bat is different, and that took some getting used to. But the Oneonta Yankees staff was more than willing to help me make that adjustment. Brian Butterfield was a roving instructor who worked with infielders. If we had a 7:00 home game, I'd get to the park at 1:00 after grabbing a quick lunch at one of the nearby fast food spots, and he'd work with me. I took thousands of ground balls back then.

That made the transition to playing second easier, and eventually Roger Burnett, a shortstop from Stanford, and I helped out our very good pitching staff by setting a record for most double plays in a season. I played second base exclusively that first year, but I was given a set of catcher's gear just in case I was needed there. I'd caught a couple of games at Calhoun,

and because I had good hands and a strong arm, I was willing to help the team out in whatever way I could. Still, I always thought of myself as an infielder, and when I checked the rosters of the various teams above me in the Yankees organization, I was looking at middle infielders as the guys I was going to have get past on the ladder.

That's one of the interesting things about playing minor league ball and, to an extent, in the big leagues as well: you have an opponent in the other dugout, but you also have competition in your own dugout, as well as in dugouts scattered all around the country. I was able to focus on the game I was playing, but I also knew that I was competing for one of only a few spots in the organization at my position. My dad told me, and I always believed, that you have to do something to make your coaches take notice of you. So the temptation was always there to try to do too much, or to do something selfish.

The Yankees preached a team concept, though, and that included tracking things like the number of times you successfully hit behind a runner, dropped down a bunt, or hit a sacrifice fly. The Yankees weren't just about the major statistical categories. They understood that sometimes those numbers are deceiving. In fact, we kept track of something called "hard-hit balls" to

acknowledge the reality that there were times when you absolutely squared up and hit a rope but didn't get an actual hit. So there you were being told that you had to execute and you sometimes wondered if by executing you were going to end up being executed—released because your numbers weren't that good.

Even though I'd been around various major league spring trainings, until I had to do it myself, I didn't appreciate how hard it was for all those guys I saw and admired in those camps to keep a professional approach and compete with each other at the same time. My dad told me that things would take care of themselves if I kept doing what the organization wanted me to do and what I'd been doing my whole career. That was easy to say, and I tried to believe it—part of me always did— but when I didn't get off to a particularly strong start, I put more pressure on myself to succeed. The game was fun to play, but it was serious business trying to get to the top of that ladder.

Do your job, I kept telling myself, and that stayed with me my entire career. The game was fun, but the rest was a job—though I did enjoy having people, especially kids, asking for autographs. If I wanted to have the fun, I had to take the job seriously. To be honest, that was fairly easy to do in Oneonta. I wasn't making a whole lot of money. During the week he was on the

team, Sandi Santiago and I rented the top floor of a house, unfurnished, and all we could afford to rent was beds—mattresses to be precise, no box springs and no frames. We bought some sheets and pillows and blankets and a few towels and set up a basic kitchen with a table and a couple of chairs, but that was it.

Though we were roommates, I wasn't upset when Sandi left. We didn't know one another at all, and I liked living by myself, just like I had back in Decatur. I didn't have to worry about anyone else's schedule or habits except my own. I wasn't going home after games and flipping on the big-screen TV to watch *SportsCenter*. I had no idea what was going on in the world except for what was happening between the lines and in our dugout and clubhouse. I'd hear some guys talking about what had gone on in MLB and about movies and TV shows, but they might as well have been talking about what was happening in Azerbaijan or Zambia.

My contacts from the outside world were my mother and father—I spoke to them just about every day. My mom wanted to be sure that I was eating well and taking good care of myself. My dad wanted to hear how I was doing in the games. I reported to him on every at-bat, and he kept my statistics—the numbers that most fans are familiar with. At one point when it was becoming clear to me that the opposition had several

guys who would have been the number-one starter at the University of Alabama, I knew that I wasn't over-matched, but I was definitely in the competition of my life. Those guys threw as hard as anybody I'd faced, but they also had good late movement and decent control. Several of them had really good breaking balls, but few had good command of them. I needed to be disciplined, and it took all the discipline I had to not scream when my father said to me after my latest hit-less night, "That puts you at .210."

"I know," I said patiently, then added, with a bit of venom, "I can see the scoreboard."

I have to give my dad some credit. If someone had said that to me the way I said it to him, I would have come back with, "Too bad you don't see the ball that good." In some ways, I wish that somebody had said something like that to me. That's how teammates and friends get on you, let you know that you're taking yourself too seriously. Take the game seriously but not yourself—that was a lesson I was going to have to wait another season to experience up close and personal.

Toward the end of our season, I had an experience similar to one my buddy Steve from Calhoun had. A big left-hander was called up from our Gulf Coast League team in Florida. His name was Andy Pettitte, and there was something about him that said, *I'm going to be*

a big leaguer someday. First, he got promoted from rookie ball, and second, he had impressive stuff. He was a big guy too, at six feet five inches tall. He wasn't as big as he would get later with the Yankees, but you could tell he was strong, and he used his lower body to drive home about as well as any pitcher I'd seen. He didn't have great results with us, going 2-2 in six starts, but he struck out almost exactly one batter per inning. Andy and I didn't get to be great friends during that brief period. Both of us were pretty quiet guys, but when we both got promoted to Greensboro in the Carolina League for the '92 season, we got to know one another better. I did catch one of his bullpen sessions and he was throwing a *hard* knuckleball back then. One of them hit me in the knee and another got me in the chest protector. That ball could really dart. Eventually, the organization told him that he should give up on that pitch. He did, but he'd still break it out during practice while playing catch, and I'm amazed that he never hurt anybody with it since it danced around so much and was so fast. It wasn't because of that knuckleball, but I do remember telling my dad that this guy was going to be something special and he was. Andy was so much more mature physically and mentally than the rest of us on that Greensboro team, and the only time I ever saw him flustered was when he got shelled in a game

in which his wife had sung the national anthem. She was great. He was terrible. When a teammate asked him, a day or so later, if he wanted to have her sing again before one of his starts, Andy turned all red and looked like he wanted to run out of the room rather than answer. Finally, he just shook his head a tiny bit.

Before Greensboro, I got some good news when I was asked—well, told—to report to our Florida Instructional League for six weeks of intensive training and competition. About eight of the guys from Oneonta were also at that camp, including Lyle Mouton and Steve Phillips and my double-play buddy, Roger Burnett. They all had had good years, and Lyle and Steve were our top RBI and HR guys, so I felt like I was in good company. Being there with them meant that the Yankees saw me as someone worth working with. The camp also had guys from other levels there, some of the studs of the organization. Despite feeling bad about hitting just .235 with four homers and 33 RBI, I was feeling pretty good about how the team was feeling about me. That's the thing about the minors, though—a feeling is all you really have to go on. No one comes to you and says, "Hey, we think you've got some skills. You didn't hit for as high of an average or with as much pop as we hoped, but we think you're worth keeping around."

I took the small signs of encouragement wherever I could find them. One member of the organization, Mark Newman, a director of player development, made me feel pretty good. To help out the Latin players, he had taught himself Spanish and started speaking to me in my native language—that meant a lot to me. Mark was the first guy who took part in what I later would laughingly call my "brainwashing." He told me I would be really valuable to the organization if I could be there for them as a switch-hitting catcher. I was resistant, but given that I was doing my best to follow instructions and do what I was told, hearing those words about my value to the organization planted a seed that was going to grow. It was just a question of when.

I was also pleased that I got to work on my hitting one-on-one with Jim Lefebvre, a former Rookie of the Year and All-Star and a great trivia answer—what former major league ballplayer appeared on *Gilligan's Island* and *Batman*? Even better than that, he was one of the coaches who worked with players one-on-one.

This was also the first time I was given formal instruction in the art and science of catching. I did a few drills and worked with catching instructors, though the primary focus was on opening my stance when I hit left-handed. I tried it and tried it, but I just didn't feel comfortable. I did as I was told, but after the six weeks

were over, I went back to Puerto Rico, worked with my uncle Leo, and concentrated on shortening my stroke. That would effectively help me do what the Yankees wanted—be more consistent and make solid contact with greater power.

I'd led our team in Oneonta in one Yankee Way category—with seven, I had the most sacrifice bunts. I was showing that I could sacrifice myself for the good of the team, but they were sending me another signal. A light-hitting, switch-hitting middle infielder (or catcher) wasn't really what they had in mind for me. My body was filling out even more, and that was a good thing.

Working with Uncle Leo became a yearly part of my preparation. My dad's cousin was signed by the Milwaukee Braves in 1954 and got his chance in the big leagues with the Kansas City Royals, playing with them for three seasons, from 1960 to 1962. He then worked in various jobs with different organizations; when I started working with him, he was a hitting instructor for 23 years with the Dodgers. Either he'd come to Puerto Rico or I'd travel to his home in Miami, but we'd find the time to work together, and he helped me enormously throughout my career.

If I had any disappointments at all in 1991, it was not being drafted by a team in the Caribbean League. I'd

grown up watching both MLB and Caribbean League games. My dad's scouting jobs depended on him finding the best Latin players primarily from Puerto Rico. Growing up, when the Caribbean World Series came around in February, I'd gotten to see the best players from teams in the Dominican Republic, Venezuela, Mexico, and Puerto Rico. The only winter ball games that I ever saw televised were part of the Caribbean World Series. I always wanted to play in one, and I hoped that once I signed a big league contract, I'd at least get the opportunity to play.

I grew up a fan of our local team, the Cangrejeros (Crabbers) de Santurce. In fact, the first organized baseball game in Puerto Rico was played in Santurce, all the way back in 1898. When the Spanish-American War ended and Puerto Rico briefly came under the military control of the United States, US soldiers helped spread the game, and it became much more popular. It took until 1938, though, for the first semipro league to be formed. It helped produce Hiram Bithorn, the first Puerto Rican to play in the big leagues in the United States; he pitched for the Chicago Cubs in 1942. I knew of him because the stadium in San Juan was named after him, and that's where both the San Juan team and Santurce played their home games. Santurce's team, the Crabbers, didn't join the league until the second year.

Some great names from the Negro Leagues in the United States played in Puerto Rico, including Satchel Paige and Josh Gibson. In fact, the two faced off against one another. Paige pitched for the Brujos de Guayama (Guayama Witch Doctors), and Gibson was a player-manager for Santurce. Paige's team must have cast some kind of spell on my team in 1940. They beat them 23–0. Paige was the league's MVP that year, going 19-3, with a 1.93 ERA and 208 strikeouts in 205 innings. His win and strikeout totals set single-season league records that have never been broken. One of the great stories I heard is that the whole witch doctor thing got to him at one game that year and he ran off the field and out of the park because he said he saw a ghost.

Even though I wasn't drafted in 1991, I ended up signing with the team based in the city of Bayamón. My dad knew the manager and the GM, and after they let me practice, I made the team. The older guys who were playing, the core of the lineup, was pretty young and pretty talented. Among them were Eduardo Pérez, Felipe Crespo, and Oreste Marrero. The older guys played every day, but we had a pretty good team on the bench too, all young guys. As a backup catcher, I caught in the bullpen every day—for a few Seattle Mariner pitchers, including the Mariners' closer at the time, Jeff Nelson, who I would later work with on the Yankees.

On the field, I only got to play in a few blowouts as an outfielder, but being in the outfield was a good experience. I could demonstrate that I was a super-utility guy, so much the better, for them, for me, and for the Yankees.

Besides, what could be better than playing ball year-round anyway? I know that some young players think that going from college to the pros makes for a long stretch of playing, but I was used to that; in fact, junior college, semipro, A ball, instructional league, and Caribbean League wasn't enough for me. I just wanted to keep playing and getting better.

One of the ways I could get better was to sit on that bench and pay attention to what was going on out on the field as well as keep my ears open to what was being said in the dugout and the bullpen. The older players had a lot of knowledge, and I especially wanted to hear more from the guys who played in the minor leagues or the big leagues. I also can say this: if you need to learn how to hit the breaking ball or the changeup, go play winter ball. Those veteran pitchers were smart guys, and they knew they couldn't throw fastballs by anyone anymore, so they had to finesse their way through a game. Even when you were down in the count 2-0, you couldn't look for a fastball. Patience. Patience. Patience.

Later on the Yankee teams I played for were known for working the count and never giving away at-bats. That was part of my game from the very beginning, and winter ball in the Caribbean really helped me with that part of the hitting game. In a very real way, I was getting to enjoy the best of both baseball worlds. It was great to get away and get back home and still be able to play the game I loved while learning a lot.

When I'd get to the park in Bayamón, I'd keep up with a habit I'd developed about halfway through my first season in Oneonta. I'd woken up one morning, and while sitting on the floor to eat breakfast, I took out a piece of paper and wrote at the top: "Where I want to be and when." For 1992, I wrote down: "Greensboro (A)," and then the rest of the list looked like this:

1993—Double A
1994—Triple A
1995—New York Yankees

I folded up that piece of paper and put it in my wallet. I carried that slip of paper around with me for quite a while. I'd take it out to look at it and remind myself of my goals and my desires. I knew my plan was ambitious, but when did anybody ever make their dreams come true by sitting back and waiting for things to happen?

Chapter Seven
The Education of a Catcher

There's nothing natural about being a catcher. Some people can claim that they were born to catch, but I think they're ignoring that our body's natural response to things being thrown at us and swung near us is to get out of the way. Sure, you've got to be tough to be a catcher. More than that, though, you've got to love the game to no longer fight your body's natural instinct to flinch or shut your eyes when someone is swinging a 36-inch, 34-ounce piece of hardwood by your head. They're doing that in order to strike a 5-to 5¼-ounce baseball that is traveling at 90 to 100 miles per hour. Keeping your eye on the ball is one of the fundamentals of hitting and catching a baseball. That's easier to do when you're fielding a grounder or a fly ball than it is when catching a thrown ball.

In my major league career, I caught 1,574 games for the Yankees. As it stands right now, I'm ranked 25th in baseball history for most games played at what I, and many other people, think is the most crucial position in the game. Baseball people always talk about the wear and tear on a catcher's body. I had my share of injuries and bumps and bruises, and it's true that the position takes its toll. I'm proud of a lot of things I accomplished on the field, but catching full-time from 1998 to 2008 without going on the disabled list a single time still makes me feel good and fortunate. After all, just getting into position to play catcher is harder than it is anywhere else on the field and takes its toll.

I can't tell you for certain how many times I got up out of the crouch and then back down into it while playing those 1,574 games. Figuring that in the average game about 140 pitches are thrown per team, a conservative estimate is about 220,000 squats. That's just for live-ball pitches, not between-inning warm-ups, pitching changes, spring training, and all the rest. The exact number doesn't matter, and to be honest, I hadn't thought about it that much until recently. You just do what you have to do. Maybe that was one of the things my dad was trying to teach me as a kid when he made me haul that dirt, though ironically, I didn't start to

catch with any regularity until I was very far down the line in my baseball career.

I don't know why some people refer to the gear we wear as catchers as "the tools of ignorance." That's an old-school term that you don't hear people using much anymore, but I was always aware of it. Maybe the term means you have to be ignorant to catch, not in the way most of us use the word, "ignorant" as in stupid, but in the sense of learning to *ignore* a lot of things—like how much it's going to hurt your hand to have one of Mo Rivera's heavy cutters catch you in the palm or off-center near your thumb, or to experience a foul tip off flesh or padding. I don't think that anyone who's ever strapped on catcher's gear and gotten behind the plate was ignorant of the dangers that are part of playing that position. If they were, they learned about those dangers pretty quickly in the first few live pitches. And I know one other thing for absolute sure: you can't be ignorant—in any sense of that word—about the inner workings of the game of baseball and play the position of catcher.

Because of all these requirements, professional baseball became, in some ways, my real education. With baseball, I took the kind of approach that someone else might have taken to become a lawyer, a doctor, or an engineer. The one difference was that, typically, as you

advance in your education, you start to specialize, narrowing your focus of study; in my case, I widened my focus as I learned more by playing different positions, most notably catcher, all with the same goal—to get to the big leagues.

Later on, as I advanced as a catcher and had to start analyzing approaches to getting hitters out, I came to see my baseball intelligence as the kind of critical thinking skill that would have helped me succeed in other areas of life had I chosen to follow a path other than baseball. The only problem was that I didn't have the passion for anything other than baseball when I was younger. I've heard other people who've been successful talk about feeling like they were put on this planet to do a certain thing, and that's how I felt about baseball. I've often felt uncomfortable in lots of other situations—social situations, talking with fans or reporters—but that was never true on a baseball field. I felt like I belonged there—even when I was learning how to be a better player.

That attitude helped me adapt to being moved around the diamond as the Yankees experimented with me in different roles. I knew the game inside out, and it wasn't like putting me behind the plate, or at second base, or at third or first, or in the outfield, or at designated hitter was going to throw me completely

off-balance. It also didn't affect me mentally that much because I knew I was capable of playing any of those positions. Whether I liked playing them was another story, but in some ways that didn't matter. I was going to do whatever it took, be as flexible and accommodating to the organization's plan as I could, as long as it meant moving up in the ranks and getting closer to the Bronx.

That was my mind-set when I showed up for spring training in 1992. Like most of the minor leaguers, I bounced around from diamond to diamond, playing and practicing with different levels of guys based on the organization's needs. One day I might be working with a Double A squad at second, later in the afternoon playing a game at third base with Single A guys, and finishing up by catching a Triple A pitcher's side session.

After we broke camp, like schoolkids going on to the next grade, most of our Oneonta team got promoted as a group (along with our manager) to Greensboro, North Carolina, where we received a whopping $50-a-month increase in salary that failed to cover the increase in our living expenses. Greensboro, a city with more than 250,000 people, wasn't a sleepy little college town like Oneonta. That was both good and bad—there was more to do, but the cost of doing it was greater. That included rent, so Steve Phillips and I decided to live together.

Though we didn't have any kind of formal arrangement, it turned out that Steve and I helped one another in taking better care of our bodies. Steve had played football and baseball at the University of Kentucky, and he was as serious about physical conditioning generally and weight training specifically as any guy I'd come across. Also, at 24, Steve understood that, in baseball terms, he was an old guy and didn't have many years left before he'd be considered too old. As a result, he was serious about every aspect of the game and wasn't going to take any chances fooling around.

As much as Steve took care of his body when it came to conditioning, he was like a lot of guys in not being very picky about what he ate. The processed-food and fast-food diets most of us ate back then were so poor that it's a wonder any of us made it to the big leagues. Though I would learn a lot about the proper way to eat when I got to the big leagues, back in the minors I wasn't a fanatic about what I consumed—I couldn't afford to be. I missed the foods that my mom had made for me at home, but I couldn't get any of it anywhere in North Carolina from a store or a restaurant—and Taco Bell was a poor substitute.

Out of desperation and longing, I started to cook for myself. I was no master chef, but I could cook eggs and pasta and got very handy around the grill. I don't think we ate many salads or vegetables, but at least we

weren't loading up on junk. I had a vague sense that what I ate had something to do with how I felt during games. Remembering meals that Steve Congwer's mother made us and Martha Frickie's home cooking, I realized that after those meals I felt pretty good and had pretty good days at the plate—well, at both kinds of plates, really. Eventually other guys heard about our home cooking, and we'd frequently have guys over for steaks and pasta. A couple of guys made cracks about me being "Mrs. Phillips" and how I was going to be a real catch for someone one of these days, but when I gave them the evil eye and threatened to cut off their meal privileges, that ended pretty quick.

In addition to trying to eat better, Steve was constantly leading me through weight-based workouts. My dad was the old-school "don't lift heavy, don't bulk up, don't lose your flexibility" kind of guy. That approach was somewhat backed up by the Yankees' take on improving flexibility. We did a form of yoga, we did some variations on cardio/aerobic workouts, we used stability balls to strengthen our cores (though we didn't have that term yet), and we did resistance exercises with various bands and weights to strengthen our shoulders. Heavy-weight workouts, like the kind football players have used forever, weren't a part of that. But they were for Steve, and he exposed me to some concepts like

"pyramids" and "reverse pyramids," alternating upper body and lower body on different days, and things that later I'd do when working with a personal trainer.

It makes me a bit sad to have to say this, but given the era in which I played, I'll just confirm what I think has been obvious: I played clean and never crossed the line and took performance-enhancing drugs of any kind—from steroids to the stimulants. Given my paranoia about violating any kind of team rule or even being late for an informal meeting, you can imagine what that kind of cheating would have done to my mental state. I would never have been able to go out on the field knowing that I was doing something that gave me an unfair advantage or was either borderline illegal or was flat-out against the law. I wanted to succeed on the field, but I would never have done so by breaking the law, putting myself in any kind of jeopardy, or violating my sense of ethics or fairness. I say that at the risk of sounding judgmental. Other guys were also driven to succeed, and they made their choices. I made mine. End of story.

Working out with Steve, I didn't do nearly the kind of poundage and sets that he did, but I did do far higher totals of each than I'd done before. I was grateful that I was naturally flexible, a trait that my sister and I shared and that I've passed on to my two kids. I was stiff and

sore a couple of times after beginning that new routine with Steve, but I was never as bad off as some guys who did squats for the first time and could barely make it up a set of stairs without their eyes tearing up the day after.

Because Greensboro was larger than Oneonta and my commute to work was longer, it didn't make sense to ride a bike anymore. I bought a used 1988 Camaro IROC (International Race of Champions), a high-performance version of Chevy's classic. With this car, I could pull into the players' parking lot and not hang my head in shame. Boys being boys, a lot of our conversations were about cars and what we owned and what we'd buy when we got to the big leagues. It was good to dream, but the reality was that we were still pretty far away from the Bronx.

Because many of us had been together the previous year, we were all pretty comfortable with each other, but my real teacher that year was our manager, Trey Hillman. Having the same guy leading the club who'd been with us in Oneonta was huge because from the start he understood what we needed as a club and as individuals. Except for a brief time with Minnesota, Trey had played his minor league career with the Indians organization, mostly as a utility guy, playing second, short, and third. He played until 1987, but by

1990, the year before I arrived in Oneonta, the Yankees already thought enough of him to make him the manager there. Trey was only 28 when he got his first job as a manager, and I think that says something about the kind of baseball man he was. He might have been only five years older than Steve Phillips, but it seemed like he was a dozen years older. He commanded that kind of respect and carried himself with authority. That doesn't mean that he was a hard-ass, but he knew what he wanted from us, knew the game, treated us like adults, and expected us to respond like adults.

Trey was one of the guys who really made me into a Yankee. He was tough on me, but he taught me a lot, especially about focus. As much as I was used to playing the game throughout the year, I had to learn to focus all the time—not just during the 144 days when we had games but every day we worked as a team— and Trey helped me tremendously with that.

Whenever my focus slipped, whether on or off the field, Trey was there. One night in mid-June we were back home after a road trip. We were scheduled to play the next night, and a bunch of guys got together at a local bar to hang out, unwind, and have a few drinks. Steve and I were both there. We had a midnight curfew, but that was okay. Who was going to track us down? At one point I looked up, and there was Trey. We made

eye contact briefly, and then I saw him reach into his pocket and take out a pen and a little notebook. I looked at my watch and saw that it was 1:00 A.M. Busted.

The next day Steve and I walked into Trey's office before the game. He was sitting behind his little desk reading something. Without a word, we walked up to his desk, laid down $50 each to pay our fines, and turned to walk away. We heard Trey laughing, and then he said, "The kids thank you." Trey always took our fine money and donated it to a local charity.

I liked how Trey handled that situation—he had us, we knew it, and nothing needed to be said about it. We manned up and paid up, and he appreciated it.

Similarly, I still remember when I failed that year in Greensboro to live up to what I expected of myself. I don't know how, but my alarm failed me and I over-slept. Steve had gotten up early to work out, and I would have missed the team bus entirely if someone hadn't knocked on the door of my apartment to get me. I heard that knock and I was instantly wide awake and scrambling to get dressed and out the door. Trey fined me $100, which was huge considering how little I earned each month, and he reminded me, much as my dad had always done, that the little things matter. How people perceived me mattered, he said. I could just shrug it off and say, "Hey, everybody oversleeps,"

but that would be more than just a comment on how I slept. It could be interpreted that I didn't care—that I was too lazy to set an alarm, too unreliable to take care of the little things, or so much inside my own head that I didn't care about the team.

Honestly, he scared the crap out of me by saying all of that, but it was a good reminder. He also let me know in talking to me that way that he cared about me and what happened to me and my career. He was like that with all the guys. It was kind of like a big brother relationship in some ways, but he was also like a father to us in that he knew that how we performed reflected on him. He wanted to advance in his career, and he was going to do that if we were successful. I didn't know this at the time, but his first year in Oneonta he managed that team to a 52-26 record, or a .667 winning percentage. That's amazing to me now: you get a bunch of guys who don't know one another, who have never played together before, who didn't have a spring training together, and you get them to perform at that level? That's good coaching and managing.

Not that he was even-tempered all the time. At one point during the season in Greensboro we got beat pretty bad by the Asheville Tourists at their place. It wasn't that the score was so bad—we lost 5–3 or something like that—but we wasted a bunch of scoring

opportunities. From the time I got into the organization, the Yankees just preached and preached and preached to us about having good at-bats and making our outs count for something. In that game, we didn't do that, failing several times to move runners along or get a sacrifice fly to drive in a run.

I could see that Trey was steaming when we walked past him into the clubhouse after the game. He sat there with his notebook, writing furiously. He didn't come into the clubhouse right away, so we were in the showers and all of a sudden the helmet bag came skittering into the middle of the shower room. A few seconds later, Trey came in, fully clothed, and even in the steam and spray of the showers I could see that he was the hottest thing in there. He pointed at the helmets lying on the floor.

"Everybody grab one."

With shampoo foaming in our hair, we all looked at one another in shock, everyone unwilling to make the first move.

"Put 'em on!" Trey shouted. His voice got really high and pinched, and in that room with all the tile it sounded even more piercing.

We each grabbed a helmet and put it on. Trey, who was standing in the entrance to the showers, leaned over and then grabbed a bat bag and slid it into the room.

"Everybody grab a fucking bat."

I knew better than to say anything, but I was thinking that we didn't want the bats to warp. Still, I did as I was told, just like the rest of the guys.

The next thing I knew the table with our postgame meal on it was skidding into the showers, shedding cold cuts and rolls all over the floor. I looked into the clubhouse, where the guys who had been eating a few seconds earlier sat chewing with shocked expressions on their faces.

"Do you know what a two-strike approach is?" Trey's eyes were bugging out of his head at that point.

We all mumbled that we did, and that really got to him: "What did you say!"

We all mumbled a little louder, but with the water coming down and hissing out of the showerheads, we would have had to shout, and to be honest, most of us were trying not to laugh.

"You've got to choke up on the fucking bat! Choke up! Show me!"

At that point, I looked around the room—big mistake. I saw us all standing there buck naked, helmets on, and bats in our hands. Then I saw Lew Hill, who was a funny dude and had been stuck in the South Atlantic for a couple of years already. Because of the water and the shampoo and his helmet, bubbles were

coming out of the vent holes in the top of his helmet. I tried to stop myself, but I couldn't.

Trey stepped toward me, but the shower spray kept him from getting too close.

"Hey, what the fuck is so funny about the way we lost?"

I said, "I'm not laughing about the game. I'm laughing at Lew."

"Why are you laughing at Lew?"

"His helmet is making bubbles."

"Not that funny." He shook his head as he said that and bent toward us, squinting through the steam and looking like a crazed chicken with his head bobbing up and down.

By that point everybody but Trey was laughing. I could see that he was getting angrier and angrier, but all he kept saying was, in contrast to the obvious, "It's not funny. It's not fucking funny!"

The more he said it, the harder we laughed.

He turned and said, "You guys are not leaving. None of you. Sit your asses in this clubhouse for the next 90 minutes and talk baseball. And I mean *talk baseball.* No other bullshit allowed."

With that, he left.

While we took off our helmets and bagged the bats, we all tried to figure out how we were going to talk

baseball for 90 minutes. After we'd showered and gotten dressed, we did sit on our folding chairs and say a few things about how we had to start playing better. A couple of guys made cracks about how we better if for no other reason than to preserve Trey's sanity. When the hour and a half was up, we opened the clubhouse exit door, but the bus was gone.

Asheville was a great place, kind of hippy trendy but with some good restaurants and lots of spots to hear live music. As the team's nickname indicates, it was also a place that a lot of tourists visited and that meant that lots of talent—pretty girls—could always be found. Missing out on an opportunity to be out there was a huge loss. We settled back into the clubhouse, some of the guys lying on the floor, others sprawled in front of their locker. A few minutes later, we heard our bus pulling up. Steve said that, instead of scrambling out the door and piling onto the bus in hopes of salvaging some of the night, we should all "be cool. Look contrite." Then he looked at me and said, "That means look sad."

Everybody cracked up, but quickly regained their serious looks.

Trey came in, his arms loaded with paper bags from what smelled like a barbecue place. Still looking pissed, he snarled, "Sit your asses down and eat."

We all pulled up chairs and waited like schoolboys for our teacher to tell us it was okay. The room was silent. Normally, Trey would eat in his office, but he sat down with us.

Then, keeping a straight face, he said, "Baseball. Baseball. Baseball. Baseball. Baseball. Baseball."

He couldn't keep himself from laughing, "What kind of stupid shit was I thinking? Let's eat. At least I know your hands are clean." Then he looked at me and said, "Go ahead, Bubbles. Dig in."

Fortunately, the name didn't stick, but the incident did help bring the team together. Trey would be my manager again the next year in High A at Prince William, and though I didn't always understand his methods, over time he understood me better than I understood myself. A few times he called me into his office before or after a game and started to give me a really hard time, calling me out, and then he'd say, "You want to hit me, don't you? I can see it. You're so pissed at me, you want to take a swing at me." He was playing around with me to make his point.

"No, I don't want to hit you." The last thing I wanted to do was get released for punching a manager.

"Well, you should want to. You should be pissed off. You know you play better when you're pissed at the world, don't you? Use that energy the right way, and you'll be better off."

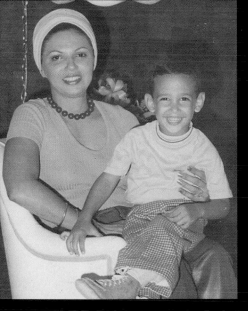

Sitting with my mother, Tamara, at about age four in Puerto Rico. She was always there to take care of me.

A school photo from my early days in the American Military Academy.

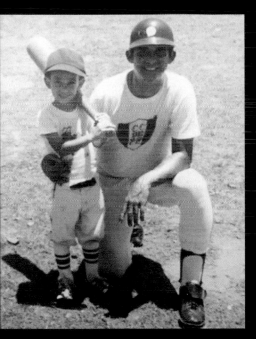

With my dad at age five. When I was little, my dad wanted my swing to be quick, so he didn't have me bat with anything heavier until I was seven.

Riding Big Wheels with my neighbor and best friend growing up, Manuel.

My friend Ernesto's dad would sometimes take us to a field near our houses to play ball. Here I am with another friend Che, Ernesto, and Manuel, ready to go.

With my first Casa Cuba team, when I was eight years old. I'm standing in the top row on the left next to my coach. Back then I wa always one of the smallest kids.

Me, Michelle, and our cousin Melissa visiting Papí Fello in the Dominican Republic.

Practicing judo for class at the American Military Academy

In 1983, my dad took me with his softball team on a trip to Elizabeth, New Jersey, as their bat boy. That trip to the states was the first time I laid eyes on Yankee Stadium and decided that one day I would play on that same field.

Spring training, 1986, when my dad was working for the Braves. It was the first time I got to attend their spring training in West Palm Beach in person.

Dale Murphy of the Braves helping me pick up balls from the batting cages right after he said those two life-changing words: "nice swing."

On the field at Calhoun Community College. Behind me, you can see the small airport that stood between our residential cabanas and the field, the same one I was caught jumping the fence to cut through

With Yankees scout Leon Wurth, finally signing my contract in 1991.

I was fortunate to have my father (pictured here with my mother) and his years of experience as a scout to help me negotiate my contract.

Me and my sister, Michelle, in the old Yankee Stadium in 1996.

Laura and me in 1998, eating at our favorite Cuban restaurant in New York, Victor's Café.

This was taken during one of Derek's trips out to visit me in Puerto Rico. My father and I were being interviewed that day by David Colon (*second from the left*).

At a family gathering with Laura's parents, Ninette and Manuel; my grandmother Mamí Upe; Laura; my mother; Michelle; and her husband, Migue.

Laura and me celebrating our World Series win in 1998.

With my mom and Laura (who was pregnant with Jorge at the time) following our win in 1999.

With my sister, mother, and father at our wedding celebration in Puerto Rico, January 21, 2000.

My dad gathered a few guys and all the bats in his trunk to give us this great sendoff.

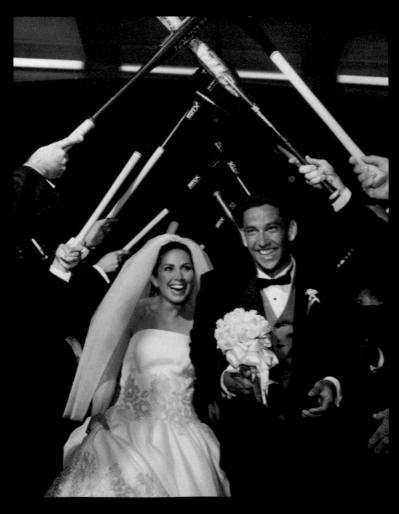

Jorge's first birthday party. This is actually the last photo we have of Mamí Upe. She passed away just a month later.

With Laura in New York. After Jorge was born with craniosynostosis, we promised we would remain strong for him and for each other.

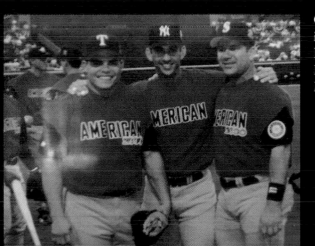

On my first All-Star team in 2000 with two players I've really looked up to, Ivan Rodriguez (*left*) and Edgar Martinez (*right*).

Jorge back in the locker room before going on the field during my 2002 All-Star game. *(Courtesy of the New York Yankees. All Rights Reserved.)*

Jorge and me heading out to the batting cages during spring training. After the team was done practicing, Jorge loved getting a few swings in the batting cage himself. *(AP Photo/Tom DiPace)*

You can see Jorge making eyes at Matsui. Jorge always liked Matsui because his nickname was "Godzilla." *(AP Photo/Mark Duncan)*

Joe Torre was like a father to me on the team. His support during Jorge's surgeries helped me survive one of the hardest seasons of my life. *(AP Photo/ Brian Kersey)*

Yogi Berra was always great to have at our games. The wisdom he shared was invaluable. *(AP Photo/Kathy Willens)*

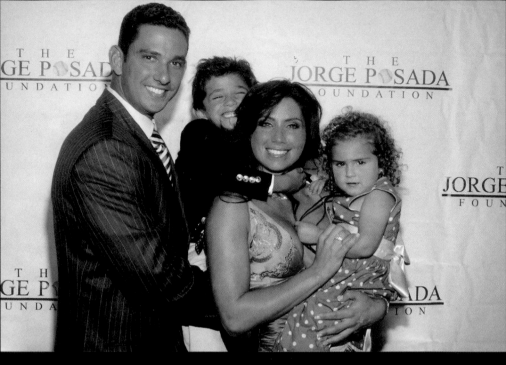

Me, Jorge, Laura, and Paulina at a Jorge Posada Foundation dinner event in 2005 or 2006.

On vacation, swimming with the kids.

The whole family, including our dog, Mimi, celebrating Jorge's birthday. Look at Paulina blowing out his candles!

Laura and I were seated right next to Barack Obama at an event before he was elected president.

Attending Family Day at the old Yankee Stadium.
(Courtesy of the New York Yankees. All Rights Reserved.)

The Core Four—me, Mariano, Derek, and Andy—together in 2008.
(Courtesy of the New York Yankees. All Rights Reserved.)

As a pitcher and a catcher, Mariano and I made a great team for so many years. *(Courtesy of the New York Yankees. All Rights Reserved.)*

My locker in the old Yankee Stadium.

I loved bringing Jorge out for early hitting before games, like this day back in 2009 after we moved to the new stadium. *(Courtesy of the New York Yankees. All Rights Reserved.)*

Thurman Munson's locker in Yankee Stadium, which is kept empty in his honor. When we moved to the new stadium, the locker was moved in one piece with us.

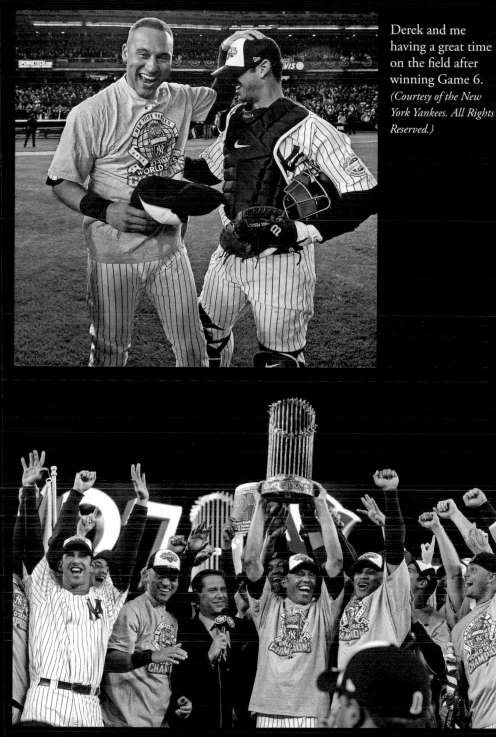

Derek and me having a great time on the field after winning Game 6.

The whole team lifting up our trophy in 2009, our fifth win throughout my career.

Celebrating with Mariano after our 2009 World Series win.

Jorge taking a picture of me as I leave the field after our 2009 win.

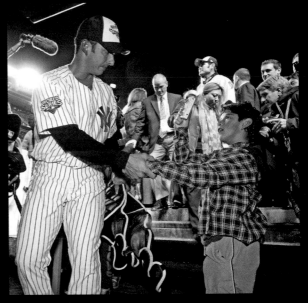

Top row from left to right: My five World Series rings, a special World Series ring gifted to the players by Roger Clemens in 2000, an American League Champions ring, and an All-Star team ring.

Bottom row from left to right: A perfect game ring gifted to me by David Wells (one of only two in existence), three All-Star team rings, an International League Champions ring, an All-Star team ring, and an American League Champions ring.

Congratulating Derek on his last game at Yankee Stadium. I couldn't have written a better way for my friend to go out. *(Courtesy of the New York Yankees. All Rights Reserved.)*

The family posing for a recent Puerto Rican magazine cover.

During Women's Fantasy Camp 2015, Laura was assigned number 2 instead of 20! Had a talk with Derek after that one . . .

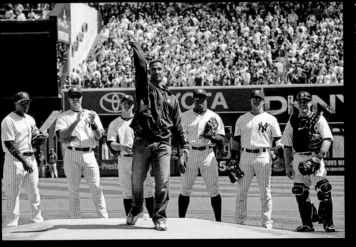

Throwing out the first pitch on opening day to my father after Mo agreed to give the spot to him. *(Courtesy of the New York Yankees. All Rights Reserved.)*

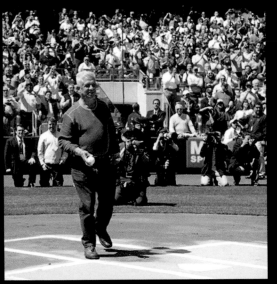

My dad hadn't caught a ball in front of that many people in a long time, but as always he was ready. *(Courtesy of the New York Yankees. All Rights Reserved.)*

Three generations of Jorge Posadas sharing our favorite pastime, baseball. *(Courtesy of the New York Yankees. All Rights Reserved.)*

He was right. My whole life, even though I didn't really know what this English expression meant, I'd had a "chip on my shoulder." I'd also eventually hear it described as "having a bit of the red ass," or what we Spanish-speaking guys call "*encojonado*." Some guys can play with the kind of cool that Derek Jeter exhibited—he was a fierce competitor, but you couldn't really tell it from how he carried himself. Some guys have to let their emotions show, and it took me a while to realize that if I kept all that passion and all that "I'll show you" energy bottled up, I wasn't as effective as I was when I let it out in proper ways. That was one of the things that Trey tried to get me to understand—how to channel that energy and passion and anger instead of letting it explode uncontrollably. That was tough to do, and it would take me a long time to learn how. I'm not sure I've ever mastered the art of it.

Another part of my baseball education was reading a book that several guys recommended to me. H. A. Dorfman, a sports psychologist, wrote *The Mental Side of Baseball: A Guide to Peak Performance*. It was loaded with practical tips and stories from major and minor league ballplayers. I could relate to them because the situations those guys faced were ones that I had faced. It was good to know that other players struggled with self-doubt and frustration. Knowing that guys who made it to where I wanted to be still

felt some of those same fears and anxieties was really helpful.

That wasn't the only reason, though, why I needed to read the book. Of the 101 games I played in that year, I was at third base for five of them and caught 41. In the rest I served as the designated hitter. I think my fielding stats at third base say a lot—I had four errors in those five games. A lot of that was mental. I wasn't playing the field regularly, and I wanted to. So when I got in the game I put too much pressure on myself and didn't make some routine plays. That's why I needed to read that book. Behind the plate, I was okay. I had six passed balls and one error in those 41 games. Because I was new to the position and expectations for my performance weren't as high, somehow I relaxed more. This may sound a little strange, but I was thinking so much about having to focus that the thinking got in the way of being able to actually focus and perform.

The place where I felt most at home that year was the batter's box, and I had decent numbers, batting .277 with 13 home runs and 58 RBI in 339 at-bats. I was striking out a bit more than I would have liked, with 87 of them, but I was still taking a good approach, and I managed to walk 58 times. I didn't see much of a difference in the quality of the pitchers we faced in A compared to low A, and the lights and batter's eye

weren't any different either. The nearly 40-point jump in my average over what I'd hit in Oneonta was mainly due to relaxing a bit and having more at-bats.

I don't know if being a DH the majority of the season helped or not. Yes, I did get to focus more on my offense, but not being out on the field made me feel less a part of the game. It also gave me a lot of time—in some ways too much time—to spend thinking about my last or next at-bat. It was a bit of a struggle to get to the point where I could really embrace the idea that one at-bat, or one pitch in an at-bat, really had no relation to any of the others, that they were separate opportunities. By that I mean that the result of that pitch or at-bat wasn't tied to what happened before it. Pitches were tied together in how a pitcher worked to set me up, or in the approach I took depending on the count—but not in the result.

Toward the end of the season, what seemed like a relatively minor footnote in Yankees history came about when a young player I'd never heard of before, a guy named Derek Jeter, played with us. Our third baseman, Tim Cooper, got hurt, so Richard Lantrip had to move from short to third. We needed a shortstop, so they were bringing in this new guy. I heard a few guys talking before game time, and I kept hearing, "Jeter's coming." I'd heard that he was the first guy

the Yankees selected back in June, so I was eager to see him. Then he showed up, and I was like, "That's a *Jeter?*"

This guy shows up, and he's about six feet four inches tall, and he can't weigh more than 150 pounds. He was so tall and skinny, and he wore these ankle braces on both legs and high-top shoes. Was he afraid that his skinny little legs would collapse? And the guy didn't know how to wear a baseball hat. He tilted it up in the front and down low in the back and had this "gosh, gee whiz, fellas" expression on his face like he was the new kid at school looking for the cafeteria or where to meet his mom for a ride home. I was hating on how he looked.

What was the big deal? The first game he got in, I was DH-ing, so I got to see him from the bench. Ground ball up the middle on the right side of second base, he gloves it, does a spinderella, and fires the ball for a strike to just get the runner. *That was pretty good,* I thought. Next inning, a ball deep in the hole to his left. Backhand. Plant. Laser to first. *Okay, he can go in both directions.* He struck out his first time, and I thought, *Decent glove, no stick.* Back to hating on him.

Next time up.

Yard. Those spindly legs got him around the base paths okay on his home-run trot, with dainty little

clouds of dust coming up from his Bambi paws as the ball sailed over the fence. I thought we should give him the silent treatment when he came back to the dugout, but I slapped his hand, being careful not to hit the delicate little guy too hard.

It didn't take someone with a baseball IQ like I had to see that the guy was going to be pretty special. He just needed someone to dress him better and tell him to wipe his runny nose. He also needed someone to tell him that he should be very careful who he chose for friends. In time, payback for all the jokes he made at my expense was going to be tough.

I wouldn't see him again during the regular season until 1994, but I vaguely remembered who he was.

At the end of the season, I got selected again to go to the Florida Instructional League. Even though I'd caught nearly 50 professional games by that point, I look at that six-week period in 1992 as the start of my catching career. I was told that I would be catching full-time from that point on. Having my options being limited was difficult in some ways, but it freed me in others. If I was going to have to catch, then I could devote all of my time and effort to it.

One downside remained—I didn't actually enjoy catching. I wasn't afraid of the hard work and the wear

and tear on my body, but I also wasn't a masochist who loved the idea of getting beat up by pitches and foul tips.

When I reported to the instructional league that year, it was like I was being demoted to a lower grade because I went back to Catching 101 and working on the fundamentals of the fundamentals. We worked for hours and hours on everything from the catching stance to footwork, to transitioning from catching the ball to throwing, to receiving the ball, to catching pop-ups, to a dozen other fine points of the position. At that point we weren't talking about strategy and calling games yet. This was all just the physical grunt work. And believe me, I was doing a lot of grunting. We'd generally start the day with blocking balls in the dirt. At first, I had to do it with my hands behind my back to force me to not get lazy and try to catch them but to move my body—chin tucked into my chest, forehead pointing down, bending at the belly. First a coach pointing in the direction I was to move. Then ball after ball in the dirt. Left. Right. Then with the glove. Coaches nearby yelling, "Block it!" Then balls from the pitching machines, same routine, faster speeds, breaking balls with spin you had to account for.

I felt like a target in a shooting gallery. Again, I didn't mind the pain of being hit by a ball—well, I did,

but what troubled me was that at times it seemed like I wasn't getting any better at getting hit by the ball. I thought I had decent reflexes from playing the infield for all those years, but this was different. I tried not to get too discouraged, something that my dad tried to help me with as well.

Since I'd first left home for Calhoun, he'd told me that my future lay in transforming myself into a catcher. He'd heard from some other scouts that my size and arm made me a good candidate to catch, and he agreed with them. I hadn't really wanted to hear that back then. I loved being a middle infielder. A lot of his assessment and that of the Yankees was based on my size and my arm. I could always throw, and that's an important part of being a catcher. What I had to work on was the technique of throwing from behind the plate.

Ideally, when you throw a ball from any position other than the mound, you want to throw a four-seam ball. In other words, you want to hold the ball so that the two horseshoe ends are parallel to the ground. That way, the seams cut through the air better and the ball travels straighter. In theory that's the way to do it, but when you're under pressure and don't have a lot of time, any seam—or in the worst-case scenario, any grip—will do. Making the transition from having the ball in your glove to having it in your throwing hand is

one of the fine points of the game that you really work on more and more as you advance through the ranks. An infielder can sometimes make up for a slow transition with a strong arm, but a catcher trying to throw out a runner who's stealing a base is less likely to be able to compensate that way.

The average time for a runner going from first to second on an attempted steal is 3.55 seconds. Some of the top catchers in the game, guys like Pudge Rodríguez, could get the ball out of their glove and down to second in 1.8 to 1.9 seconds, and sometimes even faster than that by a tenth of a second or so. Anything under two seconds is considered good to average. So there's not a lot of difference between great and okay. Pitchers dictate a lot of the success in defending the running game. Quick slide-steppers—guys who don't lift their lead legs very high off the ground—can get the ball to home in 1.1 to 1.2 seconds. Slower guys get it there in as long as 1.5 to 1.6 seconds. Add up the high end of both—a slow move to the plate and a slow throw to the bag— and you've got about 3.5 to 3.6 seconds. Basically, a pitcher who doesn't get the ball to home in under 1.5 seconds is making it nearly impossible for any catcher to throw out an average base stealer. All those numbers aside, the margin for error for a runner or a catcher is very, very thin.

For that reason, we spent hours and hours and hours trying to cut down my throw to the bag by tenths of a second. There are only a few actions you do in baseball during which someone can stand there with a stopwatch and give you instant feedback on something that seems so relatively simple. After all, everyone who has ever played catch has caught the ball and then transferred it to their throwing hand. All those hours spent playing table tennis helped me have quick hands to catch a ball that was off target, but there's really nothing you can do to simulate what it takes to get a ball out of the glove and into your hand. Add in the footwork it takes to come out of the crouch and throw and you've got a complicated set of tasks that you eventually have to stop thinking about and just do. We broke each of the steps down into substeps and worked on them in isolation before putting them all together. Then we added in another set of complications—pitchers and hitters, sometimes with the hitters just standing there and sometimes with them swinging.

Even catching a baseball is different when you play behind the plate. You have to help your pitcher get the call, and if you stab it and carry your glove out of the strike zone, the umpire isn't going to give you a strike call. As a result, you have to receive the ball. Here's the difference: If the pitch is high, catch the top half of

the ball. If the pitch is low, catch the bottom half of the ball. If it's too far left, catch the left half of the ball. Too far right, catch the right half of the ball. Pitchers hate catchers who take pitches away from them. So on top of everything else being somewhat new to me, I even had to think about the simplest thing I'd been doing since I was a little kid—catching the ball.

And as embarrassing as it is to admit, I wasn't very good at doing that. When I was assigned to play high A ball at Prince William in 1993, I led the league in passed balls with 38! Thirty-eight. I gave new meaning to the idea of a catcher being called a backstop. I spent almost as much time turning around to face that barrier as I did going out to the mound to talk to pitchers.

Actually, the guys were pretty patient with me, as was the organization. The first year I did instructional league gave them some idea of what to expect. They had drafted a lefty out of high school named Brien Taylor with their first pick. He was a big, big deal. He threw in the mid-to upper 90s, and they sent him to instructional league. I was told to catch him while he was doing some side work with a bunch of the organization's player development people and some coaches watching him. First few pitches were fastballs with some good tail on them. I managed to snag them. Then Taylor said, "Two-seamer." He fired one in, and it moved so much

I couldn't catch it. He did it again, and I missed that one too. One of the AAA pitching coaches came down by me and said, "That's no two-seamer, that's a cutter." Didn't matter what you called it—I had a hard time catching it.

Just to put things in perspective, I had 142 passed balls in my 17-year major league career, with the highest number in a single season being 18—which was 20 fewer than that year in Prince William. That was sad and ugly, but I didn't let it affect me at the plate, where I finished second on the team in homers and RBI. I'm proudest of the 17 stolen bases I had in 22 attempts. All that talk about how to deal with runners on base as a catcher helped me out.

I recently heard about the author Malcolm Gladwell writing that successful people have to spend 10,000 hours at something in order to achieve at a high level. I never counted the hours, but I'd say that's a pretty fair estimate of what I put in. I'm not sure I could have made it through all that if my dad hadn't taught me early on that persistence is an essential skill. He wouldn't let me give up, and the chores he assigned me, initially at least, seemed like they'd take forever to finish—if I even was able to do that. He showed me time and time again that the job would get done as long as I stuck with it, put in the time every day, did things the right way, and didn't take shortcuts. As a result, I didn't question the

practice or the diligence that any job required; instead, I just trusted that doing the work was the only way to get it done.

At the end of the year I got promoted to the AA Albany team for the final games of the season and the playoffs. I got into seven games, allowed two passed balls, but more than held my own at the plate, hitting .280 in that brief appearance there. I switched to a smaller glove, the Wilson 1791, which was about three-quarters of an inch shorter than the Wilson 1790 I'd been using. A smaller glove forced me to center it better, and fewer balls went off its tip and helped me receive the ball with more finesse.

My glove might have been getting smaller, but my goal was getting larger in my vision. I was learning something else at that point. Despite my struggles, and even though I'd told management that I really wasn't sure that catching was what I wanted to do, all the work they put me through and the mental discipline I was developing were helping to make it clear that I was on the right track. And all those sprints I'd done were helping me get to those passed balls pretty quickly.

The following spring training I was told that I was going north to play for the Yankees' AAA affiliate in Columbus, Ohio. Seven games in AA had been enough—I was one step away from the big leagues.

Chapter Eight
On the Brink

The more I thought about the Yankees' big league team, the more I understood that I had to deal with my failures in order to succeed. Though I'd come so far, I knew this final stretch would be the hardest. To get there, I had to confront my weaknesses—not let them get me down, not forget about them, but acknowledge them.

Yes, I was one step closer to the big leagues, but I'd only caught one full season in the minor leagues, and only 280 games total over three seasons. I was miles behind other catchers at the Triple A level in any organization. I was also only 22 years old; I may have been a three-year veteran in the Yankees organization, but I was very young and a baby at my position. Still, I had visions that at some point in that first year, maybe at

the very end when rosters expanded, I'd get my first shot in the big leagues. I kept that paper I'd written my goals on, and though it included a stop in Double A, I had written it in pencil and could make changes to it.

In 1994, I joined a team that employed six catchers during the course of the year, including former big leaguer Bob Melvin. The thing that struck me first when I met all the guys on the team was that this was a much older group. I was the only position player who'd made the jump from Prince William to Columbus, but pitchers Andy Pettitte, Matt Dunbar, and Keith Garagozzo spent time in Columbus too. So did two other guys who'd been a part of my past and were going to be an even bigger part of my future—Derek Jeter and Mariano Rivera.

I first met Mariano at the first instructional league I attended. I didn't know it then, but he was there recovering from Tommy John surgery. Because I was learning to catch, and he wasn't throwing, we only spent a little bit of time together. What I most remember is watching this guy run in the outfield doing sprints with the position players. He could cover some ground. When I first spoke with him, I asked him why he was throwing left-handed as he lobbed the balls in while shagging flies. He pulled up his sleeve to reveal the scar. I raised my eyebrows and shook my head.

"I'm sorry."

"I'll be fine."

He smiled that amazing Mariano smile. If it had been me with my career in jeopardy due to an injury, I don't think that I would have had Mo's optimistic attitude. As much as anything, that's what I remember about him from that fall. Nothing seemed to get him down for very long. He was one of the most energetic and positive people I ever met. He was having so much fun being out on the field just shagging flies and running. He would laugh and smile and you would have thought he was a little kid at spring training like I had been all those years before and not someone whose future was in doubt.

I got to know him better at spring training in '93. The first time I caught him, I wasn't that impressed. His fastball topped out at about 92 miles per hour and it was really straight. He didn't have much of a breaking ball or an off-speed pitch, and I wondered about his durability. He was such a thin guy and for him to get to 92 seemed like a real feat. The thing was, though, he had absolutely perfect mechanics. He could also put the ball where he wanted it with amazing regularity. I thought that was the one thing he had going for him, but against big league hitters, I didn't think it was going to help him too much. Eventually, he'd prove that my

assessment was wrong, but he was a much different pitcher by then than the one I first saw.

We went our separate ways for the '93 season. He was assigned to the Rookie League and then to Greensboro. The organization was taking it easy with his arm post-surgery, and he threw less than 40 innings that entire season. Like me, he had a big transition to make, from a starter to a relief pitcher, but that was still ahead of him in '94. He started six games for us after starting a total of 16 others in high A and AA. If I was feeling good about being double-promoted, then Mariano was skyrocketing through the minors. Like Derek, he was a skinny guy who didn't impress you with his physical presence, but there was something about the way he carried himself, some calm assurance that was never cocky but let you know he believed in himself and his ability to get people out. He could humiliate you at the plate, but he was always humble.

Everything in AAA was an upgrade—the salary, the fields, the fans, the meals, all of it, including the umpiring. As my education as a catcher went on, and with Bob Melvin's assistance, I was learning that the relationship you develop with umpires is another part of the job. I always had respect for them, but there was more to it than just that. In some ways, though, dealing with the umpires was more than I could handle in those

early days of catching. There were just too many different pieces of the puzzle. Calling a game, managing the different personalities on the pitching staff, learning the hitters—all of those were things I needed to work on. Bob was great in helping me develop a better feel for pitch selection and strategy. He was a big believer in not messing around too much with hitters. Get ahead. Put them away. I can still hear Bob telling me over and over again, "Finish them."

Learning to master all of that would take more time, and suddenly that was the one thing I was out of. In mid-July, just after the All-Star break, we were playing the Mets' AAA team, the Norfolk Tides, at home in Columbus. Pat Howell was a small guy, a little under six feet tall and about 150 pounds. The scouting report on him was that he could run and make contact, but that he really didn't have much power, so we didn't worry too much about him. We fell behind in the count when he led off the inning, and he slapped a "get me over" fastball into right-center for a base hit, then advanced to second on a hit-and-run.

I saw him break for third on a steal and was rising up out of the crouch as a ground ball went to short. We got the runner at first, but I could see Howell rounding the bag and coming home. I started to yell, "Four! Four!" and for some reason our first baseman, Don

Sparks, hesitated a bit before making the throw home. I knew the play was going to be close, so I planted my left foot on the edge of the plate and had my knee turned out slightly toward the third-base bag to try to block the runner. The ball, the runner, and a truck-load of pain all arrived at the same time. Sparks didn't do anything wrong—the throw was good. Howell didn't do anything wrong—he just slid straight into the plate and had nowhere else to go. I didn't do anything wrong—I was trying to block the bag as best I could and reach for the throw at the same time. None of us did anything wrong, but I was the one who paid the price.

I have never felt such intense pain. The impact itself is something that I don't really remember. That memory was wiped out by a sharp searing pain that traveled from my foot and ankle up past my knee and into my spine. I looked up and I was lying on the ground on my back, screaming, and I saw that my foot was lying turned all the way to the left at nine o'clock and my kneecap was pointing straight up at 12 o'clock. I'm a flexible guy, but not that flexible. My ankle was dislocated, the tendons torn, and my fibula, the bone in my lower leg, was broken just above the ankle. I was alternating screaming and gritting my teeth. I tore at the ground, grabbing fistfuls of dirt.

Almost worse than that was the mental anguish I was going through. I wanted to scream to keep my mind away from the thoughts that were running through my head and colliding with the reality I was experiencing, sprawled out in that dirt.

My career is over. My career is over. I'm done. It's over.

The trainers were probably there, but I don't remember much. I was in so much pain that I was barely aware of being taken off the field. I know that a couple of guys lifted me up, and I kept raising my head from the ground to the sky, like a wounded racehorse. Dirt. Sky. Lights. Career over. When they managed to squeeze me through the narrow opening between the dugout and the clubhouse, I was placed on the trainer's table. I struggled to hold still with adrenaline and frustration and fear coursing through me. Stump Merrill, our manager, came in, and I looked at him while the trainers worked on me, first taking off my shin guards and my chest protector. They dumped them on the ground. I grimaced and gestured toward the gear, "I'm not ever putting that fucking stuff on again. I'm done. I'm not catching again. Never. I'm done."

He started to say something, and I rose onto my elbows to prop myself up. I watched as the trainers were cutting off my socks and the leg of my pants. They

were supporting my leg with their hands underneath my calf and thigh, and my foot hung there, drooping, pointing toward the ground.

"You're going to be okay," Stump said. "Just relax."

I think he thought I was talking about the injury ending my career. I was trying to say I didn't want to catch again. I'd gone along with everything everyone had told me to do, I'd improved, and this was how the baseball gods rewarded me? Work your ass off for what?

The trainers gave me something for the pain, and as it kicked in they wrapped my ankle in ice. But even then it was swollen and discolored and looked like it was some part of an extraterrestrial from *The X-Files*. A few minutes later, I was loaded into an ambulance and taken to the hospital in Columbus. As clichéd as it sounds, the rest is just a blur. I remember waking up the next morning in the hospital. The orthopedic specialist who did the work came in at one point and talked to me about plates and screws and being non-weight-bearing for six weeks. That figure was what stuck with me, even though I was in a haze of anesthesia and painkillers. Six weeks. I wouldn't be able to walk on it for six weeks.

I called my mom. She started crying. She couldn't stay on the line for long because she was so upset. My

dad got on, and he asked me how it happened, what they'd done, what I'd have to do to get back out on the field. He was both sympathetic and already thinking about the next steps. His attitude got me out of the funk I was in, made me stop thinking about what had happened and about what to do next instead.

Even when I was back in Puerto Rico, the Yankees were great about keeping in touch with me. My not being in the States complicated things a little bit, but they kept an eye on my progress. I had to return to New York to see one of their specialists, Dr. Hershon, to remove one of the seven screws. It was just in there temporarily, and it had to come out. I hate horror movies, but I was kind of fascinated by what Dr. Hershon had to do. They gave me a shot to numb the area, and then he asked me to help hold back a flap of skin, using a clamping device while he removed the screw. I wanted to see what was going on. Even though blood was running out of the little incision, I could see how white the bone was and I could also see the tendon, like a bit of uncooked chicken under there.

After six weeks, I was able to start walking, and I rehabbed with the same attitude I had brought to other challenges. I went to a local clinic, and the rehab specialists there put me through a set of exercises that the Yankees' doctors prescribed. I was surprised by

how stiff the ankle was at first. After six weeks of not moving, it was like the joint on an action figure left out in the rain collecting rust and dirt. I felt even more like an action figure sitting there passively as the physical therapist manipulated my ankle, tugging my foot from side to side and up and down.

I had work to do at home as well. I was given stretchy Thera-bands to add resistance to the movements. Some of the exercises I couldn't do on my own, so Michelle helped me complete them. The hardest thing to do, because it was so repetitive, was moving my ankle to trace out the letters of the alphabet in the air. Spending hours and hours doing ABCs wasn't fun, and then there was the icing, always the icing. I had been measured for the number of degrees of range of motion I had in several directions and was told the optimum number I should be working toward. I liked having that measurement as a specific target, a tangible goal I could work toward.

I'd had that pity party for myself early on, but I kicked all of those partygoers out to make room for rehab. I wasn't going to let anyone else know about my doubts.

Still, they were there. It's funny, baseball is a game of math, of fractions and percentages, and there was no way that I could convert those 92 games I'd played and

the 50 I would miss into a comfortable equation. I had so much to work on to become a big league catcher that for every game I missed I felt like I was losing hundreds of experiences—at least one experience per pitch. How was I ever going to be able to make up for that?

One thing that helped me maintain my focus was hearing from some of the guys in the organization. Ricky Ledée and Rafael Quirico checked in on me, as did Mariano and a few others. Darren London, the Columbus trainer, was also in contact a lot, making sure that my rehab was going okay. Everyone talked about next spring and next season, keeping me focused on what everyone expected was going to be my quick return to the game. "Quick" is a relative term, and being away from the game from July to February was by far the longest break from the game I'd taken in my baseball life.

My dad was great, offering assistance and support. Together the two of us went to Casa Cuba. My dad had the idea that if I used swim fins and propelled myself up and down the pool just using my legs, I'd strengthen my calf and work my ankle. Since I hadn't been able to use it at all for six weeks, my calf had suffered the most and was less than half the size it used to be. With a float board in front of me and those fins behind me, it was slow going, but I enjoyed being in

the water and the sun. Sometimes my dad would join me in the pool, but my most vivid memories of that time are coming to the end of the pool, seeing him sitting in his lounge chair, a cigar dangling from his mouth as he counted the number of laps, and being told "*Diez más.*"

Though the Yankees had been flexible in letting me do most of my rehab in Puerto Rico, at the beginning of February 1995, I reported early to Tampa for an even more intensive round of rehab. I was still feeling a bit frustrated, like my foot and ankle were in a big heavy boot that didn't allow me to move naturally. I got put through catching drills, and the foot and ankle started to loosen up, but very, very slowly. I also was told to do a lot of walking on the beach, and I did some work there, the sand providing both a soft surface and some resistance.

Therapy didn't end once spring training began. I showed up an hour earlier than everyone else each day just to do more work, more ABCs, more Thera-band resistance, more calf raises, more ice. After the daily routine, I was back at it for at least another hour doing much the same work I'd done before, a pattern that continued throughout the regular season. In spring training, being able to take soft-toss and hit off a tee and throw again was some of the best therapy I received.

Feeling like I was back doing baseball things was great for me mentally.

That spring I also was introduced to a man named Gary Tuck. Around baseball, he is widely regarded as one of the best catching instructors, and the Yankees had brought him in to help me. If I'd been nearly overwhelmed before by the emphasis on what seemed like tiny elements of technique, Gary came in with an even more microscopic analysis of what I was doing and was enormously helpful. With all the rehab and all I was absorbing about pitching strategy, the pain in my brain helped take my mind off the pain in my ankle.

I don't think I felt completely comfortable that entire season. This was especially true hitting left-handed. Always a back-foot hitter, not having that stable base beneath me, not feeling connected firmly to the ground with that back foot, was frustrating. Hitting a baseball takes the whole body, and when any one part of your body doesn't feel right, it can produce a whole set of other negative consequences and sensations.

My power numbers were down. I also struck out 101 times, 20 more strikeouts than I had the previous year in just a little more than 16 games. That was aggravating, especially given the Yankees' emphasis on not wasting at-bats and having good plate discipline. (The image of Trey Hillman shouting and the rest of

246 • JORGE POSADA

us standing butt naked in the showers was something I couldn't unsee.) I also had to make adjustments behind the plate to give my ankle as much of a rest as I could, going down on my left knee a lot more between pitches or when I tossed the ball back to the mound.

Having to think about every movement was mentally exhausting sometimes. Fortunately, Bob Melvin was still around to help me with the finer points of handling the staff. Also, Guillermo "Willie" Hernández was on that club. A Puerto Rican veteran player who was 40 that year and had been in pro ball since 1975, he was a huge help to me. Out of the 108 games I participated in, I caught 93, so I still felt like I was falling behind in terms of experience. Being on the bench and sometimes in the bullpen with guys like Willie and Bob nearly made up for it. In fact, there were times when I felt like maybe the Yankees were trying to cram too much game experience into me. At one point in July I'd caught 11 games in a row, including the front end of a doubleheader. Between games, Bill Evers, our manager, came to me and said, "You ready to go again?"

I looked at him. By this point my left calf was still not its normal size. I thought I was back at the pool with my dad, except Bill didn't have a cigar in his mouth.

I told him about the 11 games in a row and suggested that DH seemed like it would be fine for me.

"No, no. You've got to get tougher. This will be good for you."

Oscar Acosta was our pitching coach, a great guy and a tough SOB who rode bulls in the off-season. He stuck up for me and said, "He's tough enough. He just caught eleven straight days. That's enough."

Oscar was like that. He had our backs, but he was also really hard on guys too. Pitchers didn't like coming to Columbus on their rehab assignments because he drove them pretty hard, telling them that if they couldn't throw as hard or as long as they wanted, then they had to keep the rest of their bodies in shape.

I didn't catch that game, but apparently, no matter how much I worried about not getting enough experience, I was getting enough: I managed to cut down my passed balls to 14 and I threw out 32 percent of the runners who tried stealing on me. Just for comparison purposes, I would have finished third in the entire major leagues in 2014 with that caught stealing percentage. As uncomfortable as I was at the plate early in the year, I hit my stride again by midseason and wound up being named to the International League All-Star squad.

The last day of August we had a doubleheader in Toledo. Bill Evers came up to me before the first game and said, "You're not playing today."

248 · JORGE POSADA

"What do you mean? What's going on?"

"You heard me. You're not playing. In fact, pack your stuff and get on out of here." He couldn't control himself any longer and started to smile. "Congratulations. You're going to New York. You need to get on a plane ASAP."

I couldn't believe it. I ran back into the clubhouse, and there was Derek stuffing things into his bags.

"We're going to New York," Derek said. His words conveyed his usual dry, low-key, "everything's cool" attitude. But I could see the look in his eyes. He was pumped to be getting another opportunity to go play in the Stadium. As I was about to learn, once you get to that level, you never, ever want to go back down again.

Derek Jeter and I had gotten closer as the year went on. We had a similar approach to the game, the same drive, and we sensed that about one another. Hanging out together, going to meals, watching movies, talking about sports, something just seemed to click between us, and now here we were going up to New York together. It didn't matter why at that point, but I eventually was told that by being brought up before the roster expanded, I'd be eligible to play in the postseason. Buck Showalter wanted a third catcher on the roster so he could use one of the three of us as a pinch hitter and still have a catcher in reserve.

The rest of that day is just a swirl of images of car rides, airports, taxi rides, and arriving at Yankee Stadium. I'd been there before of course, as a kid, but nothing—and I mean nothing—can prepare you for the difference between looking down at the field and looking up from it into the stands. I was about to take the field for the first time as a big leaguer, and I was a little hesitant to do this. I stood for a few seconds in front of Thurman Munson's locker. I thought of how much he had meant to the teams he played for and to the game itself. I was now playing the same position he had, but I knew I was not in his league yet. Few catchers ever are.

The tunnel from the clubhouse to the dugout was dim, and a rectangle of light beyond that seemed brighter than any light I'd ever seen before. It was the first day of a new month. The Yankees were struggling, at 58-59, and trailed the Red Sox by 14 games. It looked a lot like there wasn't going to be any postseason to be eligible for. I showed up at 2:00 for a night game, well before anyone else was around. Before going onto the field, I sat in the dugout. The grounds crew was busy watering the field. Tears came to my eyes. I'd told my mom all those years ago that I was going to play here someday, and now I was about to do just that.

I wasn't thinking about the injury and what I'd done to overcome it. I wasn't really thinking about switching positions, becoming a catcher, and how hard I'd worked to do that. This also wasn't about my education as a catcher, about learning to receive a ball, track a pop-up, or set up a pitcher. This was just about soaking in the feeling. Yankee Stadium. The big leagues. The pinstripes. Monument Park. I told myself to remember this moment, to remember those feelings of pride and gratitude. My dad had a plan for me and it was about to pay off.

I'd called my mom and dad from Columbus before I got on the plane. But I wanted to speak with them again. I got up and went back into the clubhouse to use the phone. I talked to my mom, and she sounded so excited for me. Then my dad got on the line, and we talked a bit about the game and the Mariners as if I was going to be starting and needed to go over their lineup. That felt good and a little bit funny, and at the end of the call I told my dad thanks. I started to choke up and couldn't figure out how to list all the things I was thankful to him for. He let the silence last, and then he said, "Go get 'em."

Later that evening I trotted to the outfield to stretch and loosen up. Derek Jeter was there, his hat still not quite right on his head, but looking good. He patted

the ground next to him, and I settled alongside him to stretch. Andy Pettitte jogged by and held out his hand. Mariano was next. I stood up, and he gave me a bro-hug, thumping me on the back as he did so, telling me how glad he was to see me. Paul O'Neill strode by and congratulated me, wishing me well.

I stayed in left field during BP to shag balls. As I was standing there, I saw Don Mattingly coming out there. He'd been taking ground balls at first, and now he was making his way to left field. I figured he was going to do some running or something; instead, he came up to me, held out his hand, and said, "Congratulations, kid, I'm happy that you're here." I mumbled something, but felt great. Then Mike Stanley came up to me. He was a veteran, a great guy, but he knew his days were coming to an end, and he said something I'll never forget: "I'll hold the position until you're ready. Next year you might need a little time off, just call me and I'll back you up. You should wear my number when I'm out of here." He turned, and I saw the number 20.

I had this strange sense of being both a part of that team and separate from it. That was heightened when I sat on the bench and the game began. I turned into a fan at that point.

Before I knew it, Rickey Henderson of the A's was leading off the game and Wade Boggs and Don

Mattingly were out there on the field. Both of them contributed to a three-run rally in the bottom half of the inning, but in the second Mark McGwire hit a towering blast. Derek and I were sitting next to one another, and we jumped and watched the ball fly out of there, both of us saying something like, "Holy shit," under our breath. The rest of the guys on the bench just sat in place.

A few days later, on September 4, I got the word that I was going in. It was the top of the ninth in a blowout win over Seattle. We were up 13–3, and Andy Pettitte was coming out after eight strong innings. Joe Ausanio was going to mop up. We'd been on a bit of a roll and had finally gotten to .500 with that victory, though we still trailed the Red Sox by 14 games. The announced attendance was over 24,000, and most of them were still there, waiting to sing and celebrate a Yankees victory. I was excited but not nervous—I'd caught Joe at Columbus several times, so it was good to have someone familiar on the mound.

The inning was uneventful, with Joe getting the first two outs before allowing a single. We got the third out, and I joined the congratulations line. Derek had come into the game as well that inning, along with Rubén Rivera. It was nice to share that moment with guys I knew and liked and who were experiencing

some of these things on the big league level while still early in their careers. I hadn't contributed much to the victory, but still, it felt great to be out there listening to the guys congratulating one another while the fans sang.

Shortly after that, we played the Orioles in Camden Yard. Derek and I were on the bench again, and we watched as Roberto Alomar went deep into right field to snare a ground ball. He dove, got up, and fired to first to just get the runner. Derek and I jumped up shouting, not because we disagreed with the call, but because we'd just witnessed a great play. Buck Showalter turned and glared at us. We knew we weren't there as fans, but hey, that was a great play, and as the expression goes, we were just happy to be there.

I went back to Columbus after that brief call-up, but when the season ended, just as they'd told me, I was on the roster for the playoffs. The Yankees had an amazing run at the end of '95, going from that 58-59 record when I'd arrived to finish 79-64. That hot streak didn't last in the playoffs, though it was a classic series in which we lost 3-2.

What I remember is how seriously everyone took those games. I'd been impressed in spring training by the guys' level of preparation, the professionalism of it all, but that didn't prepare me fully for the before-game

preparation I saw. Mike Stanley was nice enough to include me in the catchers' and pitchers' meeting where they went over every hitter with a level of detail that I'd never heard before. They dissected every guy, and it was clear that Ken Griffey Jr. was a guy they didn't want to have beat them. I sat there flipping through ten pages detailing every pitch that the staff had thrown to him for the last four or five seasons, breaking it down by how each pitcher, like David Cone, had approached him. It was a lot to absorb, and I wondered who put all that information together.

Something else that has stuck with me all these years is how the guys on that club really wanted to win it all for themselves, but also for Don Mattingly. I didn't count the number of times I heard guys say some equivalent of, "Win one for Cap," but it was a refrain I'll never forget. You know, even now after all these years I get a chill when I think about that. We're adults playing a game, and it's a business and we're all supposed to be professionals, but we care more about winning than fans can ever realize. We're also fans, like Derek and I were during some of those games. We understand the history of the game. We know where certain guys are in their careers, and we know what they've contributed— in Don's case, we knew how much he suffered from injuries and how hard he worked. Because he cared so

much, because he was so competitive, he raised that team's level of desire.

As someone who had grown up emulating Mattingly's stance, I'd long known about what he brought to the field, but to see firsthand the effect that he had on his teammates raised my admiration to a whole new level. His presence made everyone in the locker room better. I saw that, and I wanted to be like him, I wanted to be a leader. That's what it meant to be a Yankee. You can look at the Yankees history as a blessing or a burden— those expectations can either crush you or elevate you. I loved being a part of it in '95, and it just fed the hunger that I had to contribute. It was no longer just about being in the big leagues. It was about winning in the big leagues.

The sportsmanship I experienced during that series wasn't just limited to our side. Out on the field before the game, Edgar Martínez came up to me and, in Spanish, congratulated me and wished me luck, as did Alex Diaz, a guy I played with in winter ball. These were small gestures, but they had a big impact on me. Ever since I'd come to the United States to play for Calhoun, I hadn't heard Spanish around me very often. Hearing their words offered a small reminder that, however far I'd come, and even though everything looked different, I could still find connections to my home.

As loud as I thought Yankee Stadium could get when we came from behind with four runs in the bottom of the seventh to put away the Mariners in Game 1, the Kingdome was even louder. Though when Jim Leyritz hit that home run to win Game 2, I couldn't hear the crowd in Yankee Stadium at all because of how much noise we were making in the dugout. I'd been in some great games, but a 15-inning thriller that ended like that was something I doubted I'd ever get to witness again but sure hoped I would. The highs and lows of the 11th inning of Game 5 stayed with me for a very long time. Going up a run and then seeing it disappear so quickly with only three batters coming to the plate was a quick but definitely not painless way to go out.

Yes, guys were professional and all that, but I could see and feel the disappointment. I hadn't been with the team the whole year, but going through that series and that intense complex of emotions bonded me to them. I really felt like a Yankee as I sat there, watching those games from the dugout and the bullpen. That was a long walk back to the dugout and into the silence of a losing locker room. It was like the first bittersweet taste of something addictive, the feeling that these games mattered so much, that you put so much of yourself on the line. As Buck addressed the team and told us that we had a lot to be proud of, that we shouldn't hang

our heads, and that we had a lot to look forward to in '96, I really felt like he was talking to me as well as everybody else in the room. I knew how to come back from a physical injury. Another test waited for me and the rest of the Yankees. How do you come back when you feel like you've been gutted? What do you do to get even better than being on the brink of doing something really, really special?

We—and that's how I thought of it then, as "we"—had a long and silent six-hour flight back to New York to contemplate those and other questions. Hopefully, before the following October we would find the answers.

Chapter Nine
Settling In

Like a lot of students, I was often told that, while I might have heard what was being said, I wasn't really listening. Before our disappointing finish in 1995, I had heard a number of my teammates say that they wanted to win in part for the Cap, but also because they weren't all going to be together again. While I heard those words, I wasn't really listening to what they meant. I was too busy being caught up in the thrill of the big leagues to fully understand what they were talking about. Going into that off-season, I thought I understood some of the realities of the professional life of a baseball player, but I quickly learned a lot about how this business worked.

Take Mike Stanley for example. When I first joined the team in September, I heard him saying to me that

he was basically conceding his role with the Yankees to me the next season. I guess I should have listened and thought about it more. He was coming off a series of productive years with the Yankees, not to mention an All-Star season in '95. His skills weren't eroding and he wasn't passing the torch. Instead, he got a better offer to go play someplace else—in his case, Boston. I'm not saying that Mike already knew that he was leaving the Yankees when I first arrived, but he was a free agent and probably knew that he was going to test the waters. What was going on in the minds of the Yankees front office is something I don't know. But as happens nearly every year with every club, changes were coming.

The changes in the Yankees organization that year affected me and my perceptions of where I fit in the big picture. In November 1995, to fill Mike's spot on the roster, the Yankees traded for Joe Girardi, who came over from the Colorado Rockies. When I heard the news, I was back in Puerto Rico, and while at first I was happy about the Stanley signing (and happy for him that he got a nice deal), I wasn't so happy about having new competition in Joe. I had nothing against Joe—I didn't know him at all—but he was somebody I was going to have to compete with for a spot on that roster. The baseball equivalent of Mother Teresa could have been brought in as a catcher, and I still wouldn't have been pleased.

I wanted that job. I believed that I was ready and that I had done all that was asked of me to transform myself into a big league catcher. Did that mean that I was ready to start every day?

Yes.

If I didn't have that kind of faith in myself, then I wouldn't have achieved what I had to that point. Show me a guy who doesn't think he can or should be an everyday player, and I'll show you a guy who sits on the bench and deserves to because he doesn't have enough faith in himself. I was never going to be that guy. That doesn't mean that in '96 I felt like I knew everything or had refined every skill it took to be an everyday catcher. That means that I knew I was capable of being one and all I needed was the opportunity to prove myself. Throughout 1995, I had said as much to the people around me. I told my agent, Willie Sanchez—who began representing me in place of my dad my second year of pro ball—that I was ready. Willie, and later Hardy Jackson who took over for Willie, told me to be patient and not to worry about it. They had sensed that Mike Stanley was going to leave and that the Yankees didn't have any other options. It was clear the organization liked me and was grooming me to be their guy, but now the Yankees had another option in the form of Joe Girardi.

I spoke with my dad, and he set me straight. He liked that I was getting angry and impatient. I had to turn that anger into something more productive. So what if the Yankees brought in another guy? There was always going to be another guy, either in the organization or on another team, they'd have interest in. That was the nature of the game. Teams wanted to get better, so I had to get better. If I went out there and busted my ass in the off-season and had a great spring, then I'd give them no choice but to start me. He stressed that no one was ever going to give me anything—I had to take it.

Unfortunately, the way things played out in the off-season undermined what everyone had been saying about my future role on the team. I started hearing rumors that I was being offered up, or at least that my name had come up, in trade discussions. That's always tough for a player. While my top priority was playing professionally, the truth was, I really wanted to stay in the Bronx. The Yankees had drafted me, and they were the only home I'd known. The club had treated me well, the team was in a good position to win, and especially after coming up through the farm system, I wanted to be a part of that Yankees tradition. Even though I'd only been in New York City a little bit, I really enjoyed it and was energized by the big Puerto Rican population there. This desire to stay in pinstripes

might have been a little naive of me, maybe a case of slightly premature loyalty, but in the end there wasn't a whole lot that I could do about it, so I tried to stay optimistic about my chances in New York.

To confuse things even more, though, the Yankees then let Buck Showalter go. Because my time with the club had been brief, I didn't have a great relationship with him, but at least he knew who I was. It was very possible that the new guy, Joe Torre, wouldn't. He was a National League guy. Maybe that was why they traded for Joe Girardi, another National League guy. My mind was working overtime, and I was starting to get headaches from worrying about things I couldn't control. I hated the feeling that my career was being determined by outside forces—I was in a hurry and I was being blocked.

So I did what I always did: I went to work. I had started to collect sayings to help me stay focused and inspired, and one the earliest ones I kept with me was this: *Work ethic eliminates fear.* I know that some people say that fear of failure is a powerful motivation for them, but I was wired differently. Fear made me anxious, and being anxious made me put too much pressure on myself. My motto that off-season became: *less thinking and more working.*

For the first time, I hired a personal trainer. Félix Hernández opened a gym near my parents' house in

Río Piedras, so I went to his place and told him who I was and what I did for a living. I was honest with him—I didn't have a whole lot of money to pay him. I'd gotten a small—and I mean *small*—bonus for the playoffs that year, but money was still really tight. Félix was great about it, telling me not to worry. We'd work something out down the line, he said, when I was making more.

Félix was a body builder himself, and so were most of his clients. I wasn't interested in bulk for bulk's sake, but I'd seen some of the guys in the Yankees locker room, and I felt a bit like I was still a kid in terms of my physical development. I weighed 205 at that point, but it was kind of a soft 205. Félix did some initial testing on me that showed I had a body fat count of 19—not bad, but still not as good as it could be. He also knew that as a catcher it was important for me to work on my quickness and agility, so he put together a two-phase program for me. Early in the day, we'd go to a nearby track, where I'd run and do agility drills. We'd work with medicine balls as well to build up my core strength. Then it was into the gym to lift.

That off-season I also saw Ivan Rodríguez, Rubén Sierra, and Juan González working out at the gym. I could see how much weight those guys were throwing around and how cut they were, and they were all in the big leagues, so I figured I should go at it as hard and

heavy as they were. Félix, though, kept my expectations in check—I was going to have to work up gradually to that level. His primary concern was for me to have functional strength, so we tried to simulate the movements that I did as a catcher and as a hitter and target the muscle groups specific to those actions. In a lot of ways that was what the Yankees were also emphasizing with their program, but Félix brought in the heavier lifting element to complement what I had already been doing.

I also played a bit of winter league ball, and during the winter Derek came to visit. We worked out, threw, hit, and got ready for spring training. I liked showing him around, going out to eat. One evening we were joined by Ricky Ledée, a teammate and friend who lived near me. We weren't sure where to go, so we asked Derek what he wanted.

"What's good?" Derek asked.

"Seafood," I said, thinking that here we were after all, surrounded by water.

Ricky shook his head and laughed. "Don't listen to his recommendations," he said. "Did Jorge ever tell you the Dennis Springer story?"

"Don't—" I started to say, not wanting to give Derek any more ammunition to use against me. It was too late.

Ricky told Derek that in '92, when I was catching for Ponce, he was on the team and lived nearby, so one day we decided to get lunch together before a game. We went to a spot right on the beach, and I ordered a version of *asopao de mariscos*. It was loaded with lobster, fish, shrimp, clams, and calamari. The waitress brought out this giant bowl that looked like a modern art sculpture with all these tentacles, claws, and tails and heads poking out of it. I dug in and started pouring on the hot sauce. Ricky sat staring at me as I went at it.

After we got back to the field, I started feeling kind of sweaty and woozy as I was taking BP. I told Ricky, and he said, "I heard that's what happens to sharks when they devour something." The trainer was only a little more helpful. I swallowed an Alka-Seltzer cocktail and started the game. As Ricky said to Derek, I looked more like a hockey goalie that day. He couldn't understand why I had a big glove on because pitches were bouncing off my chest and my shin guards, and I was humiliated. After the game, I said to Ricky, "I'm never going back there again."

That night, after hearing that story, Derek nodded and pursed his lips. "Sounds good. So where is this place?"

Derek has that way about him. He'll say something, and you have to be sure that you're both hearing and

listening carefully to get his meaning. He's the master of the subtle comment, and it takes some getting used to, but there's always a reward at the end.

Eventually I packed up my stuff and headed to Tampa for spring training. Derek had bought a house there, so I moved in with him for the few weeks we'd be there. Despite the off-season drama, as soon as I got there I felt comfortable. I'd done everything I possibly could to prepare myself to make the team and go north with the Yankees.

When we arrived at camp, I was pretty impressed with both Joes. Joe Girardi was a stand-up guy, kind of quiet and no-nonsense. It wasn't like it was with Bob Melvin back in Columbus. Joe wasn't there to help tutor me. He was there to catch and to learn the staff. I paid attention to him and how he went about his job the same way I paid attention to what all of the veterans were doing. Besides Girardi, we also had Jim Leyritz in camp.

I felt like I was having a good spring, and as I packed up to leave for home each night I'd look at a quote I carried with me: *All my expectations, efforts, and work won't be in vain. It's my journey to be a winner.* I'd think about the day I'd just spent working, assessing whether or not I'd done as much as I could to make that journey north with the big league team.

One day as the preseason games wound down to just a few remaining, Joe Torre called me into his office. When I arrived, he was there with Bob Watson, our general manager at the time, and I walked in fully expecting to come out smiling. That didn't happen. Instead, Joe told me I was getting sent back down to Columbus.

I don't know if I have the words to adequately explain how Joe made me feel that day in March of '96. Unhappy as I was to hear things I didn't want to hear, in listening carefully to them I was getting another message: *I know what you want, we want the same thing for you. You're going to be here, but not just yet. We could have you come up here, but you wouldn't benefit from sitting on the bench as much as you would from playing every day.* I imagine that over the years hundreds, if not thousands, of guys have heard similar things from a manager or a general manager, but the way Joe said it left me disappointed but not devastated. Part of it was his voice and his tone. He was very calm, but authoritative at the same time—you knew he knew what he was talking about. He made his expectations clear from the very beginning, but his genuine warmth and decency always came through. While I was pissed at the outcome, I wasn't going to allow that to change my mind about the Yankees. In fact, because of how

Joe dealt with me, I was more convinced than ever that I wanted to play for him and for the organization.

Coming out of that meeting, I felt like Joe had respect for me. He acknowledged all the hard work I'd done, how I'd performed in the games, how I'd carried myself. He saw all the things I was doing to do my job, to make an impression, and he appreciated them. It just wasn't my time yet. He didn't talk about Joe Girardi or what he brought to the team that I didn't, but when I reflected on it, I realized that we had a pretty veteran pitching staff—at 24, Andy was the youngest starter, by seven years. They'd signed David Cone, they had Jimmy Key, and maybe those guys wouldn't have needed much from a catcher, but as I was learning and would continue to learn throughout my career, the chemistry between a pitcher and catcher is as complicated a relationship as there is in all of sports. In football a quarterback might throw to a wide receiver ten times a game, tops. In basketball the point guard is having a great day if he's in double figures in assists. For the guy on the mound and me to have a good day, we have to be on the same page and really clicking for 90 to 95 percent of the 100 or so pitches a starter typically delivers.

When I looked at it that way, the argument that I'd be better off doing and not watching made more

sense. Gaining more confidence and developing my approach to being behind the plate became my mission. I was going to tighten up every part of my defensive game to make sure that no one had any doubts about my ability to catch in the big leagues every day, with every pitcher, in any situation. I told myself repeatedly: *Character is tested when you're up against it.* I couldn't spend the time in AAA pouting. I remembered what I'd heard my dad say about making sure I did something to make coaches and scouts notice me. Though he didn't say it, I knew what he meant: do something *positive* to make coaches notice you. You don't want negative stuff to be the reason you get their attention.

You know, the baseball gods can be cruel or kind. After reporting to the minor league camp and working out there for a few days, I got a call right as the big league team was leaving for opening day in Cleveland. Just before the team broke camp, Jim Leyritz had injured his thumb. Nobody knew how serious it was, so I got the call that I'd be traveling to Cleveland for opening day on April 1. Then, an April Fool's Day present arrived in the form of a big snowstorm that dropped seven inches on Cleveland and pushed opening day back to April 2. Jim was okay by then, so I didn't get to be on the roster after all. I also missed Derek's first

opening day and wasn't able to witness his first big league home run and a great over-the-shoulder catch.

Something similar to that April Fool's Day joke on me occurred later in the month. I got the call to get on a plane for Minnesota on Wednesday the 17th. The following day was an off day, and I expected to be on the bench for the Friday game. When I showed up before game time, Joe and Bob Watson told me that there'd been a change in plans and I should head back to Columbus. I told Derek, and he promptly went out and had one of his worst days in baseball—striking out four times in four plate appearances. As someone I won't name later said of Derek's day, "Why'd you even bother to go up there with a bat?" I guess you can blame me. Actually, to be honest, I'd forgotten about that bad day Derek had. He's the one who told me the story years later. And no, he wasn't trying to blame me for that bad day. As much as I kid him, he never made excuses—just outs, lots of them that day.

I was paying close attention to how Derek was doing for a lot of reasons, but one had to do with a rumor I heard. Apparently, Mr. Steinbrenner wasn't convinced that Derek should be the everyday shortstop at age 21. Joe, Bob, and others thought he could handle it. All he had to do was hit .250 and play a good short-stop and he would be okay. Fortunately for Derek, he

got off to a pretty good start, and at the time of the
Golden Sombrero (the four strikeouts) he was still hit-
ting .308. That was important to me because I had a
sense that Mr. Steinbrenner didn't trust young players
and I wondered how that might affect my present and
my future. If Derek was being put on a short leash,
then what did that mean for me? I knew a little bit
about Mr. Steinbrenner's spending habits and how he
would go after free agents or make trades for veteran
players—"proven" guys who had been through the
wars, as the saying goes. I wasn't one of those guys,
and I wondered whether the Yankees would go after
a veteran catcher if Joe Girardi or Jim Leyritz went
down with an injury.

I had seen Mr. Steinbrenner around camp but
hadn't had much contact with him. I didn't think much
at all really about upper management or ownership. I
knew that I'd gotten that letter from him when I was
first drafted, and that he had something of a reputa-
tion when it came to talent, but he also seemed like
a good man who cared about his players. That off-
season the Yankees had signed Darryl Strawberry,
and Dwight Gooden was also on that '96 club; both of
those guys had had their troubles in the past, but Mr.
Steinbrenner rightly believed in them—everything
I saw and heard indicated that they were really good

teammates. Until I had any real face-to-face interaction with Mr. Steinbrenner, I had no reason to judge him. I was just one of his many, many employees, and to be honest, few of the guys I hung around with in the Yankees organization had much to say about him. It seemed like those crazy "Bronx Zoo" days were part of another era that we had no real connection to.

Despite the attention I focused on the big league club, I did have a season I needed to play and focus on too. Typical of a AAA club, Columbus had guys coming and going all the time—we had 30 different pitchers take the mound for us that season. Brian Boehringer, Dave Eiland (who later was the Yankees' pitching coach from 2008 to 2010 and now does that for the Royals), and Ramiro Mendoza anchored the starting rotation. Ramiro is a great guy, a Panamanian who's no bigger than a fungo bat, but he had great stuff. Catching him was always a good time because he could throw any pitch at any time and he was fearless. He had some great success down the line with the Yankees, and I don't think he always gets as much credit as he should for the job he did during our amazing run to start the new century.

Nineteen ninety-six was the last year the AAA team would be in Columbus, and we went out in style,

eventually winning the International League title, but I wasn't there because I got a September call-up. The 11-game lead we'd had in late July was down to four games.

If I hadn't known the situation, Joe's demeanor wouldn't have revealed anything about the fact that the team had lost seven games on its lead, or that we'd gone 13-15 for the month of August. He acted the same way he had back in Tampa in the spring. It wasn't that he was loose or joking around or doing something else to ease the tension. He was his same calm and collected self, even when the lead over the Orioles shrank to just two and a half games in the middle of September. I didn't realize just how important that was until we reached the playoffs. Winning two out of three at home against Baltimore got the lead back up to four games, but even when we lost the last game of the series, letting the Orioles back in it after we took a 6-1 lead, Joe was the same.

I didn't get into a game until September 25. In the first game of a doubleheader, we jumped all over the Brewers, eventually beating them 19–2. I pinch-hit for Darryl Strawberry in the sixth. I struck out and then later in the game grounded into a double play. (It's never good when the number of outs you accounted for is greater than your number of at-bats.) I started game

2 of the doubleheader, batting seventh in a lineup in which Joe rested most of the regulars. Kenny Rogers started for us. He had great stuff, but in that first time catching him, I noticed that he went away from his strengths a lot, trying too hard to fool hitters. That was different from what Bob Melvin had stressed to me about getting guys out when you're ahead. Being too fine can be a problem.

Things weren't going too fine for me at the plate, though, so what did I know about pitching and hitting? The scouting report on me would have said, "Let him hit it." Bottom of the first with two outs and runners on first and second, I grounded out to second base. Batting right-handed against the lefty Scott Karl, who was having a decent season, I got overanxious and got out on my front foot too far, then tried to correct. Finally, leading off the bottom of the sixth, ahead in the count 1-0, I drove a fastball into left field between short and third for my first hit. Still have that ball.

I started again the next night, this time at Fenway against the Red Sox. Everything you've read about Fenway is true. The fans are on top of you, the Green Monster seems like a mirage because it's right on top of you too, and your teammates are right on top of you in a clubhouse that seems like the kind of clubhouse you'd make for your kids out of appliance boxes. Still,

it was incredible to play there. Not as cool as Yankee Stadium, not even a close second, but something I can't forget no matter how hard I try.

An 0-for-4 at Fenway was bad enough, but then we also went on to lose, 5–3. I pinch-hit in the last two games of the year, striking out and walking, and that was the end of it for me.

Derek finished the year hitting .314. I don't think he ever approached the black magic number of .250 that might have made him disappear. I was thrilled for him, but not surprised. Sometimes a rookie plays like a rookie, and sometimes a rookie plays like the game comes easy to him. I don't think people understand just how much effort Derek put into refining his game. He was given some remarkable gifts, but I'd seen other guys who were so-called five-tool players, and they couldn't fix themselves when things fell apart the way Derek did.

Though that was the end of it for me on the Yankee roster, the year wasn't over. I was going to travel with the club throughout the playoffs. Classes were still in session, though the classroom was going to be a pretty rowdy place from that point on. In contrast to the Stadium rocking, the clubhouse was a relatively quiet place. Guys still listened to their music and all that, but everyone had his game face on.

After a relatively smooth series against the Rangers in the American League Division Series, the AL Championship Series against Baltimore was anything but. Most people remember the name of the guy who caught Derek Jeter's fly ball in Game 1 and not the name of the guy who probably would have caught it if 12-year-old fan Jeffrey Maier hadn't gotten his glove on it. From where I was in the dugout, it was hard to tell what happened, but the replays told the truth: it was fan interference, not a home run. I remember Derek telling me that a year later he met Maier at a card-signing event in New Jersey. He thanked the kid for helping him out. I would have loved it if Derek had brought a Tony Tarasco card for the kid to sign. Imagine what that would be worth today.

It's too bad that a lot of people forget how great Bernie Williams played in that series, earning the MVP of the ALCS. It wasn't just his walk-off homer in Game 1 and hitting .474 for the series; it was also his defense and just his cool confidence that made him so important. I'm not saying anything new, but Bernie was like everyone has said—quiet and reserved, but an amazing talent and competitor. He may not have expressed his passion for the game like other guys did, but it was there. That ability to keep his emotions in check really helped him be clutch.

If Joe's steadiness paid off for us during that stretch run, it did so even more in the World Series. Even though I knew I couldn't play in the games, I still had butterflies. Seeing the Stadium decked out in bunting and all the pregame attention from the media, even just getting to the game and dealing with New York City traffic—everything seemed at a different level of intensity. Seeing Andy, our starting pitcher, get knocked around and out early in Game 1 kind of mystified me. That was so uncharacteristic of him, but as some of the guys pointed out, you're facing a team in the World Series for a good reason—they've got some players. Watching John Smoltz go through our lineup was something. He could deal, and though he walked five guys in just six innings, he demonstrated one of those baseball clichés that has a lot of truth in it. He walked four of those guys in the first two innings. We didn't take advantage, they got a lead, he got more aggressive because he was pitching with a lead, and as the game went on he became tougher to face.

I sat there thinking about what I'd do if I was behind the plate and my guy was struggling early. I know that most baseball people hate giving up walks most of the time. But if you look at Andy's line in that game versus Smoltz's, Andy only gave up one walk. So how do you handle that? One guy who's around the plate, maybe too

much over the plate a few times, gives up seven runs, and another guy who's wild gives up just one. I don't know what there is to learn from that except to do what Joe told the guys to do. Forget about that one. Move on. Trouble was, we faced Greg Maddux next. Talk about a guy who was always around the plate. Smoltz could overpower you, and Maddux kind of seduced you. He got you to do things you knew you probably shouldn't be doing and were hoping no one would see you doing because you knew better and you were embarrassing yourself a bit.

Down 2-0 after losing both games at the Stadium, I remember talking with Derek that night on the flight to Atlanta. I asked him if he'd ever been in that kind of situation before and what he thought he was going to do.

"No, I haven't. Just going to do what Joe says. Play the next game."

Our offense had scored only one run in those two games, so up and down the lineup we weren't getting any kind of production. That's when Joe went to work. He stayed the same, kept his calm and confident demeanor, but the lineup changed big time for Game 3 in Atlanta against Tom Glavine. In some ways it looked like Joe was playing the percentages, putting in a more right-handed hitting lineup. But that didn't explain

having Darryl Strawberry in there for Paul O'Neill, both of them left-handed hitters. And it took guts to replace Wade Boggs with Charlie Hayes and to put a less capable defensive player like Cecil Fielder in at first for Tino Martinez. I eventually played for Joe for a long time, and I came to see that he used numbers and matchups a bit, but mostly he went with his gut. As I look back on it, that Game 3 lineup was a gut move. He also moved Derek up from ninth in the order to second. It seemed as if every move Joe made worked out for him, including pinch-hitting with Luis Sojo, who drove in a couple of runs to help seal the win.

Joe went with essentially the same lineup in Game 4, and things weren't looking good when we fell behind 6–0 after five. I left the dugout and went out to the bullpen at that point. We'd gone through three pitchers by then, none of whom seemed to be able to put hitters away. But the relief pitchers did what you say to them when the gate opens and they're ready to trot out to the mound: "Hold 'em right there." Then the guys came back and won it 8–6 with some clutch hitting to tie it, including Jim Leyritz's three-run homer in the eighth.

I'd heard it happen at the Stadium, that sound of a crowd's enthusiasm being sucked out of it. When we won it with two in the tenth on some walks and

a mishandled pop-up, it was like getting toward the end of a movie and realizing you'd seen it before—but you liked it a lot and kept on watching. By Game 5 of that series, when Andy Pettitte and John Smoltz went through their opposing lineups with some nasty, nasty stuff, it was a totally different movie than it had been two games earlier.

I sat there mentally calling both games, trying to figure out what each of them was going to throw. I don't know what my percentage of correct guesses was, but I know that I wouldn't have seen either of them shaking his head from side to side very often. That's not because I'm a genius, but because both those guys had their best stuff and they stuck with it. Didn't matter if you thought that Andy's heater or Smoltz's slider was coming. That night they could have probably told the hitters what they were sending home and it wouldn't have mattered. As much as any other game, that one taught me something I'd take behind the plate for years to come: when a guy is on his game, don't get in his way. Don't make him do something to make it harder for him. There are no points awarded for degree of difficulty in baseball. Get an out. Get it as efficiently as you can.

That was as fun to watch as any 1–0 game could be. I wished that I could have been out there with Andy

that night. It's fun to catch when a guy is on like he was that night. There's something about putting down a sign, seeing the guy go into his motion, setting up, and then having that ball come right to your glove. You didn't throw it, but you still feel a part of it, like the whole thing wouldn't be real if you weren't there to confirm for everybody in the park that that pitch is now in the record book, verified and authentic. I think that's why I sometimes just have to say, "*Yes,*" which I've heard other players say in response to pitches, fielding plays, or hits. You can't help putting a stamp on it, certifying that it just happened.

It was especially gratifying to see Andy bounce back from a tough outing that way. To be a part of a 12–1 blowout loss and then put his team ahead 3-2 in the World Series with a 1–0 win like that says a whole lot about Andy. As much as we all say that you have to put bad games behind you, it's tough to do. You can put them behind you, but they're still there, sometimes well within range of messing you up in the next one. Some ballplayer whose name I don't remember said, when asked about his night after a bad game, "I slept like a baby. I woke up every hour and cried." Well, that wasn't Andy at all. That loss hurt; after Game 1, I saw him as down as maybe I would ever see him in his career. But even though he had to face the media and he

knew that people were questioning him, he responded like the stud that he is.

I think I yelled out the loudest *yes!* of my life the next night when John Wetteland got Mark Lemke to pop up to Charlie Hayes at third base and the ball settled into his glove. I was already tearing toward the mound, and there's a photograph of me grabbing Wetteland, and just behind us was Joe Girardi. He caught that game and had two hits, including a big triple to drive in a run. I wasn't trying to steal any attention from John or Joe. I just loved the game so much, loved winning so much, and was so caught up in the moment that I didn't even think, *I just ran.*

That's the best part of those victories—the not thinking. Your mind goes blank, and you just respond spontaneously. You let go. Whatever selfish concerns you might have had before the final out, whatever agenda or schedule you've set for yourself, however much you feel like you've contributed to that ultimate victory, none of that matters. Your guys, not the other guys, did it.

There would be time later for me to think about how much I wanted to be the guy behind the plate when a final out in a World Series ended with us winning. In those moments when we mobbed one another on the field—and during those long hours we spent in the

clubhouse celebrating and later in the parade and until it was time to start thinking about next year and spring training and all of that—I was just happy to let go and let it all sink in. That's what it felt like to be a winner, to have the matter decided in no uncertain terms. To have an answer and no questions, no doubts.

My family had come for the Series, and it was great to be able to share that experience with them. It was also good to have my dad understand me so well. As happy as I was, he sensed that I wanted to be a bigger part of the whole experience. Just before I left to go to the victory parade, he hugged me and said, "Remember this. Enjoy this. Get better."

I heard him, and I listened to him.

Chapter Ten
Making It There

Everybody has heard the expression "That's why they play the games." It means that no matter how things look on paper, no matter what the statistics tell you, once you get out on the field things don't always go as planned.

As I started my off-season workouts and once again played for Santurce in the Caribbean League in anticipation of the 1997 season, I had to wonder about my chances of sticking with the big league club. After all, between them, Joe Girardi and Jim Leyritz started 143 of the 162 games behind the plate and all of them in the postseason. With both of them still on the roster and me not getting much of a chance to prove myself, not to mention carrying a career .071 batting average in five different call-up scenarios, I only had my faith

in myself and my willingness to bust my ass to back up any real hope I had of being a Yankee full-time in '97.

A fringe player's fortunes hang on a lot of things going right for him. My own fortunes also depended, it seemed, on somebody else doing something "wrong."

I say "wrong" because I can't really say that Jim Leyritz letting out his frustrations at being pulled from a game in '96 when he was struggling had anything to do with his being traded on December 5 for a pair of minor leaguers. Joe Torre didn't have a doghouse, but he didn't let guys show him up either. From what I heard and later read, Jim did express his frustrations a little too loudly, and Joe called him into his office the next day to let him know that wasn't going to fly. If Jim had a gripe, he needed to deal with it privately, Joe said, just as Joe did himself.

When the Yankees decided to sign Girardi to a longer-term contract, Jim knew that meant he wasn't going to be the everyday catcher, so he thought he'd be happier somewhere else. When the deal was announced, Jim even credited and thanked Joe for his contribution to getting the deal done, which says a lot about Joe and how his players felt about him. Of course, if you know your Yankees history, you know that Jim wound up playing for us in 1999 and 2000.

With Jim gone, I didn't take for granted that the spot on the roster was mine. In fact, I never assumed anything, and I came to every spring training with that attitude. I had to earn my way onto the team. I know that sounds like something I should say, but it's the truth. And I wasn't the only one who came to camp that year feeling that way. The Yankees didn't make an offer to John Wetteland, even though he'd saved all four wins in the World Series, and Jimmy Key, who was a big part of the staff in '96, signed elsewhere when the Yankees wouldn't agree to a second year on his deal. Loyalty cuts both ways, but the bottom line is the bottom line, and you can never get too comfortable from one year to the next or take anything for granted in this business. That's why I went after it hard in the weight room and on the track and reported to Tampa in even better shape than the year before.

With about a week to go before we headed north, Bob Watson and Joe Torre called me in again. I was feeling pretty good about my chances, but still, I was anxious. I walked out of that meeting with their congratulations ringing in my ears and a huge grin on my face. I went to find Derek, and I told him.

"I know," he said with that little grin of his.

"How did you know?"

"Joe and Bob told me."

I couldn't believe he knew before me. "When?"

Derek shrugged. "Not sure."

"And you didn't tell me?"

"They told me not to. What do you want to do about dinner?"

Derek could only keep up the no-big-deal attitude until later that evening. When the check came, he slid it toward me.

I looked at him. We'd just had a couple of steaks, and the bill was well over $200.

"You can afford it."

Next a bottle of wine arrived, and I also noticed that what was sitting on the little plastic tray was a receipt, not a bill.

"Congratulations," Derek said. "And about time too. I knew they'd come to their senses."

We opened our title defense against Seattle in the Kingdome. Even though it wasn't our home opener, getting to be on the field on any opening day was a big thrill. The Kingdome was nearly as loud as I remembered it from the playoffs in '96. They beat us in a good ball game, and Joe penciled me in to start game 2. We jumped out ahead with three runs in the top of the first. Batting ninth, I was in the on-deck circle when the Mariners finally got three outs. In the bottom of the inning, Andy went to the mound, and I think he

was a bit amped up. He got the leadoff hitter, and then Alex Rodríguez stepped in.

At the time, Alex was just 21 years old and beginning his second full season as a starter. He was an impressive athlete. The way he carried himself, the way he moved, his size, his swing, everything screamed that he had loads of talent. He also had a wide smile and seemed to love what he was doing. Things got much better and then much worse for him. When we got closer down the line, that smile was still there, but you could see in his eyes that he was not having nearly as much fun as he did back then in Seattle and later in Texas. Not that he didn't work hard, but the game always came easy to him; life, however, would be a different story.

We wound up winning, 16–2, but even in the blowout I struggled at the plate, getting six at-bats that day with just one hit. I did drive in an important insurance run in the top of the ninth to make it 15–2. The insurance was against Derek giving me too much grief about starting out the year 0-for-6—and all in one game. The hit also ensured that I wouldn't spend the entire flight down to Oakland fixating on all six of those at-bats.

I wanted to get out of the gate quickly, but I didn't. I started three games in a row and went a combined 3-for-15. Not terrible—well, close to terrible—but not good either. Of course, I had visions of lighting it up

and convincing everyone that I should do the bulk of the catching, but that year I wound up starting only 52 games behind the plate. My first major league home run didn't come until the first week of May, against Kansas City at their place and off Jim Converse. I hit it left-handed on a 3-2 count, and it was a no-doubter off one of the supports near the fountains in right-center field. I ran around the bases thinking of all those times in the backyard on my makeshift field with my friends, fantasizing about what it would be like and making that crowd noise sound. This was in Kansas City and we were already up 9–3 on a cold Sunday afternoon, but it didn't matter to me that all I could hear was the sound of the air rushing past the ear hole in my helmet, not a crowd roaring approval. I was having a good day and wound up going 3-for-5. The guys gave me a great greeting, and since the ball had hit that support it came back into the field of play and I was able to get it.

I thought it was cool that the guys didn't give me the silent treatment, as teams often do when rookies hit their first home run. Technically, I was still a rookie, but they didn't do any kind of rookie hazing stuff because I'd been around so much. The Yankees weren't as into that as some clubs anyway. In '96, toward the end of the year when I was up with the big club, I went to my locker and saw that my clothes had been replaced

with a double-breasted pinstriped suit (of course) with wide lapels. I had to wear it out of the Stadium one night to sign autographs and then on the flight to the West Coast. To be honest, I wasn't embarrassed at all by my pimp outfit. That suit was badass, and I kind of wish that I still had it.

I avoided another rookie prank in '97 because it had already been pulled on me the previous year. During a series on the road against Oakland, I got invited to go out to eat with a bunch of the guys. Derek was there, along with David Cone, Tino Martinez, Chili Davis, and about ten other players. We went across the bay to a Ruth's Chris Steak House in San Francisco and had steaks, lobsters, and wine. At the end of the meal, David Cone said, "Okay, let's play credit card roulette." Guys reached for their wallets and put their credit cards on a plate that was being passed around. I looked at that plate and saw a bunch of specialty cards from big-name banks and companies. I put down my poor little American Express card, which I had to pay in full every month, and then handed the plate to Ramiro Mendoza, another rookie. Everyone kept talking to us, and I realized a few moments later that they were doing it to distract us.

A few seconds later, Tino Martinez held up a card and said, "*Lo siento.*" I couldn't believe it: Ramiro

had to pay the bill. I was so relieved. They sent the slip down to where the two of us were sitting. It was more than $4,000. Ramiro looked at me, and I looked at him. I know I didn't have that kind of money. When Ramiro shook his head and swore, "This is bullshit," I knew he didn't either. The room was silent, and then they busted out laughing.

David Cone had already paid it—they just wanted to see us squirm. David was one of the real leaders on those teams and he organized a lot of those team outings. He was also somebody we could all count on to step up and say something when it was needed. Coney's '97 season was typical of how things went for us that year. He started 29 games and was 12-and-6. That's not a lot of starts or decisions, but he was named to the All-Star team. His shoulder trouble in September frustrated him, though, and didn't allow him to perform at his best. It also put a real strain on the rest of the staff. Injuries are always part of the game, and Coney's shoulder and, at times, Andy's back were problems they had to deal with.

Since I wasn't up all year in '96, it's hard for me to pinpoint what the difference was in '97. I know that we didn't set the world on fire in the opening months of the season: at the start of June, we were eight and a half games behind the Orioles, who were playing really well

at 36-15. We then had a great June: by the end of the month we trailed the Orioles by five and a half games, having gone 17-8 to cut into their lead. Nobody seemed to be paying too much attention to the standings at that point, except maybe fans and some of the more vocal of the media guys. In the clubhouse, all was business as usual. Guys knew that it was a long season and where we were in June didn't really matter.

What did matter in June was playing the Mets in interleague games. Even for us, they weren't just another series in a 162-game season. Derek and I had both moved into the Ventura, an apartment building on the Upper East Side. We didn't plan it this way, but getting to Shea from there was as easy as getting up to the Stadium, if not easier. At that point, Derek was starting to get recognized more and more, and he had to pick and choose his spots in deciding when and where to go out in the city. It wasn't like we were prowling around at all hours of the night—that wasn't Derek's thing, and it wasn't mine either. We played mostly night games anyway, so we were getting home fairly late and then getting to the ballpark early. We needed rest, and I was still in that mind-set that I wasn't going to do anything off the field that could damage my reputation. More than that, I just wasn't that interested in New York's wild late-night scene.

Don't get me wrong, I loved being in New York. I loved being able to come home from a game and have restaurants still be open, with takeout places on every block and all of that. Even more, I loved coming out of my building and feeling the energy of the city. The street noise, people walking around at all hours, the sense that a whole lot of living was going on around me—all that was a real change from places like Oneonta, Greensboro, and even Columbus and Santurce. Later I would talk to a lot of guys who said that they didn't want to have anything to do with playing in New York. It wasn't just the expense, or how crowded it was, but just the intensity of it all, how much media there was to deal with; it didn't seem worth it to them. They wanted to quietly go about their business. I could respect that, but even though I wasn't born a big city guy, I think New York's rhythms suited mine. I didn't like to sit still. I liked the passion that people brought to everything—from their recommendations on where to get the best bagel or the best cannoli, to the best route to any location, to even the best strategy for crossing one of the avenues or hailing a cab. New Yorkers, for the most part, thought that they knew best, and they brought that same passion and vocal intelligence to the game.

If a guy failed to execute, or if they believed that Joe was making a wrong move in bringing in or not

bringing in a relief pitcher, you could hear either a low rumble of discontent or a loud expression of anger and indignation. I heard similar reactions in other cities, but even in that first year visiting every park in the American League and a few in the National, there was something different about the Stadium crowds. I guess that some of it had to do with how it felt getting to the park. You were in the middle of a densely populated area, driving along crowded streets with people who drove and even walked differently from everywhere I'd been before. People were hustling, or dodging around those who weren't. You'd think that this would make me feel more anxious by the time I got to the park, anticipating the game, but getting to the clubhouse was always a bit of a relief. It was a calm center where you could relax a bit and let that city-buzz settle for a while before the game began and the energy of those 40,000 to 50,000 people built up again.

That city-buzz was especially intense when we played the Mets. Usually, you played in an environment that was mostly positive. Yankees fans loved their team passionately. Mets fans loved their team passionately. Each type of fan hated the other team in the city. Mix those various passions up, and you've got a volatile environment. It was great, and the playoff-type

atmosphere for those games was real. I don't think we hated the Mets, or vice versa, the way the fans did, but you could appreciate the intensity of those emotions and wanted to reward the people who supported you and helped pay your salary. It was just fun too. The season was long, and you sometimes needed something to help keep your level of enthusiasm up. A big series like that was just what we needed.

All of this was relatively new to me in '97, so I was really looking forward to playing the Mets. The interesting thing about '97 was that for the people involved in the Yankees Suck/Mets Suck debate, we entered into that first game at the Stadium with identical 37–30 records. No matter what, except in the unlikely case of a suspended game or a rainout, one of the two sides of that debate was going to get proof of the inferiority of the other.

Things weren't looking too good for us when we lost the opener of the series 6–0. Getting shut out is always tough. But getting shut out 6–0 while getting the same number of hits as the opposition is especially frustrating. We won the next two, including a walk-off victory in the last game of the series. Because I was stuck in a stretch where it seemed like I was getting one start a week, I didn't play in any of these games. To be having a big series, with big media attention and in our

own backyard like that, and not even get the chance to contribute was frustrating.

It wasn't like the media was paying any attention to me anyway. I admit that early in my career I did follow what was being written about and said of the Yankees. I'm a big sports fan anyway, so it seemed natural to me that in a town where you had three major newspapers covering the city and I don't know how many radio stations and television stations competing for stories, I was going to be a big consumer of news.

Days before the series against the Mets, the sports headlines and sports radio shows were going on and on about David Wells being kicked out of a game in the first inning against the Marlins down in South Florida. David felt that the umpire, Greg Bonin, was squeezing the strike zone. Because we were in a National League city, David had to bat. He came up to the plate and got into it with Bonin and got himself tossed. That wasn't good. First of all, getting thrown out for arguing calls at the plate, while at the plate, was unusual for a Yankees pitcher. Second, arguing with an umpire and saying something bad enough to get yourself tossed wasn't the way to deal with an umpire. Also, getting tossed that early in the game put a strain on our bullpen. But David was an emotional guy. I liked that about him. He didn't want to take

crap from anybody, but he wasn't exactly diplomatic about it.

Joe wasn't too happy with David. Instead of calling him into his office to sort things out, he did what my dad would never have done: he played the waiting game, figuring that David should have known that he'd messed up and would come to him to let him know he wouldn't do something like that again. David didn't talk to him until three days later, and he also stated in the papers that he took offense to Joe telling the media that what he did was "unprofessional." It was, and I didn't think Joe crossed any lines there in saying that. He could have used a lot of other words to describe David's actions, but he didn't. Even though David took exception to it, eventually he came around, and after a couple of uncomfortable days of feeling the effects of what some in the media were calling "the silent treatment," things got settled.

What was interesting to me, since I wasn't a part of the whole situation, was that David Cone was frequently quoted in the papers. I admired him for the way he handled questions and managed to be really good with the media. Down the line, Mike Mussina was another one who would be excellent this way. Mussina, a bright guy who was legendary for his crossword puzzle-solving ability, was good with words, and that helped.

I was at a stage in my career when I wasn't getting interviewed with any real frequency, and I was still a bit uncertain about how to deal with the media. I know that Derek took a little bit different approach to the media in one regard. One day that year he saw me reading the papers and said, "You sure you want to do that?"

"Why not?" I asked.

"Well," he said, "eventually there is going to be something in there about you, something you might not like. It's better to just ignore it all—the good stuff and the bad stuff. Neither of them will really help you out."

"I guess that's true."

"Think about it. You go two for three, drive in a couple of runs. What are you going to find out in the papers the next day?"

"That I went two for three and drove in a couple of runs."

"Exactly. It's not like they're going to write that the game before you were getting out on your front foot too early and bringing your hands forward and you corrected that. They're not your coaches."

"That's true."

"You're getting enough advice from other people, good people. Don't let too much other foolishness

clutter your mind. The game is hard, so try to keep the simple things simple. Besides, I hate to see your lips moving when you read. Makes it hard for me to think."

"And you don't need me to add to your troubles with thinking."

I was already in touch with my dad frequently, and he was giving me helpful advice. I had my uncle Leo. I had the Yankee staff. It wasn't like I was looking for all those people to comment on my performance. I had gotten into the habit of checking in with my dad all the time, and he had some good insights and I valued his opinion. I just needed to regulate the flow of that information better—to get what I needed when I asked for it and wanted it. Still, as much as there was a lot of truth in what Derek said, keeping up with what the media was saying was an interesting part of life as a Yankee. That kind of media scrutiny would only get more intense as my career progressed, and it was easy in those early days to dismiss my newspaper reading as a guilty pleasure. It wasn't about me, since I wasn't an everyday player, so it didn't have any real effect on me. Later on, when the media would come to me more often, I'd pick up on a few things and Derek's advice became important to follow.

And apparently I did need an example to follow. At one point in '97, I got interviewed after a game I started

in which I felt like we hadn't gotten a few calls. More than that, though, I honestly felt like, if we had gotten those calls, the outcome of the game would have been different. And I said that. The next day Rick Cerrone, one of the Yankee PR guys (not the catcher), came to me and asked me to read a story that was in the *Daily News.* I read it and saw my quotes. Rick asked me what I thought.

"I said some pretty strong things."

"You did. Next time, you can still make your point about not getting the calls, but also say something about it not costing you guys the game, that you had other opportunities, or better yet, just say something neutral. They were borderline pitches. Didn't go our way. Anything else but the kind of thing that might upset an umpire. They read the stuff or will have someone bring it up to them."

I appreciated being told that. Eventually I would get to the point where I could respect that the writers had their jobs to do and needed answers, but could still protect myself and the ball club by not being too direct. It was a fine line to walk. That first year, and even later, I'd do what I was asked. I'd wait for 15 minutes after the clubhouse was open to the media, a half hour after the game ended, and then I'd get out of there. I didn't want the media's attention like some

guys did. Nick Swisher, for instance, seemed to want to be buddies with the media, though once I got to know him better I realized he was just being himself. He was the kind of guy who says, "Hey, how's it going? How's the family?" and stuff like that to everybody, strangers included. He was just being himself, though it was kind of irritating to me because I wasn't like that, and it seemed sometimes like he was trying to get attention. But at least he was true to who he was.

I'd like to say that being a non-native speaker of English contributed to my not being considered a great interview, but I was more or less the same with the Spanish-language people in the media—more comfortable, but still pretty reserved. That was my nature. I don't let a lot of people in and get close to me, but the ones I do allow in see a different me than the rest of the world does. Because I've always been that way, that's what came naturally to me when dealing with the press. I didn't put up fences, but I also wasn't widening doors and moving furniture out to make room for more people to crowd around.

I look at it this way. We all have parts of our jobs that we like better than others and are more suited to doing. I accepted having to deal with the media, and for the most part I felt like I had a good and professional relationship with them, one that improved the longer

I was in the league. But I wanted to be a good pro-
fessional ballplayer and concentrated the most on the
biggest part of my job—the competition on the field.
Media relations stuff was a smaller part of my job, so
I spent what I saw as the right amount of time work-
ing at it. I wanted to get better overall in all parts of
my work, and I think I did. I wasn't upset that people
didn't really know the real me that I revealed to my
friends and family.

When you play every day you get into a rhythm, and
it's easy to develop a routine that maximizes your time
and effort. You have a job and you develop a planned
set of activities around that job: what time you get up in
the morning, when you eat, when you leave home, the
route you take, when you take breaks or eat at work,
when you leave to go home, when you eat, how you
spend your evening, and then when you go to bed. For
most people, those routines don't change much from
day to day. As a ballplayer, though, you're subject to a
lot of variables: the length of the game, whether you're
playing at night or during the day, travel between cities,
sleeping in a different environment. Little of what we
do is as routine as it would be if we lived and worked at
home all the time.

When I mentioned earlier watching how the veterans
prepared themselves for the playoffs, I was referring to

many of these elements that make up a player's day. I only saw what those guys did when they arrived at the clubhouse, but after playing professionally for a while, I came to understand the importance of a routine that I could stick to. The variable of not playing every day was something I had to deal with, but here's where I benefited from Joe Torre being the manager. He did his best to communicate with Joe Girardi and me about the schedule. I was seldom, if ever, surprised to find out when I arrived at the ballpark that I'd be playing that day or night.

Even early on, I tried to get to the park at the same time regardless of whether I was starting or was on the bench, because I wanted to build a routine that I could stick with for years. When you have a strict routine, you don't have to think about it. You just do it. As a player, you have enough other variables—who the opposing pitcher is being the most important—that you don't want to be distracted. Then you might have other things going on, like family and friends on your guest list who've requested tickets from you, whether in New York or another city. You can't let that distract you, and a lot of the married guys turned that job over to their wives, especially when the playoffs rolled around and the demand for tickets and their time got more intense. But as a single guy, I had to handle it on

my own. And as a catcher, I also had to attend not only the hitters' meeting, where we went over the pitcher we would face, but also the pitchers' meeting, where we went over the opposition's lineup.

Even if I wasn't starting, I still sat in on the pre-game meeting when our pitching coach went over the other team's lineup. If you had to go in there in case of injury or substitutions, you had to be prepared. I saw that some pitchers kept notebooks that tracked how they performed and what pitches they used to get guys out, but I never kept one formally like that. In looking back, though, I realize that in my first few years with the Yankees, when I prepared for games, I concentrated way more on my defense than I did on offense. That was all about making up for lost time and not having as much experience at the position. That doesn't mean that I didn't think about offense at all, but it definitely took a backseat.

Some of the routine I established came from just following team rules—making sure that I was shaved, that my hair was the right length, that I arrived at the ballpark by a certain time, that when I went out for batting practice I had something on my upper body with the NY logo on it. But other parts of my routine were personal choices. This was particularly true with my equipment.

As players, our behavior with our equipment could border on obsessive-compulsive. But like a mechanic or carpenter with his tools, we used our equipment to make a living, so we were careful with our "tools" and had a lot of personal preferences about them. Baseball bats have changed over the last 20 years or so. Some people say that the quality of the wood has changed because ash trees aren't as plentiful as they once were, that the younger trees being harvested don't have as tight a grain pattern as the old-growth trees. I think that's true to an extent, and that it contributes to the number of broken bats you see. But I never stopped using ash bats, as some guys did in selecting maple models. I still believed that ash was best.

I don't know of too many players who thought that one bat was the same as any other of the same model. When I got a shipment of them from Louisville Slugger, I had to inspect them all and decide which were "gamers"—the ones suitable for at-bats that counted. When you first start out in the minor leagues, you select from the available models that the manufacturer produces. I liked an Edgar Martínez spec bat—a bat with a big barrel and a skinnier handle. (With more weight at the end, this model also breaks more easily.) After about '97, I had a contract with Louisville Slugger, and they produced one to my

exact specifications, a P320M. The "M" stood for "modified"—it was a slightly altered version of another bat they produced—and the "P" was for "Posada." It was pretty cool to get that first shipment of bats that were as close to what I wanted as possible. Notice I didn't say they were perfect. The bats we use in pro baseball are still handcrafted, and the wood has variations in it. I used a bat that was 34½ inches long and weighed 33 ounces. Even though the manufacturer could get the length right, the weight could be off a bit because of differences in the wood's density and moisture. All the bats would come labeled "33 ounces," but I could tell they weren't all exactly that weight. I could tell by feel, but I'd also use a scale on them. Toward the end of a season, as I got more fatigued, I'd get bats that were half an ounce lighter.

Since I didn't wear gloves, used a thin-handled bat, and held it somewhat lightly in my fingers, I needed a sticky handle. When I was 16, on one of my trips to Miami to work with my uncle Leo, he had worked on my hand placement. I'd been using my palms as the main point of contact with the bat, and he had me slide the bat forward in my hands. By doing that, I was better able to turn on balls on the inside of the plate, and even if the ball did get in on me and I hit one toward the handle, I didn't get that bee-sting sensation. Having

a very thin barrel made it easier to grip the bat more with my fingers, but as I said, I needed a sticky handle. So I would spend some time loading my bats with pine tar before games. Once some of the rules to speed up the game came in, that was even more important. I couldn't spend a minute or two in the on-deck circle prepping my bat anymore.

You have a lot more gear to worry about as a catcher, and the equipment guys are a big help to you. For a long time, the Cucuzza and Priore families were a big part of the Yankees, with fathers and sons handling some of those duties. They took care of all the gear, and they were the ones I turned to especially to help with my gloves. At first, I would use just one—the smaller Wilson I talked about earlier—throughout a season, from spring training through the playoffs, whether I was warming the starting pitcher in the bullpen or in a game. Later I couldn't make it through the whole season with just one glove, so I'd work in a second one. For a long time, I kept all my old gloves stored in the basement, but the Florida humidity got to many of them. I tried to salvage them, including a few that I really had fond memories of—the '98 glove that had a perfect game in it—but they had to be tossed. I didn't conduct any kind of special ceremony for them, I just dumped them in the trash. Sometimes reality bumps

aside sentimentality, but having to get rid of that '98 perfect game glove really hurt.

Some of my routine was based in practicality. As a switch-hitter, I had to stay in a groove from both sides of the plate. I had a pregame routine that didn't vary from the time I was a minor leaguer until deep in my big league career. Like most guys, I divided my routine into two phases—off the field in the cages and on the field. I'd take more swings from the side I'd be on for my first at-bat. I'd hit off the tee and do soft-toss from both sides. I'd do the same thing live or off the pitching machine in the cage, making sure that I always hit at least one round of my "off" side and always took my last swings from my "on" side so that I'd have the feel going into that first at-bat. Because I took more swings than the typical hitter who just stuck to one side, I felt like I had to work even harder to avoid fatigue. Toward the end of my career, the last three years or so, I cut down on this pregame routine and just hit from the side of the plate I was going to start out the game using.

I took a lot of cuts—off the tee, off the machines, soft-toss, live BP—but always with a purpose. I had a couple of things I wanted to focus on, and the less I played the more important they were to me. My uncle Leo had worked with me to do what he called "compress" but what other people call their "trigger."

Think about firing an arrow from a bow. Before the arrow can go forward, it has to go backward. That was what I needed to do with my hands and my arms. It's also like throwing a punch. You have a lot more behind the blow if you turn your hips and upper body away from the target before you thrust forward. I also had to focus on keeping my weight back and my head still as I stepped into the ball.

Doing all those drills every day helped me with my hitting mechanics. It was also good that I still spoke regularly with my dad. He had seen my swing evolve from the very beginning, so he was able to see things that even our hitting coaches might not have picked up on. To be honest, though, what I had to work hardest at was filtering all the input and finding consistency among the various things I was being told. Ultimately, it came down to me and what I was sensing with my body. When what I was feeling lined up with what others were observing, then that was usually input I could use. I had to learn the hard way, though, not to go up to the plate dragging too much input with me. In '98, I was still in the thinking and not responding mode.

One thing I wished that I could have brought with me throughout my career was a device Uncle Leo used with me. We called it the "air tee," but I don't know

who made it or where he got it. Basically, it was a device like a vacuum cleaner in reverse that pushed air out of a tub with enough force that a ball could balance on it. Because of the airstream and the seams on the ball, your target would move a bit, kind of like a knuckleball. That forced you to concentrate even more on centering the ball to hit it squarely. I've taken thousands of swings at that thing, and anytime I was in Miami to work with my uncle, he'd break it out for me to use. I don't know if he liked using it because he couldn't throw BP to me, but whatever the reason, the thing really worked.

I also made sure, as did a lot of guys, that I put the two bats I'd selected for a game in the same slots in the rack in the dugout. I also put my helmet in the same slot. I don't know who I heard this one from, but I also made sure that my bats were both lying flat in there. You never wanted your bats to rest on top of each other or have them be crossed. That was supposed to bring you big-time bad luck. I never questioned that one; I just did it.

That's the thing about the game. You have to find what works for you and stick with it. Sometimes you don't find those things and have to steal some ideas. In my first few seasons with the Yankees, as I've said, I observed everybody and paid close attention. Wade

Boggs, who was such a great hitter but also so different from me in many ways, taught me more about superstition than anything else. Wade became known as the guy who ate chicken every day—both as a superstition and as a way to simplify his life and develop a routine. He also had an interesting quirk that I eventually asked him about. Sometimes I'd be on the bench or in the clubhouse with him before a game, we'd be talking, and all of sudden he'd bolt. That happened once, and I thought it was odd. Eventually, I learned that it was both odd and a number: Wade always wanted to start an activity at a time that ended with the number 7. At 6:47, say, he'd start running his pregame sprints.

I didn't do things exactly as Wade did, but I had things timed down to the minute. For a 7:05 game, I would leave the clubhouse to get out on the field at 6:41 to do my running. My gear was already in the bullpen, so I only had my glove with me. My gear was already there because prior to going out that final time I'd have spent ten minutes with Gary Tuck working on defensive drills, my equivalent of taking ground balls or fly balls. I'd do around-the-world blocking drills and footwork and exchange drills every day at the beginning of my career and at least five days a week later on.

At 6:46, I would stretch, always doing the same ones in the same order. At 6:47, I would start to loosen up

my arm again. By 6:55, I was loose, so I'd have time to get to the bullpen and catch the last few minutes of the starting pitcher's warm-up session. Before the game started, I had one last routine that was a matter of respect for my family. After the national anthem was over, I would kneel down and make a small cross in the dirt to honor deceased members of my family. One cross for my grandfather, one for my grandmother. As time went on, sadly, that number increased. I did something similar when I came to bat to honor them. I'd tap my bat on each of the four corners of the plate in the shape of a cross. I also was sure to do pine tar, rosin, dirt, in that order, and kept to a routine every time I got in the batter's box.

Superstitions are supposed to help you keep going well, but they don't always work. There were times when I had to do some things to get rid of the bad mojo. If I was going through a tough period, I'd get rid of some of my gear—hats, shoes, socks, T-shirts, wristbands, the gloves I wore on my left hand underneath my mitt, even a mitt. I'd toss them in a box, and I'd ask other guys if they had things they were no longer using or wanted to get rid of. I'd send those boxes to Puerto Rico. My dad would distribute the stuff to some of the poorer kids there, or he would take stuff with him on trips to the Dominican or elsewhere in Latin America

he traveled. I felt good about doing that. I would also switch out my catcher's gear if I had a bad day, anything to keep from being infected by bad luck.

I never gave my belt away for some reason. The belt I first wore in 1997 was the same one I wore until my last game in 2011. It had to be resewn and even releathered toward the very end, but I wanted to keep that thing as a reminder. I still have it, and it sits in my office along with other baseball memorabilia I've acquired over the years. I don't want to make too much of the symbolism or the significance of that thing. With the complicated relationship that my dad and I had, and the development and deepening of that relationship over the years, I guess I keep it around as a way to remind myself of where I came from and how far I've come. And also as a reminder that the right kind of discipline and approach, the right way of focusing your emotions and your efforts, can produce great things.

It seems appropriate to me to look back at that '97 season, now 17 years in the past, and see those Wade Boggs sevens come up. Sometimes you do everything you can to control your fate and things still don't work out for you. I think it also says something about how fortunate I was to play with the Yankees during that time that I can view a 96-win season as a failure. I think that every team starts out spring training saying

and thinking that the goal is to win it all. Since I never played for any other team, this might be an incorrect assumption, but I don't think that every team actually believes they have a realistic shot at attaining that goal. One hundred and sixty-two games is a long season, and you can do all kinds of things to help or hurt your chances of winning, performing whatever routines and rituals, but given that number of games, you'd think that in the end luck wouldn't play much of a part in the outcome.

The mental side of the game is fascinating to me, but in the end the numbers tell the story—the numbers on the scoreboard, but mostly just the number of runs. We went into the Division Series against Cleveland that year thinking that we were going to win, that we should win, that we were prepared to win, but in the end we didn't. If my first full year in the big leagues was an extension of my baseball education, if it was my time serving an apprenticeship, then I didn't learn the answer to one question that fans, management, and even we as players were struggling to understand: why did we lose? The only thing I can say for sure is that in three out of those four games, Cleveland scored more runs than we did. Well, there is one other thing that I can say about it. It sucked to lose. It sucked to look back over a season and have it feel like it was a failure.

And it was. You could point out all the good things, put them on a list of pros and cons, but that one item on the list of cons wiped out everything—we didn't win the World Series.

Seeing how hard those guys took losing, the guys who would be the heart and soul of the Yankees—some for a long time, some for a short time—eventually taught me something that I thought I already knew. I always knew I hated losing. I just didn't realize how strong that feeling could get. I guess that was the price we paid for getting to the heights we did. Anything short of the top was going to feel like plummeting to the ground and being buried. It was going to take something like that happening to eventually help me gain a better perspective on life and on the game, but there were some glory days ahead of my city finding itself in ruins.

Chapter Eleven
Wins and Losses

It's hard for me to put into perspective, even after being retired now since 2011, just how much glory there was during my years with the Yankees. I'm not even sure that numbers can tell the story, but here goes.

NEW YORK YANKEES, REGULAR SEASON, 1997–2011			
Games	Won	Lost	Winning Percentage
2,426	1,465	961	.604

The lowest number of regular-season wins we had during that span was 87 in 2000. We made up for that by winning the World Series, so I guess you could say we paid our penance. In that time, we missed the playoffs completely only once, in 2008. Oddly, we won

more games in the regular season that year than we did in 2000, but still didn't qualify.

NEW YORK YANKEES, POSTSEASON, 1997–2011			
Games	Won	Lost	Winning Percentage
136	83	53	.610

When it mattered most, we won four out of six World Series in that same span of time, for a .667 winning percentage, winning 21 of 33 games (.636). You know what, though, I understand that Yankees fans will look at those numbers with a mixture of pride and frustration. That was a sustained period of success, but it included failure as well. As I said, we went into every season believing we could win it all. We did that four times in that stretch from 1997 to 2011, and that's just not good enough.

That's not to say that I'm not proud of what we accomplished, but I wanted to win more. I got a tremendous amount of satisfaction from winning as frequently as we did, and a whole lot of disappointment when we didn't. As time has passed, the disappointment is still there, and I'm glad it is. Yes, events outside the lines helped put those wins and losses in better perspective, but in isolation the losses still hurt and disappoint, and that's a good thing. I think it shows

how much we cared, how deep that desire to be the best and to improve every year, to get better at our craft, meant to me and to the vast majority of the guys I played alongside.

We lost the first three games to start the 1998 season. The veterans held a meeting to remind us that we didn't want to go through what we'd already been through the previous year. David Cone spoke up, so did Paul O'Neill, and a number of other guys added their thoughts. They understood that we needed to set the tone. Despite a baseball season being a marathon— as it's so often referred to—and not a sprint, we didn't want to get too far behind too soon. I always loved the movie *The Natural* with Robert Redford. It has a scene where the Knights call in a psychiatrist of some kind and he repeats over and over again, "Losing is a disease." We didn't want to catch that illness, and we didn't want losing to feel natural.

On a personal level, I think that the 1999 Yankees media guide sums things up nicely: "Saw increasing playing time in '98, establishing himself as the team's primary catcher by year's end." Starting 91 games behind the plate was gratifying, but it wasn't like I became instantly comfortable back there, especially when it came to catching certain pitchers.

To put it bluntly, I was intimidated by David Cone. Not because of how David treated me, but because of

his experience and certainty about how he wanted to go after hitters. That year he was 35 and coming off shoulder surgery, and as with all the pitchers, I felt responsible if he didn't do well. It wasn't that their success depended entirely on me, but if I didn't call a good game or handle their pitches properly, I felt like the loss should have gone beside my name. Even as my career advanced and I grew more confident with pitch selection and every other aspect of catching, I kept that same attitude. Wins belonged to the pitchers, but losses were sometimes my responsibility. The pitching staff's successes were easy for me to forget, while the failures stuck with me.

Of course, when your team and your pitching staff earn 114 wins during a regular season and only lose 48, those failures are few and far between. It wasn't a perfect year by any means, but we did have a perfect moment on Sunday, May 18, against the Twins when David Wells threw a perfect game.

The day after the game I read a couple of news stories about it, and Mel Stottlemyre, our pitching coach, was quoted as having said, "Wow!" when he came into the dugout after David finished warming up in the bullpen. According to Mel, David had looked really good before the game, with a nasty, sharp, breaking curveball. The funny thing is, when I'd gotten out to the pen to finish up the last ten minutes of his pregame, I'd also thought,

Wow!—but not in a good way. David was everywhere with those pitches—he had no command at all. In fact, he'd gotten so frustrated at one point that he took the ball and threw it out of the Stadium. Somehow, David being David, that seemed to settle him down, or at least got him to focus, because after that his session went much better. So, my "Wow!" was more like, *What am I going to do with this guy tonight, he's so inconsistent? Which of those two pitchers am I going to have out on the mound to start the game?*

I can't say that I thought that he was going to throw a no-hitter or a perfect game based on his stuff in the bullpen. Even in my young catching career, I'd seen it enough times when guys looked super-sharp before the game and then got lit up, and vice versa. Most of the time I didn't say much to a pitcher when he was warming up, especially not about his mechanics. A pitcher knows when his delivery is off; and especially before a game, he doesn't need anyone doing or saying anything that might aggravate him. In fact, in some ways it's a good thing if a guy is a bit erratic in his bullpen session. If a pitcher keeps missing in the same spot all the time, he's not making any adjustments to his arm angle, his release point, or any other aspect of his delivery. When I did say something to a pitcher during his warm-up, usually I was pointing out what he was *not*

doing—not making an adjustment—rather than pointing out some flaw.

David was very much a feel pitcher anyway. He had to figure out things for himself, so based on that pregame warm-up, I was just going to go with the game plan until I could get a better read on his pitches. By the third inning, when he struck out the side, I could tell that he was on and that the two of us were in synch. I'd put down a sign, and almost instantly David was rocking back and firing. He was doing a great job of changing the hitter's eye level. By that I mean that his fastball was up in the zone and really moving, but his curveball had real bite to it, starting up and then breaking sharply down. It isn't always a matter of working side to side to keep hitters off-balance; David's ability to work up in the zone sometimes really helped him, but sometimes it also hurt him. That day it didn't hurt him at all.

The other thing that didn't hurt was that Tim McClelland, the home plate umpire, was being pretty generous with the pitches upstairs. You have to take what you're being given, so we stuck with that, especially since, to a predominantly right-handed hitting Twins team, David's fastball was tailing away from them and his cutter worked in on them. Up and down. In and out. Hard and then soft. David had it all going.

He was getting ahead of hitters and putting them away pretty quickly. He went to a 3-2 count once in the third and then again in the seventh, facing the great Paul Molitor. We got him on a biting curveball that he went after. The ball hit in front of me, and I blocked it, then stood up and threw him out at first. A routine play, but when it was over the Stadium just went nuts. I couldn't figure out what was going on, but then I looked at the scoreboard. No runs. No hits. And then I realized that David hadn't walked anybody either.

That's when my baseball etiquette/superstition took over. You don't ever say anything to a pitcher who's got a no-no or a perfect game going on. So I walked past David, didn't even make eye contact with him, and went to the far end of the bench. Boomer liked to talk, and he later said that it was torture for him that I wouldn't sit by him. Darryl Strawberry got up and left him alone, so there was poor David Wells getting the silent treatment, sitting there looking around and bouncing his legs up and down, asking somebody to please talk to him.

The funny thing is, there was a lot of that going around—the silent treatment I mean. Early in May, David had gotten knocked out early in a start, and Joe Torre had questioned David's fitness level. He was basically stating the obvious, but still, David was pissed

about it. The good thing was, in his next start—the one immediately before the perfect game—he really put things together in a kind of "I'll show you" manner. I didn't catch that game in Kansas City, a tight 3–2 win, but I watched as the game went on, and David, as if saying *I've got your fitness right here,* got stronger and retired the last ten guys he faced before Mariano closed out the win. I could see Boomer's point. With that win, he was 4-1 on the season, so that one bad start could have just been that. I could also see Joe's point. David wasn't in the best shape, and maybe his poor performance was tied to that. And maybe it was also a way to address what became widely known later on when David went public about his fondness for the night life and a less-than-perfect diet. Whatever the case, David made it a point to not speak to Joe for a while.

No matter, because Coney came to Boomer's rescue. I sat there and watched as our leader sat by David and said something that had Boomer laughing. Later I found out that David Cone had told Boomer that this was the perfect point in the game for him to break out his knuckleball.

He must have eased the tension some, because the last two innings David was as good as he could possibly be. By the top of the ninth, his arms were shaking with tension and I was on edge, but when he got ahead of the

last two guys and retired them easily, I knew we were *that* close. Through the bars of my mask, I watched Pat Meares's medium fly ball arc all the way into Paul O'Neill's glove, and by the time it landed I was steps away from the mound.

"This is great, Jorge! This is great!" Boomer kept saying over and over. I was too giddy to correct him— no, big guy, it was perfect. Later, the groundskeepers presented me with the home plate used that night. One side had a painting of David and me, and above us the scoreboard with all those zeroes. I still have that plate in my office, and no Florida humidity is going to damage it or my memory of that incredible night.

I don't want to make too big of a deal about the whole David Wells being out of shape incident, but I think that how he handled it and how he responded in those very next starts says something about the makeup of the guy. It was also typical of the Yankee teams I played on.

Every now and then, when we felt like things were sliding a bit, someone would mention '97 and we'd get back on track. We went out every day with the idea that we were going to win that game. And 114 times out of 162, we did just that. The season is so long, though, that for much of the summer I didn't really have a sense of just how extraordinary that record was. Our longest

winning streak was ten games, a good number but not extraordinary, so it was more the regularity with which we won that made the season so noteworthy. For the 27 days a month we played on average during that six-month span, we had bad days eight times. When you think of it that way, in chunks the size of a month, that number, 114 total, doesn't seem so great. Breaking that down into a smaller chunk, we lost approximately twice a week in the roughly 23 weeks of the regular season.

As baseball players, we think in terms of series. So even if we stick with that number of two losses per workweek, that's like you saying that you had two bad days at work and three good ones. Put in those terms, I think you can better understand why no one was talking about how great our year was going. We weren't patting ourselves on the back. Only if someone in the media pointed out that we were on a record-setting pace did it even occur to me that what we were doing was extraordinary. We were doing our jobs, doing them well, and winning series with an efficiency and at a rate that was keeping management happy. We left the adding up and the comparing and all of that to other people.

That was the approach I took all season, and when I got to start my first postseason game—against the Rangers in the opener of the ALDS—I felt going in

that how we'd all handled that year was going to see me through the playoffs. That was true to an extent—no one had to provide me with a map to find my way to the catcher's box—but there was clearly something different about the atmosphere in the Stadium. Standing along that third-base line hearing your name being spoken by the legendary Bob Sheppard was spine-chilling, in the best way possible. As a side note, Mr. Sheppard was known as "the Voice of God," and it was true. The first time he spoke my name, he pronounced it Po-sah-DOH. The guys with the club that year knew that if God said it, it must be so. As a result, I was christened with the nickname Sado.

It also meant a lot to all of us that Darryl Strawberry's name was announced before that game. Joe Torre had called us together just before we stretched in the outfield to bow our heads and send good thoughts Darryl's way. Diagnosed with colon cancer, he'd just undergone surgery. He couldn't be there, but his wife, Cherisse, was, and his two kids joined her. Escorted to the mound by David Cone, she threw out the first pitch, wearing a jersey with Darryl's 39 on it.

Even if Darryl hadn't been through all the other difficulties he'd had, that would have been tough news. I'd lost grandparents to cancer, as well as uncles, and it was so tough to hear that a guy Darryl's age—he had turned 36 that season—was dealing with it. It was

tough to hear and really made me think. Darryl had been a big contributor that year—his 24 home runs always seemed to come at exactly the right time. His left-handed bat in the lineup was huge for us, and his power made him a real game-changer. Knowing that he could come off the bench made opposing managers' decisions about pitching changes even tougher. Always upbeat and smiling, Darryl was also valuable around the clubhouse and a positive presence on the bench— never clowning, just enjoying having his career and his life back in his control. He was especially good to Derek and me, sharing his insights about hitting with us, and on days when I wasn't catching and he was in the dugout, he'd go over his at-bats with me, telling me what he'd guessed was coming.

Like Darryl, I was also a guess hitter, though that term bothers me. It was more than a guess that we went on—past history and tendencies really dictated our approach. Some guys try to simplify hitting into "see the ball, hit the ball," but that never worked for me. I also never wanted to know what was coming if we managed to pick up an opposing team's signs. I never trusted that we were 100 percent certain that we had them, and I trusted myself more than anyone else.

We took that first series against the Rangers 3-0, all of them tight, low-scoring games. We ran into a tougher time against the Indians in the ALCS. I know

that fans want to think that we had a special motiva-
tion to beat them that year because they'd knocked us
out the previous year, but we'd have wanted really bad
to beat anybody we were up against, since a trip to the
World Series was on the line. I was glad that I could
contribute at the plate in Game 1, when I worked with
David Wells. I was 2-for-3, drove in my first postseason
run, and jumped all over a Chad Ogea first-pitch fast-
ball to hit a line-drive home run deep into right field.
I didn't need third-base coach Willie Randolph to tell
me to slow down, that I'd hit it out and could jog home.

My parents were staying at my apartment for the
postseason, and immediately after the game my dad
told me that stroke was one of the best he'd seen from
me. Having family at the ballpark, having my dad see
me do that live rather than watch it on television or
hear me tell him about it the next day—that was better
than I ever could have expected, and I could hear the
pleasure in his voice.

I enjoyed the hell out of that win and gave myself
some time to just live with those feelings. Still, by the
time I talked to my dad the next morning I was ready
for his reminder—not that I needed it—to turn the
page, just like I'd turned my hips on that pitch.

Game 2 was one that, if you believed the headlines
the next day, was destined to become another Bill

Buckner–like moment of shame for one player. It was a tight game that went into extra innings, and in the twelfth, Travis Fryman came up with a runner on first, no out. We knew he was going to bunt, and he did. It was a good one, to the right side. Tino fielded it, and his throw hit Fryman in the back. Chuck Knoblauch had to pull his arm back or risk getting knocked down, and in all the confusion Chuck argued about Fryman being out of the baseline and didn't pick up the ball, despite me and everyone else yelling at him to get it. The crowd was so loud and Chuck was so caught up in the heat of the moment that he let the ball sit there in the dirt while the runners kept moving.

I couldn't leave home plate, and by the time the throw finally did come home, even the slow-footed Jim Thome had been able to score from first on a bunt and Fryman had gotten all the way to third. Joe was sure that Fryman should have been called out for running outside the base path, but the umpires said that since he was hit when he was in contact with the first-base bag, which is fair territory, he wasn't out of the baseline.

It was one of the most surreal plays I've ever been involved in, but fortunately, it ended up not mattering a whole lot, since we beat the Indians in the series 4-2. After that bunt-play game, we lost again, to trail 2-1 in the series, but took the next three in a row to clinch

it. We were on our way to the World Series, where we swept the Padres in four games to get back on top.

That wasn't as easy as it sounds. In Game 1, we trailed the Padres 5–2 going into the seventh. After Chuck Knoblauch hit a three-run homer, the inning continued. With the bases loaded, Tino came up against Mark Langston, a tough left-hander facing another tough left-hander. On a three-and-two count, Tino homered and that really fired us up. In Game 2 of the series, I hit a two-run home run off Brian Boehringer, a deep drive to right-center field. It's always a thrill to hit a home run, but a World Series homer was especially satisfying. You know that all of baseball and its fans have their focus on those two teams only; you want to win, of course, but that added element of media attention and everything else that goes along with a World Series makes everything feel more important. Coming back from three runs down late in Game 3 was another example of how resilient that team was. We always seemed to find a way to win.

Significant as that was, it was only later, when we got our World Series rings with "125" engraved on them—to commemorate the achievement of 125 wins during the whole season—that I was able to appreciate what we'd accomplished as a group. Just as we had

done in 1996, we'd won the World Series, but this time we'd made a bit more history.

Along with all the winning that happened in 1998, another element of my life came into focus that had me celebrating in lots of different ways. The roots of that celebration actually ran all the way back to my senior year in high school, when one of my various jobs was umpiring baseball and softball games.

The thing about umpiring softball is that you call the pitches from behind the pitcher, so I got a very nice close-up view of the young woman who was pitching. I recognized her from school, but she wasn't someone I knew very well. Her name was Laura something. She was a good pitcher, but she was also gorgeous. During warm-ups before the game, I noticed that she wasn't wearing a glove, so I did a very not impartial thing for an umpire—I went to my car and got a glove for her.

She smiled and said thanks, and I felt like somebody had set my cheeks and ears on fire. If that had really happened to my ears, you would have been able to see the smoke all the way at my mom and dad's house. As the game went on she didn't say a whole lot, but I swear every pitch she threw was a strike.

After the game, she handed me the glove and said, her voice so silky and smooth that I had a hard time

paying attention to her words, "Thank you. That's a very nice glove."

I tried to figure out what I could say that was silky and smooth. (I've told you about my education in baseball, but it should be obvious that I also needed an education about women.) All I could think of to say, though, was, "Yeah." Then, realizing that wasn't the best way to accept a compliment, I quickly added, "I'm glad you like it."

In my mind, that was another error. I'd made it seem like I was taking responsibility for having made the damn thing. If this exchange had been an inning, it had started off with a hit by pitch, then a balk advancing the runner. Now I was desperate to get an out—I mean, go out with her—so I said, "I can get you one just like it."

She started to walk toward the bench and the rest of the girls on her team. I trailed after her like a puppy, saying that she should give me her phone number, so that I could let her know when I had the glove.

She slid home safely, and I didn't get her number. My bad for not executing properly.

In the offseason after '97, I was back home and living with my buddy Benjamin. One night I was standing at a place called Dunbar's with my friends, when this gorgeous woman walked by. I got this jolt of energy in

the pit of my stomach. She was with some friends, and one of them said something that made her smile and then laugh. I wanted to be that person, the one who was making her happy like that. I don't know why it is that we are attracted to the people that we are, but something told me immediately that I needed to get to know this woman, that there was something about her that was different and better for me than anyone else I'd ever met. Okay, that's one way to put it. But I told myself that night, and one of my buddies, "If I ever get to meet this girl, I'll marry her." I meant it. It was like thinking that I wanted to make the big leagues some-day. And it took almost as long, and as much effort, to make the dream come true.

You've probably figured out that the woman in the bar was Laura the softball player, but I didn't. All I knew was that I wanted to meet this woman, talk to her, and then keep on talking to her and spending time with her before I had to go back to the States at the start of the '98 season. I didn't do anything to make that happen that night. I'm pretty shy, but I couldn't stop thinking about her. I guess that I always have to do things the hard way, so I came up with a plan. Just like I had developed all kinds of routines to play the game, I figured this woman had to be the same way. The first night I saw her at Dunbar's was a Thursday, so I went

back the next Thursday, hoping to see her there. She wasn't. I happened to see her on a Saturday night at a hotel bar. Instead of just going up to her, I hung out there the next Saturday. Call it stalking, call it scouting, call it what you want, but I didn't really think I was being weird or anything until Derek came to visit.

We were out, and I saw her again. I pointed her out to him and said, "That's the girl I've been telling you about."

"You're not going to say anything to her?"

"No, man. I'm too scared."

"You gotta man up. What's the worst thing she could say?"

Maybe when you're Derek and have his confidence about so many things, you don't think about all the bad things that could happen or be said, but I didn't want this girl to shoot me down. Finally, though, the clock was ticking. It was December, and I knew that in a month or so I'd have to leave for spring training. When I saw her again, I said that I'd like to see her sometime and asked for her number. She hesitated a bit, and then said she wasn't sure that was a good idea. I didn't speak woman code, but eventually I learned that the "not good idea" was a boyfriend.

Didn't matter. I learned that fact from a girl I knew named Anita, who came up to me one night. She had

been seated at a table with Laura. Still not quite under-standing the ways of women, I asked Anita if she could introduce me to her friend. Anita told me how rude I was, but she did help me out. I ignored the "she had a boyfriend" part and made arrangements with Anita to have a bowling outing with her, Laura, and my friends. I made sure that the passenger seat was unoccupied when I stopped by Laura's place to pick her up.

Maybe it was because we weren't wearing our own shoes, or whatever it is that happens at a bowling alley, but I spent a lot of time talking to Laura and displaying my awesome bowling skills. At the end of the night, I asked her if she would like to play racquetball the next day. I was thrilled when, after hesitating a little less than the time before, she said yes. Not "Sure!" Not "That would be great!" Just "Yes." You know how announcers say that a bloop single will look like a line drive the next day in the box score? I didn't really care what words she used, just that she had agreed to spend time with me.

The following day at the court, we were having a good time when I drilled her in the butt with the ball. It's true what they say—you hit it where your eyes are focused.

We laugh about all this now, but at the time I was really struggling with all the rejection. (Laura says I

was psycho but I prefer persistent.) In a lot of ways, those early days with Laura tested my skills of observation and strategizing more than any hitter or pitcher I had to deal with. I tried several things: hosting a Super Bowl party just to get to see her (she arrived late and left early), inviting her to spring training (no thanks), and finally telling her that as long as she was coming to New York to visit her sister, she should come to see me play.

I still don't know how much of it was her sister or how much of it was me wearing her down, but Laura did show up in New York. Even then, the obstacles keeping us apart just kept coming. When a 500-pound chunk of Yankee Stadium fell down, the city said that we wouldn't be able to play there, so we had this weird situation where we played on a Sunday and then didn't play again until Wednesday, against the Angels, at Shea. We dressed in the clubhouse at the Stadium and took a bus to Queens, then traveled to Detroit. None of this was good, particularly because I was looking forward to the opportunity to spend time with Laura. She got to see the one game, but that was it.

Then I made a very romantic gesture by asking her to visit Detroit in mid-April to sit in a mostly empty Tigers stadium with a game-time high of 55 degrees. Lots of things seemed empty and cold at that point, but

eventually, as the weather warmed up, so did things between Laura and me. It's weird how you know that you've finally gotten close to your goal. For me that was the first time Laura and I said good-bye after she stayed with me for a week in New York and I then got a call from her saying that the flight was booked and the airline was looking for people who could stay longer and take a later flight or accept a voucher and Laura chose the voucher. I was a happy, happy man.

In November 1998, I decided that it was time to make good on that promise I'd made when I saw her at the bar. I went out and bought an engagement ring and planned to ask her to marry me. We hadn't talked about getting married, but we'd discussed the big things, like having kids. So I can't say that I was 100 percent sure that I was going to get the answer I wanted. My plan was to do it at dinner one night. Beforehand, I worked it out with the staff at the restaurant, a Ruth's Chris in San Juan, to have our waiter, whose name was Dort, bring it out on top of whatever dessert she ordered. I wasn't thinking things through too good, because I didn't really have a backup plan if she didn't order dessert, or if she ordered something that wouldn't support the weight of the ring. Unfortunately, she didn't want dessert, but I kept asking her to have one. Finally, just to get me to shut up about the damned dessert, she

asked for cheesecake. Dort gave me a wink to let me know that I could count on him.

I sat there all sweaty-palmed and short of breath until the waiter came by. Laura was talking and didn't look down at her dessert plate. I didn't want to have to point at it and ruin the moment, so I just sat there, listening and trying to not act like one of the most important moments of my life was about to happen. Finally, I said to her, "You're not going to have any dessert?" With perfectly executed timing, as her eyes made their first move down to the plate, I took off. I went down on one knee and said, "Will you marry me?"

The next thing I knew my shoulder hurt. Laura had punched me, and then she nodded. I started to breathe again.

We set a date for January 2000 and started to make arrangements for a big wedding, but things didn't turn out exactly as we'd planned. Shortly after I reported to spring training in March 1999, we found out we were pregnant. I'm pretty old-fashioned, as are both of our families, so out of respect for them and their Catholic faith, and my own feeling that it wasn't right to have a child born outside of marriage, we decided to make our union official as soon as possible and then have the big party later on as planned. Laura and I went to City Hall in Manhattan to get our marriage license. We

waited in line, and then when we got to the clerk, he looked at my driver's license and started to squint kind of funny.

"Do you play for the Yankees?" he asked.

"Yes," I said.

"Well, what are you doing waiting in line there?"

Confused, I told him I was getting a marriage license.

"You should be in the VIP line," he said, pointing down the hall. I didn't think I was a VIP, and we'd already been waiting, so we just went with it.

Two days later, Derek was with us to act as best man, and Laura's sister was there. Besides not having wedding rings to exchange, things went well. After the game that afternoon, we had the wedding, followed by the traditional pizza. Of course, things couldn't go off without there being some drama. The guy who officiated at the ceremony, someone recommended to us by my friend Roberto Clemente Jr., showed up at the apartment. He was wearing more jewelry than Laura and I owned combined and a suit that would have worked well if he was a Yankees rookie being hazed. Laura was in the bedroom, and I went to get her. I was trying not to laugh. She peeked around me and saw the guy and said, "I don't know if I want to do this."

She did go through with it, and that was a good thing. I'd already been dealing with sympathetic

morning sickness. What would have happened to me if I had been left at the pizza box? Laura still gives me some grief about those sympathy pains and all my pre-birth anxiety, and she still gives me crap every time I tear up watching a sad movie, but I am what I am and my emotions sometimes get the best of me.

Part of my anxiety at the beginning of the '99 season had to do with Joe Torre not being with us. He had been diagnosed with prostate cancer and underwent surgery in mid-March. It was hard to believe what was going on. At that same camp, we learned about a minor leaguer having been diagnosed with testicular cancer. The team insisted that we all get a thorough checkup and we did. Everyone from George Steinbrenner on down rallied around Joe. He had gathered us all together to fill us in, gave us a timetable for his return, and let us all know that he planned on being back with us as soon as possible. Everyone said that his health was more important than the game. His doctors urged him to be patient, as did Mr. Steinbrenner.

Selfishly, I wanted Joe to hurry back. I liked his calm presence, and how he communicated with me. Don Zimmer took over as interim manager to begin the year, and while I liked Zim, he was not like Joe,

either temperamentally or as a communicator. I think that Zim was a perfect fit with a lot of the veteran guys who knew their roles, were set in the lineup, and had more of a "just let me go out there and do my job" attitude. You can't be all things to all people, and you have to be true to who you are, and Zim was. It was just that what I needed and wanted from a manager wasn't what he was best at or comfortable doing. I was still trying to think my way through the game too much. I didn't yet have enough experiences and memories to draw on to go by feel or gut instinct—or at least I didn't think that I did, especially when it came to defense. Sports require you to react, and I was still thinking-reacting and sometimes telling myself to just react.

As a result, I didn't really know how to handle the toughest thing of all. I was told that I was going to be the guy at my position. If being the guy meant the guy who didn't get penciled into the lineup everyday, then that's who I was. I was confused and wasn't sure how to approach Zim, and when I did, the "you're the guy" responses didn't make my role any clearer or my inconsistent playing time any easier to accept.

I was making a lot of adjustments—to being married, to becoming a father, to taking over full-time as our catcher, and to a new member of our pitching staff. Roger Clemens came over from Toronto in exchange

for three players, including David Wells. I was sorry to see Boomer go, but when you have a chance to get a guy who was as dominant as Roger had been, it's hard to walk away from that deal feeling any kind of regret. It also helped that Roger really fit in. The man worked his ass off. He was an amazing competitor. He was also a very gracious guy. Coming over to a team that had just won the World Series and, in a sense, replacing one of the more popular guys in the clubhouse wasn't easy. Maybe it helped that he was so different from Boomer. The Rocket also went out of his way that spring training to get to know us. He'd invite large groups of us to the house he was renting and cook steak for us and we'd hang out.

I can't say that Roger and I were ever close friends, but we had a lot of respect for each other—for how we played the game and how hard we worked. I knew that I pushed myself hard, but I was still young and trying to prove myself. Roger was a veteran with a great career going, and he outworked everybody. He came to camp in great shape and with his arm in midseason condition. He'd have a pitch count during a spring game, reach it, then go down into the bullpen until he'd thrown a total of 100 pitches. He'd sneak in a workout in between innings when he was pitching spring games. He'd practice pickoff moves, do 40 sit-ups, and

then do 40 sets of pick-ups, moving side to side to field balls rolled to him.

After all that, he'd do weight work. At one point, I said that I had to see what this guy was doing. I tagged along to the weight room, and he said to me, "Pitchers have to have legs. You're catching. You need legs too." I saw him doing some intense lower-body work with heavy weights. I joined him for those twice-a-day workouts, and it made a big difference for my endurance and power. Roger encouraged me as well. He said that if I kept working as hard as he'd seen me all that camp, I'd get where I wanted to be and deserved to be.

Of all the pitchers I ever handled, Roger was my favorite to catch. He had his own way of going about doing things, including the signs he used: the fingers you put down didn't just say which pitch but also which side of the plate it would go to, and his "Hook 'em Horns" sign was for his amazing hard overhand curve. He always wanted us to put down three signs, even when no one was on base, and often he would change up what sign was live throughout the game, using his own system to signal which of the three was good. The system kept me on my toes, and I loved the challenge of that. If I didn't get a sign right, I could get hurt. Roger's pitches, particularly his fastball, had more movement

to them than a lot of people gave him credit for, and a busted thumb was a possibility if I crossed myself up.

Roger was intense, but in a way that I could relate to. He demanded so much from himself that it was kind of magnetic. He was on, and he was going to force me to be there with him just by how much he demanded of my powers of concentration. He also taught me a lot about setting up hitters. He went into every game knowing exactly how he wanted to attack guys. We'd get together before the game, and he'd consult this little recording device he had (this was way before tablets or smartphones), and he'd rattle off his game plan. Between innings, we'd review things as needed. He was definitely in charge—I'd make suggestions in putting down signs, but Roger wouldn't hesitate to shake me off.

I would eventually catch for other pitchers who were really looking for me to guide them through the game. A rare few didn't want to take responsibility for pitch selection, especially when the game was on the line. That was definitely not Roger. What I learned from catching him—and "catching" is the appropriate word here because I was always catching up to his thinking—were things that I could apply in catching other guys on the staff. With his work ethic and his preparation, he set a standard for toughness that I then

applied in dealing with the other guys. I knew they had different stuff, different ideas, but he was still someone they could emulate in some ways. Roger made me a better player, and he was a gamer in every sense of the word. If he had a bad day, he took responsibility for it. If he had a good day, he gave me and other catchers on the team credit.

One guy who got off to a slow start that year was Hideki Irabu. In some ways, I felt bad for him. That spring training, George Steinbrenner had called him "a fat pussy toad" for not covering first base. Mr. Steinbrenner then wouldn't let him travel with the team to open the season. Later, Mr. Steinbrenner apologized for what he said and for how he handled the situation. I'm sure our owner was frustrated that, after signing "the Nolan Ryan of Japan," it didn't work out. Irabu came up in '97 but was back in the minors by the end of that year after giving up more than seven runs a game.

I can't help but think that if he had been around, Joe would have handled that spring training situation differently. I'm not saying that Joe could have told Mr. Steinbrenner what to say, but I think Joe would have been able to convince him that not having Irabu travel with us wasn't going to produce the desired result. I figured out a way to communicate with Hideki despite

our language differences, and I think my ability to do that had something to do with not only my own experience in learning a new language but also seeing how Joe handled us. I needed to be patient, I needed to spend the extra time making sure that communications were clear, and I needed to remember to put myself in Hideki's place and see things from his perspective. Hideki had good stuff, and he rebounded that year to be a decent contributor in the regular season. I was really stunned and saddened when I found out about his death by suicide in 2011. I never saw signs of the troubles that plagued him, and your heart goes out to anyone who suffers to that degree.

When Joe returned on May 18, I felt like I was in better hands. At that point, we were 21-15 and one game up on the Red Sox, who we were scheduled to face after a day off. We lost, but that was part of a trend against them that regular season: we lost eight out of 12 times to them. We beat them where it mattered most, though, in the standings and in the American League Championship Series.

A lot has been made of the relationship I had with El Duque, and the fight we got into later, but one thing was clear when he first arrived—the man knew how to pitch. He was also a lot like me in that he was a bit of a hothead. So the two of us had our battles. We were like

brothers in a lot of ways: when one of us thought we knew what was better for the other, we weren't afraid to speak our minds. Brothers, even if they have different mothers, are sometimes going to get under one another's skin.

When Orlando Hernández arrived, I had to make another adjustment. He didn't know the hitters or the teams. In some ways that didn't matter, because El Duque was really good at picking out guys' weaknesses, varying his approach each time through the lineup, and generally being as fearless as he was smart. Still, it showed me once again that every pitcher needs something different from his catcher.

Some of what got us into trouble a few times was that we had different ideas about how to go after hitters. I knew that El Duque had his methods, but there were times when I wanted to stick with what I felt was the most effective approach—go after the guy with your best stuff and don't fool around too much with making too many pitches and trying to outfox him. El Duque also didn't mind walking hitters to get to somebody he knew he could get out. That was definitely not by the book, and I saw giving up walks as giving in, but he worked out of a lot of self-made jams that way. If you've got good stuff, then use it. Maybe it was his experience in Cuba and the influence of guys there that somehow

gave him style points or a degree-of-difficulty bonus for taking the long way or the hard way to an out. That didn't sit well with me or, at times, with the coaching staff. You don't need to make a show of it—just go after the hitter.

One way El Duque demonstrated this approach was in his ability to pitch inside. That was part of his fearlessness. He wasn't a headhunter—he didn't try to hit guys—but he believed that he owned the inside half of the strike zone and even a little more than the inside. I loved that about him, and we never had a problem with each other in that regard. He wasn't going to be intimidated, and so his hardheadedness, his unwillingness to give in, was both a good thing and a bad thing. Depending on how I was feeling on any given day, he was either my favorite or a pain in the ass. Like his pitches, there was very little about him that was right down the middle.

I will say this as well. He was a great competitor and a real workhorse—not at Roger's level, but I'd see him running and running and running to keep in shape. To this day, I have no idea how old he really is. We see one another now and then on the golf course, and he still refuses to tell me. I guess that's just another way of him trying to fool a hitter.

What I remember most of that opening game of the ALCS against Boston was Derek Jeter and Nomar

Garciaparra making stunning plays at short for most of the night. They also combined to make three errors, but they were getting to balls and trying to make plays on balls that most shortstops wouldn't have reached. After the game, Derek told me that when Nomar was on second base, he said something to him about the two of them engaging in a kind of duel. They weren't moving around like fencers, but I think I got the point. Derek had a lot of respect for Nomar, and I had to laugh when I watched the All-Star Game that year and saw Derek imitating Nomar's stance. That was a little bit (or maybe a lot) of Derek giving Nomar a hard time for his less-than-classic approach to hitting. Derek was a proud guy, and having some people debating about which of them was the best at the position gave him a little extra gas.

Maybe something like that happened in Game 3 when the Red Sox jumped all over Rocket. We lost 13–2, but we took the next two to advance to the World Series against the Braves. I got to do something in that Series that I'd always dreamed of as a kid: I was catching when Mariano got the final out on a fly-out to left.

People always ask me which were my favorite World Series wins, or the most memorable, and I have to honestly say that they all were. They were all different, but they all had one thing in common: when you end the

season winning the final game, there's nothing better than that. And how can you better "nothing better"?

Going 8-0 in two World Series was something we could all be proud of. We were the third Yankee team to accomplish back-to-back championship rounds with no losses, and now we were going to go for three in a row the next season. That was a challenge we all loved. After all, the point of the game is to win, and we went about our business trying to do that every day. So what if it was October? We were going to just keep doing what we'd been doing.

Chapter Twelve
Eyes on the Prize

People refer to them as distractions—events that take our focus away from what we are trying to accomplish or away from what we think is most important. As players, we're supposed to block them out, not let them get in our way. We're supposed to be professionals, and part of that expectation means that when we step onto the field, we leave our human concerns aside.

What's funny to me is that when those distractions take the form of a teammate or a manager dealing with a serious health issue, we all take a step back and say, in one way or another, the game isn't what really matters. What matters is our health, our families, and our friends—those things outside the game. Yet, when it comes down to it, we're paid to do our jobs despite the

distractions, and if there are things going on in our lives that make it hard to do that, we can't and don't want to offer them up as excuses. We're supposed to do our jobs no matter what.

In looking back over the success we had in winning three world championships, I'm amazed when I think about some of those serious distractions, those challenges that we had to overcome. I can't say that they were minor challenges because when they happen to you, as they did to all the Yankee players in one way or another, they can be tough to deal with and often don't feel minor at all. I can only share with you what I experienced, but this applies to most of the guys I played with, just as it applies to anyone reading this. Life happens.

During the '98 season, my mother underwent triple bypass surgery, and I was grateful that I had Laura to help me. When I was so worried about my mom that I couldn't think straight, Laura was there to listen to me and to remind me that my mom wouldn't want her troubles to affect me. That was how my mom was. She was always my greatest defender and my biggest supporter. I didn't want to cause her any more anxiety by worrying too much, but it felt impossible not to.

As much as I've talked about my relationship with my father, my mom was just as responsible, in a totally different way, for helping me get to the big leagues. We

all have to have balance in our lives. As a kid, when I didn't understand what my dad was doing, when I saw him as a negative influence, my mom helped me. Later, when I understood him better, I still needed someone to balance out the messages about being tough, about focusing on my goals, about using hard work to get over any challenge. Again, my mom came in. She knew that there were two opposing emotions driving me— the anger and hotheadedness, on the one hand, and the sensitivity, my sometimes easily wounded pride, on the other—and she let me know that it was okay to be soft-hearted and empathetic. My dad knew me and helped shape me as a ballplayer. My mom knew me and helped shape me as a man.

She understood my desire to be a ballplayer, but she knew I would also need to be a good man. We all know stories of guys who are terrific athletes but not very great human beings. My mom wanted to make sure that those two parts of me intersected squarely. I'm not saying that my dad didn't care about what kind of man I was; it's just that his emphasis was on helping me be the best ballplayer I could be. His expectation was that I would simply transfer all those lessons about dedication and hard work to other parts of my life. My mom was more direct in helping me see that those other parts of my life were just as important as baseball. They both

impressed on me that there are no shortcuts to success, on the field or off, that I could never do anything that might compromise my integrity, and that no matter what anyone else was doing to get ahead, I had to do the right thing—or else.

My mom had to work hard to recover from the surgery, and she was doing well with it. I saw my dad's tenderness and toughness in a new light as he helped take care of her and fiercely protected her from any kind of upset. Maybe because I was now married and saw how couples worked together to complement one another's strengths and weaknesses, I saw my parents' relationship as an example of how to get things done.

Throughout the 1999 season and Laura's pregnancy, I came to see how Laura struck the perfect balance between the two sides of me—she got who I was as a man and as a ballplayer and saw how those two sides of me merged. The two of us worked incredibly well together, and I could never imagine thinking of her as any kind of negative distraction.

In addition to being a great partner for me, Laura was an accomplished and ambitious woman who knew about hard work. Her life as a lawyer and as an entertainer required her to have the kind of focus and determination that I did. Though she chose to go a different way, she had also been a great athlete in high school and

could have played college volleyball if she had chosen to. So when she saw me struggling early in '99 with Joe's absence and with not playing as much as I thought I deserved to, even though I'd been told I was the starting catcher, Laura was able to help me immensely. Sometimes it even helped to not talk about baseball, to get away from the game when I was home and think about the arrival of our baby. It wasn't easy for her to be a baseball wife, an expectant mother, a newlywed, and a newcomer to Manhattan, all while coping with our suddenly very different life. Talk about making transitions—she handled it all.

So when we won the Series that year and got to participate in another victory celebration and ride down that Canyon of Heroes, I felt like Laura was the most valuable player on our team—the one who, when things were on the verge of turning bad, reminded me and showed me how good things really were. When you start off a season with an 0-for-25 streak from the left side of the plate, as I did, and then break out of it with a monster upper-deck home run, that ball's flight is just a reminder of what you've been hearing from your wife every day during that tough stretch. Things will get better.

And things did get better, in fits and starts. I needed to be more consistent to level off some of the highs and

lows, both emotionally and at the plate. For me, the two were always intertwined. That playing angry thing was a mixed bag. How can you stay angry when things are going so well for you on and off the field?

That off-season we went home to Puerto Rico to be with both our families for the big event. Thankfully, Laura was having an easy pregnancy, so when she went into labor in late November, I was anxious but no more than any first-time dad might have been. The first time I held my son, Jorge, in my arms, I was overcome by a whirlwind of emotions. Even though he was just minutes old, I was already thinking about how amazing it would be to have a son to share adventures with. Holding him in my arms, I could imagine what my dad must have experienced when he first held me, only in those first minutes I wasn't envisioning my son as a ballplayer. Instead, I was remembering the times with my dad when we cycled and swam together, when we just hung out. I wanted more of those kind of moments with my son—if we ended up creating some memories on the baseball diamond together, that would be good too, but I wasn't going to put that kind of pressure on either of us.

Throughout Laura's pregnancy, I'd been thinking about what kind of father I wanted to be. I'd teach him, of course, but I'd learn from what had troubled me

about my relationship with my dad. Most importantly, I'd communicate better with him. I'd let him know with words and actions that I loved him and was proud of him, that if I was disappointed it was in something he did but never in him. I wanted to be as positive a presence in my child's life as I could be.

In the middle of our joy, Laura and I both quickly grew concerned as well. Something about the shape of Jorge's head didn't seem quite right. We mentioned our worry to our doctors and nurses, but they assured us that his head was normal. The trip down the birth canal and the use of forceps on the baby's skull to help extract him had caused imperfections—in a few days, they said, we wouldn't notice anything unusual.

I think it's possible for hope to overcome our good senses sometimes, and as new parents, Laura and I wanted so much for our baby to be healthy that we didn't trust our guts. Something was wrong, but we wanted to chalk it up to being new at this parenting thing and to believe that our worries were just that—worries. But two days later, when we went home with our son, our worries only grew. Jorge cried nonstop, he wouldn't breast-feed, Laura was having serious postpartum headaches and nausea, and all that time Jorge's face and head still somehow looked off to us. As the days went by we noticed that his appearance seemed

to be changing daily, and in a way that couldn't be the result of him growing. When one eye seemed to be moving higher than the other, all the alarm bells that had been muted went off. We had to get help.

Through a family connection, we went to see a pediatrician. He confirmed our worries, but fortunately for us, he had seen something like this during his days at NYU Hospital and suggested we get in touch with a specialist there by the name of Dr. Joseph McCarthy. A few days later, we flew to New York with the baby, and for the first time we heard the word that would become a major part of our lives from that point forward: Jorge had a birth defect known as craniosynostosis. Dr. McCarthy was great and told us that he had seen many cases like Jorge's—we were surprised to learn that one in 2,000 babies are born with it—and he was as reassuring as could be. He knew that it was a lot to take in and that we would all be dealing with this for years to come, but he offered us what we needed most in those moments—an answer and hope.

Craniosynostosis is a condition in which the plates of the skull start to fuse together prematurely. All babies are born with the bones of the skull not fully together in a complete structure. That allows for the brain and the head to grow. With craniosynostosis, because some of the plates have already joined together, the rest of

the structures get forced to grow in different directions than they would normally. Besides the disfigurement, a child can have seizures, visual impairment, eating difficulties, and a number of other problems. To correct the condition, Jorge would have to undergo surgeries throughout his young life, starting nine months from that first appointment.

As Dr. McCarthy's words settled in, all of those visions I'd had of our future together, of my life with my son, suddenly changed. I didn't know what to do. Immediately after we got the diagnosis, Laura and I were in a cab, and we looked at one another. I could tell that she was barely keeping it together, and I knew that I was having a hard time as well. We were stopped at a light, and pedestrians were streaming past us and around us. I felt trapped, almost claustrophobic in a way I'd never felt before.

"Let's make a promise," Laura said. "We're going to be strong for one another."

I reached for her hand and held it. "Strong. For you and for him."

We kept to that promise, and throughout that ordeal we never cried in front of one another. That's not to say that we didn't cry at all—we did cry profusely, in private—but we needed to not show just how bad things were or how down we were. We could have

really spiraled into a deep depression. We couldn't do that because Jorge needed us, and we felt like we had to set an example for our family.

In particular, I was worried about my mom and dad and how they would take the news. My mom's heart condition was very much on my mind, and even in those first few days after we'd brought Jorge home, I'd seen the worry on my dad's face when he stood over his crib. I have many lasting memories from those first days and months after Jorge was born, but the image of my dad standing at my son's crib crying and crying, of seeing the man who had always told me to push aside my emotions choking up uncontrollably because he didn't know what was wrong with his grandson—that has always stayed with me.

Painful as it was to see my dad upset, in some ways witnessing his reaction helped me put my own struggle in perspective. He was such a wreck because he couldn't control what was happening, first to my mom and now to his grandson. He could help, but his old tried-and-true formula of bulling his neck, getting tough, and working harder could only carry him so far. He could help my mom—cooking for her and running errands—but he couldn't control every part of her recovery or her health. It was kind of like what he'd done with me. He could put me in a place where

I could succeed, but the rest was up to me. On the ball field there were plenty of variables, but off the field there were so many unknowns outside his experience that I'm sure he was flustered by it all.

My dad was as emotional as I was, but he just expressed it in different ways. Now faced with these difficult problems at the same time as my career continued to blossom, all kinds of circuits got crossed for him, and he responded in unexpected ways. It was both tough and in some ways gratifying to see him like that. I got to see that tender side of him. Also, it was a bit scary. I saw him and my mom both as vulnerable in a way that I hadn't before. My dad had always wanted to protect me, and now I felt that way about him.

Because of all this concern, initially I decided I couldn't say anything about Jorge's condition to my parents, but Laura talked some sense into me. When I delivered the news, they were heartbroken, but they both rallied. My in-laws were great as well. Everyone reminded us of what they'd instilled in us from the beginning: This is a challenge. You've faced them before and you've succeeded. You'll do it again.

Laura and I were both dealing with guilt and wondering what we might have done to cause Jorge's condition. So who knew what was going on in my dad's mind? I had so much going on, and we had established

such a pattern in our lives, that I couldn't just ask him. But I knew one thing: I was grateful that I had my job to occupy some of my time and thoughts. At least on the field I could control some things; my dad didn't have that kind of an outlet, and I think that compounded his emotional responses.

Derek was the first person outside the family I told about Jorge's troubles. He had called to check up on us after the baby was born, and I told him that things were good—hectic, but good, and I meant that. Later, when it became clear that something was wrong, I called him because he was one of the only people I felt I could talk to. The thing you have to understand about Derek is that he's great under pressure in all situations—on the field and off. That calm and cool, "no big deal" image he projects is real, but he's also a compassionate guy. Hearing that come through in his voice as I talked with him was what I needed. I knew that I could trust him with my feelings, and I also knew I could trust him to keep the news about Jorge as much of a secret as possible. I'm a private person and don't like my business to be out there anyway, but I also knew that I didn't want to have to deal with the questions even within the team, not to mention the press. People were going to want to express their concern and support, but that would have been too hard for me to deal with all the time.

After my initial conversation with him, Derek checked in with me frequently, and I appreciated that and was glad for the opportunity to be completely honest with someone outside the inner circle of our family. He was good at reading me—he knew when to press me for details or when to talk about other things to help get my mind off what we were all dealing with.

That's where that issue of distractions enters the picture. I knew that I had a season to play in 2000. Jorge's first surgery wouldn't be until August, and as much as I would have liked to stay with Laura and the baby until then, there wasn't anything I could do to make Jorge's condition better by being home. I had a job to do, and to do it I had to block out all my concerns and anxieties for a few hours every day.

As we moved into the season, it was good to have Derek and baseball to help keep me sane. They served as a distraction from what was going on back home, as a way to escape, however briefly, from what was most on my mind. I knew that Jorge was going to be getting the best care in the world, but still, it was nearly impossible not to think about what he faced as he got older—having more and more surgeries each year and becoming more aware of what he was having to deal with. When Dr. McCarthy explained that Jorge's scalp would have to be cut from ear to ear and peeled back to

gain access to his skull, it had become clearer than ever how serious this all was, and how long-lasting the scars would be.

Because I knew that Jorge was going to have his first surgery at some point during the season, and because I sensed that he would understand what Laura and I were going through, one day in spring training I asked Joe Torre if I could meet with him. I sat down on the couch in his office. Joe was behind his desk, and even before I could launch into my story, he knew that something was up. He came to sit next to me on the couch, his face a mask of real concern.

When I was done explaining the situation, he asked me how Laura was doing, how the rest of the family was, and if there was anything he could do to help in any way. Then he asked more questions about Jorge's condition, about what was going to be done and what the prognosis was. The more he prodded for information, though, the more I kept trying to turn the conversation around, to keep it professional by telling him that I was going to do my best to not let things get in the way.

He put his hand on my shoulder to stop me.

"I know all that. I know that you're going to be fine. You're going to do your job. I just want to make sure that you understand we're here to help you do your

most important job—to be there for your son and your wife and your family. The rest—the schedule, how to make things happen on the field—we'll figure that out as we go along. I just want to make sure that all of you are okay."

In a lot of ways, those were the kinds of words that I'd wanted and needed to hear from my dad—the kinds of things that he just hadn't been able to say because he was so overcome by his feelings and worries. I don't blame my father for that—but something about Joe's combination of control and compassion comforted me more in that moment than I can say. Joe completely understood my desire to keep things quiet, and I thanked him and held out my hand for him to shake it. He took it and then pulled me in for a hug: "We're going to help you get through this."

From that point forward, Joe was great about checking on me and asking how everyone was doing. That was when he became more than my manager—he became family, a father both similar to and different from the real one I had down in Puerto Rico.

Thankfully, my family on the team was not limited to Joe. At that point Derek and I had been playing together for several years, and I'd been thinking of him as a brother for quite a while. I don't know how it was that our friendship truly started, whether it was when

we got sent up together in '95, or when we were living in the same building in New York, or when we were on some road trip that's long faded from my memory. But I do know when it deepened; while Jorge's condition played a part in that, even before that diagnosis, Derek and I had become real close. He wasn't the best man at my wedding out of convenience. I knew that he was somebody I could count on, just like I knew that at 2:00 every day that we had a night game he'd be down in the lobby of our hotel room or our apartment building so that we could go to lunch together. It wasn't like either of us needed a reminder of that. That's how it is with brothers—a lot of things go unspoken. But Derek has also always called to wish Laura and me a happy anniversary, and he calls each of us, including the kids, on our birthdays.

In the same way that we had our daily lunches, when we were on the road we'd leave the ballpark after the game and catch a cab or a car service to go out to eat. Breaking bread with my brother, talking about the game, the season, the movie we were going to catch, some other things going on in sports or the world, was a part of that season and every other one I shared with Derek.

Of course, I had other guys on the team I was really close with. Following that meeting with Joe, I also

informed Bernie Williams and Gerald Williams and Tino Martinez about Jorge's condition and what was to come. Knowing that those guys had my back made it easier for me to put up a false front on those days when I'd get to the ballpark and be feeling down. I had to put my pregame face on, smile and laugh at all the nuttiness that goes on during the course of the year. On better days, when I heard from Laura that Jorge had slept well, wasn't crying, and was starting to motor around a little bit, those smiles and that laughter were genuine.

Baseball was my release and my relief, but as the season went on into July and I knew Jorge's surgery was coming up in August, even baseball couldn't do too much to help me. That looming sense of something darkening the horizon was tough to battle through. The irony was that things were going really well for me on the field. With Joe Girardi signing with the Cubs in the off-season, I was clearly the number-one catcher, and I played with the frequency that goes along with that. I got off to a good start and was able to sustain that throughout the first half. Hitting a three-run walk-off homer in early May and going 4-for-5 against the Orioles was great. Having the guys mob me at home plate, seeing how thrilled they all were, made for a great night. Still, the next morning when I woke up

and showered, it wasn't getting soap in my eyes that had my tears flowing.

I don't know if Jorge's troubles made it easier for me to focus or if having my mind elsewhere made it easier to perform. All I know is that it was really gratifying to be selected to my first All-Star team that year.

I contributed in other ways too. We were scuffling along at the end of June, and we lost a game to Tampa Bay 6–4 when Jeff Nelson, who was usually so reliable coming out of the bullpen, lost his control. The next day El Duque came out and lost control in another way. A batter stepped out of the box in the middle of his delivery, and he got pissed and tossed the ball high in the air in disgust. The Tampa bench started to get on him pretty good, and El Duque stared at them. I went out to the mound, glad that he was getting fired up. I knew that he pitched better when he was upset. In fact, I used to do things like throw my returns to him down at his ankles to make him mad and get his fires going. El Duque didn't like what was going on, and he backed the hitter off the plate with a fastball inside. That kind of set the tone for things, so in the seventh inning, when Bobby Smith struck out and I went to fire the ball to third, he pushed me. I pushed back. We got into it, and the benches cleared.

After the game the guys gave me a hard time, including Rocket, who saw me walking out of the locker room

in my street clothes and started to shadow-box with me. The laughter helped. At that point, we were 39-36 and fortunate to be in second place. Toronto was out front, and Boston was behind us playing exactly .500 ball. We needed something to fire us up, but nothing seemed to really work, though by the All-Star break we were 45-38 and in first place. For my part, hitting over .300 at that point, with 17 homers and 41 runs driven in, helped me stay positive. It was great to share those first All-Star moments with Bernie and Derek, to see past and future teammates like David Wells and Jason Giambi, and to play with other big stars of the game like Cal Ripken Jr., Manny Ramirez, and National Leaguers Mark McGwire, Sammy Sosa, Chipper Jones, and the rest of the squads.

I'm a fan too, so getting those guys and others to sign balls and other memorabilia was a fun part of the event. I went 0-for-2, but just being there in Atlanta was great in lots of ways. Laura and Jorge came down for the game, but when I saw all the other guys with their kids on the field before the game, holding their little ones during the anthem, I was thinking about Jorge and whether or not I'd ever have the chance to really share in that experience. My thoughts and emotions were constantly shifting underneath me. Do I go public about his diagnosis, do I show him to people and expose him to who knows what? Or do I just keep

protecting him from all that? Or was it really shame that drove me to protect us all?

When we resumed play, August was just around the corner and I began struggling a bit at the plate, but even more so mentally. I was showing up at the ballpark, but not all of me was there. I couldn't help but think about how different the time I spent with my family at the All-Star Game was going to be from the next time we were all together. We'd gotten the confirmation from Dr. McCarthy's office that we were good to go on August 2. I talked to Joe, and he said that I could take as much time as I needed, that he'd work with the higher-ups, and that if I still didn't want to tell anyone the specifics of what I was doing, he'd manage that as well. That was a big relief, but for everyone's sake, I didn't want to cause too much of a disruption. We'd settled into a workable routine at home and with the club, and I felt that it would be best if I played up until the 2nd. So the night of August 1, I caught Doc Gooden, showered, and left the ballpark knowing that I wasn't going to get any sleep that night and probably not the next night either.

My dad had come in, and Laura's mother and father and sister were all at the hospital with us. My mom wanted to come, but my dad told her no way—he didn't want her to have that much stress put on her. Going

into the pre-op area and seeing Jorge, still a tiny little guy, hooked up to various machines and with tubes and wires and beeps and displays as his lullaby before the anesthesiologist did his thing, was incredibly painful to see. As parents, our main goal is to protect our kids, to make their lives as easy as we possibly can and to keep them as free from harm as possible. Even when you know in your head that what you're about to put your kid through is for his own well-being, your heart tells you another story—a kind of horror story.

We were told that Jorge would be in the operating room for about six hours. Before he went in, I'd gotten a call from Joe, and he would check in again four times that day. Derek stopped by first thing in the morning to wish us well and then later, after the game was over, he called to check in. Incredibly, Jorge was in surgery for ten hours, not six. We got hourly updates from Dr. McCarthy through his colleague Pat Shapiro, who kept telling us that he was doing fine. But that was a long, long, long wait. Things went as well as they'd hoped, and seeing my son lying there with his head swathed in bandages, his face swollen, and his eyes shut was both tough to see and an incredible relief. He'd come through the surgery alive. Even though we'd gotten all kinds of assurances that his condition wasn't life-threatening, having all those months—and then all

those extra hours that day—to think about it makes a parade of worries travel past.

We were grateful that the first surgery was over, but we knew that he was in for another in 2001, and then again in 2002. After that, there'd be more, but at that early stage we knew that roughly every year at this time, for the next three years, we'd be back at NYU Hospital.

I didn't think I'd be able to sleep the night after the operation, but exhaustion caught up with me. I woke up feeling pretty good, and when I got to the ball-park, Joe had me penciled in to bat second against the lefty Jamie Moyer. That was the first time in my big league career I would be hitting in that spot, and I was pumped by the opportunity. When I saw Joe before the game, I wanted to thank him for doing all he'd done, but he caught my eye and just nodded. We both under-stood what was going on, and neither of us could say too much.

I had one of my best games ever, going 4-for-5 and driving in four runs against Seattle. That day, when I made my crosses in the batter's box to honor the dead in my family, I also did it as a way to say thanks to God and to all the people who'd helped us through that tough period.

The euphoria I felt that night didn't last. I went back to the hospital after the game and spent the night there,

and I ended up sitting in that hospital for a lot of hours before Jorge was finally able to open one of his eyes. To me that was the sign that things were going to be okay. Hitting two home runs that second night was another expression of my gratitude and relief. After that game, Derek, Bernie, Gerald, and Tino all stopped by the hospital to show their support.

As the regular season wound to a close and Jorge's recovery progressed, the team started going in the other direction. I'm the last guy to ask about those 15 out of 18 losses, a stretch that everyone later referred to as our "collapse." I was trying so hard to not collapse from my own mental exhaustion that even though things were better in our world, that stretch was surreal.

Nothing was going to come easy against the A's in the ALDS. Even Game 5, when we jumped out to a six-run lead in the first, turned into a 6–5 victory. Our bullpen came up big for us that game, as they had done much of the year. You'd think we'd have felt more of a mixture of relief than joy once that series ended. The truth, though, is that we all still had a lot of faith in ourselves. We believed, especially as we moved into a longer seven-game series, that in the end our talent was better than that of anybody else in the league. We knew how to win, and we believed that we should and that we would, especially with Mariano in the bullpen.

Playing against the Mets in the World Series was intense and fun. Normally, with travel days, you get away from the focus a bit. Spending every hour in the media capital of the world meant that there was no escape. That made it even more fun and, if possible, raised the stakes. Having my whole family there to share the experience was great, and they offered me a few moments to get away from the game, but not many. Like me, and the rest of the city, the Subway Series overcame any inclination you had to think about something other than what was going on in the Bronx and Queens. Every newspaper, every television news program, every kiosk, bodega, and even the sidewalks, served as reminders of the rivalry. Seeing businessmen and-women in their suits wearing Yankee hats, and a few with Mets hats, was fun.

It helped that the games were equally intense. With 44 years of buildup to the first pitch, that was going to be tough to do. I think that Mariano put it in perspective though, telling the media, "I don't know nothing about history. I just want to win." José Vizcaíno, who played for the Mets for a while, also helped keep things in perspective. This was his first World Series, and to him the Subway Series was what happened in July when we played the Mets. He understood that as much as the media in town thought of this as the battle for New York, it was for a World Series title.

As usual, we capitalized on the other team's mistakes in Game 1. Timo Pérez of the Mets failed to run hard on a Todd Zeile drive to left. He thought it was going out, but it didn't. David Justice threw to Derek, who fired a rope to me and we just got Pérez. The rookie thought two runs were going to score but, instead, none did. We trailed 3–2 going into the ninth and I led off, just missing a pitch and flying out to deep right center. Fortunately, Luis Polonia and José Vizcaíno both singled and Chuck Knoblauch came through with a sacrifice fly to tie it. José, a Dominican who used his $4,500 signing bonus to buy a cow for his family, came up huge for us in the twelfth. Tino singled, I doubled, and then with two outs, José singled for the game winner. I don't really care how we win, but it's nice to see guys contribute up and down the lineup and off the bench.

I went 2-for-3 with an RBI in Game 2, but whatever satisfaction I could have felt in that was nearly taken away in the ninth inning. We were up 6–0 and the Mets came back to score five times off Jeff Nelson and Mariano. Those two were awesome all year and sometimes these things happen.

And, of course, there was the Rocket and Mike Piazza incident. Everything happened so fast that I really didn't have a sense of what was going on at the beginning. I was watching the ball go down the line and hit off the barrier in front of the dugout. When

I turned back to the field, I saw Mike stopped in the baseline. I did what your instincts tell you to do when a guy looks like he wants to challenge your pitcher. I went out to the mound to help protect my pitcher. The benches were clearing at that point, and I heard Roger saying, "I thought it was the ball." I tried to get Mike to retreat and also repeated what Roger was saying.

I'm glad that nothing else came of it. I wasn't catching when Roger hit Mike in the helmet, but I know that Rocket wouldn't go after somebody that high intentionally and that he wasn't trying to hit Piazza at all. The ball got away from him, but I could, after seeing the replay, understand why Mike was upset about the bat coming near him. He wasn't looking and all of a sudden a bat came through his field of vision. That doesn't mean that Rocket was trying to hit him with it. It was just a case of everybody's attention being focused on different things and no one seeing the big picture. Most important fact? We led the Series 2-0.

El Duque battled his ass off in Game 3, leaving in the eighth after throwing 134 pitches. The game was tied 2–2, but he and Mike Stanton couldn't hold the lead and we wound up losing 4–2. You always want to win at least one of the games on the road, in this case Interstates 87 and 278, and Derek set the tone in Game 4 with a leadoff home run. We never trailed in

that game, but it was a tense one. Joe showed that you have to do what you have to do to get a win in the post-season. Mike Piazza had crushed a *long* foul ball off Denny Neagle in the first. Then, in the third, he hit a two-run shot deep into the bleachers. He came up in the fifth with no one on and two outs, and Joe pulled Denny. Normally, you do everything you can so that a starter qualifies for a win by going five innings. Neagle was one out away, but Joe was not going to let Piazza start anything. David Cone came in and got Piazza on a pop-up. We still led 3–2 and no one scored after that. Joe had Mariano come in to start the eighth, and he got the two-inning save. Pulling a pitcher with two outs and no one on, letting a guy throw 134 pitches, switching up the lineup to take advantage of guys' tendencies: Joe was making the right moves, and we were one win away.

Andy started Game 5 for us against Al Leiter. Two guys with a lot of postseason experience and a ton of heart meant that not a lot of runs were likely. Andy not handling a bunt that resulted in two runs scoring in the second put us behind 2–1. Bernie had homered earlier, and then Derek tied it in the sixth. Derek always knew when to pick his spots to muscle up, and when he got ahead 2-0 he did just that. In the ninth, we did what seemed to have developed into a habit. With two outs,

I worked for a walk off Leiter after nine pitches. Scott Brosius singled and then so did Luis Sojo. Scoring what was eventually the winning run was a thrill, but we still had the bottom of the ninth to get through.

We all had our hearts in our throats when Mike Piazza came up with two out, representing the tying run. His drive sounded good off the bat, and I remember Joe telling me afterward that he jumped up and had a sickening feeling in his stomach. But when I saw Bernie going after it, I knew that things were in good hands. Running out to Mariano and seeing the jubilation on his face was amazing, and all I could do was bow down to Derek for the great Series he had. I wish that Andy could have gotten the win—we didn't give him the kind of defensive support we usually did—but it didn't matter to him. Winning three World Series in a row—no matter how you get them, who gets them, and even if you lose one World Series game after winning 14 in a row—is pretty damn good. Sure, we would have liked it to be 16-0, but considering we'd had the lowest winning percentage of all the teams entering the playoffs, we knew we'd won when it mattered most.

I also knew better that season that other things mattered more than the game. Of course, my mind was on Jorge and Laura, but I got another reminder of my dad in an unusual way. While riding in the victory parade,

I was alongside El Duque for a bit. Like my dad, he had escaped Cuba, and he saw all the ticker tape coming down and then fans throwing rolls of toilet paper that unspooled as they floated above us.

"This is crazy," he said. "Back in Cuba people can't even buy or find toilet paper. Here . . ." I watched his eyes follow another celebratory lob. I thought of my dad and everything he'd done for me, and how far I'd come as well. The bitter would always be there with the sweet, but victory was always welcome.

There's a lot to be said for having winning experiences to fall back on, for being familiar with how it feels. To be able to say, "I've been here before and I succeeded," is a much better place to be at than to be saying, "I believe I can do this." We didn't just believe we could do it, we could say, "And here are examples X, Y, Z to prove it."

I think that was why Jorge's health problems threw Laura and me off-balance so much. Yes, we could point to things we'd done in other parts of our lives to overcome career challenges and personal difficulties, but this was new territory to us, and even more important, it involved our *child*. He couldn't help himself, and it was our responsibility to find him the best help we could. We did that, but I sensed that the surgeries weren't going to get easier as time went on.

After our initial shock, Laura and I viewed Jorge's condition as a message to us. As we learned more about craniosynostosis, how many lives it altered, we decided that we needed to do something to help others. Because of my job, and the fact that we lived in New York City, we could afford the best care for our son. Not everyone could. To honor Jorge and the fight he was going to have to undertake, we created a foundation in his name, the Jorge Posada Foundation. Using her legal training to its fullest, Laura turned her fears and upset into a positive force. She wanted the foundation to serve different purposes—educating parents, medical professionals, and the general public about the condition as well as the various treatment options. We also wanted to raise funds to increase awareness and support families in a variety of ways.

Luis Espinel, a friend from Laura's law school days and the guy who served as my agent, was also instrumental in helping us get the foundation up and running. After the conclusion of the season, we held a press conference to announce the launching of the program. Many people stepped up immediately with donations, and George Steinbrenner was one of the first and most generous among them. The Steinbrenner family continued to support our efforts throughout the years. The foundation made a difference in the lives of many

people in many ways. Once the website was up and active, Laura talked to mothers of children affected by craniosynostosis, we helped fund a playroom at NYU, and we created a symposium where doctors from around the world could share information.

Eventually, the success of our efforts meant we had to make a difficult choice. Laura had wanted to keep administration costs to a minimum so that the largest percentage of dollars donated went to help people and not to keep the organization operational. We eventually merged the foundation with a group called myFace. For all the things I've accomplished on the field, for all the success that Laura has had as an author, television personality, and lawyer, we're both proudest of what the foundation was able to do. Second to raising our kids, it has been the most important work we've done. Both her parents and mine were responsible for making that happen. They taught us that when things seem to be at their worst, you can always do your best by reaching out and offering someone else a helping hand. We had no way of knowing it, but that lesson was going to be put to use in the most unimaginable way less than a year after the foundation was created.

Chapter Thirteen
Our City, Our Loss

Leave it to Joe Torre to figure out that I was super stressed and needed a break. From September 2 to September 9, 2001, I'd gone 2-for-21. We had a day off on the tenth before we were to fly to Chicago. Joe let me know that I wouldn't be starting the first game. "Take it easy. Get some rest. Stop pressing," he told me.

I'd told Joe about the latest developments in Jorge's case. The second operation was over, but complications had developed. The bone graft that had been placed in his forehead had become infected. It had to come out, meaning that the whole procedure had been a failure. Worse, his head was swollen and red from the infection and when Laura had been out with him a stranger made a cruel remark, telling her that she shouldn't beat her own child. She was understandably upset, both by

Jorge's condition and the man's disgusting accusation. Having to put Jorge through another surgery made us feel like we'd made no progress at all. The procedure to remove the infected bone was completed, but that was no real consolation. Laura was stressed. I was stressed. Sleep seemed like the only escape we might have.

Knowing that Laura needed the rest even more than I did, I went straight to the hospital after the game to spend the night. Jorge had developed an infection after his procedure, something we always feared. On top of everything else my son had to deal with, an infection felt like someone was adding insult to injury. I struggled to get a decent rest as anxiety and frustration kicked at me all night.

So, on the morning of September 11, I was up early, awakened by a nurse coming in to check Jorge's vitals and his IV. I dozed off again, and I was still a little bleary-eyed when I woke up shortly before nine. Seeing Jorge in bed smiling helped. I asked if he wanted to watch one of the *Blue's Clues* videos we'd brought to the hospital. He nodded and his eyes lit up. As I turned toward the TV to put it on, an image of blue skies and a tall building flashed on the screen just as I was hitting Play on the VCR.

A few minutes later, I heard a commotion in the hallway, but didn't think much of it. Hospitals aren't

always the quietest places. The tape was nearly over, so it only played for a few minutes, and when it ended the TV came on again. This time I saw video of an airliner going into one of the twin towers of the World Trade Center. I stood there staring, and then heard people outside the room screaming.

I opened the door and saw nurses and other hospital employees in surgical scrubs scrambling around, shouting instructions, wheeling beds and wheelchairs. It was like a giant vacuum was pulling all these people and all this equipment out of the hospital. My mind was racing. I went back in the room and looked at Jorge, who was hooked up to an IV and various monitors. I thought that if all those other people were rushing out of the hospital, I needed to get out as well. And I wanted Jorge out of there. If this place was as chaotic as it was, if some guys had flown a plane into a building just south of where I was on 31st Street, where my son was, we had to move.

I returned to the hallway and found a nurse. "Can you please show me how to unhook my son from all the things? I have to get him out of here."

She looked around her, wide-eyed and fearful. Finally she shook her head and said, "You're safe here. Everything is fine. He is in a safe place. Just stay here."

While she was talking, I noticed another TV over her shoulder and saw videos of the attack. When I went back in the room, I looked out the window and could see outside in the streets hospital personnel and beds and gurneys lined up. All of them empty.

I called Laura and alerted her to what was going on. She didn't know anything about it, and I shivered at the sound of her gasp.

"Another plane just hit. The south tower this time."

"What is going on?" I asked.

"This can't be real. Oh, my God. Oh, my God, those poor people." Her words cut through my fog.

Laura said that she needed to get to the hospital as fast as she could. As soon as we hung up I called Derek. I knew that he'd still be sleeping, but I wanted to make sure that he was aware of what was going on and could get out of the city if he needed to.

"Turn on the TV, we'll talk later."

He called me right back.

"Is this real?"

"Yes. And it's not just here. Now they're saying a plane hit the Pentagon."

"What is going on?" he asked, his voice the most rattled I'd ever heard it. "What are we supposed to do?"

I think that Derek was asking the question that was on all our minds in New York. You didn't just want to

sit there and watch this. You wanted to do something. I had to do something to protect my family.

Laura's mom was the first to show up. She'd been dressed and ready to come to the hospital when I called. She was upset, but not panicked, and she let me know that if I was going to the apartment to pick up what I needed for our upcoming road trip, or to just get out of town, I'd better leave right then. Transportation around the city was coming to a halt. Laura probably wasn't going to be able to get a cab, and even if she did, avenues were closing. I headed uptown, running through the crowded streets. The further north I got, the more normal the day seemed. It was so clear and bright and warm that it was hard to believe such chaos was going on down below 14th Street. I got into the building, sweating and breathing hard, but no one looked at me like anything was wrong. Everything was wrong, and there was no such thing as normal that day.

I threw things in a bag and headed out the door. By the time I got back to the hospital, it was clear that we weren't going to be able to go anywhere—or even that we needed to. Bridges and tunnels were closed to vehicle traffic, streams of people walked the streets, people were lined up to give blood, and everywhere you looked people had the dazed look of survivors unsure of what it meant to be one. Like everybody else in the country,

we sat and watched the news coverage. Only for us in New York, we had the added element that the images were coming from just a few miles away and not from somewhere in the Middle East or elsewhere.

At some point before noon—time had become irrelevant really, those moments all seemed to stretch into one long scene out of a horror movie—I got word from the club to stick by the phone. Eventually we learned that that night's game was canceled.

As we all know, that night stretched into many more nights when stadiums were empty. I thought that was a good thing, both out of respect for the victims and their families and for the safety of my family and everyone else's. In the days following the attacks, I still didn't feel safe and wanted to be sure to protect everyone I knew and everyone else. Those horrible images just kept replaying in my mind. Jorge remained in the hospital, and although Mayor Rudy Giuliani encouraged New Yorkers to get back to their normal lives, I told Laura to avoid any place where large groups of people might be gathered. I didn't want her to go to the mall, and I didn't want us to go to restaurants together. That uneasy feeling faded over time, but it took a while.

Going to the Stadium to work out helped bring back some sense of normalcy, but being in a mostly empty stadium in early September, when the pennant

races should have been in full swing and the crowds should have been going nuts, made it all feel very surreal. Mayor Giuliani was a huge Yankees fan. I know that he wanted us all to resume normal activity, and I understood all the reasons why, but being away from my family was going to be hard. We arrived in Chicago to resume play on the 18th, and not having played since September 9, there was nothing any of us could have done to prepare ourselves in advance. One nice moment was to see the banners Chicago fans displayed saying that Chicago loved New York.

Here's where that word "distraction" comes up again. I felt like people wanted us to play, and so when it came time for the players' representatives on each team to vote about whether or not to cancel the season, Mike Mussina came around to get our input. Despite whatever personal concerns I had, I told him yes, let's play. We needed to do this for the city. For the rest of the teams, with the exception of the Mets, the issues they had to face were different. This was our home. This was deeply, deeply personal. We'd all been terrorized. We couldn't let them make us give up what mattered to us and to our wounded and grieving city.

And just as had happened with Jorge and his surgeries, it was good for all of us, players and fans, to have something else to focus on. In the big picture, there

were so many things that mattered more than a baseball game, but we were also an important part of the lives of a lot of other people. That was on our minds when we voted to continue the season. We didn't want to keep doing our jobs just because that was how we made our livings, but because we could do something to help the city, maybe help people in some small way to move on and resume their normal lives, as our mayor had asked us to do in the earliest days after the attacks.

Nothing, though, could prepare me for what it was like the first night back in the Stadium, on September 25. Members of the police and fire departments and the emergency services teams lined the tunnel from the clubhouse to the dugout, and later joined us on the field. Walking toward the dugout, we shook a few hands and thanked those men and women for what they'd done for the city. They thanked us back, and one policeman said to me, "Thank you for what you guys do. We need it. You guys are great. You're being really brave." I looked at him. Knowing what he did and what I did, I didn't see it that way at all. Those people are the bravest and the finest, a title that they've earned over and over again. And as I said to that officer, "We're just lucky and grateful." I'll always feel that way.

Rocket was on the mound that night, and he told me as we walked in together from the bullpen that

he had chills. I knew that he always wanted to win, but I could hear in his voice that he *really* wanted to win. He was wearing a warm-up jacket that guys from a firehouse had given him, and his usual game face seemed a bit different that night. Hearing "Taps" and Ronan Tynan sing "God Bless America," seeing those representatives of the police and fire departments and other agencies lined up along the foul lines, getting to shake a few of their hands and then gathering on the mound to salute the fans—all this had my mind very far away from the Tampa lineup and what we needed to do to get them out. When Mayor Giuliani got called out onto the field and the fans chanted his name, I could see how much that meant to him. It felt good to smile. It felt good to be an American and a New Yorker.

Before that game, I thought I understood how much the Yankees meant to our fans, but those days in September demonstrated more clearly than I'd ever seen before the place that we had in the city's heart. I hated what had happened, but I loved how we responded as a city and as a team.

With all that going on, it was hard to remember exactly where we left off. When the season got interrupted, we had just swept the Red Sox in a three-game series to go up by 13 games over them. That first night

back at the Stadium we didn't have a lot to cheer about, and somehow that felt both strange and appropriate. How were we supposed to celebrate? Though we were being shut out and Roger was on the losing end of a game for the first time since May 20 and would see his record "fall" to an almost unbelievable 20-2, the fans showed us the way. They'd been scoreboard watching, and when the Orioles' win over the Red Sox was posted, they erupted in cheers because that meant we'd clinched the division. It was okay to be happy, but we didn't know if we should celebrate. We all gathered together as a team before the media came in. Joe addressed us all, congratulating us but saying this wasn't a time to celebrate, not when so many people were grieving. We all agreed.

We wanted to be together, so we ate our postgame meal in the clubhouse. We had champagne in the locker room but didn't open it. Mr. Steinbrenner walked through the clubhouse congratulating us. It wasn't like we'd completely backed into the playoffs, but given the circumstances, we all had really wanted to give the city a win that night.

Sometimes that was what it meant to be a Yankee. On a night when you win the division, you can lose a game and walk away disappointed. For a team that consistently showed heart all the time, to not win on

a night when broken hearts were starting to heal, felt like a moment had been missed.

I was 29 years old and on my way to completing my second full season as a catcher, putting together a second season in which I was voted an All-Star, and winning a second Silver Slugger Award as the top offensive player at my position by hitting .277 with 22 home runs and 95 RBI. I'd hit a home run on opening day and gone 3-for-4, then hit my first grand slam six days later. That was the second homer of three that I hit in three straight games. I was thinking that my usual slow start wasn't going to show up, but then I went 87 at-bats in May before breaking that homerless drought.

I'd had minor injuries before, but I really had to battle through the sprained ligament in my thumb that kept me from catching for seven games in a row. Mentally, I think it helped to have come forward in the off-season to let people know about Jorge and his condition. We'd received a lot of generous donations, and the foundation was thriving. When Laura and I were honored at the Thurman Munson Awards Dinner in February 2001, that meant as much to me as the recognition I received that year for what I did on the field.

Throughout the 2001 season, I got to watch as my good friends Bernie and Tino had outstanding years, both of them hitting over .300 with more than 25 home runs each and 207 RBI between them. Derek continued his string of seasons of MVP consideration and All-Star appearances, as did Mariano, who hit the 50-saves mark. Andy joined us all on that All-Star team, as did Roger, who went on to later win the Cy Young Award. Alfonso Soriano emerged as the Rookie of the Year and seemed destined to be a big part of our future. Given all that as well as our track record of success in the postseason, and given the wide margin by which we won our division and how well we'd played all year, we were well positioned for four in a row.

I can't say that we saw it that way at the time, though, because we took seriously both teams we faced in the AL playoffs. The Oakland A's had won 102 games and could easily have won either the Central or the East, but they finished second in their division that year. With 116 wins, tying a major league record, the Mariners ran away with the West. We were going to have to be absolutely on our game to beat the A's, and we weren't in Game 1.

I noticed that Roger wasn't as loose as he normally was. His upper body wasn't really following through on his pitches. He didn't want to talk about it, but

when only one A's hitter swung and missed in the first, I knew something was up. When Roger tweaked his hamstring going after a bouncer to the right side in the fourth, he was done. We didn't capitalize on some early chances in that game, and when Tim Hudson shut us out the next night, we had to take advantage of that long flight to Oakland to think about the times in the past when we'd been down.

We just weren't hitting, and that continued in Game 3. We only had two hits, but one of them was a homer I hit in the fifth off of Barry Zito. We were playing a day game, and with the hitters in the shadows and the pitcher in sunlight, the glare from the glass out beyond the fences made it tough for both sides to see well. Zito had fallen behind me in my first at-bat. When he came in with a fastball, I hit it hard but on the ground for a double play. When he fell behind again in my next at-bat, I was looking fastball all the way and got it. I took off running and watched as the ball hit the top of the fence in left and went over. I was so pumped up that I kept churning around the base paths, not even stopping until I got to the dugout. That was it for the scoring, though, and we only had one hit the rest of the way.

Thanks to Derek, that was all we needed. I'm more than okay with the fact that the story line the next

day wasn't about my home run or Mike Mussina's great start—it was all about a defensive play that has gone down in history as one of the greatest in Derek's career. Not to take anything away from Derek's athleticism and baseball knowledge, but what I think is most remarkable about what came to be known as The Flip is that we had actually practiced it in spring training that year. That shows how smart Joe is, and also how smart Derek is. We ran that play in spring training once, because we were going to open the season on the West Coast, including a series at Oakland. Their field has acres of foul territory, so that kind of backup-and-relay play could happen there. That it did in the seventh inning of that game under those conditions, with us clinging to a one-run lead and having scored only four runs through 25 innings, was huge.

The play started when Shane Spencer—Joe had started him in place of Paul O'Neill—made a strong throw on a ball down the right-field line that was high and got past both Tino and Alfonso Soriano. Derek was where he was told to be—near the mound so that he could read whether the play was going to be at third or at home. When he saw the ball getting by the men in front of him, he took off. I had to stay at the plate, of course, but I was counting on Derek to get it. He did, and then his amazing flip to me just barely

arrived before Jeremy Giambi thundered to the plate. Derek couldn't get a lot on the throw, and it was out in front of home plate, but fortunately it came in low, so I could go down to my knees as it was coming in and pivot toward the runner. I was able to reach Giambi's far leg—just barely—before his lead foot touched the ground. It was as close a play at the plate as I've ever been involved in. Everything had to be right to get that out, and it was.

You know that Derek and I are friends, so it's easy to say that I'm biased, but over the years other guys who played with him only briefly, guys like David Justice, have said to me that Derek was special. That was one of the most clutch defensive plays I've ever seen. We practiced it once in spring training, and then in game 164 he put himself exactly where he needed to be and made an amazing play with his body to complete what he'd done with his brain. Not only did that play save a run, but the A's would have had a guy on at least second and most likely third base and could have easily gone ahead.

Season saved.

This time I wasn't the one in tears. Joe said that he was struggling to hold them back during the last couple of innings of Game 5, he was so proud of what we'd done, accomplishing what no other baseball team had

done before in coming back like that. We were the old guys, if you believed what was being written, and the A's the young guns. I know that I didn't feel old, especially not when I ran out to Mariano and the two of us danced and jumped around like little kids. Maybe the champagne you spray around when you win is the real fountain of youth.

While the Seattle series wasn't as dramatic, simply getting to a fourth consecutive World Series was a huge deal because of what had gone on in September. Seattle was a club that had won more games than anyone in AL history, but we carried the hopes of a recovering city with us. None of us took that lightly. Winning that year especially would have meant so much to me and the other guys, even if we hadn't been going for four in a row. The city deserved it, and we wanted to give it to them and earn it for ourselves. Beating Seattle in the first two games of the series was huge, but after they jumped all over in Game 3, winning 14–3, momentum could have swung their way. Whatever hopes they had got Rocket-ed. Coming back from that tweaked hamstring, Rocket struggled with his control, walking four, but he struck out seven and only gave up one hit. He willed himself through five innings before Ramiro Mendoza and Mo didn't allow a hit the rest of the game. We won with a walk-off home run from Alfonso

Soriano. That took the fight out of the Mariners, and we cruised to a 14–3 win to end the series.

Despite Arizona having a devastating one-two punch at the top of their rotation, I thought we could win both of those first two games. Our staff was great, and we had the best closer in the business. Randy Johnson and Curt Schilling were particularly difficult for me because I had to switch sides of the plate against them, but they were tough on anybody.

What made Schilling so tough was that he could spot the ball anywhere around the plate. He rarely threw the curve or the slider, so you could go up there looking for a fastball or a splitter. He made a living working down and away, but as I said, he could move his pitches, particularly the fastball, all around the zone. If you went looking outside, he could bust you in on the hands. I don't know what to say about Randy other than that it was really tough to pick up the ball coming out of his hand. He was so tall, his motion was so disjointed, he threw so hard, and he had a 91-mile-an-hour slider that broke so late and so hard, that even if his arm angle had been more conventional, closer to over the top, he still would have been tough to hit. We scored one run in 18 innings in losing to each of them at their park, but we'd been down before, and Joe was his usual positive and calm self.

In Game 3, I gave us a lead for the first time in the Series when I led off the bottom of the second with a home run off a 3-2 changeup from Brian Anderson. Roger was great that game, giving up only one run and three hits in seven innings. Scott Brosius drove in the lead run, and when Mariano came in, he just dominated for two innings, striking out four of the six hitters he faced.

The next night and into the next morning, Derek introduced us all to the magic of November baseball for the first time. Game 4 had plenty of drama, even before it stretched to extra innings. El Duque didn't need me to get him fired up. He didn't quite understand how the starting rotations for playoffs worked, and he was fuming when he didn't get a start in the first three games. He showed why he had the best winning percentage of any pitcher in postseason history to that point. He didn't get the win, but he left his guts out on that field. He was coming off a season shortened by toe surgery, and I think he wanted to ram that foot up home plate umpire Ed Rapuano's butt in the third. He gave up a huge home run to Mark Grace the next inning. I had a feeling he was going to take that personally, and he did. El Duque being El Duque, when Joe took him out in the seventh, he took a detour before going to the dugout. He said a few things to Mr. Rapuano, smiling

before he went to the dugout and with Yankees fans cheering him. I think he also took a little bit of everybody's life expectancy into the dugout with him after working around four walks and four hits.

We were still down by two with two outs in the bottom of the ninth, but we had a chance after Paul O'Neill had one of those great at-bats, working the count to 3-2, spoiling a pitch, and then singling. That was important, because Arizona's closer, Byung-hyun Kim, had just entered the game and we got to see all his pitches. Bernie struck out, but after seeing how Kim had gone after Paulie and Bernie, Tino had a pretty good idea, he told me after the game, of what to expect. Also, Paulie had told him that Kim came after him with a fastball to start and to look for it. With two outs, Tino jumped all over the first pitch to tie it with a home run. I was in the on-deck circle and was there to greet him at the plate, jumping up and down with excitement. Tino was as excited as anybody, and his cartoon-character eyes were bugging out of their sockets. The crowd was so into it that even though Tino and I were screaming at one another, we couldn't hear what was being said.

With the game tied, I knew that my job was to get on base somehow. I had to take a couple of deep breaths just to calm myself. I stayed disciplined and worked a

walk, got to second on a single, but was stranded there. The game went to extra innings. Next inning, enter Derek, exit the baseball, and the Series was tied at two games apiece.

Derek came up with two outs in the bottom of the tenth. He battled and battled Kim in a nine-pitch at-bat before hitting a home run to right field for his first walk-off home run in a Yankees uniform. As usual, he picked a pretty good spot. I had a pretty good spot myself to view it from—I was standing in the dugout, and when he hit it, I wasn't sure that it had enough to get out. I ran onto the field, almost to the first-base coach's box, and when it went over, I jumped up and down, screaming my head off and running toward home plate. Everybody was out of the dugout—and I mean *everybody*—and we mobbed him at home plate. Derek had this look on his face like everyone pounding on him was really hurting. He'd jumped and come down funny on his ankle and twisted it. He didn't say anything, but the next day he came in early for treatment and taping.

You had to figure that the advantage was in our favor for Game 5. The old line about momentum being your next day's starting pitcher would have told you that. Coming into that season, the Diamondbacks' Miguel Bautista had a *career* record of 15-31. Mike Mussina

had won 15 games in a *season* seven times to that point in his career. It wasn't like Bautista was an inexperienced rookie. He was tough on us, holding us scoreless until he left with two outs in the eighth. Greg Swindell came on to get the last out.

I don't know if I could ever be a manager. I'm a little too hot-tempered, and I don't know if I could have brought in the same closer who'd blown the save the night before to try to close another one out. I mean, if it was Mariano, I'd have no doubts, even if he had thrown 61 pitches like Kim had. Regardless, we were pretty happy to see Kim coming in to start the ninth.

The thing about submariners like Kim is that they can get movement on the ball, especially down in the zone. A lot of sinkerballers will tell you that when they're too rested, feeling too strong, they don't get as much sink on their pitches as they want. Another thing about those sidewinders is that the first time through the lineup, their delivery can be deceptive. But we were all seeing the ball pretty good off of him. It was easier to face him as a lefty, since the ball didn't seem to come in from behind you, as it did for righties. Also, with runners on base, he wasn't able to use the hesitation in his delivery that could throw us off-balance. Those 61 pitches had come against 13 batters, so all of us, even the guys on the bench, had gotten a chance to watch

closely and get adjusted to that arm angle and release point. I sat in my usual spot next to Joe and asked, "Are we taking a pitch?"

"No. If it's there, jump on it."

After a first-pitch ball, I got one that was flat and fat and drilled it to left. Standing on second, I was pounding my hands and urging the guys on. I was still standing there cheerleading when, two outs later, Scott Brosius came to the plate. To that point, as a team, we were only 1-for-24 with runners in scoring position. But I had a good feeling. In Game 4, Kim had retired Brosius twice, once on a strikeout and then with a fly-out on an 0-1 pitch. That first strike had been a well-struck, deep foul ball. Scott was on that pitch, but he was really on the first strike that Kim gave him. His home run was a few rows into the seats to the left of the bullpen.

We receive video compilations of the World Series, and that's one that I can watch over and over. Still, there's nothing like being on the field when that happens. You're down to your last out, and then you get this shot of adrenaline that just electrifies your body. I crossed home plate with my arms and legs tingling. Even when I went to put my gear on after all the commotion had quieted just a bit, I felt light, hollow, almost as if gravity didn't have any pull on my body.

Mariano gave up a couple of hits in the 11th, they bunted the runners over, and we intentionally walked Steve Finley to load the bases. Reggie Sanders was coming up, and the scouting reports had told us that he was a low-ball hitter and had trouble with pitches up in the zone. We played for the double play up the middle, and Joe made the right move. Sanders lined one toward the second-base bag, and Alfonso Soriano made a great diving catch. If we hadn't pulled the infielders in, he might not have gotten to that ball. One out later, I was in the dugout feeling that feeling again. And I was overwhelmed by that same sensation in the bottom of the 12th when Soriano drove in the winning run and Frank Sinatra started singing and we'd come back again after trailing in the ninth, the first time that had happened twice in a World Series. New York. New York.

We couldn't finish them. I don't know what to say about the 15–2 game except that the second, third, and fourth innings were like those horror movies I always try to avoid seeing. It was clear that they had figured out something, either our signs or something we couldn't see that Andy was doing to tip his pitches. We couldn't get anything past them, and that just didn't happen with Andy.

Whatever the feeling was that we'd had in New York was gone that day. At least we had a Game 7 to look

forward to, but then the thing that none of us expected to happen did happen. Mariano had been so good in the Series, in his whole career, but when he blew the save we got a taste of what we'd been forcing down the throats of a lot of other teams all season. I didn't like the taste of it at all. Adding in the disappointment I felt in having let down the fans and the city, it was even harder to come to terms with not winning the last game of the year.

What I remember most is how quiet that locker room was and seeing Mo at his locker staring straight ahead. I walked up to him and held out my hand. He shook it and I said, "You don't have to do this."

He nodded his head. "I know. But I need to. The sooner the better," he said of having to face the media. "I made a couple of mistakes. They hit them. There's nothing I can do now. The sooner I talk to everybody and answer their questions, the sooner I can put this behind me. I'll be better next time. I just wish we could have done it for the fans."

A lot of players say words like that, but I knew that Mariano really meant them and would do what he said. He had that closer's mentality. He wanted to be in there with the game on the line and was willing to accept the consequences when things didn't go his way. We'd all contributed to the loss, but Mariano was there to take

the blame, hold himself accountable, and then do whatever it took to make sure that it didn't happen again.

We hugged and I walked away, knowing that he wanted to be alone to get his thoughts together before the media came in.

A crowd gathered to greet us when we arrived in New York, and later people kept thanking us for our effort and for what we'd done for the city in its time of need. I didn't know how to explain to them that the city had been there for me and for us, my family and my Yankees family, in ways that they didn't know.

We'd all been through some tough times, individually and collectively, and I was better able to put that loss and the game in perspective than I'd have been able to do without the events of September 11, 2001. In looking back, I realized what it meant to play with the Yankees, for New York. Those are little words, "for" and "with," and they may seem kind of interchangeable, but if the fans rooted both for us and with us, it felt more like the latter after that year. I wanted the feeling of disappointment and frustration at having fallen short of our goal to end, but I wanted that feeling of "with"—the fans rooting *with* us—to stick with me and my teammates, my family, and my friends. I wasn't just working hard *for* them, I was doing it *with* them.

Ultimately, I learned that what happened in that Stadium mattered to people in a way that I don't think I had fully appreciated or understood before. I knew how much winning mattered to me and to my teammates, and though I understood now that other things mattered more, that didn't mean I had to care about winning any less.

I can point to the events from September 11, 2001, to the end of that season as marking a turning point, a time when my affection for and commitment to the Yankees franchise, its fans, and the city only deepened. I can't find a similar marker, though, to indicate when or where the long stretch of failing to bring home a championship really began. When a drought begins, no one really notices those first days or even weeks of dryness. It takes time for those days to pile up before you notice how the landscape has been transformed. In many ways, though, that analogy doesn't quite work. It wasn't as if the team fell into a shambles and we struggled to make it to .500 or even to the playoffs.

I pointed out previously how consistent we were with our record and our winning percentages over the bulk of my career. I don't think I can say the same thing about the losses, though, because it didn't seem like

there were consistent reasons for them or consistent connections between them. Everybody, including me, wants a nice neat explanation for why a bad thing happens, but we don't always get the comforting answers we want to hear.

In a lot of ways, those Diamondback losses point to that. As difficult as it is to lose to a team 15–2, at least you can say you flat out just got beaten. But all the close ball games could have gone either way, and those are much harder to put behind you. I do think that it's possible to do your job, to execute well, to want to win as much as the opposition, and still lose. Luck does play a part in games. We usually refer to it as "breaks," though I'm not sure why. I do know that in 2002, after that hugely disappointing first-round loss against the Angels, I came out and said that they wanted it more than we did. I intentionally made that statement in the heat of the moment because I wanted to piss people off. Not because they didn't actually want to win, but because I knew that what got me going was to be angry. I wanted to carry some of that anger forward into the next season, to motivate us to do the off-season work we needed to do.

Sometimes when a team doesn't win you can point to a diminishment of skills or productivity, but that wasn't the case in 2002 at all. We had a great club. Jason

Giambi added a big bat to our lineup. As a team, we finished first in the American League in runs, walks, on-base percentage, and slugging percentage, and second in home runs. We ranked near the bottom in triples and strikeouts. That last one was always a concern to me, but the nature of the game had changed. Putting the ball in play, doing the things that people refer to as "small ball"—that just wasn't a part of the culture of the game at that time. Fans came to see guys mashing, and salaries rewarded that approach. There's no way, though, that I'm saying that emphasis on the big blast was responsible for our losing to the Angels. We struck out 25 times in that four-game series, to the Angel's 18. Not huge numbers or a huge difference, but maybe the outcome had something to do with when those strikeouts occurred? I know that we preached and preached having a good and patient approach at the plate. I don't think we abandoned that approach in that series, but were we getting away from it?

In the two years prior, we ranked eighth and sixth in that category, with 36 and then 64 fewer strikeouts. But we also finished with far fewer runs scored. So what does that tell you? You can look at the numbers and twist things around to make just about any point you want, but that still doesn't explain the loss to the Angels. I was pissed because we had some guys,

me included, who'd had really productive years that wound up meaning not a whole lot. I hit .268 with 20 home runs and 99 RBI. As much as Wade Boggs loved sevens, I hated nines. Batting .299? Terrible. Hitting 19, 29, 39 homers? Bad. And 79, 89, 99 RBI? Bad.

I remember coming to the plate with the bases loaded in a game early in September of that year and striking out. I came back into the dugout and looked at Derek and said, "Watch. I'm going to end up with 99 at the end of the year. All I had to do was put the ball in play, and I couldn't." Sometimes I wish I wasn't so smart. Another All-Star appearance and my third Silver Slugger Award in a row were nice honors, but who remembers that? I was grateful for the recognition and don't mean to diminish what I accomplished, but that season that's how I felt about myself and about the rest of the guys.

I take a lot of pride in handling a pitching staff, and we were in the top five in every major statistical category except losses—which is a good thing—and hits allowed, where we finished sixth. We were well below the league ERA average of 4.46 at 3.87. We got great contributions out of the bullpen, with Ramiro Mendoza winning eight and Mike Stanton winning seven. That part of the game hadn't changed in my time in the big leagues. Everybody was mixing and

matching and monitoring pitch counts. We didn't have a 20-game winner—David Wells was back with us and won 19 that year—but only three guys in the entire league reached that mark. As a team, we had an ERA of 8.21 against the Angels, and we averaged a little more than six runs a game. I take responsibility for that. I always looked at it that way. If the staff wasn't being successful, it was on me. I didn't have a great series at the plate or behind it. I know that taking the blame can come across as arrogant, like I think that, as Jorge goes, so go the Yankees, but my mind-set was always that if I didn't do my job, if I didn't help the team win and the staff do well, then the blame was on me.

The best thing to happen to me in 2002 was the birth of our daughter, Paulina, in July. I think she entered the world feisty and funny and fearless, and she's stayed that way.

Laura and I were relieved that Paulina wasn't going to have to endure what Jorge was going through. He was holding up well, but having him go through a third major surgery in three years was agonizing for us all. Fortunately, there were a lot more bright spots, including his first All-Star appearance in Milwaukee. Lots of kids were around the festivities, and Jorge was doing so much better that he got to attend the game. I was down on the field when I saw him and Laura.

I waved her down and took Jorge from her. He was in a little Yankees uniform with a hat and everything. He hung out with me during batting practice, and I was feeling great about him being there with me. Then I had an idea, but I kept it to myself. I put eye black on his cheeks and then I told him, "When you hear the man say 'Jorge Posada,' I want you to run out there." I pointed to the field, and his eyes lit up.

Of course, I probably should have been a little more specific. He ran out there right on cue, but I didn't tell him to stop when he got to the other guys on the foul line. I yelled out to Manny Ramírez to grab him and he did. Jorge got a huge ovation. I don't know how many people there knew the whole story, but being able to be there with my son like that? I can't even tell you.

He is a tough kid, and having to endure what he's gone through makes me feel like I had it so easy by comparison, and it's true. Laura and I remain so grateful to Dr. McCarthy and later Dr. Ernesto Ruas and Dr. David Staffenberg, who all eventually operated on Jorge. It isn't easy to put your child's life and future in anyone's hands, but those surgeons always made us feel like we'd made the best possible choice in trusting them and their guidance. I had a lot to be thankful for in 2002, and with that gratitude to balance my anger and disappointment, I was ready for 2003.

I know that there's no way to talk about 2003 and the playoffs without discussing what happened against the Red Sox in Game 3. It was a regrettable incident that in my mind had only one cause—Pedro Martínez. There are a lot of unwritten rules in the game of baseball for how we conduct ourselves as professionals. In all our minds, the ones that have to do with not purposely injuring another player trump all the rest. You don't fuck with a man's career. You don't throw behind a man's head. You do that and you're not a man, in my opinion. You also don't throw a 72-year-old man to the ground. I'll admit that I jumped all over Pedro verbally for what he did on that day. I let my emotions get the best of me. If anybody thinks that I crossed a line for doing so in any way, shape, or form that compares to what Pedro did in taking the risk of hitting Karim García in the head and seriously injuring him, or in tossing Don Zimmer aside, then we don't exist in the same world.

All you need to know about Pedro Martínez as a person was revealed shortly after he was voted into the Hall of Fame in January 2015. At a time when he was being recognized for his accomplishments as a pitcher, he decided to set himself up as an example of one of those people I mentioned earlier—the great athlete

who's a lousy human being. Why Pedro, who was already being lavished with attention, would choose that moment to come out and talk about deliberately hitting batters isn't a mystery to me. He loves and needs attention. The spotlight on him wasn't bright enough, so he decided to intensify it. All he did, stupidly, was to shine the light on the darker side of who he is.

In Game 3, he was being roughed up and he took the coward's way out. In January 2015, when he was being treated with great kindness and respect, what he chose to do next was not out of character for him. Pedro showed that the best side of him isn't worthy of respect, admiration, or kindness. Those of us who have played the game at the highest level know that Pedro's going after opposing teams' hitters put his own teammates in danger. You can do something that puts your team at risk of losing by doing something to get ejected—like punching a water cooler, a door, or whatever—and that's stupid and selfish. But when you do something that puts another guy at risk of serious injury, that's the height of stupidity and selfishness and shows you have no respect for the guys on your side. As a teammate, you're supposed to have your own players' backs, not put a target on them. That's cowardly. That's stupid. That's not how you should play the game. When you

lose the respect of your peers and your teammates, you've suffered the worst kind of loss there is.

Todd Walker, the Red Sox second baseman who was an unfortunate victim of Pedro's stupidity, put it best. When asked about Karim García going into him to break up the double play like he did, he said, "The intent was not to take me out but to do damage, and I was very upset about that. But if I were him, I'd do the same thing in that situation." Todd Walker understood what Pedro had done to him, just like we understood it. He understood that we couldn't let Pedro get away with throwing behind a hitter's head. Somebody was going to have to pay for what Pedro had done, and Pedro wasn't going to bat. I respect Walker for saying what he did, just like I respect their manager, Grady Little, and the rest of the Red Sox who acknowledged that the pitch that set things off, a fastball inside to Manny Ramírez, was nowhere close to hitting him. Why did Manny act like a pitch had low-bridged him? Because he apparently believed that we were going to retaliate, so on a pitch that wasn't even close to him, he reacted like he did, hoping that would be the end of it. It wasn't, thanks again to Pedro Martínez.

It's too bad that fight took attention away from what was a great series and a great Game 7. That game has been described as a case of the "Curse of the Bambino"

for the Red Sox, but it was more about the patience and determination of the Yankees as we came back from a 4–0 deficit to tie them in the ninth. Jason Giambi came up big for us, homering twice off Martínez in the fifth and seventh innings to bring us close. Bernie's single in the eighth brought us back to within two after David Ortiz homered. Our eighth-inning rally started with Derek doubling off an 0-2 pitch. Bernie singled, Hideki Matsui doubled, and I came up. I could hear Derek shouting at me, urging me to stay back. We all could see that Pedro was losing something off his fastball, and on a 2-2 count, I got enough of one to double to center field to score both runners and tie the game.

No matter who was on the mound, that was an incredibly satisfying moment in one of the tensest situations I can recall. After what we had let happen in 2002, we had to reclaim our title of American League champions, and we had to get to the World Series. And if it meant using a Muhammad Ali strategy to rope-a-dope an opponent, so be it.

With all that had happened before, having the game-winner come from Aaron Boone, who hadn't started the game and was struggling a bit with the bat, was sweet. It happened so quickly that I felt like one second I was coming into the dugout and the next I was running back out onto the field. I knew what had

just happened, but that crazy disconnected sense of not really being in my body happened again, and I loved it.

All that intensity of the ALCS made what happened in the World Series that much harder. I can never accept losing, and the loss in that Series especially was one that I refused to accept on nearly every level. I didn't have a good Series at the plate, and I didn't do my job with the pitching staff. Congratulations to the Marlins, and bad on me. Bad on all of us. Time to turn the page.

Chapter Fourteen
Painful Changes

On a personal level, the end of the 2003 season and the loss to the Marlins was a huge disappointment because I'd had the best regular season of my career to that point: All-Star, Silver Slugger, 30 home runs, 101 runs batted in, a .286 average, and a career single-game high of seven runs driven in. Those better power numbers (a .516 slugging percentage) didn't come at the expense of my on-base percentage (.407). I thought that not only was that the best regular season of my career, but that I deserved some votes for the Most Valuable Player Award (I finished third in the balloting). I wasn't even thinking about the award until Bill Madden, one of the sportswriters for the *New York Daily News*, sat near me in the dugout during a playoff game and said to me, "I voted for you as the MVP." I looked at him and felt a chill.

One of the other reasons I was upset about how 2003 ended, and in particular how I ended it—hitting only .222 with seven runs driven in during 17 postseason games—was that I had spoken my mind after the 2002 postseason and said that the Angels wanted it more than we did. Derek was the captain—and deserved to be—but it wasn't like him to come out and say something publicly. I said what I did in the heat of the moment, but also because I wanted to give the rest of the guys as well as myself something to think about for the next season.

I didn't back up my own words in the 2003 playoffs, that's for sure. As I tried to diagnose what had gone wrong at the plate, I struggled to come up with a convincing answer. Although preparing for the pitching matchups in the playoffs was a priority, I didn't think that I'd reverted back to doing what I'd done early in my career, when I focused so much on my defense that my offensive contributions suffered. Sure, the pressure is more intense in the postseason, the scouting reports are more detailed, and more is at stake with each pitch that you call, but I approached regular-season games with the same intensity, and I'd been doing that for years. All I could guess was that perhaps I was burned out—maybe I'd let my intensity and passion get the best of me.

I thought of myself in 2003, and even after, as baseball young for my age. Because I made the transition

to catching later in my career, I didn't feel like I had as much wear and tear on my body as somebody my age who'd caught his entire career. Joe was great about giving me strategic rest breaks and letting me in on deciding when to take them. He would come to me and we'd review the schedule and go over when it made sense for me to take a break from catching by taking a day off entirely, working as a designated hitter, or playing first base.

Over the years I'd heard both Joe and Derek telling me some version of the same thing: I needed to relax. I needed to stop putting so much pressure on myself. That wasn't who I was, though, and I wondered if I'd ever be able to do that and whether you should ever try to be someone you're not.

I didn't hear anything about easing up or relaxing from my dad. Mostly, we talked about my hitting stroke. If he noticed anything, he'd point it out, but he wasn't going to give me big-picture kind of advice like that. Maybe the pressure I was putting on myself had resulted in some swing flaw or being overaggressive or too defensive, but my dad—ever the scout— usually focused on the mechanics of my swing and not my mental approach. He'd ingrained in me the habit of working hard and the perfectionist approach. That approach had gotten me to a good place in my career,

so in his mind, it had paid off and there was no reason to stop now.

Whether it was a problem with my swing or my intensity level, I didn't really think that burnout was my problem. Tough as that season was, I didn't think that I was any different from any major league player who got to the end of the season and then spent the first few days mostly collapsed in bed.

I know that's an interesting word choice considering what happened in 2004 in the playoffs against the Red Sox. If I thought we had a strong lineup in 2003, getting Alex Rodríguez in exchange for Alfonso Soriano only made us even better. Like Rocket before him, Alex came to us with a long track record of success. We all knew what he could do, and he did just that in 2004. In the first four years he was with us, he won the MVP Award twice. That wasn't surprising if you knew that from 1996 to 2010 he received at least some votes for that award every year.

Despite all of the talk of the rivalry between Alex and Derek that preceded his arrival, Alex fit in well with us. He's a friendly guy, and even though we weren't real tight, I liked him and really liked how he played the game and approached his job.

Besides, we were used to having a lot of different personalities on the team. While there were several

of us who seemed to remain constant, each year the makeup of our team changed a bit, just like every other team's roster changed. Everybody on those Yankees teams knew that, because of how the Yankees operated and some of the rules we had, they had to fall in line. Nobody had to lead anyone else by the hand or say, "This is how we do things here"; guys picked that up immediately. It wasn't like we were robots and didn't have personalities and express them, but we conducted ourselves a certain way on the field. As long as you did that and performed at your best, no one had any kind of problem with you. Whether that's true on all teams, I don't know. Things worked well for us, and I don't think any of the turnover or changes contributed to our struggle to win another World Series title.

Still, whether it was because of our personnel or our playing, those struggles remained. Looking back on the Red Sox series in 2004, I know that I had no doubt in my mind that we were going to beat them. Whether that was in four, five, six, or seven games, the answer would be the same. We were going to win that series. Obviously we didn't, and I still don't have any real answers as to why.

If I differed with Alex on anything that year, it was about his statements going into Game 6 and then after we lost in Game 7. He used the word "embarrassed"

both times. I'm not saying that he was wrong, just that I had a different way of looking at it. I wasn't embarrassed. I was angry and frustrated, but embarrassed wasn't in the mix. I take too much pride in what I do and the effort I gave, and I think most of the guys felt that way. I don't want to make too much of those statements Alex made because I know that he's a proud guy and he played well and we all lost together. I just want to make a point about how we all differ in our perceptions of things. I think that Derek said it best after the game when asked about why we weren't able to put the Red Sox away. "It's not the same team. We've had teams that have been good at it, but this team is not the same team."

Derek wasn't just commenting on the makeup of the roster, but on how we performed. This wasn't the same group of guys that were relentless in going after teams and putting them away. It's not completely the same as a pitcher trying to put a hitter away, but it has some similarities. We had the "stuff" to do that—to go after a team and put them away as quickly and efficiently as possible—but it isn't always stuff that allows you to do that. You have to have that mind-set, that experience, and we had not completely demonstrated that ability like we had in our run from 1998 to 2000. You can go back and look at those numbers again, but I'll quickly

restate them here: We were 16-1 in those three title-winning series. Maybe that 2004 team needed to learn not just how to win but how to have a sense of urgency. More likely, I think, is that, as talented as we were in later years, there was something about those earlier teams that was rarer than we knew.

Good chemistry on a team often comes from winning, but it also comes from other sources that aren't always identifiable. Joe Torre was better than anybody else when it came to providing an environment for us to be successful. He helped us to find the other ingredients of that magic formula. That's all a manager can ever do—create for players the opportunities and environment that give them the best chance to succeed.

Before each playoff series began, Joe would sit down with us and have a meeting. At the end, he'd ask me, "Georgie, how many more games do we need to win it?" I'd tell him the number, and then he'd ask, "How are we going to do it, Georgie?"

"Grind it," I'd answer.

And that was how we approached those games. "Grinding it" meant paying attention to every detail, giving it your all, and doing anything and everything it took to win. It didn't have to be pretty. It didn't have to be spectacular. You just had to compete as hard as you

could all game every game. Even when we lost, I still felt like we were grinding it, but maybe I was hoping more than seeing. All I know is that in '98 we had the term "grind it" engraved on the inside of our World Series rings, not visible to anyone seeing it on my hand but there for me as a reminder.

That we didn't succeed to the greatest extent possible, both in 2004 and in subsequent years, is on us, on me, and not on Joe or anyone else in the organization. We didn't rise to the occasion; in 2004 the Red Sox did. Our bad. Congratulations to the Red Sox for their title run.

Similarly, there's no easy explanation for our early exits from the playoffs in 2005 and 2006. Over the years we added some really talented guys to the mix—Robinson Cano and Hideki Matsui in particular—but just didn't get it done. It was great to have Tino back on the ball club, but he didn't have the kind of year that was typical of him in his prime. He was still combative, still wanted it, but I got the sense that if he couldn't perform the way he wanted to, then he'd leave the game, and he did.

At 41 years old, Randy Johnson joined us, and his stuff was still nasty. I think that, like me, Randy needed to be angry to perform well, and he seemed to find a lot to be pissed off about in New York, including me. He

would show me up by raising his arms in frustration when he was looking in for a sign and didn't like what I was putting down. That didn't happen all the time, just mostly when he was struggling. I was willing to take responsibility for the staff and how they performed and to shoulder the burden or the blame, but I didn't like, and wouldn't tolerate, having someone else put it on me. In one game in Detroit, I got really pissed off and confronted him. We almost fought but Joe pulled me away. Randy apologized the next day. John Flaherty took over catching him. I didn't like the idea of giving up, but I needed rest days, so that approach seemed to work for everyone.

Those kinds of things will happen, and it's funny to look back and realize that I was once intimidated by some of the veteran guys on the staff but later got to a place where I wasn't going to put up with another veteran's shit. I guess that meant I was a veteran myself.

I'd certainly had to handle a whole bunch of diverse personalities on our staff. As a catcher, I had to be a part-time psychologist to deal with the pitchers and a part-time diplomat to deal with the umpires. I always treated them with respect, except on the rare occasion when I got tossed for arguing balls and strikes. You spend a lot of time back there with those guys, and I think because we have to battle some of the same

things—like foul tips and wild pitches—you have a little of a soldiers-in-the-trenches thing going on with them.

I did achieve some personal highs along the way. In 2005, my 175th career home run tied me with Bobby Murcer for 16th on the all-time Yankees list, I hit a home run from each side of the plate in one game for the sixth time in my career, and I was third on that all-time list behind Bernie and Mickey Mantle. By the time 2006 ended, I had climbed to 11th in home runs in Yankees history and third behind Yogi Berra and Bill Dickey for the most by a Yankees catcher. Seeing my name mentioned along with some of the franchise's best and most popular players was great. I also was doing okay in comparison to my contemporaries. From 2000 to 2006, I had more RBI than any other catcher in the big leagues during that span, and Mike Piazza and I were tied for first in home run totals. I was in the prime of my career, still being productive, but those damn playoff losses haunted me.

Heading into 2007, I can't say that I did anything different in terms of the quantity of work I was doing, but the quality of it got better. That was especially true of how I ate. I'd always been pretty good about not eating a lot of junk food and snacks. The lone exception was drinking a big glass of milk or chocolate Nesquik

before bedtime as a recovery drink. Fortunately, Laura was on top of the latest food and fitness research, she was my stretching buddy, and she made sure that the kids and I ate well-balanced meals. It wasn't enough for her to just read a book about these concepts or to have someone at the gym plan her workouts or to ask a nutritionist to give us meal plans. Back then, she took classes to become a certified fitness professional so that she would be in control.

On the road, I brought along those principles I practiced at home in a more concentrated way in 2007. When you're on the road half the season, it's easy to fall into restaurant habits—large portions, desserts, and all that. I knew that I couldn't eat like I had as a younger player and that I couldn't work out the same way either. Making adjustments was important.

I can't attribute all of my success in 2007 to just those off-the-field habits. I think that hitting 60 points higher than I had the year before—I batted .338 for the year, establishing a career high in batting average, doubles, and slugging percentage—was the result of a lot of things coming together. For one thing, Jorge was doing much, much better. He had surgeries each year from 2000 to 2002, skipped 2003, then had them again in the off-season in 2004 and 2006. Now he was having a break from surgeries until 2010.

More important than being able to take a break from the anxiety over those surgeries was what I'd learned from seeing what Jorge went through. I was still intense, and I still put a lot of pressure on myself, but I was also more patient. For the first time in my life, I was better able to put things in perspective and actually listen to what Derek and Joe had been telling me all those years about relaxing. Jorge was a happy, active kid, and I was feeling more secure in my position as a veteran who knew the pitchers, and all that just came together in a way that made me even more eager to come to the ballpark every day.

At the same time, I faced another challenge that was ramping up my "I'll show you" mind-set. I was in the last year of my contract, the Yankees hadn't negotiated a new one, and it looked like I was going to head into free agency for the first time in my career. I understood the economic realities of the game, but I'm human: I wanted to stay with the Yankees, and I thought I'd demonstrated my value to the team.

That 2007 season my average never fell below .311 and I never went more than three games without getting a hit. Finishing in the top five in hitting is something I can look back on with great satisfaction. When you do that, when you hit for a high average and still have decent power numbers like I did (20 home runs

and 90 RBI) while finishing third in the league in on-base percentage (not striking out a lot), that means that you're being consistently good, consistently disciplined, and consistently well prepared.

And okay, it is also a hell of a lot of fun. I'd come to the ballpark and Derek would ask, "So, how many hits are you going to get today, Ted?" Referring, of course, to Ted Williams. I was doing so well that every well-struck ball, and even some not-so-well-struck ones, found a hole. Guys were coming up to me and rubbing me for luck—I'd find their bats in my locker when I showed up the next morning. I knew that they were hoping some of my luck could be transferred to them.

At first, my dad, who really, really wanted me to hit more than .300, was very serious in his reminders. But toward the end of the season, when I was still in the top five in the league, he'd get on the phone and start laughing. "Unbelievable," he'd say, stretching out the word with great delight.

That was as close as my dad came to stating right out that he was proud of me. Even after all those years, we hadn't changed in how we communicated with one another, and that was okay with me. I knew he was proud; how he said those words and how he laughed communicated more and meant more to me than if he'd been constantly saying, "Good job" or "Proud of you."

I didn't need that from him because it would have come across as insincere and out of character. In a way, it would have been like him speaking a foreign language to me, sending an awkward and confused message. We spoke a language between us that had its own rules and meanings and that worked for us at that point in our lives. I didn't need his approval or his acknowledgment of what I was doing. It was enough to know that my performance on the field and as a father was giving him pleasure.

Only when it was over and I saw our official press guide for the 2008 season was I really able to put my performance in perspective. Offensively, according to the numbers, I'd had one of the best seasons at the plate of any catcher in the game ever when you factored in my average, home runs, RBI, and doubles. That was pretty cool. By hitting more than 20 homers for the seventh time in my career, I was in pretty good company. All-time, I was eighth behind Piazza, Bench, Berra, Carter, Fisk, Parrish, and Campanella. I was also proud of my record of durability: to that point, despite numerous dings and tweaks, I hadn't been on the disabled list a single time with the Yankees.

Yet, once again, despite the strength of the regular season for both the team and myself, we basically got shut down in the playoffs against Cleveland. As a team,

we batted .228 in that ALDS, after hitting .290 during the regular season and finishing at the top of the league in that and every other major offensive statistical category. I can understand the fans and the media being upset and making all kinds of wild guesses about what went wrong. Believe me, I was asking myself the same questions, and I think every guy on the roster was asking them as well. We hit a lot of balls hard, but right at people. I know that some writers compared the invasion of insects in Game 2 at Jacobs Field with the plagues from biblical times. It certainly felt a little like our supply of luck—especially mine—had been chewed up that regular season.

I didn't find this out until later, but there was a lot more on the line than just a chance to play for the American League pennant in that Division Series. Management felt that changes needed to be made: if we didn't win that series, Joe was going to be out as manager. They later changed their minds, but they put conditions in his contract offer, along with a cut in pay, that Joe couldn't agree to. He was out as manager, and that was it.

I was shocked. I didn't know if letting Joe walk was intended as a wake-up call to the rest of us, but as the old saying goes, you can't fire the whole team. As I've

said before, those losses were on us, not the manager. Whatever else was going on behind the scenes was not my business. My job was supposed to be taking care of business on the field, and I didn't do it.

Though I tried to keep away from management concerns, that doesn't mean that I wasn't hurting for Joe personally. I know he loved his time with the Yankees. Shortly after I heard he was not coming back, I spoke with him. I thanked him for how he treated me, what he taught me, and for being my "father on the field."

"Georgie, thank you for saying that. Thanks for everything you did for us. You were special to me. I don't want you to worry about me. I'm going to be fine. We'll both be fine, and we'll keep in touch."

The conversation was short and to the point. We both knew how we felt, but we still had to say it. I could also hear the hurt in his voice. I knew we'd keep in touch, and we've done that to this day. Your on-field dad might not still be occupying his usual seat in the dugout, but that doesn't mean he's lost his place in your heart.

Like a lot of people, I was concerned about who the Yankees were going to bring in to manage the team, and when I heard that Don Mattingly was being interviewed, I was really, really happy. I had so much respect for him, and I knew that he had been a big part of the

franchise for so long. I felt like it was important to have somebody who had Yankee bloodlines, who knew how the organization operated. I'd grown up as a Yankee, as had Derek, Andy, Mariano, and Bernie. Hiring Don was like keeping it in the family—because he'd been on Joe's staff, we all knew one another, and knew how things should be done. So even though there was going to be a change, it wasn't going to be a drastic one.

When Don didn't work out, and the Yankees hired Joe Girardi, I was still very excited. Though not quite as entrenched in the Yankees family as Don, Joe had obviously been with the club as a player, and I knew him. After he got the job, he reached out to me to talk a bit, but mostly just to tell me how excited he was to be able to work with me. I was looking forward to working with him as well. Having a manager who, like Joe, had played the same position was going to make things easier. I was excited to get back to playing and hoping the continuity would be helpful.

The same was true with how I felt about the Yankees. That I didn't seriously test the waters of free agency and agreed to a contract shortly before becoming a free agent tells you what you need to know about my feelings regarding the organization that had been so good to me. I later found out that one other team was really interested in having me and was prepared to

beat whatever offer the Yankees made, but I wouldn't have signed with anybody else. That maybe wasn't the smartest business move, but it was the right move for me and my family—both my families.

Re-signing with the Yankees didn't change the fact, though, that my baseball family was shrinking. As it became clear that Bernie wasn't going to be offered a contract, I was hurt. It wasn't my business, and I certainly wasn't being paid to consult with management about personnel moves, but when a friend is hurting, you hurt. I may have understood the personal side of things more than the business side, but I have to say, I felt like Bernie could still help the team and had shown that he'd be a valuable contributor on a part-time basis.

Guys I'd been close to had left the team before, so this wasn't a case of first-time pains being the worst. I was torn about losing Andy after the 2003 season. I knew that Andy missed his family—he'd often go home on one of those rare off days we had to be with them. His contract was up after 2003, and during the 15 days the Yankees had to sign him before he became a free agent, they didn't go after him hard, wanting to honor his desire to test the free agent market.

Communications often get mixed up this way. Andy's an honest guy, so when he was asked about how it all happened, he told the truth. He really didn't

think that he was going to be anywhere else than the Yankees. But when he became a free agent and the Astros offered him a good deal that would allow him to be closer to home, he started to think that was best. By the time the Yankees made him an offer, lower than what Houston offered, he'd already committed to the Astros and wasn't going to go back on his word. I felt both good and bad for him: he couldn't get both things he wanted. I also felt bad for us and for our pitching staff because Andy was such a good example to have around. Fortunately, he signed to come back to the Yankees for the 2007 season, and it was great to have him back. I'd missed having him around. Andy had a solid year in 2007, and he was set to anchor the 2008 staff.

In the winter of 2008, a baseball family matter came up just before we reported for spring training. I got a phone call and heard Andy's familiar voice. He told me that he needed to talk to me about something. I could hear something different in his voice. Andy told me that the Mitchell Report was about to come out and he wanted me to hear this from him. Andy was named as one of the guys who had tested positive for a performance-enhancing drug. I knew Andy well, and I figured that there had to be some kind of extenuating

circumstances, and there were. He told me about the times he used human growth hormone.

"Georgie," he told me, "I did it because I was hurt."

He had heard that the stuff could speed up your healing process. The Astros had paid him all that money and he wanted to get better and get back out there and earn it. He also said how embarrassed he was, and he hoped I'd understand.

"Andy, I appreciate it, but you don't owe me or anybody else an apology. I know the kind of guy you are. You don't have to worry about me thinking any less of you. We've been through a lot. You've always been honest with me. You're going to deal with this, and we're all going to move on."

He let me know that he was going to talk to the media, and he hoped that would help put an end to it. The media stuff was getting out of hand, and it was better to get it out of the way as soon as possible. We had a season to worry about.

At that point, though, I was more worried about my buddy than the season.

I showed up the day of the press conference and took a seat alongside Derek. Mo was sitting on Derek's other side. We hadn't spoken about Andy's press conference and hadn't made a plan to meet there together. We just showed up, knowing that if Andy had to deal

with a tough thing like that, we were going to support him. That's what family does, and you don't have to plan it all out—you just do it.

I felt so bad for Andy having to take questions for about an hour, and the whole thing just made me sad that this was what was occupying all of our time and taking the focus away from what we needed to be doing. And I wasn't sad about it just at that moment but overall. I don't mean that I wanted everything to be swept under the rug, but guys had been in front of Congress, the Mitchell Report was now out, and I wanted my friend's troubles to be over with. To hear Andy talk about how torn up he was when he spoke to Mr. Steinbrenner and apologized (and Mr. Steinbrenner said what I had said—that no apology was necessary) was tough to hear. Andy took it like a man, saying that it would have been the coward's way out to retire after the revelations came out. He is a deeply spiritual guy, and I was hoping people wouldn't judge him when they learned how sincere he was about feeling he had to answer to God. He made a mistake, he owned up to it, and I was proud of the way he handled the situation.

It's kind of an odd coincidence that during that 2008 season I got a better understanding of the pressure Andy felt to get back on the field quickly to earn his money. I was soon worried that the Yankees were

going to regret their decision to sign me when, during a game late in spring training, I fielded a bunt down the third-base line, grabbed it, spun, and threw to first, all in one motion. I felt a burning in my shoulder, like nothing I'd ever felt before. I tried to ignore it and didn't say anything to anybody, but when it was still bothering me the next day, I went to Gene Monahan, our longtime trainer, and told him. An MRI revealed that I had a tear in my labrum, a muscle that is part of the very complicated shoulder joint. I had two options at that point: rest it and rehab it or have surgery right away. Since surgery would have meant being out for the rest of the year, I wanted to wait to see how it felt.

I was doing some exercises to strengthen the joint, and every day before the game I would see how it felt while throwing. If it felt strong, I'd catch. If it didn't, I'd play first or be the DH. I'd tell Joe Girardi how I was doing, and he'd adjust the lineup accordingly. For a while that seemed to work, but eventually, when it became too painful to even raise the bat up into position to hit left-handed, I knew it was time to get the surgery done. I played in 51 games, splitting my time between catching, playing first, and DH-ing. I hated to give up on a season, but I didn't have much choice.

I underwent surgery on July 21 at the Hospital for Special Surgery in Manhattan, with Dr. David Altchek

doing the work. He told me that when he got in there, using an arthroscope, he saw that the shoulder was worse than what the MRI revealed. I had a loose capsule as well as the torn labrum. He repaired both, but it looked like being able to start the 2009 season was in doubt. I was supposed to be in a sling for four weeks, but I couldn't deal with that. After two weeks, I had a follow-up appointment, and Dr. Altchek soon understood I wasn't going to be his most cooperative patient. So he told me it was okay to wear the sling for another two weeks only when I slept and when I was walking on crowded sidewalks. If the shoulder got bumped backward, that would be the worst thing. Let's just say that I heard what Dr. Altchek said.

The biggest regret I have is that I didn't get to play in the final game at the old Yankee Stadium. I loved that place. The field itself was outstanding, and it was such a great place to hit because of the large and very dark hitter's eye in center field. The lights were also perfect. Every park is slightly different in that regard.

As players, we were 50-50 about the new park. We heard that there was going to be a restaurant near center field, and having lights and glass out there wasn't going to make us happy. All the amenities—a state-of-the-art clubhouse, batting cages, a video room, a weight room, and all the rest—would be great. But would we

be able to see the ball like we had? Would we be able to count on the same kinds of hops like we had? Change is inevitable, but you still want to have some things you can count on.

All this really hit home for me during that final game at the old Stadium when the whole team and many old friends, including Bernie, gathered to say good-bye to the House That Ruth Built. I don't think that I could have put it as well as Derek did, but when he gave that amazing speech I felt what he was feeling and hoped what he was hoping. He talked about what an honor it was to put on that uniform, about our pride and our tradition, things that wouldn't change even though we were moving across the street. He also said to fans, "We're relying on you to take the memories from this stadium, add them to the memories of the new stadium, and continue to pass them on from generation to generation." Looking around at my old friends, I was struck by how much Derek, Mariano, Andy, Bernie, and I had been through together. In spite of that, it wasn't until Bernie had left us that I really started to think about how special it was to be part of a group of guys who'd been together for so long. I thought that Bernie still had a lot to offer the team and was valuable to us even on a part-time basis. It was kind of like how I felt about the world championship drought: when you're at the

start of it or in the middle of it, you don't really see it, but when you're forced to take a step back, it becomes obvious.

Bernie's departure from baseball brought into focus what had been so much a part of all our lives. Leave it to Bernie—he did the quiet thing that caught our attention. As much as I missed him, I knew that Bernie, like Joe, was going to be okay. The man had too many talents and interests to just fade away. We kept in touch, and still do. Just because he was gone, well, you know the rest of how that goes.

All the attention we would eventually get, the coining of the term "the Core Four," was really flattering for me, but there was another group of guys who had already been called "the Fab Five." I'm not very good at rhyming, but I know that one of the biggest reasons we had the kind of success we did as the Core Four was the guy who covered the ground closest to Monument Park in the old Stadium.

One of the great things about catching is that all of your teammates are out there in front of you and you can see them all doing their thing without having to turn around. I knew that crouching down behind the plate and looking out past Andy and Derek and not seeing Bernie out there didn't feel right. Looking to my side and not seeing my "father on the field" was also

taking some getting used to. Now, with the prospect of the Stadium coming down, it felt like things were really changing. Some things were ending, and some were starting. I was hopeful about the future, but I couldn't help wishing that things could just remain the same.

I was hurting. It didn't take an MRI for me to figure out the source of that pain. Now that I think of it, with all of those changes going on, maybe I hurt my shoulder just struggling to turn so many pages.

Chapter Fifteen
That Winning Feeling

If I thought that things were changing for us in 2008, learning in November of that year that Mr. Steinbrenner's son Hal was taking over control from his father was just a sign of more things to come.

Mr. Steinbrenner hadn't been around the Stadium as much as he once had, so there wasn't going to be a hugely noticeable difference there, but that wasn't true in the clubhouse in 2009. Mike Mussina had retired. Jason Giambi didn't get re-signed, nor was Carl Pavano. We'd traded for Nick Swisher and signed C. C. Sabathia, A. J. Burnett, and then Mark Teixeira. And Andy had come back. I didn't need a whole lot of motivation to keep up with my rehab and my desire to beat the doctor's predictions and be on the opening-day roster. I really wanted to be a part of this ball club.

Of course, being part of this ball club—and most others that year—also meant dealing with the lingering effects of the scandal over performance-enhancing drugs (PEDs). Just as had happened during spring training that year with Andy, Alex came forward, when he was confronted with some revelations about his use of PEDs, and admitted that he took steroids during the 2001–2003 seasons. I admired him for his honesty, but like a lot of people, I was tired of hearing about performance-enhancing drugs and tired of being asked about them. Andy and Alex both wanted to avoid that happening—the pressure on the rest of us to answer questions—but it was unavoidable. I knew that PEDs were around, but I was never tempted to take them. I believed strongly that hard work, and hard work alone, was going to keep me where I was because it had gotten me there. Beyond the fact that taking them wasn't fair, I'd heard about some of the side effects, the links to cancer, and I wasn't going to risk my future health.

And my health was very much on my mind since I'd had the shoulder surgery. My rehab was progressing well, but it really kicked into a higher gear in February. I met with Gene Monahan in New York on February 1 to go over our plan and then went to Tampa. He had set up a throwing program for me that gradually increased the length and duration of my throwing

sessions. I started at 30 feet for 30 throws and moved on from there. I showed up at the complex in Tampa at 7:00 A.M. every morning to work with resistance bands, light weights, and something called a UBE machine—basically a device with bicycle-like pedals that I turned with my arms instead of my feet. It provided a tough resistance workout and also increased my range of motion.

I was busy off the field as well. With C.C. and A.J. joining the staff, I had homework to do. I'd called our video coordinator shortly after they signed and had begun watching video of them. Studying pitchers is something you do as a hitter, but as a catcher you watch video with a slightly different set of concerns in mind. I'd faced both guys as a hitter, but knowing how they'd pitched to me wasn't going to be enough to help me figure out how they worked and what their tendencies were. I knew that A.J. had nasty stuff with a plus fastball, a good split changeup, and a great curveball. C.C. threw hard, but didn't have great command of the strike zone to that point in his career, though he wasn't wild. Often missing just off the plate, he used that to his advantage, frequently getting hitters to chase his off-speed stuff. I call guys like that "cheat and chase" pitchers. They get you to cheat yourself out of a good at-bat by chasing balls

outside the zone. I was eager to put C.C.'s skills to use against the opposition.

I watched all that video in preparation to talk to them when they arrived for spring training. That was the time when you really got to know your pitchers' strengths and weaknesses. I didn't just watch those six or seven quality starts I had on video. I'd sit down with the guys and ask them what they used as their out pitch, their ground-ball pitch, and their "must have a strike" pitch, along with other things. As much as I believed it was important to go with a pitcher's strengths, I also had to take the hitter's strengths into consideration. Let's use Albert Pujols as an example. He is a fastball hitter. C.C. was a fastball pitcher. So the question then becomes how to maximize C.C.'s strength while reducing Pujols's strength. The hole in Albert's swing or zone was breaking balls down and in at his back foot. C.C., being a left-hander, had that kind of breaking ball. It wasn't his best pitch, but it was exactly what we needed to get Albert out.

When we started working together, I was pleased to see that C.C. had better command than I'd originally estimated. That made him a pleasure to catch. The other thing that surprised me was how agile he was for such a big guy. Fielding bunts and covering the bag at first, he impressed a lot of us with his athleticism. Both

he and A.J. were great competitors, though A.J. seemed to take a nastier temperament to the mound. C.C. was one of those quiet, "give me the ball and let me do my job" kind of guys.

I was feeling really optimistic about our chances, and especially about my chances of being with the big league team for opening day. My shoulder was feeling strong, and I realized that I must have been dealing with some weakness in that area long before the major tear because it was feeling better than it ever had when I was hitting. Throwing was another matter. I was still having good days and less good days.

As spring training drew to a close, it became clear that I was going to be ready. I just needed as many at-bats as I could get. The last week before we headed north, I went over to the minor league camp to hit in games there. I'd lead off every inning to get as many at-bats as I could against live pitching. On one of those days, I got to face Roy Halladay, who was still with Toronto and was getting some final work of his own in. He looked at me funny when I stepped to the plate to lead off the game, and then again in the second inning: "You again?"

I nodded and smiled. I didn't tell him this, but yes, I really was feeling like me again.

Homering on opening day in Baltimore was huge for my confidence. It felt so good to be back out there in a

regular-season game. Then, with all the fanfare going on with opening day on April 16, I hit another one, the first ever at the new Stadium, off the tough left-hander Cliff Lee. I was just excited about hitting a homer and didn't think about that until I got to the bench and started to strap on my gear. "Oh my God," I said. A couple of guys looked over at me with puzzled looks. I went to the bat rack and pulled that one out and gave it to one of the equipment guys.

"I'm saving this one," I told him. That bat still sits in my office, along with other awards and mementos. I really wanted to take something from the old Stadium, like my locker, but everything was going to be auctioned off. At least I had that bat as a reminder of the good start at a great new facility.

I was pleased by how far that ball traveled. It went out to straight away center field on a cold day. Maybe that layoff had done me some good, and I know the rehab and strengthening did. I was in my 13th season in the big leagues, I was 37 years old, and I still felt pretty damn strong, strong enough to catch all 14 innings of a game against Oakland, also in April.

Yankee Stadium III was in its first year, and from the start it seemed to be doing well. I loved the new facilities, and the batter's eye seemed to be working. With our input, the walls beyond the center-field fence

had been painted a deep, deep blue, and that seemed to work. We were still going to have to wait until it got warmer to see how the ball carried there. Eventually we realized that the right-center alley was a sweet spot in a field whose dimensions were smaller than the old one. Everyone kept saying that was going to be a good thing, and it proved to be, but that was only because our pitching staff was up to that challenge.

And even when, at the end of April, we were only 12-10 and in third place, I felt like we were going to be okay. More than okay, actually. I'm not trying to pass myself off as having a sixth sense about these things, but I did feel and believe that this club was different from previous ones—especially in recent years. Something about the way we carried ourselves, the atmosphere in the locker room, reminded me of those teams early in my career.

Some of that might have had to do with Andy being back with us. He did what he'd done most of his career. On days I DH-ed, I sat with him while he intently watched each at-bat. Between innings, he'd go to whoever was catching and ask pitches and locations of outs. Andy had a habit of watching three innings live in the dugout, three innings inside watching the pitches in the clubhouse, and then coming out to watch the last three live. That was something he picked up from Jimmy

Key when he was with us. Andy's studious approach was something that other guys picked up on.

It wasn't just in 2009 that Andy served as a leader of the staff—from the start of that season, his Yankee Way seemed to be having more of an effect on guys newer to the organization and their careers. This is no knock on the veteran pitchers we had prior to that. Those guys were great, but as veterans, they were all set in their ways and didn't need to learn from Andy. He was more of a pupil than a teacher back then. Even in early 2009, I felt a little bit more of that collective sense of purpose that was an important part of who we were when we were so successful. That wasn't true only with the pitching staff. Everyone on the team seemed to be more willing to ask for insights and to help one another out than they had in the past. That was another important part of learning to win.

That's not to say that Andy was completely transformed into Professor Pettitte. It's a good thing that he didn't instruct the rest of the pitchers about his other skill—stirring things up. Andy was the best at instigating mini-disputes in the clubhouse. If I wore a suit that was a little too tight or a pair of pants that was a little too short, Andy would be there with his critiques, but in the slyest of ways. He never stated his opinion directly, but he always heard from so-and-so that you wore a

pair of floods. Eventually, I caught on, and any time someone made a smartass comment about me, I always figured that I'd somehow be able to trace it back to the big left-hander. I also knew that he'd deny everything, but the delight in his eyes usually gave him away. He was kind of like a sniper, hiding out in the weeds with his Tommy Bahama clothes working like camouflage.

Being a veteran changed my perspective as well. I don't know if, or how much, my age contributed to my hamstring troubles. I was running down the first-base line and felt a grab in the back of my leg. It was a grade 2 hamstring strain—not the mildest and not the most severe, but enough to put me on the DL and keep me out of the lineup from May 5 to the 29th. I got sent down to Tampa for treatment but continued to play and to work on strengthening my shoulder. I knew that I was going to be down there, at minimum, 15 days. I was able to catch some, but mostly I DH-ed.

I felt pretty good at first, and as each day went on I was feeling better and better. As the 15 days went by, I felt like I was getting close to 100 percent. Then I *was* 100 percent, and I was getting impatient. When I didn't get the call after May 19, my impatience increased. I kept telling Pat Russell, one of our player development guys in Tampa, to let everybody know that I was ready. Still, the call didn't come. Finally, on the 26th, I'd had

enough. I bought a plane ticket and showed up at the stadium in Arlington in time for the game on the 27th.

I walked into the ballpark and immediately went to the training room. I wish you could have seen Gene Monahan's face.

"What are you doing here?"

"I'm ready."

"Nobody told me you were coming back."

"That's because nobody told me to come back."

A few minutes later, Joe Girardi came by. He did a double-take and then laughed. "So, you called yourself up?"

"Yes, sir. I'm ready."

Brian Cashman got on the phone a few minutes later and said much the same thing. They all agreed that they had to see me run before I could play. We had a day off the next day. I came in and worked out and got the approval to play. Brian filed whatever paperwork he had to, and I started that night in Cleveland and caught Andy in a 3–1 win and went 2-for-3 to raise my average to .325. I'd missed 22 games and wasn't happy about that, but I was glad that I was no longer scared to not do anything but follow orders to the letter, like the youngster I had once been.

I wasn't the only one who showed up unannounced early that year. You hear about the "June Swoon" in

baseball. The excitement of the new season wears off a bit, and the long grind you're facing becomes a reality. I don't buy into that, but in 2009 people were looking at our struggles in the middle of that month during interleague play as a sign of that trouble. We'd lost four out of six games and were heading to Atlanta. Brian Cashman spoke up at a team meeting. He'd never done that before, and his message was pretty clear. He chewed our asses a bit. We were underachieving. I could understand his frustration. The club had gone out and made all those big changes, and they wanted better results. He also told us that we weren't going to be getting any additional help. This was the lineup, and we had better produce. We were 38-31 at the time and four games behind the Red Sox.

Things weren't looking good the next day. We were being no-hit through six. Brett Gardner walked and then got picked off first on a close play. Joe ran out to protest and got booted. But we came back to win, 8–4.

It's easy to look back at a season and talk about turning points. A lot of media people said that game was one of the big ones in 2009. Maybe it was. Maybe it wasn't. We had a really talented team, but to that point, not everyone was playing well. We knew it, but Brian's reminder did have some effect on us, mostly because he'd never spoken out like that before. As far as Joe

getting tossed, at the time I wasn't sure if he was really that upset or if that was a calculated move on his part to try to fire us up.

As a veteran, I felt like I'd seen it all in my career, so some of those kinds of tactics didn't seem necessary. However, I also know that there'd been a shift in my relationship with Joe. In 2008, because of my shoulder, I went to him nearly every day to let him know how I was feeling. We talked face to face, and he decided where or if I was going to play. In 2009 those face-to-face encounters turned into text messages. I'd be on my way to the field and I'd get a text saying, "You're playing first," "Catching," or some other quick note on my status. That seemed strange to me. I know the nature of texting is different from talking to someone, so it wasn't so much about how brief those messages were. It was about the lack of face-to-face contact I had with him. And it wasn't just about my position for the day and how that was communicated.

I take some of the responsibility for what I see now was a miscommunication between us. Joe was maybe thinking that a text was a good and efficient way to let me know in advance what was going on, but I saw it as impersonal and distancing. I wouldn't have felt that way if it wasn't for the fact that he was so different from Joe Torre. I didn't feel like I could go to him

and talk to him about whatever I wanted to or needed to. I talked about Joe Torre's empathy before, and how he set a high standard for me. He'd been there for me when I was dealing with some serious personal issues with my son. I'd thought of Joe Torre as my "father on the field." Joe Girardi was my manager.

As I've pointed out before, managing in the big leagues is about managing people and acknowledging their differences and knowing how they need to be treated. With the exception of a couple of guys, Joe didn't seem to have the same kind of open-door communication approach that Joe Torre did. Everyone has a different style, and obviously it didn't have an effect on how 2009 turned out, but for me it was a tough adjustment to make.

I know this all seems to contradict what I said about how I felt about the chemistry on the club, but that was among the players, not necessarily with Joe. The best way I can think of it is that it was like my shoulder injury: eventually something traumatic happened to make it really noticeable, but years of wear and tear contributed to it. In 2009, nothing happened that was really obvious, but damage was being done to that relationship.

Maybe it was coincidence, maybe Joe's getting tossed had its effect, but we did start to win. I was thankful for

that, and hoped that no one thought it had to do with Joe's guest speakers coming in to talk to us about the mental side of the game. No offense to those people, but I just wasn't the right audience for those kinds of approaches at that stage in my career. I'm not saying that I knew it all, but with everything else on my plate that I needed to worry about to get ready for the season and then to play during the season, I really didn't need one more thing added. I sometimes felt like I did back in school, when I'd wondered, *How is this ever going to help me?* Not a great attitude to take, I know, but that was how I felt.

Mostly I believed that talent and hard work would pay off. I saw guys doing the right things and felt it was just a question of time before things would align and we'd all start to play better collectively. By that I mean that, for a while, a couple of guys were doing well and a few others were doing just okay. When we all got in a groove offensively, we were going to be tough to beat. I'd also been around long enough to know that a club is only going to go as far as its pitching staff can carry it.

Over the years I'd come to realize just how important it is to go into a game believing that you have a chance to win with the guy who starts. We were fortunate to have the greatest closer in the game, but Mariano was only going to get saves if we had the lead. Obvious, I

know, but that meant he was dependent on the guys in front of him. So it wasn't just the starters but also the middle relievers, the setup guys, who were going to play a big role in how the season went. As it turned out, we struggled like a lot of clubs do to find a consistent fifth starter, but we had guys like Alfredo Aceves and Brian Bruney, who contributed 15 wins between them out of the bullpen, and Phil Hughes, who contributed eight wins in a starting role as well as out of the bullpen. What I enjoyed the most about the regular season was that sense that all kinds of guys were stepping up when needed.

That was true on the mound and at the plate. I wasn't there when this happened, but the guys won three straight games with walk-offs against the Twins on May 15 through the 17th. In the first of those games, we were down 4–2 going into the eighth when Mark Teixeira homered to tie it, and then Melky Cabrera got a big two-out hit to win it. The next night we gave up a lead in the eighth, tied it that same inning on a Teixeira hit, and then won it in the 11th when Alex hit a home run. The next night, down 2–0 in the seventh, we tied it on a homer by Alex and a Melky sacrifice fly, and then Johnny Damon ended it in the tenth with a home run.

Those are just a few examples of how different guys contributed, but it was like that all year. Johnny Damon

amazed me. He could look terrible on one pitch and then the next put the best swing on it and drive one out of the park. He tied his career high with 24 home runs and drove in 82 hitting second behind Derek. The Caveman wasn't stealing as many bases as he once did, but he was still one of the smartest base runners I'd seen and had a really keen understanding of the game overall.

One of the overlooked parts of the game is defense. Even though we were struggling a bit at the beginning of the year, in early June we set a Major League Baseball record of 18 straight errorless games. In sports, one guy's performance can lift another's. We see that with pitching staffs sometimes when the starters compete against one another. Or hitters take advantage of one guy being on a roll and maybe being pitched around to make the opposition pay the price. That kind of momentum can happen with the gloves as well.

So maybe I wasn't a psychic so much as just a guy who'd been around enough to see all kinds of positive signs in the three main aspects of the game to recognize that when we started to fire on all cylinders, we were going to be really good. Even when we went into Boston for a series June 9–11 and lost all three, I felt that way. The last of those losses set off a bunch of alarm bells in the media, though, and among some

fans. We had lost all seven games to the Red Sox at that point. Chien-Ming Wang, who had not fully recovered the form that had him being our ace for almost two entire seasons before this, lost the game, and the Red Sox took over first place.

If you believed everything you read, outside the waters were rising, but in the clubhouse we were still hoping to be named Johnny Damon's "Star of the Game" and earn the coveted championship wrestling belt that went along with it. Derek and Mo also got involved in judging who the winner should be. The award itself had started out as a toy that one of A. J. Burnett's kids gave him, but then Johnny received one from the former pro wrestler Jerry Lawler, and that made it even more desirable. That was also a lot better than seeing Jason Giambi strut around in his gold thong, which, he claimed, had magical powers to help get anybody out of a bad stretch. That thong gave new meaning to the term "bad stretch." I don't know if anybody used that thong in '09 or if Jason took it with him, but there are some things you just don't ask about. Anyway, as the year went on Johnny stopped just putting the belt in the winner's locker and began doing a presentation in the clubhouse, shouting out the name of the winner like a game show host. He had us all laughing our asses off.

Teams need to have those kinds of things going on in the clubhouse because if you let too many outside influences in, especially in New York, you go crazy. It took us a while, but we went crazy on the field. In July, August, and September, we won 58 and lost 25, for a .698 winning percentage. It was hard to say what had us playing so well—the meeting with Brian, Joe getting tossed out of that early game, or maybe Nick Swisher playing Michael Jackson and Paul McCartney's "Say, Say, Say" in the clubhouse before every game. That song was one of Derek's favorites, and even though we didn't always remember to have it blaring, it became one of our good-luck charms. Hey, once we got going, we weren't about to question it.

I only played in 111 of the games owing to a couple of injuries—a finger, a toe, a stiff neck—and the need to be careful to not tax the shoulder too much. I had a couple of thrills in hitting two pinch-hit home runs, which is kind of like winning the lottery instead of bringing home a big paycheck all the time. You're not in the game, you walk up there, boom, and then you got guys fist-bumping you and the fans screaming. That's a lot of fun.

And fun is the most lasting impression I have of that year. Yes, we had fun even in the down years, but winning and having fun is the best combination there is.

462 · JORGE POSADA

We led by as many as 10.5 games, and despite the ups and downs that are part of any season, we ended up in front by eight games at the end of the regular season, when my amazing managing skills helped us to a 10–2 victory.

Joe Girardi gave me the reins for that game. This was a holdover tradition from Joe Torre's days: a veteran got to run the club the last day of the year if we had already clinched and the outcome of the game wasn't going to affect the playoffs. Victory number 103 of the season came despite Derek Jeter's reaction when he discovered who was going to be managing for the day. Before the game he walked past me a bunch of times saying, "*I'm* not playing. I'm *not* playing. I'm not *playing*." The club was my ship that day, but he was still the captain.

Actually, one of the biggest thrills for us as a club and for Derek that year came on, ironically, September 11. I'm not kidding about this: for a while before that date, Derek had been saying to me, "I want this over with." What he meant by "this" was the intense focus on him passing Lou Gehrig for the most hits in a career. Derek never liked having the focus on him. He put up with it, was gracious about it, handled the media with finesse, but he did it because he had to, not because he wanted to.

In a way it was unfortunate for him that on September 9 he went 3-for-4 to tie the record. That meant that with the off day coming up, there'd be even more in the news about his quest. I can't say that the pressure was getting to him, but I know that he didn't like how the pursuit of the record was taking attention away from what we were doing on the field. As Derek had been telling me, it seemed like everywhere he went—in a cab, on the street—everyone was asking him, "When are you going to get the hit?"

He got the record on September 11 with a leadoff single in the third. Going the other way, not trying to do too much with a pitch, was typical of him. He got to first base, and we poured out of the dugout to congratulate him. It was a rainy night in the Bronx, so it wasn't exactly how we all wanted the story to go. That didn't have an effect on the fans' enthusiasm, though. The ovation seemed to last as long as the rain delays. During one of them, Derek got a call from Mr. Steinbrenner, and that meant a lot to him. We lost that game, but that was okay. We all knew that his taking over the lead in hits was coming, and we were prepared for it.

We honored Derek formally on September 29. At a pregame ceremony, Andy and I got to present Mo and Derek with gifts that the guys had chipped in to commission and pay for. We had wanted something

special and unique, and Andy came up with idea of a work by Opie Otterstad. It was a portrait of Derek and that tie-breaking hit, so the artist had to work hard to get it ready in time, and it was amazing. He incorporated other things into the piece—a Yankees uniform, a Lou Gehrig model bat, and dirt from both Yankee Stadiums among them. Derek also got home plate, first base, and a sign from the old Stadium that meant a lot to Derek: it said, I WANT TO THANK THE GOOD LORD FOR MAKING ME A YANKEE. We all felt that way that night, and when I got on the podium to speak to them and the crowd at the Stadium, I said what was in my heart: "I'm really proud that I got a chance to play with you. I think you guys represent what the Yankees are all about." Derek got another gift that represented what he was all about—two of the seats he crashed into while making a catch against the Red Sox in 2004.

We also honored Mo, who had reached 500 saves in June. For that accomplishment, he got the bullpen bench and the rubber from Citi Field from the night he reached that milestone there. It was a fun night to share with their families and friends. The whole thing was a nice break and a chance to reflect on what we'd accomplished during the regular season before the craziness of the playoffs took hold.

If I had one thought nagging at me, I could trace its roots to our August series in Boston. On August 22, the Red Sox had hammered us, 14–1, at Fenway. A.J. was on the mound. He'd been on a pretty good run of not allowing runs early in the game, but that wasn't the case this time. Three Red Sox runs in the first and four in the second had us down early. He wound up giving up three home runs, and after one of them he said, "How can you call that pitch?" I bit my tongue. He'd been shaking me off a lot early in the game, and we seemed a little out of synch. *Why not shake me off then?* I thought. I also thought, *How can you throw that pitch?*

After the game, he and I were in the clubhouse, about the last two guys in that cramped little space. I could see him giving me the eye. I wasn't happy about the game, about how the whole staff pitched, and I took responsibility for us getting our asses handed to us. Those games are no fun. I wanted to clear the air, so A.J. and I talked about it. We're both passionate guys, and the conversation wasn't the most polite it could have been, but I thought we both made our points. Later on I went to Joe and A.J. both—again, to try to sort things out. After that game in Boston, José Molina had begun to catch A.J. regularly, and I didn't want that to go too

far. I wanted to be in the lineup no matter who was on the mound. Joe told me that it wasn't A.J.'s call and left it at that. Well, that could only mean one thing—Joe wanted José to catch A.J. from that point forward.

No matter who was making the decision, I didn't like it. When I tried again to talk about it, Joe seemed to hear me but not listen to me. With the playoffs about to start, I didn't want to be in and out of the lineup, but that seemed to be how it was going to be. It was time to be the best team player I could be and just let it go.

The Twins entered the ALDS hot, winning 18 of their last 25; even though they'd won only 87 games all season, we heard what Joe was telling us about not taking those games for granted. With Joe Mauer, Justin Morneau, and Michael Cuddyer in the lineup, they posed a challenge. Each of them wound up hitting more than .400 in the series, as did Nick Punto and Denard Span. Still, we managed to beat them in three straight games. They had more hits than we did in the series, but they only scored six runs. In every game, they had the lead but we came back to win. That tells you something about pitchers coming up big when needed, and that's just as true for our hitters. The big story that series was Alex. He had a couple of hits and also drove in two. Given our poor postseason track record since he'd joined the team, you couldn't escape stories about

his postseason failures with runners in scoring position. During Game 1, he broke an 0-for-29 streak dating all the way back to 2004, and I think that his solid start was the key to our entire playoff run. He got some confidence, and he also got that monkey off his back.

When your cleanup hitter does his job like that, the whole team feeds off his success. That's why that guy is in the number-four hole—to drive runners in. The way the lineup turns over, you can almost bet that in the last two innings he's going to come up in a clutch situation with men on base. That's a big burden, but you get the big bucks and the big-time attention that goes with it. That's just how it is, and Alex stepped up for us. His home run in Game 2 in the ninth inning got us into extra innings, Teixeira's blast in the 11th won it, and that was going to be a tough one for the Twins to overcome. They didn't.

I didn't catch Game 2 with A.J. Burnett on the mound. As unhappy as I was about that, I just had to shut my mouth and do what was best for the team. I was happy to contribute in Game 3 with a home run to give us the lead in the seventh and to add another RBI with an insurance run in the eighth on a base hit. When Mariano closed it out for us, all those numbers that seemed to say the Twins were outperforming us didn't matter. We did our celebrating off the field out

of respect for the Twins and their fans, and it felt great to have some of that magic back. It seemed as if some of the breaks had gone our way and unlike a lot of times in the past when we hadn't taken advantage of them, this time we did. That was what it was going to take.

We'd led the league in all the major league offensive categories in the regular season, but in the playoffs all that was wiped clean. This was the new season, the one that we had always played so well in and come so close to winning five out of seven years. We were going to face the Angels, and they were coming in off a sweep of the Red Sox. For scheduling reasons, we would have four days off. That was a good thing and a bad thing. You can lose your edge a bit with that much time off, but you can also set up your rotation and spend more time preparing for the next squad. We had split the ten-game regular-season series with the Angels, but we had a history of not playing well in Anaheim, where we'd won only one game that year. The flip side was that they'd only won one at our place.

I don't know how much of an advantage we had in facing a warm-weather team in the middle of October, but I do know that it was 45 degrees and drizzling at the start of the first game. I felt it a bit when I went out for batting practice, but I wasn't going to wear an Elmer Fudd hat. Our equipment manager, Rob Cucuzza,

had kept earflap hats stocked all season, but I couldn't wear one. Robbie Cano chose to wear a ski mask and got a lot of crap for that. Fortunately for us, the Angels seemed to be having trouble with fielding the ball, and we scored two unearned runs off their three errors. Whether it was the cold, the layoff, or the slick ball, I don't know, but we took advantage of our opportunities and I was loving it. I hate the cold, but being a catcher and moving around the whole time made it a nonfactor for me. C.C. was outstanding. He came to us with a reputation for underperforming in the playoffs, but in his first two starts with us there was no evidence of that.

Andy had something to do with that. During the season, he would talk a lot with C.C. about big-game pitching. When you've got a guy talking to you about playoff pitching who has won as many postseason games as Andy, you listen. And C.C. wanted to be the guy for us. That's why we brought him in, and he knew that. He was going to be the big horse that we were all going to ride, and he liked that role. It's always great to see a guy who wants to take the ball in every situation and then goes out there and does it. It was still early in the postseason, but it was clear that C.C. was on a mission. He attacked the zone, throwing first-pitch strikes to 17 out of 29, a good number for him. He set

the tone early, throwing 12 of his first 15 pitches in the zone.

For Game 2, the weather was more of the same, cold and wet. On those kinds of nights, you always hope for a quick game, a 2–1 pitchers' duel in at most two and a half hours. We were out there for five hours and ten minutes in a 13-inning game with no rain delays. It was a tense game. A.J. Burnett started for us and was strong through six-plus innings, giving up just two runs on three hits. We scored our two runs with three hits, a Cano triple and a Jeter home run. Hitting in those conditions is always tough, and the ball wasn't carrying, but Derek managed to drive one out. In the fifth the Angels tied it, and it would stay that way until the 11th. I pinch-hit and then came in to catch Mo in the ninth. He had come in to get out of a tight spot in the eighth. Derek had booted a routine ground ball, one of three errors we had, but none of them hurt us with a run. Guys were picking each other up, and that's the sign of a championship team. Give them an opportunity, but don't let them capitalize on it.

We'd be having a day off the next day, so Joe was going to extend Mariano a bit. Mariano kept us tied going into the 11th. Joe kept checking with Mo to make sure he was okay, and Mo assured him he was. Joe

checked with me as well, and I told him Mo was on, jamming both righties and lefties.

Joe and I had some communication issues between us, but that wasn't the case when it came to handling pitchers. He and our pitching coach, Larry Rothschild, were excellent in that area. It wasn't just about in-game pitching changes. They knew how to keep a staff fresh and ready. Joe was, and is, an exceptional manager, as well prepared and knowledgeable as anybody I'd played for. He showed that throughout my time with him, both as a player and as a manager. We had our differences, but that doesn't take away from the job he did. How he handled that '09 club is proof of it. I didn't like everything he did, but the results were there.

In the 11th, Joe had no choice but to take Mo out of the game. He'd gone two and a third, and we were only in Game 2 of the series. Joe brought in Alfredo Aceves, who was essentially a rookie, though he had those ten wins in the regular season. Unfortunately, he committed one of the cardinal sins of baseball: he walked the leadoff hitter, who then scored. It looked like maybe the Angels were going to do to us what we'd done so many times ourselves—51 times in fact, to lead the major leagues—and come back from a deficit to win. Having 51 comebacks in your pocket, though, makes it a lot easier to believe you can do it. Alex led off against

Brian Fuentes, who was the league leader in saves but had also blown seven. He got ahead of Alex 0-2 and then committed another cardinal sin—he left a fastball out over the middle of the plate and Alex just crushed it to right field.

David Robertson did a nice job of working around a leadoff error, and we went to the bottom of the 13th. Jerry Hairston Jr. came on to pinch-hit. He had played his first big league game in 1998, but had never played in the postseason. He got a hit. Brett Gardner bunted him over. They walked Robbie, and Melky came up and hit a ground ball to second. Maicer Izturis fielded it but fired wide of the bag, and Jerry Hairston came around to score. We swarmed him, Nick Swisher knocked him down, and then, when Jerry was being interviewed on TV, A.J. got him with the traditional shaving cream pie to welcome him to postseason baseball in the Bronx. I love those moments, and that was what I loved about that team. With contributions from everybody, the camaraderie had made the five-plus hours of that game worth every second.

We were late for a 2:00 A.M. bus to the airport, and even though things eventually calmed down, the electric buzz of pulling out a game like that, taking two at home, made the long flight to Rally Monkey Town a more restful one. To be honest, I liked the Rally Monkey. As bad as we played in Anaheim, I got a kick

out of watching that thing. With the whole Hollywood/ Disney thing going on, enjoying Jurassic Sock Monkey and the other variations was a way to deal with those long West Coast swings. On visits to the mound, Derek would come in sometimes saying, "Don't look at the monkey. Don't look at the monkey." Real insightful baseball strategy right there.

Maybe we loved postseason baseball so much that we wanted it to last as long as possible, but the four hours and 21 minutes we spent on Game 3, eventually losing 5–4, was not a great way to spend our time. The Angels took the lead in the bottom of the seventh. Hideki Matsui walked, and Brett Gardner pinch-ran. He got thrown out stealing, with me at the plate facing Kevin Jepsen. Jepsen had a plus-fastball and a good cutter. For some reason, on a 2-1 count, he decided to go with the cutter, hoping to get the ball in on me, but I got all of it to tie the game. Unfortunately, we lost it in the 11th. It's a game of inches. If Gardner is safe, that's a two-run home run. Who knows how it would have played out from there, but with Mo rested and able to go more than one inning, I liked our chances. We wanted to get that runner into scoring position, and it took a good play to get him.

C.C. came up huge for us in Game 4. He'd gone to Joe and said that he was good to go on three days' rest. In any playoff series, if there's a pitcher going on three

days' rest, you'll hear all the numbers saying that it doesn't work out most of the time. C.C. had done it with Milwaukee in the regular season the year before: in one stretch, he started four times in 12 days, going 2-2 in those games. Now he wanted to do it again, and you like to see a guy put himself on the line like that. He was awesome, giving up just one run on five hits. We'd done what we needed to do—win one in Anaheim. That assured us of getting back to the Bronx, where we needed to win just one more game.

That doesn't mean that we were okay with losing Game 5, because we weren't. We also lost it in the toughest way. The Angels jumped out to a 4–0 lead in the first. A.J. is a very emotional guy, and he may have been too hyped up at the beginning of the game. He fell behind early and walked the leadoff man. He wanted to get ahead, but on an 0-1 pitch, Bobby Abreu singled. Still trying to work ahead, A.J. gave up first-pitch hits to the next two batters, and all of a sudden you're down three to nothing and you've only thrown nine pitches. You want to be more careful, so you throw two pitches narrowly out of the zone. You've got to come in with a strike, the hitter knows it, and there's another hit. Twelve pitches and four runs. That's tough. I'm not criticizing A.J. or José Molina, who was catching. I don't know that I would have done anything different

if I'd been back there. My point is, that is how quickly things can turn on you, especially with a club as good as the Angels were.

We battled back in the seventh, but then we gave up the lead, a problem that had troubled us some in the past. Up 6–4 with nine outs to go, Dámaso Marte, who was a stud for us all year, nearly got us out of a two-on, no-out situation. Joe brought in Phil Hughes to relieve him—the right move to make—but he let it get away, and three runs came in.

A rainout pushed Game 6 back a day, so Andy, working with five days' rest, was able to pass John Smoltz to become the all-time wins leader in postseason play. Somehow that seemed fitting—one of the old guard going out there and putting us back where we last had been six years before. The 5–2 score in Game 6 was a bit deceiving. We trailed by one early, came back to lead 3–1, and then the Angels added one in the eighth off Mo. He was his Sandman best in the ninth, though, getting them down in order and going to 3-2 before getting Gary Matthews Jr. on a swinging strike. I held on to that ball and ran out to Mariano to hand it to him, hoping that I wouldn't fumble it in all the commotion. I didn't want to think too far ahead, but that was the second time that postseason I'd been able to be out there with Mariano celebrating a series

win. I wanted that last dance with my friend more than anything.

I'd been in touch with my dad throughout the series, doing what I usually did, calling home every day. He was still being very protective of my mom and didn't want to leave her or expose her to the cold weather. He was happy for us and said that we still had a ways to go. He wanted me to stay aggressive. You've done your job well, he said; keep that up, and we'll see what happens.

I'd had a decent series offensively. I would have liked to contribute more, but we won, and I took a lot of pride in how C.C. and I worked together. Seeing him come through for us like he had, getting the win in three out of our seven wins, was something else. I also thought that Melky Cabrera deserved a lot of credit. He, along with Nick Swisher and Robbie Cano, brought a lot of youthful energy to the club. Not to take anything away from what Alex had done, but Melky's numbers were comparable. He hit .391 to Alex's .429, they each had nine hits, and Melky drove in four runs to Alex's six.

I still believe that having a balanced lineup and contributions from everybody is important. Those home runs were great, but we were still doing things the right way. I didn't realize it until we were getting ready for the Phillies, but a writer pointed out to me that the

Angels' staff had walked us 38 times that series. That's more than six a game. All those lessons we heard back in the minor leagues about quality at-bats, working the count, were still paying off for us. We made our share of errors but allowed no earned runs, while the Angels allowed five. We got the job done with big hits, disciplined at-bats, pitchers who rose to the occasion, and solid defense.

Six years is a long time to wait, but it was worth it. I loved the intensity of being back in the World Series. I loved that we were playing the Phillies. I saw their swagger as defending champs, knew that they were on a 17-4 playoff run, and heard Jimmy Rollins predict that they were going to win it in five. I thought, *Fine. Let's see.* With the exception of that public prediction, they reminded me of the Yankee teams I'd played with early on.

We knew it wasn't going to be easy facing Cliff Lee. We knew all about him because the Yankees had pursued him in the off-season. He had a great reputation as a big-game pitcher, a guy who was supremely confident, and somebody who could back up that confidence with great performances. Cole Hamels was young but had had two very good seasons in '07 and '08 and had won the World Series MVP title in '08. He was struggling a

bit in '09 and in the playoffs, but was capable of shutting anybody down with his great stuff.

In a way, this series for both clubs was about lefties. Charlie Manuel wanted to give us a different look, so instead of starting two of them back to back (Lee and Hamels), he decided to insert Pedro Martínez in between them to start Game 2. We felt good about our chances. Pedro wasn't the same Pedro after all these years, and even if he had been, he had a losing record against us. The other part of the lefty equation was our staff having to deal with lefties Chase Utley, Ryan Howard, and Raúl Ibañez. We had two left-handers in our starting rotation, which worked to our advantage, but Utley was the key. He could hit left-handers well and was a more patient hitter than Howard. I felt that we could get Howard to chase, but Chase wouldn't chase. The other guys who wouldn't chase were Jayson Werth and Carlos Ruiz. I thought we needed to pay particular attention to Ruiz, a clutch guy who I knew wouldn't let the big stage affect him.

Speaking of stages, seeing the new Stadium all dressed up was quite a sight. Pregame activities are sometimes tough to deal with because you want to just get out there and play. But that first game was different, especially with Tony Odierno throwing out the first pitch. Tony worked for the Yankees, was a West

Point grad, and an Iraqi war vet who lost his left arm in combat. We'd honored him before, but this was a huge thrill for him, and I think he was as excited about the game as we were.

The game would feature two big lefties who were former Cleveland teammates and were both doing well so far in the postseason. Sometimes those big pitching matchups don't live up to the hype, but in this case the scouting reports and the hype proved to be true. Lee was really tough on us. He used his Greg Maddux–like two-seamer and that funky delivery of his that made him sneaky fast. When we tried to get Utley out on sliders, he hit two of them out of the park, in the third and the sixth. Those were really the only mistakes that we made. C.C. left after seven innings and 113 pitches, trailing 2–0. The final was 6–1, but that didn't reflect just how great C.C. pitched. He was upset with himself for getting behind hitters too much and not setting the tone for the series the way he wanted to. He pitched well enough to win, but with no run support, that wasn't going to happen. I had one hit but struck out to end the game, and that never feels good.

What Cliff Lee did was historic. The one run he gave up was unearned, so he was the first pitcher to go nine against us in the new Stadium and not allow an

earned run. He was on a postseason roll as well. In his first postseason ever, he had pitched 33 innings to that point and allowed only two runs. This was one of those "tip your cap and move on" games.

In Game 2, A.J. didn't quite match what Cliff Lee had done, but he did do what the Phillies had done to us in Game 1. Matsui and Teixeira each hit solo home runs, I drove in an insurance run with a pinch-hit, and A.J. and Mo shut them down in our 3–1 win. There was some controversy over whether or not Ryan Howard had caught a ball Johnny Damon hit. The umpire ruled that he had. I didn't see it that way, the rest of us didn't see it that way, but I was the one who ran to second and got tagged out. Fortunately, that didn't affect the outcome of the game and we avoided another potential controversy.

We didn't know this at the time, but Matsui was late for the game because of traffic. The Japanese reporters who followed him told Derek that in Japan, whenever Godzilla was late for a game, he hit a home run. Derek said, "He can come late every day." I agreed. The real trouble was, moving on to a National League city, there would be no designated hitter.

I was happy to see A.J. do so well. He talked about hearing Cliff Lee speak about having confidence in his stuff, and he went out there in Game 2 with that

in mind. He went with one of his strengths, a quick-breaking curveball, and the Phillies hitters all commented on that. A curveball can really throw off your timing, and I stored that bit of information away in preparation for Andy's start in Game 3.

We were going to play on Halloween at Citizens Bank Park—a scary place for pitchers. We hadn't played there since the 2006 season, so seeing it again after that long was an eye-opener. It was comparable to the Stadium, though longer down the lines and shorter to the alleys and to straightaway center. It was also a place where it felt like the fans were right on top of you, and they had some interesting things to say.

Those dimensions came into play. Between the two teams, five balls left the yard. Jayson Werth hit a couple off Andy. The first one led off what turned out to be a three-run inning. Alex hit a two-run shot that was off a camera and, thanks to instant replay, ruled a homer. Alex was involved in a lot of things being hit that night. The Phillies hit him twice, and he responded in the best way possible with that home run.

Andy helped himself by driving in a run. Like a lot of pitchers, Andy thought he was pretty good with the bat, and that hit *was* pretty clutch. He came around to score later in the inning, along with Derek, and then we were up by two going into the bottom of the fifth.

We traded home runs, I drove in an insurance run, and we got the road victory we wanted, 8–5.

We couldn't feel too bad about those Werth home runs. They were his sixth and seventh of the postseason. The guy was hot, like Utley had been in Game 1, but we did a great job of executing our game plan against their first four hitters—Rollins, Shane Victorino, Utley, and Howard—in Game 3: they combined for one hit in 15 at-bats. With that lineup in that ballpark, the Phillies were a team we weren't going to be able to shut down completely, so limiting their production at the top was a real victory. Andy improved to 3-0 in the postseason with that win.

In Game 4, the Phillies showed a little bit of their feisty nature when Joe Blanton hit Alex with a pitch in the top of the first. That was the third time in ten innings. The umpires issued warnings, and the whole unfairness of the rules came into play. They pitch inside and hit our guy three times. If we pitch inside and/or hit a guy, it's up to the umpire to rule on intent and we could lose a pitcher and a manager. Alex was pissed and stood at home plate looking into our dugout while the Philly fans chanted, "You used steroids." I was pissed about that, pissed about the warning, and really had to compose myself. I wanted to hit one all the way up Interstate 95 to the Bronx. In my mind I heard my dad

telling me to be aggressive, but I also heard my uncle Leo telling me to keep my weight back. He was thinking that the Phillies were going to attack me soft in and then away hard. I took a strike, looked away, got a pitch away and tried not to do too much with it, and then hit a sacrifice fly to right to drive in a run.

I really wanted us to shut them down in the bottom of the first to quiet the crowd, but that damned Chase Utley doubled to drive in Victorino. He was killing C.C. and me. We got him to pop out in the third for the last out. The big guy and I were happy about that, and we were determined to keep going after him that way. We got him to pop out again in the fifth. But that lineup was like a Whac-A-Mole game. Utley was down, but Howard got a hit and scored a run. Then in the bottom of the seventh, when we were leading 4–2, Utley hit another home run. That was it for C.C., but not for the Phillies. They tied it in the bottom of the eighth on an Ibañez home run off Joba Chamberlain.

We went into the top of the ninth against Brad Lidge, their closer. In 2008, Lidge had one of the best seasons a closer had ever had. He was 2-0 with a 1.95 ERA, appearing in 72 games and converting 41 out of 41 save opportunities. He finished fourth in the Cy Young voting and eighth in the MVP race. That's a season. It was also a season ago, and 2009 was not nearly as good

for him. It was clear that he wasn't the same guy. He was struggling so much that he lost his closer's job, but he had come around in the playoffs, saving four and winning one. Game 4 was his first appearance of the Series.

Even if it had been the 2008 version of Lidge out on the mound, I still think we would have gotten to him. As an individual, you sometimes see the ball better coming from certain pitchers. I felt that way about Lidge. So did other guys. From the video we saw, there wasn't that much of a speed differential between his fastball and his slider that year. The slider was his out pitch, but you could look for it, or look for the fastball, and still adjust because the speed was about the same. Bad for him. Good for us. At least, that's how it seemed. He got the first two outs, and then Johnny Damon, who needed to get into scoring position for Teixeira, singled. That's when the Caveman's baseball instincts and intelligence kicked in. The Phillies put a radical shift on that had their third baseman, Pedro Feliz, at shortstop. When Johnny took off, Feliz covered second on the steal, and it one-hopped him. Johnny bounced up and went to third, stealing two bases on one pitch.

Derek had done something similar in the regular season, and most of us thought that was a once-in-a-lifetime thing to see. I don't know if Lidge was trying

THE JOURNEY HOME · 485

to figure out if he'd seen that before and lost his con-
centration, but he hit Teixeira with a pitch. I don't
know if Charlie Manuel, the Phillies' manager, thought
of walking Alex—that would have loaded the bases
with two out—but they pitched to him, and Alex made
them pay, doubling to bring in Damon. Teixeira was
on third. They pitched to me. With a 2-2 count, I was
looking slider, got slider, and drilled one into deep left-
center. I didn't expect Ibañez to be able to cut it off, but
he did and threw me out at second. No matter—two
runs scored and we were one win away.

A.J. tried to step up for us in Game 5 by going out
there with three days' rest, but it just didn't work out
for him. By the top of the eighth, we were down 8–2.
We fought back, with three in the eighth and one in
the ninth, but couldn't pull out the win. Still, having a
chance in the ninth was a good way to end that game.
We were still one win away, but only 93 miles from
home.

I was enjoying the hell out of that Series for a lot
of reasons, and one of the main ones was that Jorge,
Paulina, and Laura were at every game. My kids were
now old enough to really appreciate and understand
everything that was going on and how much it meant. I
was super-excited to be back in New York and so look-
ing forward to having them be a part of a New York

victory celebration. Knowing that we needed to win one out of two, but still aware that we had once lost four in a row, I wasn't taking anything for granted. None of us were. "The Girl Is Mine" was still playing in the clubhouse, and the Star of the Game belt was still being handed out, but one thing struck me as bad mojo.

I was fine with Jay-Z and Alicia Keys performing before the start of Game 2, but something about "Empire State of Mind" and its "New York, New York" lyrics troubled me. That was getting a little too close to Sinatra territory, and we played that song only after a win. I was hoping that in Game 6 we wouldn't have a repeat of "Empire State of Mind." I loved the song, but there's a time and a place for everything. Let's not get too far ahead of ourselves, I was thinking. Still, Derek had been using it as his walk-up music every now and then, so I didn't want to have any kind of conflict with that. This may sound like something I should not have been concerned about prior to a potential World Series clincher, but I was trying to relax just as I'd been told to. Trying to take my mind off the game for a bit. Still worrying, of course, but at least I wasn't completely focused on the lineup or facing Pedro Martínez again.

What can I say about the game? Godzilla was a monster with six RBI. Andy, Joba, Dámaso, and Mo limited them to six hits and one run. Andy got the win,

which gave him the victory in the deciding game of the ALDS, the ALCS, and the World Series. Mo got the last out of each of those series. I caught the last out of each deciding game, and Derek was at short. If it seemed like going back in time, it was only for an instant, and only looking at it later in hindsight. In the moment, when Shane Victorino's ground ball headed toward the right side, I did what I'd done thousands of times. I put my head down for an instant and started churning up the first-base line to back up the throw. That's my job.

But this time, in defiance of all the rules about doing the right thing the right way all the time, when I saw that Robinson Cano was in front of it, I trusted that he would glove it and get it safely over to first. I had that much faith in him, and in that bunch of guys, and I didn't want to miss a moment of the celebration. Of course, I wouldn't be me if I wasn't going to be careful and avoid doing something stupid that might get me hurt, so I skirted along the outside of the pile. That's where I found Mike Harkey, our bullpen coach. I'd given him so much shit over the years. Hang around in a bullpen long enough before games and during games and you'll get toughened up, that's just how it is. But sometimes when you say things in jest, even if the other guy knows it's a joke, you still have to let him know how much you care about him, how happy you are that

he's getting to share in the moment. I was so happy for Mike Harkey, and for all the other guys who were experiencing their first World Series win—Alex for one.

Next, I tried to find Laura and the kids. Jorge was on the field trying to capture it all on video, and when I got to them, Paulina and Laura and I hugged and kissed. I don't care that I didn't say these words first: I felt like the luckiest man on the face of the earth.

By the time I got to the locker room to check my phone for messages, it was too late to call my dad back. That could wait until morning. They needed their rest. First thing after I got up, I called them, just like I'd done every day for years and still do.

My mom was in tears and told me all the things a mom does. She was proud of me. She couldn't wait to see me. When were we going to come visit? She hoped I didn't keep the kids out too late.

"*Te amo, Mamá.*"

"*Te amo, mi hijo. Hable con su padre.*"

"*Hola, Papí. Cómo está?*"

"*Bien. Bien. Felicitaciones, Jorge.*"

I thanked him and waited. I was almost too tired to say anything more.

Then he said, "You guys did it. You did your job."

I smiled and looked at myself in the mirror.

"*Sí, Papí.* I know what you mean. I did. We all did."

"It will be good to see you."

"I'll be home soon."

"I know you will. I know that you have things to do before then." He paused again and said, "It would have been nice to be there."

"I know. But you were. This time and all the others. Just different ways."

I meant those words, and I knew that he understood what I was trying to say by his silence. Jorge poked his head into the room. I waved him in. He lay down on the bed with me and showed me his phone. He brought up the video he'd made, and while my dad and I chatted briefly about a friend of his from Cuba who'd recently been in touch, I watched the last outs of the game unfold from my son's perspective. He had zoomed in on me, not as I ran or celebrated, but there in the crouch, wiping my fingers in the dirt before putting down another sign.

I told my dad that I had to go. I had something that I had to do.

"Rewind that, please. I want to see that again."

"Is it good?"

Wrapping him in my arms, I said, "The best. You'll have to show me how to do that."

I also thought, *Jimmy Rollins must have forgotten he was playing the Yankees.*

Chapter Sixteen
Home Again

When I arrived at the intersection of the Grand Concourse and East 161st Street in the Bronx on January 24, 2012, I knew I'd made the right decision. First, I was in a car with Laura, Jorge, and Paulina, the most important people in my life. I was not alone, as I had been when I first came to Yankee Stadium to play. Obviously, they couldn't have been with me back in September 1995. At that point in my life, marriage and children weren't something I spent any time thinking about. All I thought about then, all I had thought about for years, was becoming a big league ballplayer, and that dream was about to come true.

Now Laura and the kids were very much on my mind. They had been important reasons for why I was sitting at that traffic light, waiting for that turn.

Mostly, though, I knew I'd made the right choice—to stop being a big league ballplayer—because I wasn't feeling that same excitement and anticipation I did when I arrived at the old Stadium after being called up for the first time and every time I showed up at a ballpark to play. I shouldn't have been feeling what I was. I was nervous, and that had never been a part of the mix of emotions that accompanied my visits to that place in the Bronx. In some ways, that January day, I didn't want to be there and couldn't wait for it all to be over. I dreaded doing what I was about to do. I was also happy and relieved, sad and angry, joyful and all the other emotions roiling around inside me. I'd had all those feelings at various times before, sometimes all in one moment, when I'd arrived at a ballpark or spent time in one. But not nervous. That part wasn't right.

A baseball field was my home, the place I went to where I felt most at ease and could let people know, this is who I am. I did that as a child and then as a man. So it was very strange for me to have to go to my home away from home in the Bronx to announce that I was leaving home, that I was ending my boyhood dream to focus on my role as a husband and father. It felt both right and wrong to do this at the Stadium. Baseball fields and stadiums are supposed to be places

to have fun. This was not going to be fun. I never liked being the focus of attention, but this was going to be my event, my chance to say something that from my earliest days my father had told me not to say about anything to do with baseball: "This is it. I'm not going to do this anymore."

I may have thought or said that at various other times in my life—when moving that pile of dirt, for instance, or after another frustrating strikeout while learning to hit left-handed, or while lying in a clubhouse with a broken leg. But this was different. This was final.

That makes it sound like the end came suddenly, but just like you look back on a season to try to figure out why things went wrong or why they turned out right, the same is true of a career and the decision to end one. In 2010, I was still very, very excited about playing the game. Yet something was different about that ball club and the approach we took. It was almost as if we expected to repeat, instead of knowing we had to work toward that goal with everything we had. I don't know if that group understood just how hard it is to repeat as champions.

To his credit, Joe Girardi sensed that things were not right. He called us on it and tried to get more from that club, but it was a case of being heard without being listened to. Derek and I both tried to talk with guys,

but that's hard to do when their headphones are on and their faces are looking down at their phones. At the risk of sounding like an old guy moaning about these kids and their damned new ways, it was tough for me to take when a rule was instituted that no one was allowed to go into the clubhouse between innings to check their phones for text messages. That seemed to be substantially different from how my dad, Trey Hillman, and some of my other early managers worked with me on maintaining focus.

It also wasn't just about the new technology getting in the way. The work ethic had changed with some guys—a very few guys, but enough to make the difference between winning and losing. It's a shame that a guy like Robinson Cano who played the game the right way didn't get to enjoy the run of success that the Core Four did. He should have won more than one MVP Award with the Yankees, considering he was the best hitter in baseball for at least my last two years in the league.

In 2010 and again in 2011, I also noticed more and more often that after the game had ended, the clubhouse was empty just a few minutes past the time we were required to stay to make ourselves available for the media. I'd sit there. Derek would be there. A couple of other guys would linger for a while. But no

one else. That was a lot different from before, when we all wanted to sit together as a team, have a beer, share a meal, and talk about baseball or whatever else was on our minds. That wasn't happening, and it made me sad. I know that families grow apart over time, but that wasn't how I wanted it to be.

Winning is such a fragile thing. If you take away any element that supports it, it falls to the ground and shatters. That might sound overly dramatic considering we had some success in my last two years, but we didn't have success in the one way we defined it, the only way that mattered. I don't think I've ever been so angry in my life as I was after we lost in the 2001 World Series. Afterward, a guy who shall remain nameless, someone who was with us briefly, said, "At least I finally got to play in a World Series game." He was gone the next year. I don't know how much a part that statement played in his departure, but I was glad I didn't have to see that face again. A decade later, it made me sad to see even some small fraction of that same attitude those last two seasons.

The fact that I still remember that 2001 incident, and still get upset thinking about it, says a lot. I loved the game so much, loved being a Yankee so much, that it was never going to be easy to leave. Nothing ever came easy to me in this game, and I went out of it the same

way I went in—with my heart and pride not just on my sleeve but bleeding all over everything for everybody to see, good and bad. That meant it was going to be messy, and at times it was. That's how it sometimes is with family. You think the people who know you best will understand you best. You think you've made yourself clear. Misunderstandings happen, and you both try to make amends.

I made some mistakes in 2011. In August of that year, I let my emotions get the better of me. I felt like I wasn't being treated right, that people weren't always being as straightforward with me as I wanted them to be or treating me as I deserved to be treated, and I exploded. I took myself out of the lineup. I spoke with all the people who mattered most to me and whose views I respected—my wife, my father, my agents. They all talked me down. They didn't want me to do anything that tarnished my reputation. I felt like I already had, though, and I hated that feeling.

I expressed my regrets, but those sentiments were never returned. Anybody who had been around me for very long knew that I was an emotional guy, a proud guy, and as events unfolded my last year with the club, I don't think that was taken into consideration. No one thing had incited my decision to not play that day. I'm emotional, but not recklessly so. I'd just put up with enough.

I knew that my role with the club was changing, but I don't think that anyone making those decisions knew how much the things being done hurt me. So much of who I was as a player was tied up in being a catcher. I knew that I couldn't play every day any more, that I hadn't earned that role. But to be told that even catching someone in the bullpen was not allowed, to have even that taken away from me without an adequate explanation, hurt me and confused me. My pride was injured, not my body. I felt that I could still catch, I was willing to accept a diminished role, and I said that in case of an emergency I'd be willing and eager to help out. But I was told, no, that's not what we want from you. If I wasn't even considered third-string, then what was I? How did I fit in?

I'll admit that I struggled being a designated hitter. I didn't know what to do with myself between at-bats. I'd been so central to every pitch in a game, and then I wasn't. I had a lot of baseball experience and insights. I wasn't sitting in on catchers' meetings, even when I asked if I could. I felt as if all those years of experience, another way I could contribute, were being ignored.

I'll put this as plainly as I can: when you take me out from behind the plate, you're taking away my heart and my passion.

I continued to play, but it wasn't the same. At various points during the year, starting early in the year, I would say to Derek, "I think this is it." Derek didn't say a whole lot, and I respected that. He knew that I had to do what was right for me.

Laura and I talked and talked about it. We'd bought a home in Miami in 2010, and she was there with the kids until spring break and then summer, and I missed having them around all the time. Laura wanted to be sure that I was sure. Almost every day she'd check in with me about it. I can't give you a percentage of "yes I'll stay" days and "no I'm done" days, but as the season went on those numbers shifted, the average climbing and trending toward "I'm done."

I did get to catch one more time in an emergency situation in Anaheim and threw out a base runner. Derek put it best after the game when he said that having me back behind the plate was like coming home after a long time away and seeing all your furniture in the same place as it had been before you left. You knew you were back home, that things were going to be the same.

I understood, of course, that things couldn't be the same, and except for that brief lapse in judgment when I took myself out of the lineup for one game, I think I handled it well. Even after being benched for a week in the wake of that incident, I responded the way that

I wanted to. On August 13, 2011, I was 3-for-5 with a grand slam. Maybe those guys knew me well enough to know they had to piss me off to get me to play better. The ovation I got from that home run did a lot to soothe me and heal my wounded pride. The fans understood me, understood what was happening in my career and in my heart, and I can't ever thank them enough for that. Knowing that you have nearly 50,000 people in that building on your side, and who knows how many others watching or listening, is something I wish everyone could experience once in their lives. I got to experience something like that again on September 21 when I came up as a pinch hitter in the bottom of the eighth inning in a tied game.

As I completed my warm-up routine in the on-deck circle, I heard the first trumpet notes of Willie Colón and Héctor Lavoe playing "El Día de Mi Suerte" coming over the speakers. That was the walkup music I'd been using for the last few years, and the lyrics "surely my luck will change" ran through my mind, especially when I heard the fans responding to what had become my signature song. I knew that in a lot of ways I didn't need my luck to change at all. I'd been incredibly fortunate to play in front of such amazing fans all those years, and I really wanted to reward them for how they'd rewarded me. That single to put

us ahead in a game that clinched the Eastern Division for us, for them, was just a small way to let them know how much they meant to me.

By that time I was fairly certain that I was done. My dad told me that I should play another year, regardless of my contract situation with the Yankees. I think that he was even more aware than I was of how I stood in terms of career numbers. I had some goals, and I'd reached them. In 2010, I got to 1,000 runs batted in as well as 1,500 hits. Earlier my dad had told me that I was in reach of 300 home runs, and I told myself that when my contract with the Yankees was up in 2011, if I was within ten of that number, I'd re-sign and try to reach that mark as well as 400 doubles.

Eventually, though, none of those target numbers mattered to me. I missed my family, I seemed to have misplaced the passion that I had for the game, and I knew that I wasn't likely to ever wear a Yankees uniform again. Once again I turned to my dad, the voice I'd trusted all those years ago when I was first drafted. He pointed out that maybe if I was in a better situation, one that made me happier, I'd change my mind. But when I thought about it, I knew that what made me happiest was being a Yankee and being behind the plate. I could have settled for less, but that's not who I am.

During the final game of the Division Series against Detroit, I led off the eighth inning with us trailing 3–2. I grounded out, and as I crossed the first-base bag and turned toward the dugout, I got a sinking feeling in the pit of my stomach. This could be it. This could be the last time. When we lost and all the guys filed into the clubhouse, I needed to be alone. I went into the empty weight room. I'd had no idea how heavy finality can be.

I thought I did. Losing games to end a series had felt final, but you always had thoughts of next year to support you.

Now I didn't.

I went down on my knees as if something incredibly heavy was crushing me. I put my head on the ground and wailed, shoulder-heaving sobs tearing at me. I don't know how long I was down in that position, like a catcher recovering from a foul tip that has bitten him, when I felt a hand on my back like an umpire checking to be sure I was okay. With his hand on my shoulder, Kevin Long, our hitting instructor, said, "You had a great series. You were a true warrior." I nodded and thanked him.

Later, when I faced the media, I said that I'd have to see what happened. I didn't want to be one of those guys, then or even months later, who said they were

done and didn't follow through. You had to keep your word. I spent a few weeks in the off-season recovering, considering a few offers, still hearing what my dad had to say about keeping at it and not giving up when it was clear that I could still do it. I had hit .429 against Detroit, my best average in the postseason ever, but I hadn't driven in a run and we had lost. If I couldn't be productive, if I couldn't help us win, then hanging around just to raise meaningless numbers for personal gain wasn't what I wanted to do, or who I wanted to be, or what my father had taught me.

I'd sit there in the off-season thinking about how much things had changed, how fast time had passed. One instant you're a young kid eager to make the club and looking at those old guys hanging around, taking up spots on the 40-man roster. Don't they know it's time to move on? The next instant you're wondering if you're one of those old guys. I didn't want to be that guy, the last one to figure it out. Then, as the off-season progressed, another sign came to me. Normally, I would have started to work out in preparation for the next season, and I hadn't.

In November I attended a Joe Torre Foundation dinner in New York. Don Mattingly was there too, and we spoke briefly. I always considered him a mentor and a man I trusted.

"You still want to play?"

"I don't know."

"If you have any doubt, then don't. Stay a Yankee."

Shortly after that, I decided it was time to announce my retirement. I had no idea how to do that. I had some experience with guys talking about retiring, but not with the logistics of it. Bernie hadn't made a formal announcement. Derek, Andy, Mo, and I hadn't ever had any kind of discussions about the subject of retiring, let alone how we planned to go out. I didn't like the feeling of not being prepared for something, but the Yankees organization stepped up for me. I contacted Jason Zillo, our head PR guy, and he set things up for me. As a result, there I was on January 24, sitting in a car waiting to make that turn. Once I did, there was no turning back.

At the press conference, after I'd said my tearful thanks, I was happy that several people told me that, based on how the year ended, it was clear that I still had gas in the tank. That meant a lot to me. That meant that I was still in control, that the decision was mine, not one that was being made for me by my body or my skills failing me or someone in a front office somewhere. I could go out on my terms and as a Yankee. The Yankees continued to be good to me during my retirement, and I just recently learned that they are

going to retire my number on August 22 this year. It will be an amazing honor, and I'm not sure that the reality of it has sunk in yet, or if it ever will.

As I had predicted while answering questions after my announcement, I did feel strange when camps opened and I was still home. I was antsy and adjusting to a new schedule and routine. Laura was suffering the most, telling me when I was too much underfoot, like a little kid, "Go see one of your friends. Go out and play." My work for so long had been playing, and now this added to my slight confusion. The more time passed, though, the less confused I felt.

As I said, making the decision to retire was never going to be easy—my emotions, once again, could get in the way as much as they could contribute to my success—but just as it's always been, the organization was great to me. I was thrilled that the Yankees invited me to throw out the first pitch to open the 2012 season. Being one of only 11 Yankees who have been invited back to throw out the first pitch on opening day put me in pretty exclusive company, and I thank everyone involved for that. My family and I attended the Welcome Home Dinner, and I was enormously grateful that the Yankees presented me with the Pride of the Yankees Award. Pride. Yankees. Those weren't just words to me. The family understood.

The plan was for me to throw that pitch to Mariano. Getting to the ballpark with my family and having my mom and dad with me made me realize that I could do things a little differently, make a meaningful moment even more special. I didn't want to embarrass myself with a bad throw, so I warmed up a bit before the game underneath the stands. My dad was standing there, watching me, and I thought of all the times the two of us had played catch when I was back home in Puerto Rico.

I took a break and said to Mo, "Do you mind if I throw it to my dad instead?"

Mo smiled. If anybody understood about family, it was him. "That's perfect."

I told my dad, and we got him a glove. I hadn't picked up a ball since that final Detroit game, and I didn't know how long it had been since he'd caught a ball. I threw one to him. He caught it, but he stared me down and said, "Don't fire one in there like that. Toss it. Toss it."

I knew that he didn't want to go out there in front of all those fans and not catch it. He's a proud man.

I'm his son, so I did what he told me.

Surrounded by my family and members of the Yankees representing all the guys I'd played with for those 17 seasons, I stood on the mound. I looked in,

and things seemed so different from that perspective, but I liked it.

Even with 50,000 people there, something felt familiar to me. I needed to focus. In that moment, things were back to how they had been—just my dad and me, tossing a ball around, both of us sharing a dream.

Acknowledgments

Even though I only played for one team in my entire career, I have a few teams to thank for making this book possible.

First, I have to thank my parents, Jorge and Tamara, for all their support and for everything they did to make me the man I am today. My sister, Michelle, has always provided me with support and unconditional love. My lovely wife, Laura, has always pushed me to become a better player and a better person. And I thank my beautiful kids, Jorge Luis and Paulina, for teaching me what true love really is. I love you all.

I'd also like to thank my agents, Sam and Seth Levinson, for making my life easier. To Michele Tronolone for always answering the phone when I needed her the most. To my attorney, Luis Espinel, for being my friend above everything.

I'd also like to thank Gary Brozek for his help in telling my story. Behind the scenes at HarperCollins, my editor Matt Harper was passionate about the book from the very beginning, as was Lisa Sharkey. It's great to have people in your corner supporting you, and I know that we all benefitted from the efforts of Matt's assistant, Daniella Valladares, to get the book complete. Thanks also to my publicist Danielle Bartlett for her hard work.

Lastly, I would like to thank the Steinbrenner family and the Yankees organization for supporting me and encouraging me through every part of my career. And to all my Yankees teammates and to all the fans, thank you for everything you have given me. Your help and support through the years made this whole journey possible.